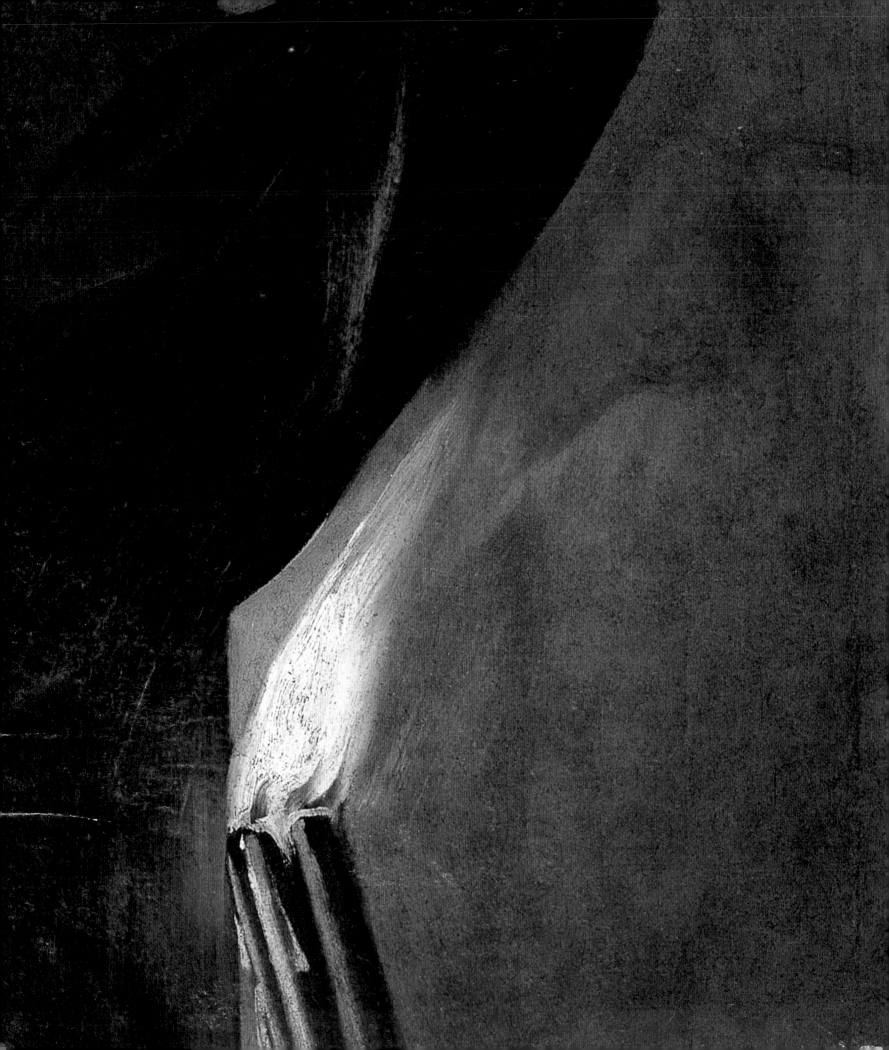

Caravaggio

The Final Years

 electa napoli

Electa Napoli

Editing
Silvia Cassani
Maria Sapio

Graphic Design
Paolo Altieri

Art director
Enrica D'Aguanno

Layout
Gianni Manna

Translation
Mark Weir

Printed in Italy
© copyright 2005 by
electa napoli srl
Gruppo Mondadori Electa S.p.A.
All rights reserved

ISBN 88 510 0277 0 Hardback
ISBN 88 510 0264 9 Paperback

Frontispiece
Michelangelo Merisi da Caravaggio
The Seven Works of Mercy, detail
(cat. no. 4)

Caravaggio
The Final Years

London, The National Gallery
23 February - 22 May 2005

Supported by the American Friends of the National Gallery as a result of a generous grant from Howard and Roberta Ahmanson

Presidenza
del Consiglio
dei Ministri

Ministero per gli Affari
Esteri

Ministero
dell'Istruzione,
dell'Università e della
Ricerca Scientifica

Ministero per i Beni
e le Attività Culturali

Soprintendenza
Speciale per il Polo
Museale Napoletano

Regione
Campania

Provincia
di Napoli

Comune
di Napoli

Steering committee
Keith Christiansen
Gabriele Finaldi
David Jaffé
Nicola Spinosa

Committee of honour
Silvio Berlusconi
Presidente del Consiglio dei Ministri
Franco Frattini
Ministro per gli Affari Esteri
Letizia Moratti
Ministro dell'Istruzione, dell'Università e della Ricerca Scientifica
Giuliano Urbani
Ministro per i Beni e le Attività Culturali
Nicola Bono
Sottosegretario di Stato Ministero per i Beni e le Attività Culturali
Raffaele Squitieri
Capo di Gabinetto Ministero per i Beni e le Attività Culturali
Roberto Cecchi
Capo del Dipartimento per i Beni Culturali e Paesaggistici del Ministero per i Beni e le Attività Culturali
Giuseppe Proietti
Capo del Dipartimento per la Ricerca, l'Innovazione e l'Organizzazione del Ministero per i Beni e le Attività Culturali
Salvatore Italia
Capo del Dipartimento per i Beni Archivistici e Librari del Ministero per i Beni e le Attività Culturali
Mario Serio
Direttore Generale per il Patrimonio Storico, Artistico e Demoetnoantropologico del Ministero per i Beni e le Attività Culturali
Stefano De Caro
Direttore Regionale per i Beni Culturali e Paesaggistici della Regione Campania
Antonino Caleca
Presidente del Comitato di Settore del Ministero per i Beni e le Attività Culturali
Charles Saumarez Smith
Director, The National Gallery, London

Antonio Bassolino
Presidente della Giunta Regionale della Campania
Salvatore Cuffáro
Presidente della Giunta Regionale della Sicilia
Dino Di Palma
Presidente dell'Amministrazione Provinciale di Napoli
Rosa Russo Iervolino
Sindaco di Napoli
Gaetano Cola
Presidente della Camera di Commercio, Industria, Artigianato e Agricoltura di Napoli
Marco Di Lello
Assessore ai Beni Culturali della Regione Campania
Teresa Armato
Assessore al Turismo della Regione Campania
Alessandro Pagano
Assessore ai Beni Culturali della Regione Sicilia
Fabio Granata
Assessore al Turismo della Regione Sicilia
Antonella Basilico
Assessore alla Cultura dell'Amministrazione Provinciale di Napoli
Rachele Furfaro
Assessore alla Cultura del Comune di Napoli
Giulia Parente
Assessore allo Sport e ai Grandi Eventi del Comune di Napoli
Nicola Oddati
Assessore al Turismo del Comune di Napoli
Fernando de Montemayor
Soprintendente del Pio Monte della Misericordia
Franzo Grande Stevens
Presidente Compagnia San Paolo di Torino
Antonio Maccanico
Presidente Associazione Civita
Gianfranco Imperatori
Segretario Generale Associazione Civita
Tommaso Iavarone
Presidente dell'Unione Industriali della Provincia di Napoli

Scientific committee
Denis Mahon (*president*)
Ferdinando Bologna
Dawson Carr
Keith Christiansen
Mina Gregori
David Jaffé

Executive committee
Nicola Spinosa (*president*)
Gioacchino Barbera
Maria Grazia Benini
Caterina Bon di Valsassina
Brigitte Daprà
Denise Maria Pagano
Antonio Paolucci
Albino Ruberti
Claudio Strinati
Mariella Utili

Exhibition secretariat
Brigitte Daprà and Tiziana Scarpa
with the collaboration of
Federica De Rosa

Acknowledgements to
Regione Sicilia

Conservation revision of works exhibited
Luigi Coletta, Alessandra Golia, Claudio Palma

Restoration
Laboratori di Restauro della Soprintendenza Speciale per il Polo Museale Napoletano: Giuseppe Abbagnato, Angela Cerasuolo, Giuseppe Marino, Vincenzo Nacarlo, Vincenza Pipitone.
Works of Mercy restored by Bruno Arciprete with the co-operation of Salvatore Borrelli, Edwina de Linares, Gloria Desiderio and Simona Sollazzo.
Diagnostic tests by Emmebici, Rome.
Salome with the Head of Saint John the Baptist, Madrid, Patrimonio Nacional, restored by Maite Camino Martín and Carmen Alquezar Gómez.
The Martyrdom of Saint Ursula restored by Donatella and Carlo Giantomassi

Photographic credits
Barcelona, Rocco Ricci
Bordeaux, Musée des Beaux-Arts, © cliché du M.B.A. de Bordeaux, photographer Lysiane Gauthier
Catania, Comune di Catania, Gestione Patrimonio Storico-Artistico, Museo Civico di Castello Ursino
Cleveland, The Cleveland Museum of Art
Florence © 1999 Scala
Firenze, Gabinetto Fotografico Soprintendenza Speciale per il Polo Museale Fiorentino
Genoa, Archivio Fotografico Soprintendenza per il Patrimonio Storico, Artistico e Demoetnoantropologico della Liguria, Roberto Caccamo
Macerata, Pinacoteca Comunale
Madrid, Patrimonio Nacional
Messina, Laboratorio Fotografico Galleria Regionale, Alessandro Mancuso
Milan, Archivio Fotografico Soprintendenza per il Patrimonio Storico Artistico e Demoetnoantropologico di Milano
Nancy, Musée des Beaux-Arts, C. Philippot, 1998
Naples, Archivio Fotografico Soprintendenza Speciale per il Polo Museale Napoletano
Naples, Luciano Pedicini/Archivio dell'arte
New York, The Metropolitan Museum of Art, The Photograph Library, 1997
Rome, Archivio Fotografico Soprintendenza Speciale per il Polo Museale Romano

Rome, Antonio Idini
Rouen, Musée des Beaux-Arts, photography Catherine Lacien, Carole Loisel
Syracuse, Museo Regionale della Sicilia
Vienna, Kunsthistorisches Museum
For illustrations of paintings, © copyright of the owners

Authors of catalogue entries
Vincenzo Abbate v.a.
Gioacchino Barbera g.b.
Gabriele Barucca g.ba.
Ferdinando Bologna f.b.
Arnauld Brejon de Lavergnée a.b.l.
Dawson Carr d.c.
Keith Christiansen k.c.
Anna Coliva a.c.
Mina Gregori m.g.
Ferdinando Peretti f.p.
Keith Sciberras k.s.
Ludovica Sebregondi l.s.
David M. Stone d.m.s.
Rossella Vodret r.v.

Translation from French
Giuseppina Ianni

Soprintendenza per il Polo Museale Napoletano
Annachiara Alabiso, Luisa Ambrosio, Lelia Anzano, Umberto Bile, Vittorio Brunelli, Fernanda Capobianco, Maia Ida Catalano, Silvia Cocurullo, Ileana Creazzo, Katia Fiorentino, Fara Fusco, Paola Giusti, Liliana Marra, Linda Martino, Luisa Martorelli, Serena Mormone, Rossana Muzii, Rita Pastorelli, Lilia Rocco, Marina Santucci, Maria Tamajo Contarini, Angela Tecce; Michele Alfieri, Adriana Boccanera, Luigi Calcinella, Paola Castaldi, Giovanni Cerbone, Rita Cuomo, Antimo D'Abrunzo, Giosuè De Angelis, Lucio De Matteis, Giuseppe Esposito, Silvana Grassi, Venanzio Guarino, Gennaro Iorio, Cristina Liguori, Sergio Liguori, Vincenzo Manciacapra, Gennaro Mancinelli, Vincenzo Mancinelli, Biagio Mauriello, Ciro Mauriello, Tommaso Musella, Rosanna Naclerio, Vincenzo Paciello, Anna Palmieri, Silvana Pelvi, Agrippino Piscopo, Francesco Porzio, Maria Rosaria Riccucci, Callisto Russo, Anna Santoro, Salvatore Scatozza, Antonio Tirelli, Pasquale Totaro, Giuseppe Troso, Lucia Tucci, Antonio Velotti, Maurizio Vitiello, Mario Zurlo; il personale di vigilanza del Museo di Capodimonte

Soprintendenza per i Beni Architettonici e Paesaggistici e per il Patrimonio Storico, Artistico e Demoetnoantropologico di Napoli
Enrico Guglielmo
Laura Giusti, Flavia Petrelli, Anna Pisani

Grateful thanks for collaboration and suggestions to
Cristina Acidini Luchinat, Santiago Alorda, Antonella Amorelli, Carlo Arditi di Castelvetere, Alberto Arditi di Castelvetere, Gloria Arditi di Castelvetere, Luisa Arrigoni, Angel Baleo González, Giovanni Barzòli, Delfina Bergamaschi, Maria Grazia Bernardini, Pino Bianco, Carmela Borruso, Stefano Casciu, Giovanni Castellaneta, Daniela Cecchini, Lina Cennamo, Blandine Chavanne, Rosaria Cicarelli, Gaetano Cioffi, Anna Coliva, Giuseppina Coniglio, Marcello Dell'Utri, Emanuela De Luca, Rosario Díez del Corral Garnica, Heidi Disko, Dominique Ducassou, Ch. B. H. Faber, Alvaro Fernández Villaverde y Silva, Maria Teresa Fiorio, Maria Luisa Fuente Martinez, Sarah Francis, Benvenuto Gamba, Maria Grazia Gargiulo, Claudio Gasparrini, Sergio Gelardi, Maria Teresa Giannotti, Peter Glidewell, Giuseppe Grado, Fabio Granata, Venera Greco, Alessandra Gregori, Silvana Grosso, Vittoria Guazzelli, Mary Hersov, Michel Hemmer, Ivana Iotta, Fouad Kanaan, Elisabetta Kelescian, Luigi Koelliker, Enrica Landini Capoquadri, Gioacchino Lanza Tomasi, Olivier Le Bhian, Katherine Lee Reid, Fabrizio Lemme, Gianpaolo Leonetti di Santojanni, Valentina Maderna, Anna Marcone, Juan Carlos de la Mata Gonzalez, Josè Milicua, Lorenza Mochi Onori, Philippe de Montebello, Rosanna Morozzi, Marzia Moschetta, Mariella Muti, Eduardo Nappi, Fausta Navarro, Marina Nelli, Vincenzo Pacelli, Serena Padovani, Aldo Parisi, Corrado Passera, Maria Patanè, Ornella Pazienza, Vincenzo Pelvi, Nuria Poch, Wolfgang Prohaska, Miguel Angel Recio Crespo, Fulvio Rocco, Pierluigi Rocco di Torrepadula, Giancarlo Rossi, Stefania Santini, Paolo Sapori, Umberto Scapagnini, Olga Scotto di Vettimo, Alessandra Sfrappini, Gretchen Shie Miller, Fatima Terzo, Giovanni Trevisan, Charles L. Venable, Gerhard Wiedmann, Ugo Zottin

Acknowledgements to lenders
Bordeaux, Musée des Beaux-Arts
Catania, Castello Ursino
Cleveland, The Cleveland Museum of Art
Cremona, Pinacoteca Civica Ala Ponzoni
Florence, Galleria Palatina
London, The National Gallery
Macerata, Pinacoteca Civica
Madrid, Patrimonio Nacional
Messina, Museo Regionale
Milan, Pinacoteca di Brera
Nancy, Musée des Beaux-Arts
Naples, Banca Intesa
Naples, Sanpaolo Banco di Napoli
Naples, Pio Monte della Misericordia
New York, The Metropolitan Museum of Art
Rome, Galleria Borghese
Rome, Ministero dell'Interno - Fondo Edifici di Culto
Syracuse, Palazzo Bellomo

Further thanks to
Ministero dell'Interno - Direzione Centrale per l'Amministrazione del Fondo Edifici di Culto

Note
The order of the catalogue entries corresponds to the chronological hypotheses of the authors

contents

sponsor's preface

In 1951 the respected Italian Caravaggio scholar, Roberto Longhi, organised a show in Milan called *Mostra del Caravaggio e dei Caravaggeschi*. Ever since that event, Caravaggio has held a special place in our contemporary imagination. As Helen Langdon put it in her biography, *Caravaggio: A Life*, '[Caravaggio] has risen to new and unparalleled fame, celebrated initially as the first popular artist, a rebel who cast aside academic convention and ideal beauty'.

Caravaggio remains an enigmatic figure. In the years since 1951, scholars have seen in him a wide range of personas – the storyteller, the metaphysical existentialist, the narcissist, and the homosexual artist. Recent research has shed new light on this hard-to-define but clearly gifted man. Scholarship carried out by Keith Sciberras for this exhibition removes a part of the mystery shrouding Caravaggio's time in Malta.

Born in 1571, the year that the forces of the West defeated an Ottoman armada at Lepanto in the Corinthian Gulf, Caravaggio grew up in Counter-Reformation Italy. It was a time when the Church sought to infuse the images it defended with new life. And church leaders insisted that beauty was to be found in the commonplace: everyday things, everyday people. That, Caravaggio did with a vengeance. Often his artistic success, his portrayal of beauty in the commonplace, meant his works were rejected by a public not quite ready for such honesty.

This show, the first to focus on the years after he had to flee Rome for his part in a murder, gives us the first coherent view of Caravaggio working under fire. We live in a visual age, an age perhaps better equipped than many to grasp the message behind the work of Caravaggio, perhaps even better able to begin to comprehend the man. Over the past decade we have sponsored several art exhibitions, on Stanley Spencer and Grant Wood for example. Each time our goal has been to contribute to a deeper understanding of what it means to be human through the insight into that mystery that can only be gained by encountering provocative images such as these. In that spirit, it is our joy to be a small part of *Caravaggio: The Final Years*.

Howard and Roberta Ahmanson
Fieldstead and Company, Irvine, California

Visitors to the National Gallery have been able to appreciate Caravaggio's *Supper at Emmaus* since 1839, when it was presented by Lord Vernon. But only in the last generation has it become one of the most popular paintings in the collection. Today Caravaggio's paintings speak with unusual directness to a wide variety of audiences. We are compelled by his extraordinary skill at recording reality in paint, but his popularity ultimately derives from his ability to convey the drama of everyday life, the universal desires and fears that we share across the centuries. These aspects of his art created a sensation in his own time, but his intense realism was largely forgotten a century after his death. It was not until Roberto Longhi's monumental exhibition in Milan in 1951 that Caravaggio's stature as an artist began to gain widespread recognition. In the half century since, many exhibitions have contributed to our picture of the artist, but none has addressed his final years, the period of his exile from Rome.

The National Gallery has long wanted to show its paintings by Caravaggio in the context of a major exhibition. Over the years, many proposals were considered, but when Professor Nicola Spinosa invited us to take part in the present exhibition, it was clear that the project offered an exceptional opportunity for original scholarship as well as the potential for great popular appeal. The exhibition features two of the National Gallery's paintings. Although the *Supper at Emmaus* was painted in 1601, it will be juxtaposed with Caravaggio's second version of the subject from the Galleria di Brera, Milan, painted shortly after his flight from Rome, to demonstrate his remarkable stylistic development and serve as a point of reference in the assessment of his last paintings. *Salome receives the Head of Saint John the Baptist*, produced towards the end of his life, will be compared with his other half-length narrative paintings of this period, in which subject and execution are reduced to essentials.

We are especially grateful to Professor Nicola Spinosa and the staff of the Soprintendenza per il Polo Museale di Napoli, and we look forward to many future collaborations. We must also express our gratitude to our former Curator of Spanish and Later Italian Paintings, Gabriele Finaldi, who even after he became Deputy Director of the Museo del Prado, Madrid, has helped with the arrangements for this exhibition. The curatorial responsibilities at the National Gallery were assumed by his successor, Dawson Carr, in 2003, who has picked up the baton with great flair. We would also like to offer great thanks to Philippe de Montebello, Director, and Keith Christiansen, and Jayne Wrightsman, Curator of European Paintings, at the Metropolitan Museum of Art, New York, for their exceptional generosity and kindness in the making of this exhibition.

Several British scholars played pioneering roles in the study of Caravaggio's art and the redemption of his reputation. On the occasion of this, the first major exhibition of Caravaggio's paintings in the United Kingdom, we would like to pay special tribute to Roger Hinks, Michael Kitson, and particularly Sir Denis Mahon. Sir Denis's contributions now span more than half a century. He published his first articles on Caravaggio in 1951 and his passion for the artist has never waned. Ever vital at 94, he is busy working on his next project on the artist. The National Gallery has especial cause to thank Sir Denis because he championed the purchase of *Salome receives the Head of Saint John the Baptist* in 1971, as well as the *Boy Bitten by a Lizard* in 1986. The acquisition of the *Salome* was particularly difficult, even though Sir Denis was a Trustee, because Caravaggio's late style was not so well understood or appreciated at the time. Indeed, this period of Caravaggio's career remains the least understood, and we hope that Sir Denis will be pleased to see the *Salome* in the context of this exhibition, which he has supported from the outset.

We are particularly grateful for the support this exhibition has received from the American Friends of the National Gallery as a result of an extraordinarily generous grant from Howard and Roberta Ahmanson. Their generosity stems from their enthusiasm for Caravaggio's powerful treatments of religious subjects and we thank them for helping us present this exhibition to the public.

Charles Saumarez Smith
Director, The National Gallery

It has been twenty years since the major exhibition dedicated to *Caravaggio e il Suo Tempo* was mounted in the Capodimonte Museum in Naples. Now, *Caravaggio, The Final Years*, an unprecedented collection of works produced during the final years of this great Lombard painter, highlights this essential period in his life.

It is indeed an occasion of great international significance that after Naples the exhibition has transferred to the National Gallery in London, an institution associated with the Capodimonte Museum through a long-standing relationship of reciprocal, fertile collaboration. There have been many spectacular exhibitions devoted to Caravaggio but we are not often privileged to see such a succession of masterpieces. This exhibition enables us to reconstruct the last years of a genius who never spared himself and who proved fundamental for the history of art.

Together with the Ministry of Heritage and Cultural Activities and the Campania Regional Council, the support of many prestigious institutions has made it possible not only to mount the exhibition itself, but also to effect long-awaited conservation and restoration, permitting the ideal combination of the display and preservation of our artistic heritage.

We are particularly proud that Naples, venerable European capital *par excellence* and cradle of Mediterranean civilisation, can share with London this opportunity to emphasise the importance of our cultural patrimony.

Giuliano Urbani
Minister for Cultural Heritage and Activities

Caravaggio exerts the irresistible appeal of a personality close to our modern sensibility, and truly universal. There could be no better way of enhancing the itinerary which, first in the rooms of the Museum of Capodimonte in Naples, now in the National Gallery in London, leads the visitor through the evolution of the culture and figurative art of the South of Italy.

Furthermore, as if the occasion was not remarkable enough, thanks to the collaboration of numerous partners and institutions which have supported the Regional Council of Campania and the Italian Ministry for Heritage and Cultural Activities, some of the Lombard master's most renowned works have been scrupulously restored. Viewers will thus be able to experience the tragic epilogue of the life of a genius more profoundly and with greater immediacy than ever before.

It is the crucial period from 1606 to 1610 which this exhibition places in the limelight, the arrival in Naples in the summer of 1606, in precipitous flight from Rome by way of the Lazio estates of the Colonna family; the stay in Malta, brusquely interrupted once again by misadventures, now better known to us; then the months spent in Syracuse, Messina and Palermo, before returning to Naples, fleeing his would-be assassins and apparently pursuing honours and pardons which, however implausible in judicial terms, were unlikely to be denied him by his well-placed patrons, so enthralled by the artistry of his 'scandalous' idiom. These four years of ceaseless travelling, intricate personal adventures and masterpieces of rare intensity and unprecedented innovative force were to change the course of European art, revolutionising the traditional canons with a bold and brilliant language.

Is it a coincidence that Michelangelo Merisi da Caravaggio became so intensely involved with Naples, this crossroads of ancient civilisations and crucible of talent in both the arts and the sciences, torn by irreconcilable contrasts but with the capacity, so remarkable for a metropolis, to constantly regenerate itself?

Four hundred years on, and with not a little secret pride, we leave this question to the intelligence and curiosity of all those visitors who take advantage of this unique occasion to admire Caravaggio at first hand.

Antonio Bassolino
President of the Regional Council, Campania

10

Preface

Nicola Spinosa
Superintendent, Polo
Museale Napoletano

The years Caravaggio spent travelling between Naples, Malta and Sicily were the most intense and arduous in his life, both in his personal affairs and for his art. They followed the infamous episode of the death of Ranuccio Tomassoni, in the summer of 1606, when Caravaggio was forced to flee Rome after killing his comrade in a dispute over a ball game. This precipitous departure must have cost him dear, at least in terms of his life-style and prospects, because it came just as he was beginning to savour success. His art displayed a new visual dynamism and disconcerting immediacy as he reproduced moments and details of everyday reality in the aspect of eternal truths. His appreciation of human and natural phenomena was immediate, direct and unconventional, and this resulted in a new approach to painting. He would fix on the canvas, amid stark, searing contrasts of light and shadow, fragments – we might almost say – of 'revealed truth', human situations captured at the moment of greatest tension, not just physical but also emotional and psychological. This involved a profound renovation of the practice of painting, all the more striking for taking place in Rome, where the Counter-Reformation tendencies of the *maniera tarda* still held sway. Following a difficult but nonetheless impressive debut, above all in the service of the Cavalier d'Arpino, he had formed close and fruitful professional, and personal, relationships with some of the leading lights in the most culturally advanced and, in its own way, mould-breaking milieu in the capital. The salient figures, from both lay and religious walks of life, were Cardinal Scipione Borghese, nephew of Pope Pius V, the Giustiniani brothers, Ciriaco Mattei, Maffeo Barberini and Cardinal

Francesco Maria del Monte. These men were among the most active patrons of the young painter from Lombardy, providing him with commissions and also buying his products as collectors. And now, as a result of the absurd and futile crime, the outcome of a litigious and impulsive nature, these professional relationships and ties of friendship risked being severed definitively.

In fact, even when he was away from Rome, Caravaggio always found plenty of work which was just as important and prestigious. This was the case during his brief stays at Paliano, Palestrina and Zagarolo, but also during the hectic years of his restless roaming around the Mediterranean, between Naples and Valletta, Syracuse, Messina, Palermo and back to Naples again, anxiously awaiting the papal pardon which would enable him to return to Rome, as he so longed to do.

Caravaggio's final years, then, witnessed a series of outstanding artistic achievements which still appear quite incredible to us today, if only for the circumstances in which the works were executed; they were years of a truly turbulent and picaresque existence, terminating in a little hospital at Porto Ercole, where the artist died, perhaps from malarial fever, certainly in abject solitude. These are the years to which our Soprintendenza has chosen to dedicate the exhibition which opened here at Capodimonte.

The exhibition grew out of a project which I initially proposed as a joint venture to David Jaffé and Gabriele Finaldi at the National Gallery in London, and which was subsequently greeted with enthusiasm by Philippe de Montebello and Keith Christiansen at the Metropolitan Museum of Art in New York. During the first preparatory meetings we had to face up to the difficulty of securing authorisation for loans for three different venues, and it was agreed with Philippe de Montebello and Keith Christiansen that the exhibition should be presented only in Naples and London, but would continue to benefit from the latter scholar's expertise.

11

Certainly it can be objected, and in one quarter it already has been, that there have been any number of exhibitions on Caravaggio. These often feature what is purported to be 'his circle', or even, as quite recently to great acclaim from art-goers and, let it be said, from art critics, merely photographic reproductions, albeit in 'life size' dimensions, of the whole of his known production. Or again, there are the exhibitions which trade on his name, and not always coherently, on account of a few pictures of uncertain attribution. This phenomenon will continue, I am sure, and not because it meets any real scientific or cultural need, but simply because – as everyone knows – the name 'Caravaggio' is a guaranteed crowd puller (in Italy and abroad, in Rome as in Mantua, Sidney or Tokyo) and, above all, generates income, which is what counts for organisers and the services sector. Caravaggio, 'peintre maudit' par excellence (formerly by tradition and nowadays from expediency), has joined company with other famous artists from the distant or not so distant past – the Impressionists, in particular, but also Van Gogh, Gauguin and the prolific Picasso, for example – to draw in, with the complicity of the media, never-ending queues of 'dutiful', excited visitors, for the greater glory of politicians and local administrators and the benefit of publishers and purveyors of posters, postcards and assorted merchandise. It hardly matters, when the doors open, whether the public realise (but how many will, of the few who actually see the exhibition or know what they are looking at?) that the vast majority of these exhibitions are simply inflated 'events', if not downright frauds based exclusively on commercial interests.

What can be done about this? In terms of sensibility, visual intelligence and good taste, it reflects all too accurately the cultural level of the vast public who throng to the innumerable exhibitions that have sprung up in Italy and abroad over the last few years. Sometimes they even overlap, and are put on in far-flung venues, so that no one can possibly manage to visit them all. They invariably lay claim to the collaboration of experts 'of great distinction', professionals who are either too ready to please or too conniving.

And meanwhile, faced with these 'hugely successful' exhibitions, our museums are increasingly poorly attended (the few exceptions of the 'must sees' on the mass tourist circuit do not count). Cut off from the surrounding civic and cultural reality, they are slowly sinking into neglect and oblivion. Of course a museum – as I know only too well – is no easy option in the leisure sector. It possesses less 'popular appeal' and is less attractive than a temporary exhibition, especially if the latter features a big name or 'fashionable' artistic movement. The museum may suffer from inadequate display facilities or reception services, it may be insufficiently or badly publicised, or it may lack even the most basic presentations of its history and contents. To this we have to add the constant (and increasing) lack of financial and human resources (both in numerical terms and from the point of view of professional competence), with all the dramatic and patent consequences this has on museum management. (It is still to be seen whether the entry of private backers, however laudable in principle, is really going to improve matters, at least here in Italy.)

There can, however, be no doubt that, despite its structural and organisational limits and even with recurrent shortcomings in the display criteria, the museum is always (or almost always) a genuine 'treasure trove' of exceptional art works and objets d'art, providing the occasional sensational 'discovery' and unfailing enrichment, and also in many cases a place for people to meet and socialise, much more so than a one-off exhibition.

The crisis of the museum vis-à-vis temporary exhibitions has reached dramatic levels in Italy, but is also affecting other countries in Europe and beyond. A wide-ranging and in-depth debate is called for, including a degree of self-criticism on the part of museum directors and keepers, if we are to safeguard what is still an extraordinary and indispensable instrument of civic and cultural growth, before it is put into the dangerous care of managers and hands-on economists.

However, let us get back to the exhibition highlighting the final years of Caravaggio and consider its aims and, even, some of its limitations. This is an exhibition, as I said before, which focuses on the last four years of the artist's activity, prior to his sad demise in a little hospital at Porto Ercole, in the baking hot marshland of the Tuscan maremma. He had left Naples confident of his imminent papal pardon, taking with him on the felucca bound for the coast of Lazio, not far from Rome, three of his most recent works (possibly his last, but not necessarily). They were intended as a gift for Cardinal Scipione Borghese, the powerful nephew of the Pope who had continued to protect and appreciate Caravaggio even after the latter's flight from Rome, although we know that the Cardinal only received one painting, the Saint John the Baptist now in the Galleria Borghese, Rome.

Since his arrival in the summer of 1606 in Naples, the densely populated and effervescent southern capital of the Spanish Viceroyalty, Caravaggio had found lodging

and unfailing protection from the Colonna family. Many other patrons and collectors (not only Neapolitans) had also been generous with their support, requesting works from him up to the last moment, and putting up with his 'impossible' character. Following his successes and 'misadventures' in Malta and his prolific roving in Sicily (how many paintings, and on such a scale, painted in such a short time!), he returned once again to Naples and to the residence of the Marquise Costanza Sforza Colonna, in Borgo di Chiaia. Over the next few months he painted a series of pictures which in their quintessential pictorial realism were more astonishing than anything he had yet done, as if he sensed his approaching end. Yet for all that he did not renounce his habit of frequenting seedy taverns and bad company, which as we know led to serious consequences.

Thus during this final period Caravaggio's prestige was untarnished, his intense and uninterrupted activity meeting with extraordinary success, whatever certain recent 'biographies' may claim. These four years were marked by an increasing, almost breathless clinging to life, and at the same time, in stark contrast, by a more mature awareness of the precariousness of existence, and a more sensitive and tempered knowledge of the tragic human condition. The artist acquired a new, more direct and comprehensive understanding of grief: not so much physical as interior, affecting the soul more than the body, as a result of his perception of how the brief and ephemeral reality of each and every human existence is profoundly branded by insuperable limits and privations. This had decisive consequences on the development of his art, conditioned by the radical conception of painting as the only concrete and immutable testimony to the value of man.

It is these final years of the life and activity of Caravaggio to which our exhibition is dedicated, apart from immediate precedents which document his brief passage, on the territory of Lazio, between Palestrina and Zagarolo, from his affirmation in Rome to the first successes in Naples. Certainly, given the immense difficulties in securing some of the loans (what museum or private collector, in fact, would ever choose to be parted, even for just a few months, from 'his or her' Caravaggio, whether authentic or presumed?), it is a small-scale exhibition. No more than twenty pictures, if that, all certainly by the Lombard master, to which we have decided to add some seventeenth-century copies (exhibited only in Naples) of lost originals and a limited number of paintings which, amid doubts and dissenting voices, have been proposed, in the past or recently, as belonging to this final phase of his activity. First-hand

comparison with the works certainly by Caravaggio on display *should* make it possible (the conditional is obligatory, since considerable personal and commercial interests are at stake) to 'say the last word' on such proposals.

A small exhibition, certainly, but what an exhibition, if I may say so with a certain pride, and what a remarkable sequence of 'masterpieces'! All this in defiance of those who, excluded from the organisation of this initiative, have been decrying it for some time past and will no doubt continue to do so, criticising its opportuneness, its contents and its limits. And also in spite of those who, blessed with conspicuous financial support (and we are still waiting for the resources promised by the Ministry to materialise), exploit the name of Caravaggio to give lustre and appeal to 'great events', or which at any rate are highly publicised as such, but prove to be none other than so many flashes in the pan.

One of the masterpieces included in the exhibition in Naples but unfortunately not able to travel to London is the *Seven Works of Mercy* (no.4), sensitively restored and cleaned for the occasion. It is a scene which appears to have been painted from life, in a dark malodorous alleyway of the Naples of the Spanish Viceroys, amid striking contrasts of light and shadow, of misery and nobility. A young woman, child at her breast, is seen on a balcony, amid washing out to dry and some galants, perhaps come to 'pay her court'; a rotund and rubicond innkeeper invites some taciturn, grim-faced noblemen, certainly of the 'cape and sword' brigade, into his smoky dive, where a drunken madman is gulping down solace straight from the jawbone of an ass. In the foreground a beggar is awaiting his rightful alms; and a florid wench is giving her breast to a wizened old man. Meanwhile further off, in torch-light, the graveyard shift is taking place, accompanying the departed to his final resting place. This is early seventeenth-century Naples, an ancient and crowded metropolis, part Greek, part Roman and part Spanish, chaotic and uninhabitable then as now, which welcomed the fugitive from Rome. Caravaggio was able to appreciate, with his heart as much as his eye or mind, to just what a degree of frustration, marginalisation and soul-destroying desolation the human condition could sink, among hopes constantly dashed, rare intervals of carefree festivities and more frequent occasions of unspeakable grief, an existence marked by drama and tragedy. At the same time he recognised how this same reality could give rise, precisely in the most humble and deprived sectors, to extraordinary examples of dignity and profound humanity, concrete acts of individual and collective participation in the troubles and sufferings of

others, even against a background of senseless violence and intolerable abuse of power.

The *Flagellation* (no.6), which Caravaggio painted during his first stay in Naples for the de Franchis family in San Domenico Maggiore, is, as Ferdinando Bologna shows in the catalogue, an exact reprise of a superb work by Titian on the same subject. The latter painting, displayed at Capodimonte some time ago, works on different levels of visual intensity. No difference is made between the powerfully built, heroic figure of Christ at the column and the no less monumental physiques of his vigorous and aggressive captors, just as no distinction is made between the oppressed condition of the victim and the impassivity of his masters, all are united in the common immutable destiny of pain and death.

Among the other pictures on display are the *Supper at Emmaus* from the National Gallery, London (no.1), and the Pinacoteca di Brera, Milan (no.2), *The Crucifixion of Saint Andrew* from the Museum of Art, Cleveland (no.5), and the two versions of *Salome with the Head of Saint John the Baptist* from London (no.14) and Palacio Real, Madrid (no.13). All represent fundamental stages in the artistic maturing of Caravaggio during his first stay in Naples. Despite being made for different commissions, all are characterised by increasingly dense and sombre shadows, and by the presence of characters whom we have already 'met' in the two works described above, the citizens whom the artist could observe each day in the alleys and taverns of Naples.

Since it was impossible – for reasons of size – to secure the loan of *The Beheading of Saint John the Baptist* from the Cappella degli Italiani in the Co-Cathedral of St John, Valletta, but also, for entirely specious reasons, the *Saint Jerome* now in the Museum of the Co-Cathedral, we come to the paintings assigned by critics to the end of the artist's stay in Malta and the beginning of his intense and frenetic activity in Sicily: the *Sleeping Cupid* (no.8) and the presumed portrait of Antonio Martelli (no.9) from the Galleria Palatina, Florence (the loan of the famous *Portrait of Alof de Wignacourt* in the Louvre, Paris, which is now excluded by some critics from the corpus of unquestionably autograph works, was refused, in what has apparently become standard practice for the Louvre).

Thanks to the highly responsible attitude of the scientific and administrative staff of the Regione Siciliana, we are fortunate to have three pictures from Caravaggio's activity in Sicily. *The Raising of Lazarus* (no.11) presents a confrontation with daily reality in which the mental and emotional overtones dominate the purely visual impact. The artist has perceived this reality in a world enveloped in gloomy, impenetrable darkness, inhabited by wandering spectres who have been transfixed, immobile as the statues in stone or marble of ancient heroes and pagan divinities, eroded by the passage of time. The solemn, silent *Adoration of the Shepherds* (no.12) is a sort of 'snapshot', a moment of tranquil familiarity, an unexpected hiatus in the frenetic rhythm of everyday living, yet genuine and profound, intimate and almost domestic, such as is only to be found in a gathering of the meek and pure in heart. The large altarpiece of *The Burial of Saint Lucy* (no.10), despite being marred by past damage and quite recent conservation work, is another superb and disquieting fragment of an intimate drama, at once individual and collective, which takes place in the vastness of an emotional and immutable silence, captured in the instant of maximum tension, scrutinised and plumbed merely through the medium of painting, fixed for ever on the canvas, with sudden gleams of light amid the encroaching shadows, in all its absolute and unforgiving reality.

And then again, bringing the exhibition to a close – surely a close to take one's breath away – the paintings Caravaggio did on his return to Naples, prior to his ill-fated sea voyage to Rome: *David with the Head of Goliath* in the Galleria Borghese (no.16), *The Denial of Peter* in the Metropolitan Museum, New York (no.17), the unfinished *Annunciation* in the Museum of Nancy (no.15), *Saint John the Baptist* (no.19), also in the Galleria Borghese, and *The Martyrdom of Saint Ursula*, painted for Prince Marcantonio Doria in Genoa and now the property of Banca Intesa (no.18). The latter is perhaps the most completely documented work of Caravaggio known to us, and while not necessarily his last, it undoubtedly stands as both an existential and artistic testament, the last statement of a man who showed himself capable of loving life and art beyond all limits, even unto death. This painting suffered irreversible alterations in the past, but has recently been conserved and restored at the expense of its owners, Banca Intesa. It focuses, with images of moving visual impact and an intensity equal to that of some recent 'real life' video sequences of savage violence and terror, on the scene of a barbarous crime, involving a violent death, which caught even the protagonists unawares. In this picture everything is frozen for eternity, each gesture, each physical and mental reaction, even the air itself, gloomy and thick. Yet, unlike a photograhic still, everything is expressed exclusively through its pictorial quality: dark, unfathomable shadows, sudden illuminations, fragments of hands, limbs, bodies, glimpses of faces, terrified or appalled, of clothes and precious fabrics, plumed hats

and scintillating swords. A scene of ordinary if disquieting madness: truly the illustration of the martyrdom of a saint. This was the brief of the high-ranking nobleman who commissioned the work, and yet for the artist it is merely, or first and foremost, the hallucinatory representation of the martyrdom of a defenceless human being in all her essential fragility. And for Caravaggio this constitutes the eternal condition of the human race, the individual up against the abrupt violence of a destiny which is fixed and irreversible and which, just as in this work, not even the outstretched hand of a friend or a loved one can avert.

The only expedient enabling us to accept our inescapable destiny is to live to the full the time allotted to us, however short. And Caravaggio, even *in extremis*, was always strong in the knowledge of the eternal, boundless value of the practice of art and painting, working with passion and enthusiasm, without hesitation or respite, eschewing all ambiguity and compromise.

And this is precisely what this exhibition, with all its limitations, sets out to document and demonstrate.

* The following works could not be lent, for various reasons: Louis Finson, *Magdalen in Ecstasy*, Marseille, Musée des Beaux Arts; Caravaggio, *Flagellation*, Rouen, Musée des Beaux Arts; Caravaggio (?), *Portrait of Alof de Wignacourt with Page*, Paris, Musée du Louvre; Caravaggio, *Saint Jerome writing*, Valletta, Museum of the Co-Cathedral of St John; Louis Finson, *Resurrection*, Aix-en-Provence, church of St Jean de Malte.

Caravaggio, the final years (1606-1610)
Ferdinando Bologna

If we were to reconstruct the history of 'Caravaggio's final years', as this exhibition is entitled, merely on a chronological basis or as a succession of events, we would have to start from 28 May 1606, when the painter inflicted a mortal wound on Ranuccio Tomassoni during an altercation in Campo Marzio (also apparently sustaining injury himself), and was obliged to flee Rome. If, however, the historiographic enquiry is to consider, as it should, the artist's inner convictions, in the context of his own approach to his art, then our starting-point must be a good deal further back.

It seems there is a growing tendency among scholars to endorse the belief that the fundamental orientation of Caravaggio's art lay in his 'submission' to the Church of the Counter Reformation ('a basic tenet, indeed one which was continually reiterated', is how Maurizio Calvesi put it). A prime element in this orientation is held to be a personal connection with the Cardinal of Milan, Federico Borromeo, of whom the painter is alleged to have been not just a disciple in matters of devotion, and an interpreter in the subtle symbolism of Christology, but indeed, from an early age, a protégé (Calvesi once again). The connection is then extended to the most distant ramifications of the Borromeo kinship: in particular to the Marquises of Caravaggio, who had dealings with the artist not only at his birth and the outset of his career but also when he was in Naples, as he took ship for Malta in June 1607, in Malta itself, and again in Naples in 1609–10, and even posthumously, in the days following his death on the beach at Port'Ercole (Calvesi once again, but also some unlooked-for adherents). Our starting-point must thus be a rigorous verification of the historical basis for such a connection.

In my opinion, this verification can, and indeed must, depend on the following passage I have found among the papers, as yet unpublished, of Cardinal Federico Borromeo in the Ambrosiana in Milan:

'In the order of human things, men of science have observed a certain exquisite correspondence, and proportion, on which they have this to say. That just as is the condition of the ground, so (are seen to be) the fruits and crops ..., and as are human bodies, so is ordinarily, speaking naturally and in the majority of cases, the condition of minds, and lastly as is the condition of men's minds, so is the condition of their works; for the which, it must be true that the vices of the author, writing under certain shadowy and dark influences, will be apparent. Thus we know that Virgil was extremely prudent in every action of his life, but this was not the case for Messer Trifone or Burchiello. In my times I knew a painter in Rome, who was of slovenly habits, and always went about in tattered clothes which were terribly dirty, and lived amongst the scullions of the noblemen at Court. This painter never did anything of worth in his art except depicting taverners and gamblers, gypsy women who read hands, and the cripples, delinquents and paupers who sleep out in the public squares; and he was the happiest man in the world when he had painted an inn, with whoever was eating and drinking therein. This was the consequence of his habits, which were just like his artefacts'.[1]

This passage was first published fourteen years ago by Tiziano Margetich and has been republished several times, also by the present author,[2] when I drew attention to it as 'the most important new information to have appeared in recent years concerning Caravaggio'. Without exception, scholars concur in recognising this 'painter' of 'slovenly habits' as Caravaggio in person: the mention of paintings featuring 'gypsy women who read hands', 'taverners', 'gamblers' and 'cripples' is a clear allusion to well-known early works of Caravaggio, such as the 'portrait of an innkeeper offering hospitality', the two versions of the gypsy woman telling the fortune of a young man encountered in the street, the tavern boys who dress up as Bacchus and the card sharpers – in a picture 'comprising three half figures at a game of cards' which came to be known as the 'Cheats' – can surely leave no doubt whatsoever. Moreover, while it is clear that the Cardinal only mentions works and events relating to the first years of Caravaggio's activity in Rome (from 1592 to the end of the century), corresponding precisely to the period Borromeo spent in Rome (from 1587, when he was created cardinal, to 1601, when he occupied the cathedra in Milan, assigned

to him in 1595), it is equally clear that this account coincides perfectly with the idiosyncrasies for which the young artist was criticised by all his 'moralistic' biographers over the following decades, and not only by them. As early as 1604, for example, Karel van Mander wrote: 'He is a mixture of grain and chaff; in fact he does not dedicate himself continuously to his studies, but when he has worked for a couple of weeks, he goes around town for a month or two with his broadsword at his side and a servant at his heels, much inclined to duel and get into scraps, so that it is rarely possible to be in his company. Such things are not at all in keeping with our art'.[3] This account was followed by those of Mancini, Agucchi, Carducho, Baglione and Scannelli, who, each in his own way, report circumstances, episodes and incidents very similar to these, through to Giovan Pietro Bellori's *Life* of Caravaggio of 1672, in which the observations and judgements of the Cardinal, who had died in 1631, recur with obsessive insistence, even word for word, suggesting that Bellori may in fact have had first-hand knowledge of Borromeo's remarks.

'The old painters brought up in the tradition were appalled..., and never stopped decrying Caravaggio and his style, proclaiming that he was unable to get out of the cellars, and that, lacking in inventiveness and draftsmanship, with no decorum or artistic sense, he painted all his figures in one and the same light and plane, without any perspective ...'[4] Such works as the two versions of the *Supper at Emmaus*, one in London and the other in Milan, 'are lacking in what concerns decorum, for Michele often degenerates into base, vulgar forms'.[5] 'That was the beginning of the imitation of base things, seeking out dirt and deformity, as some do all too eagerly: if they have to paint a coat of armour, they seize on the rustiest, if it's a vase, they will not do it in one piece, but chipped and broken. Their chosen garments are stockings, breeches and flat caps, and so it is when they represent bodies, they give all their attention to the wrinkles and blemishes of the skin and adjuncts, making the fingers calloused and the limbs affected by palsies. For these traits Caravaggio suffered reverses, having pictures of his taken down from altars'.[6] 'These traits of Caravaggio matched his physiognomy and appearance: he was swarthy, with dark eyes, eyebrows and hair; and this came out naturally in his painting: his first manner, sweet and pure in its colouring, was the best ... But he subsequently fell into his gloomy [manner], dragged down by his own temperament, just as in his habits he was turbulent and quarrelsome: first he had to leave Milan and his birthplace, then he was obliged to flee Rome and Malta,

to go to ground in Sicily, run risks in Naples and die a forlorn death on a beach. We cannot omit mention of his way of behaviour and dressing: he would dress up in garments and velvets fit for a nobleman, but once he had put on a suit, he never took it off again, until it fell to pieces. He was totally careless of cleanliness; for many years he ate off a canvas bearing a portrait, using it as his tablecloth for lunch and supper.'[7]

Nor do the coincidences end here, in this remarkable exemplar of the general principle according to which an artist's habits are just like his artefacts, as are his physiognomy and appearance. When Cardinal Borromeo left Rome in 1601, immediately after the unveiling of the *Scenes of Saint Matthew* which Caravaggio had painted, not without disagreements, for the Contarelli Chapel, he cannot have ignored subsequent developments, and above all Caravaggio's growing tendency, in the closing years of the century, to apply his criteria to religious paintings intended as altarpieces. The case of the *Saint Matthew* refused by the clergy of San Luigi dei Francesi, but retrieved by a guest staying in the Roman residence of Cardinal Borromeo, Marquis Vincenzo Giustiniani, already went back a few years; in 1603, another Cardinal in the Roman curia, Ottavio Paravicino, made no secret of deriding Caravaggio's habit of not only seeking commissions for works to adorn churches, but daring to execute them 'in that half-way manner between the sacred and the profane'.[8] Here, then is what Federico Borromeo had to say in 1624: 'Men who are contaminated must not occupy themselves with divine things, since they have proved unworthy of such a function; ... full of vices and faults as they are, it is not clear how they can imbue their images with that piety and devotion which they themselves lack'.[9] Thus it should not really be a surprise, although it does still come as such, that about a century later Caravaggio's Messinese biographer Francesco Susinno delivers an almost identical judgement: 'His desire to go beyond his calling and pry into the things of our sacrosanct religion taints him as a misbeliever, when the ancients themselves displayed great modesty with respect to its mysteries: "*Sanctius ac reverentius*" – Tacitus said – "*de actis Deorum credere quam scire.*" Tertullian too, among the fathers, said, "*Ignorare tutissimum est*"; and Sixtus Sanius: "*De Deo etiam vera loqui periculosum est, scrutator Maiestatis opprimeretur a gloria*".'[10]

When confronted with such an array of references, each harking back to Borromeo as the source of the most scathing opinions about Caravaggio, a bad painter on account of his 'dirty habits' and altogether a 'contaminated' man, what remains of the thesis (which

has found, be it said, no lack of consensus, even in quite unexpected quarters) portraying the young Caravaggio as the protégé – no less – as well as the disciple and interpreter of Federico Borromeo, in the wake of his famous cousin Saint Carlo?[11]

It is hardly necessary to explain why the present author is so keen to get the facts straight. I must, however, make it clear that I was deluding myself in affirming at the beginning that all scholars were agreed, *without exception*, on the identification of Caravaggio as the painter of 'dirty habits' described by Borromeo. I was wrong because, in a review for *l'Unità* of an excellent collection of sources and documents concerning Caravaggio published by Stefania Macioce in December 2003,[12] and taking it upon himself to dispel the 'blunders and legends of every description' which have come to 'surround in the media the figure of [Caravaggio], *peintre maudit*', Maurizio Calvesi deplored the fact that one of the first excerpts included in the anthology of texts presented as an introduction to the exhibition of digital reproductions of the artist's works promoted by the RAI[13] was this passage from Borromeo which, to his mind, it would be misleading to consider as a 'historical reference to Caravaggio', as it certainly referred to a different painter.[14]

I must confess here a sin of omission: I have omitted to cite a contribution to the question made by Barbara Agosti – a contribution which Calvesi either overlooked or passed over in silence. In a review of the highly questionable criteria behind the reopening of the Pinacoteca Ambrosiana, this critic republished the final part of the passage given above, and added in a note a decisive piece of information: in one of the preparatory notes for Borromeo's treatise, completing his verdict on those books which are 'badly flawed, imprudent, soiled', such as those by Burchiello, in which one finds indeed 'vivacity' but also 'much sinfulness', Federico added in his own hand, as if it were a pro-memoria for himself: '*Narra a simile de Michel Angelo Caravaggio: in illo apparebat l'osteria, la crapula, nihil venusti; per lo contrario Rafaelo. Etiam aspectus indicat scriptor: Titianus, Michael Angelus, Caietanus* [that is, Scipione Pulzone]: *e contrario Caravaggius.*'[15]

Errors and omissions aside, and with the *placet* of those who seek to deny the facts as a matter of principle, the identification of Caravaggio with the painter deplored by Borromeo is thus beyond doubt; hence the need to reiterate not only the question with which I concluded my opening remarks, that is, what remains of the thesis presenting the youthful Caravaggio as a protégé, as well as a disciple and interpreter, of Federico Borromeo? But also the broader question: what validity is there in the

thesis, implicit in the one concerning Borromeo, according to which all Caravaggio's art is oriented by his 'submission' to the Church of the Counter Reformation? The answer to both questions can only be in the negative. And perhaps I may recall that in my essay entitled *L'incredulità del Caravaggio* of 1992, in which I returned to arguments I had already set out in 1973, I dedicated two chapters (over 120 pages) to showing just how far Caravaggio's approach diverges from the Tridentine prescriptions and adhesion to the Counter Reformation and, in a specific section, the non-existence of the supposed favour accorded the artist by Federico Borromeo, or indeed of the abstrusely symbolic and Christological inspiration, *presumed* (above all by Calvesi, but also others, including the experienced 'Caravaggist' Mina Gregori) to inform a number of his most significant works.[16] It is true that Federico referred admiringly to the celebrated *Still Life with a Basket of Fruit (Fiscella)*, then in his collection and now in the Ambrosiana, but it is also true that, for all his praise, he can only have looked at it fleetingly and rather absent-mindedly. Roberto Longhi was the first to point out, and Calvesi's subsequent interpretative contortions have done nothing to refute him, that the work is in actual fact a still life featuring only fruit, whereas the Cardinal described it as if it was of flowers: '*ex qua flores micant.*'[17] I am obliged to add that these theories have not found many adherents. For example, Marco Bona Castellotti, another devotee of the tendency to associate Caravaggio with the most rigorous adepts of Catholic orthodoxy of the times, has gone so far as to state, in a verdict that surely smacks of pure dogma, that opinions such as those of Calvesi and Gregori, 'supported by historical and philological expertise, rather than stirring up objections should be accepted without reserve' (sic);[18] and Barbara Agosti too, who following the publication of the passage from Borromeo quoted above has shifted her stance, dissociated herself in the previous year from my theses, which she duly cited and acknowledged, but which in practice she disapproved (or at any rate had reservations about) on account of the 'tendency to radicalise the problems which on occasion are caused by the need for clarity'.[19]

Enough, however, of such shilly-shallying. The common ground we have established between the opinions of Borromeo, Baglione, Agucchi, Bellori and so on is amazing.[20] And the question of Caravaggio's convergence with (or dependence on) the devotion of Borromeo, together with his 'submission' to the tenets of the Counter Reformation, must be considered closed without leave of appeal.

The time is ripe to take a very different approach, and return to a tradition of scholarship that, although in the minority, has always attempted to establish the truth concerning Caravaggio. There are two essential points to be clarified. First, it is vital to reaffirm the historical truth that that period was not characterised by mere passive obedience to the programme of the Counter Reformation, but rather by divergent trends, quite as far-reaching, which were an active counterpart to such obedience. 'The question,' in the words of the historian Rosario Villari, 'has to be viewed in the context of the last internal resistance to the orientation of the Counter Reformation, a resistance which was nurtured both from the spheres of indiscipline and moral licence [this should certainly be borne in mind whenever Caravaggio is spoken of as being 'licentious', 'subversive', 'an assassin'], and from the attempt to reopen, within the Church, the theological and philosophical debate, or even to contest the more specifically politico-social orientation that Rome sought to impose on the Church.'[21] In the second place, and this is equally important, it must be stressed that, in the interests of the 'observation of things' (Giulio Mancini, c.1620), meaning the 'imitation of what is natural' in the most fundamental sense of the term, Caravaggio laid the foundations for a radical revision of all the values then current: in the pictorial hierarchy, a propos the representational genres recognised by official society; in the elaboration of the iconographical image, whether sacred or profane; and in the exercise of a quality of 'manufacture' which rejected any form of discrimination between 'formulating' and 'creating', recognising the autonomy of visual culture *vis à vis* verbal culture inasmuch as 'seeing' involves a cognitive capacity which is in no way inferior, and indeed is more efficacious and direct, to expression through words. This coincided with the research pursued by such figures as Giordano Bruno, Giovanni Battista Della Porta and Tommaso Campanella on the one hand, and by Galileo, Kepler and Francis Bacon on the other, who all collaborated, each in his own way, in the discovery of a 'nature' – and also of a blueprint for a society to be constructed and a way of life to be attempted, as well as a religion in which one could believe – based no longer on a hierarchy of 'forms' but on 'phenomena' which were on an equal footing.[22]

In order to achieve a more detailed reconstruction of the circumstances which brought Caravaggio to Naples than is usually attempted, and which led in particular to the commissioning of the first important work in his years in Southern Italy – the large canvas for the Pio Monte della

Misericordia (see entry no. 4 in the catalogue) – we need to go back a few months before the artist, following the killing of Ranuccio Tomassoni after a quarrel 'over a decision concerning a foul shot while playing at racquets', was obliged to flee Rome.

On 24 October 1605, wounded in the throat and in the left eye, Caravaggio was in the house in Rome of the lawyer Andrea Ruffetti da Toffia, not far from Piazza Colonna. That is where the notary of the Criminal Court charged with interrogating him found him '*jacente[m?] in lecto [...] vulneratum in gutture et auricola sinistra*' and took down his statement – provocative to say the least – that he had accidentally caused these wounds himself: 'I wounded myself with my own sword when I fell over in the streets around here, but I don't know where it was, and there was no one about'.[23] It is certainly significant that in such a serious situation Caravaggio should choose to lie low in the house of the said Ruffetti, but it is even more significant that he stayed on there for all of four months (from 31 October to 13 March), working on the most demanding painting of his last months in Rome: the *Madonna of the Palafrenieri*, painted for the chapel of the confraternity of the Palafrenieri di Sant'Anna in San Pietro Vaticano (but removed after a month on the order of the cardinals). We learn of all this from a letter, written a long time after the events but containing unusually fresh and detailed memories, from the man of letters Gian Vittorio Rossi, *alias* Janus Nicius Erytraeus, to Giovanni Castellini Zaratino, on 4 September 1620. It also informs us that Andrea Ruffetti asked Castellini to compose an epigram in praise of the picture while it was still in his house.[24]

Who then was Andrea Ruffetti, who showed himself so amenable to taking in the wounded Caravaggio and enabling him to work on a picture of such importance in terms of destination, aesthetic demands and sheer size (292 x 211 cm)? And who were his two acquaintances, Rossi and Castellini, with whom Caravaggio was in such confidence and who clearly appreciated his work in spite of the rejections he had suffered, the latest concerning the *Death of the Virgin* for Santa Maria della Scala, although the same fate was about to befall the Madonna of the Palafrenieri for which Ruffetti asked Castellini to write an epigram?

Taking an overview of the research pursued by scholars in a range of disciplines,[25] by the years 1605–6 the circle in which Caravaggio moved had established itself in the vanguard of the ideological and cultural trend we alluded to above, in particular in artistic and literary terms.

In November 1603, Andrea Ruffetti had been involved with Onorio Longhi in pursuing, sword in hand, two of Caravaggio's most acrimonious artistic foes, Giovanni Baglione and Mao Salini. Onorio Longhi, son of the 'valorous architect' Martino Longhi, a contemporary of Giacomo della Porta and Matteo da Castello, had studied with Ruffetti in the law faculty at La Sapienza, and was in touch with the leading biologists, botanists, philosophers and historians of the day. At the end of the 1580s he had published some poetry, and he had begun to make his name as an architect, even before the death of his father (in 1591), taking over from him such prestigious projects as the Chiesa Nuova and Santa Maria della Consolazione. Thus it was as an up-and-coming architect that he teamed up with Caravaggio in escapades of bravado, culminating in the dramatic duel in late May 1606 whch left Ranuccio Tomassoni dead; but he also served the artist by introducing him into the cultured and modernising circles in Rome. These circles were the meeting place for those 'transgressive' young bloods which the establishment did its best to sideline as being amoral, irreligious and no better than delinquents, but who were in fact the paladins of those opposed to the hierarchies of contemporary society, as well as to the matrix of religious, philosophical, political and social tenets that made up the ruling ideology. What is more, Ruffetti was a close friend of another friend and fervid admirer of Caravaggio, and fellow Lombard, the poet Marzio Milesi, who penned this tribute to the artist: 'let others go on imitating, sketching in and embellishing things, / you make them true and living' (*fingha pur le cose altri, adombri e lustri, / voi vive e vere l'arrecate*). Milesi was a correspondent of the Bishop of Vicenza, Paolo Gualdo, an insatiable and non-conformist devotee of a culture ranging across many spheres of knowledge (including the history of architecture, and Palladio, of whom he wrote a biography). His personal interest in Caravaggio dated back to 1602–3, when he obtained a work of his in Rome; as early as 1603 he was marked down by Cardinal Ottavio Paravicino as possibly subversive; and it is surely significant to find him later on, in 1611–12, the friend and correspondent of Galileo. Giovanni Zaratino Castellini, a renowned scholar of antiquity and epigraphy who also took an interest in questions of iconography, was another friend of Monsignor Gualdo, whom he conducted on a tour of the ancient sites in Rome when the latter – who 'in conversation touches elegantly on every matter' and 'seems to be versed in all the sciences', again in the words of Paravicino – wished to study them at first hand. And finally Gian Vittorio Rossi, or de' Rossi, who

habitually signed himself in Latin, Janus Nicius Erytraeus. In his youth he associated with Tommaso Campanella, courageously taking a public stand in his favour; for a period he had close links with the most notorious libertines in Rome, including Gabriel Naudé, who encouraged him to write the three volumes of the *Pinacoteca imaginum illustrium doctrinae vel ingenii laude virorum qui auctore superstite diem suum obierunt*, which present a keenly satirical picture of contemporary Roman society, as a pendant to the *Eudemia*, published with the same intentions in 1637. Together with Ruffetti, Milesi and Castellini, he was a founder member of the bizarre Accademia degli Umoristi, promoting the libertine spirit, and he frequented professed heretics, such as Traiano Boccalini and in particular the Pope's physician, Giulio Mancini, who went so far as to urge people to eat meat on Fridays. The latter was also a renowned connoisseur and writer on art, collector and dealer in paintings, and another well-known admirer of Caravaggio: it was Mancini who, stealing a march on the Duke of Mantua's agent Rubens, first tried to purchase the *Death of the Virgin* following its refusal by the church authorities. We can also recall that de' Rossi's *Eudemia* reveals a great interest, verging on imitation, in the Latin work *Argenis*, a hybrid of courtly romance and political allegory published in Paris by John Barclay, the half French and half Scottish writer, born at Pont-à-Mouson in 1582, who moved to Rome in 1616 and died there on 15 August 1621. The debt of de' Rossi to Barclay is significant since the latter was the son of William Barclay (Aberdeen, 1546 – Angers, 1608), author of the treatise *De potestate Papae* opposing the popes' temporal power. This work was published by his son in 1609 and provoked the wrath of Cardinal Roberto Bellarmino, who brought out the vehement *Tractatus de potestate Summi Pontificis* the following year, to which John Barclay replied in 1612 with a work whose title is quite touching: *Johannis Barclaii Pietas, sive publica regum ac principum et privata G. Barclaii sui parentis defensio*.[26]

Thus by the end of May 1606, when he was forced to leave Rome following the ill-fated duel with Tomassoni, Caravaggio could count on the support of this social and cultural milieu, and indeed can be considered one of its protagonists. The fact that he sought to cover his tracks in Zagarolo, Paliano and Palestrina, fiefs of Don Marzio Colonna, is not of course a detail we can ignore, but nor should we overlook the fact that, of the two works he painted during those weeks, one, a swooning Magdalen in half-length which has not yet come to light must have remained in the hands of Caravaggio himself (for it was copied shortly afterwards by the Frisian painter Louis Finson, resident in Naples in those years); the other, the moving and sombre *Supper at Emmaus* now in the Brera, was purchased and taken to Rome by the well-known Genoese merchant banker Ottavio Costa, who had been a patron of the artist since the closing years of the previous century.[27]

This brings us to the most characteristic class of Caravaggio's patrons during his Roman years, and it can hardly be a coincidence if it was the grain merchant Niccolò Radolovich, native of Ragusa and based in Bari, who on 6 October 1606 gave Caravaggio his first Neapolitan commission, which alas has not come down to us, although it is documented. With this commission Caravaggio survived the first difficult period of his flight, but he still lacked any credentials with the establishment, and indeed he was held to be of irrepressible unruliness and suspected of serious ideological heterodoxy. However, he would not have secured the commission for such an important work as the altarpiece for the newly founded Monte della Misericordia without being able to count on a considerable degree of confidence and credit. Once we have recognised the largely marginal role of Tiberio del Pezzo, who appears as signatory to the documents authorising payment for the picture,[28] the most likely cultural link must be the Marquis of Villa, Giovan Battista Manso. As a friend of Torquato Tasso, he had his name immortalised in one of the latter's dialogues, and he was a leading light among the aristocrats in the Neapolitan intellectual milieu. The research that has been done concerning him, admirably assembled by Dottoressa Loredana Gazzara in various publications,[29] shows Manso to have been part of a circle which was very similar to Caravaggio's circle in Rome. During the last two decades of the sixteenth century Manso had formed close ties with Colantonio Stigliola, of whom Biagio de Giovanni wrote that he combined 'an esoteric approach to magic and politics with a highly practical interest in "mechanical" science and the relations between physical forces, and he was probably the most "Galileian" of the first Neapolitan scientists'.[30]Through Stigliola Manso also came into contact with Giovan Battista Della Porta, in whom he appreciated the concept of 'natural magic' founded on 'natural observations', and the ever alert Spampanato reported that he had even served as 'interpreter' to Della Porta of the novelties of Galileo.[31] On his admission to the Accademia degli Svegliati at the close of the sixteenth century, Manso made the acquaintance, through the academy's founder Giulio Cortese, of Tommaso Campanella, whom he visited when the latter

was imprisoned. He also had close links with the young Giambattista Marino, and through him with the Crescenzi family in Rome, who in turn had had dealings with Caravaggio over the pictures for the Contarelli Chapel in San Luigi dei Francesi. Nor is this the end of it, for in 1600–1 Marino had his portrait painted by Caravaggio, to add to the picture showing Susanna with the Elders which has never come to light. Caravaggio also painted the portraits of some members of the Crescenzi family, at least Crescenzio and Melchiorre, according to Bellori. In Naples, as scholars well know, the young Marino had found a first patron in Manso; but from 1596 he found a second one in the Prince of Conca, Matteo di Capua.[32] From a letter written by Vincenzo Gonzaga's agent in Naples, Ottavio Gentili, on 3 July 1607, we learn that Gentili had been instructed to make a valuation of the Prince's picture collection, 'but since this is a matter of evaluating paintings, which is not my line, and not knowing whom I can trust in this city, I shall go and see them *taking with me Michael Angelo Caravaggio, who did that large picture Your Excellency bought recently in Rome, and shall ask his opinion*'[33] (my italics). We do not know whether Caravaggio did in fact go to see the Prince's pictures, or indeed whether Gentili even mentioned it to him, since he left for Malta immediately after the Feast of Saint John, on 24 June, and is known to have been on the island by 13 July.[34] Given that the 'large picture' by Caravaggio is clearly the *Death of the Virgin* now in the Louvre, secured for Gonzaga after it had been rejected by the Carmelite fathers of Santa Maria della Scala, with Giovanni Magno acting as intermediary and Rubens as consultant, in the period 17 February to 28 April 1607;[35] and that the picture collection of the Prince of Conca[36] is the same as the one which the Flemish painter Franz Pourbus visited in the following September, having been sent to Naples from Mantua for this purpose; and bearing in mind that Caravaggio had departed in such a hurry that he left two well-known works of his still for sale, the *Madonna of the Rosary* and *Judith and Holofernes*, recorded in another letter sent from Naples to Mantua, this time by Pourbus, on 25 September;[37] the connecting tissue of all the circumstances we have outlined, extending both forwards and backwards in time, once again highlights Marino as the vital link between Caravaggio and the circles who were to support him in Naples, those same circles which, beginning with Manso and Di Capua, had given the most immediate and fruitful support to the future author of *Adone*.

In any case, while it is quite possible that Caravaggio's access to Manso and those in the Pio Monte was a result (wholly or in part) of his contacts with Giambattista Marino, in terms of his intellectual affiliations there is another, considerably more important circumstance. In about 1610, the Marquis of Villa was part of a group of admiring disciples of Galileo's revolutionary astronomical discoveries and his work *Nuncius sidereus*. This emerges from an important correspondence between Manso and Paolo Beni (another protagonist of dissident circles) and also with Galileo himself, as the present writer has already had occasion to point out, with specific reference to its implications for our knowledge of Caravaggio.[38] On the subject of the picture he painted for the Pio Monte, which was a further indication of Caravaggio's place in the vanguard of the modern movement, and also one of his most outstanding pictorial inventions, we have to make two other preliminary observations. The first concerns the original statute of the Pio Monte, drawn up in 1603: this leaves no doubt as to the importance given by the founders to the practice of 'corporal mercy', in total independence from official ecclesiastic control: 'finally we wish that our Monte be not subject to the ordinary [i.e. the archbishop], but that the workings of the Monte be autonomous and free from the jurisdiction of this ordinary'. This concession was granted by the papal authorities, but on condition that it remained strictly secret, for it obviously represented a very dangerous precedent. In any case, the Monte embodied a form of charity expressed in a highly personal and autonomous way, linked to the concrete *exercitio* and *prattica*, and serving the needy in a practical sense. The second goes to the heart of the poetic and moral intentions behind Caravaggio's religious paintings. Some time ago the present author took pains to demonstrate that one important source for the artist's vision was to be found in the historical and religious doctrines of Erasmus of Rotterdam. These works, together with other writings which we can call 'Protestant' although they were not yet known as such, were common reading matter in sixteenth-century Lombardy, in the town of Caravaggio as in Bergamo, Brescia and Cremona. In the *Eximii doctoris Hieronymi stridonensis vita*, a premise to the four volumes of the epistolary of Saint Jerome published in Basle in 1516 by Giovanni Froben, Erasmus had this to say: 'There is a surprising credulity, or rather, something profoundly ingrained in the human spirit, which makes men listen much more readily to tales that have been invented rather than facts which really happened, and take greater pleasure in imaginary and incredible fabulations than in real events. Thus it was, in ancient times, that the learned who wanted to make something particularly appealing to the multitude would

adorn it with prodigious marvels: this they did for devotion to gods, for the origins of cities and peoples, for the founding of noble families, for the exemplum of illustrious princes ... But ... to my mind, ... there cannot be a single wise and right-thinking author who holds such a poor opinion either of the saints or of his readers. Of the saints, who would appear to be so lacking in merits of their own as to need to be embellished with falsities quite alien to them, or so vainglorious and full of importance as to take pleasure in parading on a stage like Aesop's crow, adorned with fictitious praise like borrowed plumage. And of his readers, considered so stupid and puerile as not to know the difference between a made-up tale and a real fact, even though truth always has a beauty of its own which no invention can imitate; or else so low and perverse as to give conscious and willing assent to what is vain. ... For my part, I believe that nothing is more proper than to describe the saints as they really were, and if we should discover some faults in their lives, this too can prove to be an example of piety. ... The truth has an intrinsic force which no artifice can equal. And how can we tolerate those who set out not to celebrate but to contaminate the saints with old wives' tales, puerilities, nonsense and drivel?' And again: 'Some are motivated by the intention, apparently pious but in reality vain, of exalting the merits of the saints beyond all measure, attributing to them not what they indeed had but what one might wish them to have had. If it were possible, they would seek to make Christ greater than what He is ...; yet often it is useful even to find in the saints some failing, or as perhaps we might say, a scar. I do not know why, but their examples succeed in moving us more deeply, when it proves that they mended their ways'.

When Caravaggio began to give pictorial form to the highly innovatory iconographical theme proposed by the commission, he began by trying to identify the linking factor between 'bodily mercy', exercised with no formal or hierarchical constrictions by a congregation of men intent on performing charity through good works, and the idea of the 'divine' and 'holy', learnt from Erasmus, on which he had based all the religious works he had painted thus far, and the most complex, which for this very reason had been rejected.

In the upper part of the composition he depicted the Madonna and Child in simple terms: not just as a Madonna 'without her chair', as Roberto Longhi ironically put it, alluding to Caravaggio's aim of remaking nature without the classicist aura and without the sanctifying elements of Raphael's celebrated *Madonna della seggiola*, but as a figure of touching humanity, complete

with a body, blood and feelings, reaching out towards the passers-by from the artificial wings of the two angels-cum-acrobats cartwheeling in the vortex of a rather off-white drapery. The mass of bodies, fabric and wings casts a two-fold shadow on the prison wall, a truly extraordinary pictorial invention. The boy who is leaning towards the centre of the picture is depicted bearing the weight of his body and indeed of the whole group on his right hand, flushing red from the effort at the wrist joint. But most extraordinary of all is the fact that this boy also succeeds in carrying off his role as an angel, since in a stroke of pure genius the artist has decided to remove (that is, to conceal by not depicting it) the means of support for the group.

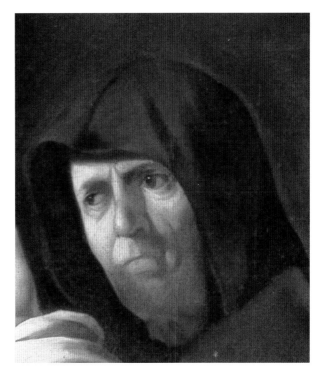

1. *Portrait of Tommaso Campanella*, drawing

2. Michelangelo Merisi da Caravaggio, *Madonna of the Rosary*, detail. Vienna, Kunsthistoriches Museum

In the lower part, there can be no doubt that it was his intention to represent the *prattica* of *opere*, and not just *la sola fede* which was the key to salvation in Protestant doctrines. It was thus all the more necessary, in his view, to depict works of corporal mercy rather than spiritual ones, coinciding, as we have seen, with the preference explicitly set out in the statutes of the congregation. This meant making a radical transformation of the 'works of mercy', no longer abstract and canonically symbolical acts, corresponding to exempla and types, but authentic slices of life caught in the moment of their realisation, at night time, *hic et nunc*, in a real alleyway of the city, since as Erasmus declared, 'truth has an intrinsic force which no artifice can equal'. In this motley company of individuals surprised as they go about their business, providing a

genuine sense of humanity filing past, we can identify a number of instances of such truthfulness. On the left are two pilgrims (one with the scallop shell of Saint James on his beret), with an innkeeper who must have been drawn from life pointing them towards shelter for the night, while a third man, pushed to the very edge of the scene by the light, is drinking from an ass's jawbone (like Samson in the Bible), and a fourth, dressed elegantly with a plumed hat, is cutting his cloak in half (like Saint Martin in the legend) to share it with the naked beggar lying in the foreground. In the centre there is a corpse bearer dragging his burden off for burial, two livid feet sticking out of the winding sheet, helped by an acolyte holding up a torch which flares out in the darkness of the alleyway at the corner of the prison. And in the foreground, on the right, a frightened woman is tendering her naked breast to an old inmate (as Pero is said to have done in antiquity for her father Cimos), whose head alone is lit up, craning awkwardly through the bars of his cell.

As Giovan Pietro Bellori wrote with only slight inexactitude: 'For the church of la Misericordia [Caravaggio] painted the Seven Works in a picture measuring about ten *palmi*. One sees the head of an old man protruding from the grille of the prison, sucking milk from a woman leaning towards him with her breast bared. Among the other figures you see the feet and legs of a corpse being carried off for burial, and by the light of a torch belonging to a man carrying the corpse rays are shed over the priest in his white surplice, illuminating the colour and giving spirit to the whole'.[39] There is no doubt that Bellori showed an acute awareness of the effect of the torch 'illuminating the colour', but we would also draw attention to his interest in the corpse: 'you see the feet and legs of a corpse being carried off for burial', not only because this seems to highlight what is perhaps the crux of Caravaggio's representation *in fieri*. May not this feature (like others) be based on episodes which the artist had experienced himself? In connection with this picture, a scholar has recalled most opportunely what Padre Michele Scaduto published concerning 'the state of the prison... of the Vicaria in Naples prior to the year 1609', in other words just when Caravaggio was in Naples and working on his painting for the Pio Monte. This included an eye-witness account of mortality among the inmates: 'in prison many paupers died from the hardships endured; and even as he breathed his last, not only was there no one to close his eyes for him, but they would strip him naked and wrap him up in an old sheet, have him carried out of the prison, and laid out at the base of a public staircase in the Law Courts until people from his parish came to bury him'.[40] It is striking how this picture matches the contemporary account in every detail; the scene is even located at the corner of a prison.[41]

In terms of style and chronology, the only significant comparison available for the *Works of Mercy* is, in my opinion, the *David with the Head of Goliath* now in Vienna. In spite of the doubts expressed by some, this is clearly an autograph work, indeed one of Caravaggio's most limpid achievements in the genre of gallery paintings, and can be identified with the picture on the same subject recorded by Bellori as belonging to the Count of Villamediana, another figure of great interest in the context of Caravaggio's cultural associations which we dealt with above. It surely stands as a fine complement to the picture done for the Pio Monte in respect to pictorial style.[42] The *Works of Mercy*, then, marks the onset in Caravaggio's art of a new relationship with reality, and a new vision. Yet the crucial moment for this breakthrough, achieved with a startling leap forwards in his development, can be identified immediately afterwards in the *Crucifixion of Saint Andrew*, now in the Cleveland Museum of Art.

In a document, a copy of which was seen by O.H. Green in 1929 but which was lost during the Second World War, the Count of Benavente was said to have two pictures by Caravaggio with him on his return to Spain at the end of his term as Viceroy in Naples, on 11 July 1610: the *Crucifixion of Saint Andrew* and a 'Saint beheaded'. There is still great uncertainty concerning the latter work, but most scholars concur in identifying the former with the picture now in Cleveland, whose provenance from the Count's collection is documented as from December 1652. Furthermore, in 1672 Bellori affirmed that 'the Count of Benavente who was Viceroy of Naples also took to Spain the *Crucifixion of Saint Andrew*'.[43] However, it is not clear whether the picture was commissioned by the Count or whether it came into his possession in some other way. There are various implications: if it was a commission, it means that, immediately after finishing the major undertaking for the Pio Monte, Caravaggio carried off the most valuable prize one could wish for in the Naples of the Viceroyalty. In this case, merit would also go to the Count of Benavente as the only person in high office who had thus far shown himself able to appreciate the work of an artist who had never achieved such official recognition. On the other hand, Benavente may have come onto the scene subsequently, as collector: this too would be significant, since he must have intervened to buy a picture which may even have been rejected, as had the Duke of Mantua some years

earlier, with the *Death of the Virgin*, and the Cardinal and Secretary of State Scipione Borghese, with the altarpiece for the Cappella dei Palafrenieri in San Pietro Vaticano, taken down after less than a month. We shall return to Benavente as admirer of Caravaggio shortly, for it is also alleged that he commissioned the *Madonna of the Rosary* now in Vienna, even though this was put up for sale in Naples as early as September 1607, when the Count was still unequivocally in office.[44]

The singularity of the iconography of the *Crucifixion of Saint Andrew* has often been remarked on. First of all, the cross to which the martyr is bound is not the X-shaped cross of the decussate type (from *decem,* Latin for ten or X), known also as the Saint Andrews' cross, but the so-called Latin cross, that of Christ, with a long upright and short crossbar. Even more emphasis has been given to the decision to represent not the moment when the apostle is put on the cross but the subsequent attempt to untie him to stop him preaching, *in extremis,* when the man charged with this task has his arms paralysed. It has been suggested that this detail derives from a rare version of the Passion published also in Italian at the beginning of the seventeenth century by a devotee of Saint Ignatius of Loyola, Pedro de Ribadeneyra.[45] However, as most scholars affirm, it is more plausible to think that the source is in fact the *Golden Legend* of Jacopo da Voragine: 'He undressed and gave his clothes to his executioners, who as they had been ordered tied him to the cross. Andrew survived for two days and preached to twenty thousand people gathered there. But finally Aegeas [the proconsul who had ordered the martyrdom], feeling himself to be endangered by the crowd..., came to the cross to have him taken down. On seeing this, Andrew said: Aegeas, why are you here? If it is to do penance, your wish will be fulfilled; but if it is to take me down, know that I shall not leave the cross alive ... And although they tried to untie him, they were not able to touch him, because their arms became inert ...'[46] It is clear that Caravaggio abided by the traditional account in all the details, depicting it at its climax: the saint is seen naked on the cross (and it is a pitiless nakedness, hollowed out by the effort of leaning forwards), bending his head down in order to speak to the man in armour (the proconsul Aegeas), who on hearing his name raises his head up towards the saint, while the executioner, having mounted the ladder to untie the victim, is bending backwards as if paralysed, clinging onto the ropes he was supposed to loosen. Nor is this all, for if we take our iconographical research back a step, focusing not on the descriptive moment but on the characterisation of the figures, one further circumstance

emerges. Without going as far back as such remote prototypes as the Romanesque capital in Besse, Auvergne, cited by Tzeutschler Lurie and Mahon,[47] we have a proto-fourteenth-century type here in Naples: the fresco of *Saint Andrew Crucified* by Pietro Cavallini in the Cappella Brancacci in San Domenico Maggiore, which Caravaggio would undoubtedly have visited during those months. It represents a renewal of a schema found in Melfi at the end of the thirteenth century (in which one can even detect a sort of prefiguration of the theme of the executioner who unties the saint's rope rather than tying it up) giving maximum emphasis to the looping of the ropes binding him to the Latin cross.[48]

There is no doubt that Caravaggio staked all his pictorial resources on the representation of the knotted cords with which the martyr's arms are tied to the crossbar of the cross: a 'still life' of unprecedented character. This enhances also the Rembrandt-like (rather than Ribera-like) character of such details as the arm and left hand of the naked saint, wrapped in coils of rope: they are caught in a flash of light, anticipating the dramatic laceration of the shadow projected by the glow of light appearing immediately underneath – which indeed reproposes in tragic mode the large shadows cast by the group of angels of almost blasphemous physicality on the wall of the prison in the *Works of Mercy*.

This reference to the latter work, delivered to the Pio Monte between the last days of 1606 and 9 January 1607, brings us to the last important problem posed by the *Crucifixion of Saint Andrew*: its dating, which I would place after the completion of the *Works of Mercy* but before Caravaggio's departure for Malta. I took issue with Mina Gregori's argument, dating the picture 'to the last months of Merisi's activity, following his return to Naples',[49] more than ten years ago,[50] although this proposal has been revived recently by Catherine Puglisi.[51] John Spike endorses the dating of 1607, which after all was the one advocated by Longhi back in 1943.[52] To steady the pendulum, it may help to clarify certain features which have not so far been noted. Among these there is the amazing resemblance between the half-naked youth with his back to the viewer looking up at the plumed knight in the *Works of Mercy* (fig. 3), and the half-naked back of the executioner attempting to untie the ropes in the Cleveland picture (fig. 4). Not only do we feel we are in the presence of the same model, which is hardly a rarity in Caravaggio, but there is also a rapid evolution in the latter with respect to the former, seen in the accentuation of forms and shadows, and in the increasing expressive tension. The two works do thus appear to follow each other, but in very quick succession.

In the opposite direction, it has already been observed how the head of Saint Andrew bears an intrinsic pictorial affinity with that of Saint Jerome in the Co-Cathedral of Valletta in Malta. The latter was painted for Ippolito Malaspina and is thus so close to the works Caravaggio did in his first stay in Naples as to suggest the possibility that it was not in fact painted in Malta but actually in Naples, from where it was sent to Malta.[53] The close affinity between the two works can be confirmed if we compare the luministic, as well as formal, elaboration of the half-length of a woman with a goitre which was introduced at the bottom left of the Cleveland picture (moreover, a very late intervention, as X-ray analysis has revealed) with Saint Jerome, no less intense and moving. To support the attribution of the *Crucifixion of Saint Andrew* to the final months of Caravaggio's first stay in Naples, and not the second stay, we can have recourse to two more comparisons. One is quite obvious, and involves the woman with the goitre in the Cleveland picture and the woman with the same malformation who assists Judith in the version of the *Judith and Holofernes* which Pourbus reported as being for sale in Naples in September 1607 (we know it from the copy in the collection of the Banco di Napoli); the second is more problematic, and concerns the man-at-arms who embodies the Roman proconsul in the *Saint Andrew* (fig. 6), and the figure present at the crowning with thorns in the Vienna picture (fig. 5). In the case of the woman with the goitre there can be no room for dissension because, given that the copy belonging to the Banco di Napoli was taken from the *Judith* Pourbus saw in Naples in September 1607, the fact that Pourbus said that this *Judith* was 'done here' proves that Caravaggio painted it prior to June of that year, and this has repercussions on the date of the *Saint Andrew*.[54] In the case of the man-at-arms, the undeniable similarity between the two figures (the proconsul in the *Saint Andrew* is a genuine reprise in reverse of the assistant in the *Crowning with Thorns*[55]) has to be set against the divergent opinions concerning both the dating of the picture in Vienna (whether it belongs to the artist's Roman period or to the months he spent in Naples in 1606–7) and indeed its autograph status.[56] Certainly, it is not impossible to trace a passage from the *Crowning with Thorns* to the *Saint Andrew* which is analogous to the formal contraction and pictorial acceleration we have identified in the *Works of Mercy* and the *Saint Andrew*. However, the observations that have recently been reiterated concerning a certain flatness and even awkwardness of execution[57] lead me to conclude that the work's conception is undoubtedly to be attributed to Caravaggio, falling midway between the *Works of Mercy* and the *Saint Andrew*, but the execution must have involved another artist, who was in all likelihood Neapolitan, as Longhi maintained when he ascribed the work to Battistello Caracciolo.[58]

At this point we are brought face to face with the radical difference, if we are not mistaken, between all this and the celebrated *Madonna of the Rosary* in the Kunsthistorisches Museum, Vienna. Many continue to ascribe this work to the first period in Naples, and – as is scrupulously argued in this volume by Dottor Denunzio, but with a conviction possibly erring on the side of over-confidence – it has been linked to another personal commission from the Viceroy Don Juan Alfonso de Pimentel, Count-Duke of Benavente, which would be borne out by the presence, in the role of patron, of his own portrait.[59]

It is no secret that identifications proposed on the basis of similarities in different portraits are always suspect, and this is undoubtedly the case here. The donor in the *Rosary* is likened to the portrait of Benavente signed and dated 'Pascual Cati f. 1599' conserved in the Instituto Valencia de Don Juan in Madrid.[60] Since the picture in Madrid bears the date 1599, and the *Rosary* had already been completed in September 1607, when Pourbus saw it for sale, it seems to me that the donor in the latter (bald and evidently ageing) is older than the first image by considerably more than the six or seven years separating the two works. Nor indeed does it seem to me that the resemblance is such as to dispel all doubts. The posture of the donor in the *Rosary*, clinging in a strangely skew-whiff manner to the mantle of Saint Dominic, seems inappropriate to the dignity of a Viceroy such as the Count-Duke of Benavente, and nor is there any sign of his marks of office: the ruff he is wearing over perfectly everyday clothes does not set him apart in the slightest from an ordinary gentleman. Finally, and this is surely the main obstacle, how is one to account for the fact – impossible to justify even for those who initially proposed this attribution, and not satisfactorily explained by the counter-proposals, however ingenious, put forward by Denunzio – that a picture commissioned from Caravaggio by the ruling Viceroy (testifying to a cultural awareness in no way inferior to that which was about to prompt, or had prompted, him to purchase the *Crucifixion of Saint Andrew*) was rejected and even put up for sale in the city in which the Viceroy was still in office, and would continue to be so for the next four years?

In the light of this we have to return to the radical difference mentioned between the *Rosary* and the

sequence of paintings leading from the *Works of Mercy* to the *Crucifixion of Saint Andrew*, giving much more weight to the stylistic affinities which point backwards from the *Rosary* to the works Caravaggio painted during his last five years in Rome.

The comparison with the *Death of the Virgin* in the Louvre, on the one hand, and with the *Entombment* in the Vatican and the *Madonna dei Pellegrini* in Sant'Agostino in Rome, on the other, shows such a striking series of correspondences as to confirm beyond doubt the substantial contemporaneousness of the four altarpieces. If we then go on to compare features in

closely recalls the one in the bottom centre of the *Rosary*, and not just in the physical likeness of the model but also in the similarity of the setting. Far from having affinities with the works from the stay in Naples (the comparisons with the *Works of Mercy*, which are the first to come to mind, have always struck me as anything but conclusive; and I confess that, among the numerous arguments in both historical and chronological terms which Longhi based on the correspondence between models, the one seeking to identify in the *Madonna of the Rosary* the Salome of the late work in London has always seemed to me the least felicitous), the *Rosary* can

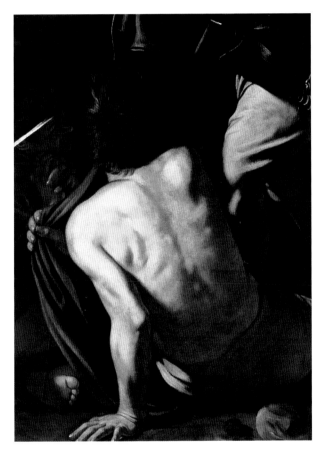

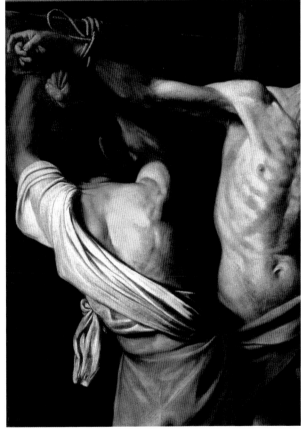

3. Michelangelo Merisi da Caravaggio, *The Seven Works of Mercy*, detail. Naples, Pio Monte di Misericordia

4. Michelangelo Merisi da Caravaggio, *Crucifixion of Saint Andrew*, detail. Cleveland, Museum of Art

which we can recognise the use of the same model or setting, we can even come up with a precise sequence.[61] The reclining head of the extraordinary Magdalen in the Louvre picture, with the hair done in little plaits and a well-defined parting, leads directly to the head of Mary Magdalene in the *Entombment*, and on, virtually without interruption, to that of the young mother seen from behind kneeling on the left of the *Rosary*. Furthermore, while there can be no doubt that this woman is the same as the one who recurs as the Madonna in the altarpiece of the Pellegrini, the peasant with dirty feet who appears almost as a protagonist in the *Madonna dei Pellegrini*

be placed immediately after the *Death of the Virgin* and the *Entombment*, but alongside the *Madonna dei Pellegrini* (prior to March 1606). This conclusion has the added advantage of not anticipating by too much the *Death of the Virgin*, which it does seem untenable to date back to the Cerasi pictures on the strength of its documented commission (in 1601). Of course the afffinities can also be extended to the *Madonna dei Palafrenieri* now in the Galleria Borghese, in view above all of the absolute identity of model and style in this Madonna and that of the Pellegrini. And last but not least, we can mention the equally obvious similarity in

thematic and compositional terms of the rich red curtain drawn across the upper part of the *Rosary* with the one, more crumpled but no less sumptuous, in the *Death of the Virgin*. This curtain forms the cone of shadow and light in which these scenes take place, and which, reworking the similar motif adopted some years previously for the Costa *Judith* now in the Museo d'Arte Antica, Rome,[62] and also for the vast red drapery hanging from the limbs of the Costa *Baptist* now in Kansas City, was to point the way for a whole succession of such drapes, from the *Annunciation* in Turin by Gentileschi to Vermeer's *Girl reading a Letter* in Dresden and *Art of Painting* in Vienna, as well as numerous other Dutch examples from the middle decades of the seventeenth century.

The possibility that the *Madonna of the Rosary* can be identified with the altarpiece commissioned from Caravaggio by the Duke of Modena prior to 29 July 1605 (and we now know that the commission was first mooted in January)[63] was argued with conviction by Walter Friedländer in 1955. Together with the problem of the engraving in reverse by Lucas Vorsterman and proposed two years earlier also by Roger Hinks, this thesis was taken up with vigour by André Chastel and André Berne-Joffroy, who gave a most accurate account, with additional evidence, in the celebrated *Dossier Caravage* of 1959.[64] In 1992 I took it up in my turn[65] and have no hesitation in reaffirming it here. I can add that the new document published in 1998, in which the commission is discussed, throws very interesting light on the question of the supposed size of the figures to be included in the picture. The Duke wanted two paintings for his chapel, one of them from 'Carachi' (Annibale Carracci), who, however, apparently could not oblige because 'for the last few months he has lost interest'. As for Caravaggio, 'after seeing the size of the other picture it seemed to him too small to do the whole subject in a suitable manner, and this makes him reluctant to take it on, saying that for such small figures there are others in Rome who could do the job better than him (and I understand that in truth he seems to excel in doing large figures), so that he wanted the dimensions to be increased at least a little in width, if possible, but nonetheless he agreed to do it to the best of his ability by April. But, however, he will not start work until it is known if it can be enlarged and by how much'.[66]

We might ask ourselves whether the real reason for the extraordinary delays that ensued, which art historians never tire of deploring, should not be attributed precisely to this difference of opinion concerning the dimensions. Surely the prolongation of the discussion, after

Caravaggio, on 16 November 1605, had promised that the picture would be 'finished this very week', was the real cause of the further delays and eventually, following the stormy events of the next six months, the failure to deliver, tantamount to a refusal on the part of the artist. We may yet live to discover the truth of the matter.

In any case it is certain that Calvesi's hypothesis, taken up by Pacelli, according to which the altarpiece of the *Rosary* was ordered by Luigi Carafa Colonna, son of Antonio and Giovanna Colonna, herself the sister of the Marquise of Caravaggio, for the family chapel dedicated to the Holy Rosary in San Domenico Maggiore, Naples,[67] is at variance with the fact that the painting had been refused and put up for sale – as we have seen – as early as September 1606. Refused by whom, we might ask. Was it by the same Dominicans who were about to agree to the hanging in a chapel belonging to the De Franchis family, in the purlieus of their church, of another masterpiece by Caravaggio: the *Flagellation*, for which they made the first down payments? And was it not the Dominicans once again who purchased the rejected *Madonna of the Rosary* for their large church in Antwerp?

We cannot leave the topic of the Dominicans without touching on another intriguing question concerning the *Rosary*. It was again Friedländer who observed that the figure of the hooded friar (fig. 2) in the background behind Saint Peter Martyr has all the marks of being a portrait.[68] We can recall that in the early 1590s the Roman residence of Cardinal Del Monte had among its occasional visitors the turbulent Dominican Tommaso Campanella, a name which recurs frequently among Caravaggio's unconventional acquaintances in Rome. We can also recall that Caravaggio was often held in the 'prison at Tor di Nona', where Campanella was also held periodically, first in the late 1590s and then during the numerous hearings for the trials he was subjected to in Naples and Rome by the Holy Office. Thus we can ask whether the shadowy Dominican who appears so disturbingly right behind the raised arm of Saint Peter Martyr may not in fact represent the Calabrese philosopher. I said above that identifications made on the basis of similarities in portraits are always dubious, and I do not mean to contradict myself. But is there not a truly striking resemblance between the 'portrait' we have indicated and the drawing bearing the caption 'Fra' Thomaso Campanella' (fig. 1)?[69]

Coming back to our consideration of the dramatic acceleration in his pictorial development which Caravaggio manifested as he passed without hesitation

or a backward glance from the *Works of Mercy* to the *Crucifixion of Saint Andrew*, it now seems clear that his move to Malta was characterised by the same impetus, as in fact emerges from the fine *Saint Jerome* in Valletta. As we have seen, Mahon and others have illustrated the stylistic and typological affinity of this work with the *Crucifixion of Saint Andrew*, which I too sought to highlight earlier on. Thus in order to grasp the direction taken by Caravaggio in the works he did in Malta, we have to start from the *Saint Jerome*. And since the *Saint Jerome* bears the coat of arms of Ippolito Malaspina, meaning it was commissioned by him, we should surely focus first on the figure of Malaspina; this will also tell us more about the reasons and opportunities behind the artist's departure for Malta, which otherwise appears so bewildering.

The excellent research carried out by Keith Sciberras, who presents further data and considerations here in the catalogue,[70] has led to the conclusion that the Grand Master of the Order of Malta, Alof de Wignacourt, had no prior interest in Caravaggio when the latter decided to move to the island, and that his admiration 'matured in Malta, after the artist had proved his worth'.

The man who commissioned the *Saint Jerome*, Fra Ippolito Malaspina, of the Marquises of Fosdinovo, was Bailiff of the Knights of Malta in Naples and a counsellor to Wignacourt. From November 1606, while 'he was in his castles of Fosdinovo in Lunigiana', he had announced to the Grand Master his intention of 'coming to the Monastery [i.e. to Malta, the headquarters of the Order], by the first ships to make the voyage'; the Grand Master had passed news of this intention to the 'General of the Galleys' of the Order, Fabrizio Sforza Colonna, Prior of Venice (one of the six children of Costanza Colonna Sforza, Marquise of Caravaggio): 'since we earnestly desire this to be performed, with the present we exhort you to do us particular and most acceptable service not only by informing him when you are next to return here, but also by doing everything within your powers to facilitate his embarkation, without, however, departing from the course of the instructions with which you are charged by our Venerable Council. In the name of God our Saviour ...'.[71] Malaspina was related to one of the first people to commission a picture from Caravaggio, the Genoese merchant Ottavio Costa, who had significant business interests in Malta and close ties with the Order; Vincenzo Giustiniani was another keen collector of Caravaggio's work throughout the painter's career who, together with his brother Cardinal Benedetto and cousins Marc'Aurelio and Orazio, maintained close relations with Malta, Costa and the Knights of St John.[72]

The previous year another correspondent of the Grand Master in Naples, Fra Giovanni Andrea Capeci, found himself involved, as Sciberras has described, in Caravaggio's passage to Malta. 'Wignacourt had been desirous for an artist and, in the early months of 1606, he was seeking to obtain the services, from Florence, of a painter (unfortunately unnamed). Wignacourt's correspondence of March 1606 shows that negotiations were reaching a conclusion, so much so that he made provisions for the painter's voyage to Malta. The unnamed painter had to pass through Naples and there, Capeci had to assist him in buying the necessary pigments and provisions and to secure his safe passage to Malta through Messina.[i] For some unknown reason, the painter did not make it to Malta; he probably did not even leave Florence to take up the job. But, in any case, Capeci now knew how desirous Wignacourt was of having a painter at his service'.[73]

If Capeci had learnt of it, so undoubtedly must have Malaspina, who, aware of Caravaggio's success in Naples, perhaps thanks to Ottavio Costa, who had just bought the *Supper at Emmaus* now in Brera, found himself perfectly placed to satisfy the wishes of the Grand Master.

If, as Denunzio demonstrates here, Caravaggio arrived in Malta on one of the galleys belonging to the Order which left Naples after the Feast of St John under the command of Sforza Colonna,[74] we can readily imagine that the artist set sail for his new port of call not just at the instigation, but actually in the company of Malaspina. Wignacourt, who as we have seen was already aware of Malaspina's intention of coming to Malta, had written again to Sforza Colonna, commander of the fleet, urging him to go and fetch him and ensure he had the best possible passage, while repeating insistently to Malaspina how 'great a desire we have concerning your visit here'.[75]

From the overall picture that emerges from these circumstances, it is clear that the role attributed to Fabrizio Sforza Colonna of privileged intermediary responsible for introducing Caravaggio into the good graces of the Grand Master has to be rethought. And so has the role that the Sforza and Colonna families played in anchoring Caravaggio in the discipline of Tridentine catholicism, a role which was always going to lead to Cardinal Federico Borromeo, just as all roads lead to Rome.

With the emergence of Fra Ippolito Malaspina, the situation takes on a different aspect: the commission for the *Saint Jerome* can simply be seen as a token of the artist's ability, to be offered to Wignacourt for the knights' chapel in the Italian Langue. This led to the

personal contacts between Caravaggio and the Grand Master, who shortly afterwards, set about obtaining his pardon from the Pope (moreover, as we learn from the official request sent on 7 February, not for him alone, and in spite of the prohibition laid down in the Order's statutes concerning anyone guilty of homicide) on the grounds of special merits and 'so as not to lose him', for admittance to the Knights of Magistral Obedience.[76]

In the document dated 29 December 1607, we find two allusions to the 'Commendator dell'Antella'.[77] As has already been observed, he can certainly be identified with Francesco dell'Antella, Commendator of the Hierosolymite Order, the person for whom the other painting done in Malta, the *Sleeping Cupid* now in the Pitti, is generally said to have been done. It bears on the back the inscription '*Opera del Sr Michel Angelo Maresi da Caravaggio in Malta 1608*' and is known to have been sent to Florence in July 1609 by Francesco to his brother, the senator Niccolò dell'Antella.[78] The *Sleeping Cupid* thus marks the second stage in Caravaggio's attempt to win the favour of Wignacourt, largely already secured,[79] and the knighthood, which was still by no means his, and for which we have only Bellori's word, when he states that 'Caravaggio was desirous of receiving the Cross of Malta, usually awarded to men who distinguish themselves for merit and virtue'.[80] It is striking that Caravaggio received the Cross of Malta before he had completed the masterpiece which was to immortalise his stay on Malta: the *Beheading of Saint John the Baptist*. In the signature written in blood and cut off short (reflecting, perhaps, the cut-off head of the saint), the name 'MichelAng' is preceded by an 'f', undoubtedly the abbreviation for 'Fra', standing for '*frater*', which was the customary title for the Knights of Malta. This detail shows, to my mind, that the picture was not delivered, or perhaps not completed, prior to 14 July 1608, when Caravaggio acquired the right to call himself officially 'Fra Michelangelo'; once he had served the prescribed year of novitiate, which must have been counted from the date of his arrival in Malta (12–13 July 1607), preparations were in hand for the ceremony of the painting's unveiling on 29 August, the feast day of the beheading of Saint John. In all likelihood the unveiling went ahead, but in the absence of the artist, who two days previously, on 27 August, had been arrested together with Fra Giovanni Pietro da Ponte, the main protagonist, for a brawl that had broken out on the night of 18 August in the house of the organist of the church of St John, Fra Prospero Coppini. Caravaggio was imprisoned in the Fort of Sant'Angelo, from where he made a daring escape on 6 October, and crossed to

Syracuse on the eastern coast of Sicily, with the aid of people whose identity remains a mystery. He was sentenced as an absconder on 1 December 1608 to the '*privatio habitus in absentia*'.[81]

While the Malaspina *Saint Jerome* contained no significant new departures, the pictorial register changes once more in the large painting of the *Beheading of Saint John the Baptist*. After the emotional turmoil which informs the *Crucifixion of Saint Andrew*, Caravaggio draws back and depicts the drama with rigorous objectivity; one may even observe it with curiosity, or share the horror of the old woman, distraught at the sight of the young woman standing, charger at the ready, to receive the bleeding head. This all takes place in a prison courtyard of silent and stony solemnity. The sombre black ashlars of the gateway, the entrance giving a glimpse of the inner courtyard through the slats of a decrepit gate, the walls a leaden blue in the early morning light, the barred window with inmates peering out, and the two strands of rope secured through a ring fixed into the wall, the ends sprawling in loops on the ground: all these features are seen and depicted as fragments of a vast still life. The peeling walls and blind arch, surely an anticipation of Rembrandt, find an echo in the archaeological ruins of the *Burial of Saint Lucy* in Syracuse. The gesture of the old woman burying her head in her hands in the *Beheading* is taken up in a harrowing reprise of the same motif in the old woman kneeling behind the right-hand grave-digger in the *Burial*. Furthermore, the figure of Cupid in the *Sleeping Cupid*, painted for Francesco dell'Antella during the same months as the large altarpiece, reveals a surprising similarity in its conception to the figure of Saint Lucy. One only has to see how the raking light which floods the face of Cupid from underneath – itself marking the completion of a pictorial and thematic itinerary which began in the supine Madonna in the Louvre picture and proceeded with the swooning Magdalen painted at Paliano – returns to illuminate the face of Saint Lucy: a desolate phantasm of death, almost an anticipation of Goya, in which the beam of light glancing off the features, reduced to essentials, seems to sum up Caravaggio's whole pictorial exploration.

In the *Cupid*, moreover, the child's tiny clenched fist is a reprise of the hand of Christ in the Vatican *Entombment*; but this time the clenched hand is isolated and thrown into relief against the plain black background, illuminated like a heavenly body rising above the horizon, caught in the sun's glare. The pictorial quality reaches truly remarkable heights in the shadows on the child's distended stomach and chest, and in the shadowy half

tones of the gleaming greys on the wing feathers cushioning the child in the foreground. In this manner the ancient myth is regenerated in the image of a child asleep, portrayed with the greatest possible fidelity. We are reminded of the madrigal which Gaspare Murtola published in 1604 in praise of '*Amor. Painting by Caravaggio*', which, if such a painting ever existed, must indeed have been a literal prefiguration of the sleeping child in Palazzo Pitti: 'If you desire to depict Love, wise painter, paint the babe and the sweet Giulietto, the one and the other charming, amorous, And if you want to paint him blind, see how he sleeps reclining in sweet

inverted the relationship between figures and setting, revealing the void within the walls as a grandiose still life, and transformed 'these great chambers recalling vast empty warehouses' (to use the words written in another context by a youthful Longhi) into a 'luminous vase and, ultimately, into a pictorial surface'.[83] He was, in effect, paving the way not only for Rembrandt (see, for example, the latter's *Supper at Emmaus* in the Louvre) but also for Velázquez and *Las Meninas*. To what extent this all fitted into Caravaggio's aim of 'imitating well the things of nature' on the basis of 'observation' – visual, which became pictorial – 'of nature', would need further

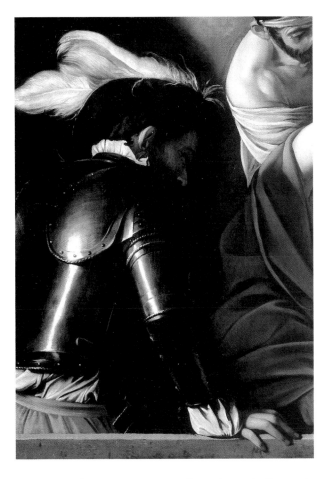

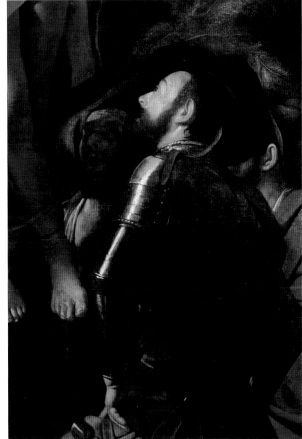

5. Michelangelo Merisi da Caravaggio, *Crowning with Thorns*, detail. Vienna, Kunsthistorisches Museum

6. Michelangelo Merisi da Caravaggio, *Crucifixion of Saint Andrew*, detail. Cleveland, Museum of Art

composure' (*Se dipingere Amore / brami, saggio Pittore, / dipingi il pargoletto / e vago Giulietto, / L'uno e l'altro è vezzoso, / l'uno e l'altro è amoroso, / Che se cieco il vorrai / pinger, guardalo alhor che in dolci forme / languidetto egli dorme*).[82]
But let us return to the *Burial of Saint Lucy*. As we have said, it features peeling walls echoing archaeological ruins, a blind arch in anticipation of the manner of Rembrandt, within which – as far as one can see from an old copy – an old unhinged door stands ajar, not unlike the one leading to the internal courtyard in the *Beheading* in Malta. In making these choices, Caravaggio

comment were it not for the fact that the circumstances surrounding the creation of the *Burial* in Syracuse disclose further leads, allowing us to document better and confirm what has so far merely been suggested. At the end of 1608 (I here repropose, with some modifications, two passages from my book of 1992)[84] an episode occurred which was narrated in 1613 by the Syracusan archaeologist Vincenzo Mirabella and which shows how, thanks to Caravaggio's observation, as well as imitation, of 'nature', the local prison of the *latomia del Paradiso* got the name 'Ear of Dionysius': 'I remember accompanying that singular artist of our times Michel

Angelo da Caravaggio to see this prison, and when he observed its might he was inspired by his unique gift of imitating the things of nature, saying: "Do you not see how the Tyrant, in order to fashion a vessel that would make things audible, looked no further for a model than to that which nature herself had formed for the self same purpose? Thus he made this cell in the likeness of an ear. The which, for not being noticed at first and then realised and studied thereafter, has produced great amazement in the most enquiring minds".[85]

On drawing attention to this passage for the first time, Longhi complained about the 'tone altogether too academic and ... anatomical which Caravaggio's "naturalistic" observation' assumed on that occasion; but it was indeed a 'naturalistic observation', and his interlocutor was fully aware both of its exceptional character and of the reasons for it. In Mirabella's account, the artist *discovered* (surely the right word) that the prison was built *in the likeness of an ear*, on the basis of an identification made possible – this is the point – by the conversance of his *intelligence* with the *imitation [that is, intensive study] of the things of nature*. We should not fail to notice, moreover, that Caravaggio gave an essentially experimental, or indeed functional, explanation of the phenomenon : 'Do you not see how the Tyrant, in order to fashion a vessel that would make things audible, looked no further for a model than to that which nature herself had formed for the self same purpose?' This is hardly an 'academic and anatomical tone'! It is surely already 'Galileian' (in the sense I shall try to clarify below), paying full attention to 'that which experience and sense show us'; providing, moreover, a clarification of what in Caravaggio's method was really meant by the 'observation of the thing', and what were the cognitive processes on which this 'observation' was based.

On coming across the remarks I made in 1992, which I have summarised above, Giuseppe Giarrizzo, a historian from Catania, informed me of the research carried out four years later by Salvatore Russo on Mirabella and his cultural, political and religious bearings, supplementing the information assembled by Enrico Mauceri in 1909 and Gabrieli in 1926–7, and referring also to the pioneering work of Francesco di Paola Avolio in 1829.[86]
It emerges from these studies that Vincenzo Mirabella, born in Syracuse in about 1570 into a noble family of French origins, married Lucrezia Platamone in 1590, the marriage being formalised in front of the notary Vincenzo Leone on 29 August 1592. On 10 January 1590, before the same notary, he entered into a commitment '*pro Reverendo Monasterio Santae Luciae Santissimae*', to

the effect that '*don Vincentius Mirabella et spett. donna Lucrezia de Mirabellis et Platamone coniuge nec non donna Sirena de Negro vidua relicta quondam Giovanni Antoni Negro eorum soror et cognata*' would donate ten *onze* a year to the monastery of Santa Lucia.[87]
In his role as Cathedral clerk of works, between 30 September 1607 and 11 April 1608 he took part in drawing up plans for redesigning the centre of Syracuse and in particular the square in front of the Cathedral. In the years 1611, 1613–14, 1616–17 he served as treasurer and then trustee of the University.

The year 1613 saw the publication in Naples, for the house of Scorriggio, of the *Dichiarazioni della Pianta delle Antiche Siracuse e d'alcune scelte medaglie d'esse e de' Principi che quelle possedettero*, which included the passage on Caravaggio quoted above. On 21 August of that year, while in Naples in the company of Giovanni Battista della Porta, Mirabella sent the newly printed volume to Federico Cesi, asking to be admitted to the Accademia dei Lincei.

On 6 September 1613, Cesi wrote to Galileo Galilei, who had been a member since 1611, sending the following appraisal of Vincenzo Mirabella: 'A knight from Syracuse, noble by birth and very rich, learned in Greek and Latin, man of letters and most erudite in Mathematics and primarily in the theory of Music, in which he is greatly esteemed and admired by his proposer, he has already published a worthy volume on the Antiquity of his birthplace with diligent description of the same. ... He wishes to be enrolled, and is proposed by Signor Porta with whom he is currently staying ...' In 1614 he is informed by the Neapolitan naturalist Fabio Colonna, a member since 1612, of his admission into the Academy;[88] and on 21 May he wrote to Federico Cesi thanking him and wishing him well on the occasion of his wedding to Artemisia Colonna, daughter of Francesco, Prince of Palestrina.

On 7 July, he wrote from Syracuse to Galileo, thanking him for the part he had played in his admission and expressing his admiration for the latter's astronomical discoveries: 'Your honourable self, who, not content to make manifest the occult things of nature here below, have chosen to ascend to the sky, and as a messenger from on high, have told us of so many and such novel things; nor indeed (what a marvel!) did you content yourself with telling us, but have enabled others to behold and admire them, perfecting those instruments with art, which nature left wanting for such grand achievements.'

On 19 August he wrote again to Galileo to ask him for two telescope lenses: 'for the desire to have a perfect

instrument has no other cause than my having read your three epistles concerning the sun spots, which you addressed to Sig. Marco Velseri, and having observed with the instrument I possess the said spots for the best part of two months, I cannot ascertain, by reason of the imperfection of my instrument, what I wish to make out around them ...'[89] This indicates that Mirabella had read the *Istoria e Dimostrazioni intorno alle macchie solari e loro accidenti*, published by Galileo in Rome in 1613. In 1615 he sent Federico Cesi a gift of forty Greek gold and silver coins; and in 1620–1 the Senate of Syracuse used his name in applying to the Viceroy for authorisation to build a stone bridge over the Anapo. After 1621 Mirabella moved to Modica, perhaps because the Academy of which he was a member had come under suspicion of 'scientific libertinism' by the Viceregal authorities. A last letter to Federico Cesi is dated 1 September 1623, and conveys his condolences for the untimely death of the Cesi's son by his second wife, Isabella Salviati. We learn that Mirabella had been informed of the loss by Fabio Colonna. The letter continues: 'Much time has passed since I sent you my respects, and the reason for the delay can only be sinister encounters, as indeed this year I have suffered, as I have partially recounted to our brother Stelluti'. According to Enrico Mauceri, and duly recorded by Salvatore Russo, the 'sinister encounters' consisted of secret accusations laid against Mirabella with the political authorities of the 'Syracusan Jesuits'. Mirabella died at Modica in 1624, and as Salvatore Russo concludes: 'If it is true that in the 1600s scientific knowledge gradually achieved its autonomy and took on a new physiognomy, there is no doubt that Vincenzo Mirabella participated in this process with a full awareness of the new horizons'.[90]

This then was the man who in 1608 accompanied Caravaggio in his discovery of the Ear of Dionysius. Archaeologist, 'man of letters and most erudite in Mathematics and primarily in the theory of Music', he frequented the leading exponents of scientific research in those years, and was an early member of the Lincei and an informed correspondent of Galileo, whose discoveries and experiments he followed with competence. The information that he also undertook, on 10 January 1590, to pay ten *onze* a year to the monastery of Santa Lucia, adjacent to the church of Santa Lucia al Sepolcro where from the first Caravaggio's altarpiece hung, surely leads to the inevitable conclusion that the altarpiece was commissioned by Vincenzo Mirabella himself. Mirabella thus, more even than Del Monte and Gualdo, Onorio Longhi, Ruffetti and Giovanni Battista Manso, brings us to the discovery of

Caravaggio's deep intellectual roots: not a disciplined and submissive adept of Borromeo, who had words of disdain for him, but autonomous precursor in art of the modern scientific revolution, who found a warm welcome also in Syracuse by intellectuals who ran the risk of 'sinister encounters'.

The *Raising of Lazarus*, painted for Giovan Battista de' Lazzari between 6 December 1608 and 10 June 1609 (now in the Museo Regionale, Messina), exploits, with brilliant reinventions, all the features of the *Burial of Saint Lucy*. The two pictures really seem to have been painted contemporaneously, as if the artist went to and fro between Syracuse and Messina, putting his brush first to one and then to the other canvas. The compositional organisation and the ratio between the large empty spaces in the upper part and the masses set out on the diagonal in the lower manifest the same sensibility to the walls of empty ruins, which loom like still-unexplored areas of the planet over the beings who roam within their confines. While in Syracuse it is a burial, in Messina it is a disinterment, the representation of which flares up dramatically and explodes in the darkness, and in both pictures an outstretched hand rises above the heads of the by-standers. The point of most acute convergence, in terms of narrative content, is achieved in the heads of Saint Lucy and Lazarus, both shown falling backwards, transfixed from underneath by the same shaft of light.

The contract for the painting, commissioned by Giovan Battista de' Lazzari for a chapel in the church of the Crociferi, specified the figures of the Madonna, Saint John the Baptist (whose name the client bore) and other saints. The receipt for delivery of the picture, dated 10 June 1609, annotated in the margin of the document of 6 December 1608 in which de' Lazzari undertook to adorn the chapel with a picture, contains this description: *fuit et est depincto resurretio Lazzaro cum immagine domini nostri Jesu Christi et cum immaginibus Martae et Magdalenae et aliorum* ... It is significan that the receipt itself records the change in subject matter, and that it also makes explicit the fact that the picture was being accepted all the same, *non obstante quia in predicto quatro dipingi debat Imago Beatissime semper Virginis Dei genitricis Marie et sancti Johanni Baptiste et aliorum*.[91] This change of subject, which Susinno attributed to Caravaggio's own suggestion that the picture should represent the patron's family name (de' Lazzari) rather than Christian name (Giovan Battista), is in fact unique in the history of patronage, and is highly indicative of Caravaggio's attitude to iconographical prescriptions. We can recall that, above all in religious

paintings but also in those with secular subjects, the artist always based his interpretation on personal, autonomous choices in which the sin of 'novelty' (as Cardinal Gabriele Paleotti termed it) appears quite as flagrant as it is deliberate.

In the same document in which the picture is accepted by de' Lazzari *non obstante* the change in subject, Caravaggio is referred to as *fr. Michelangelus Caravagio miles gerosolimitanus* (preceded by *manu*, indicating his authorship).[92] This is in spite of the fact that on 10 June 1609 the governing body of the Knights of Malta sentenced the painter to *privatio habitus*; that is, deprivation of the habit and expulsion from the Order. The anomaly has not gone unnoticed by scholars, and particularly the contradiction between the manner in which the Order usually pursued members who had blotted their copybook and the tolerance shown by its representatives in Sicily towards Caravaggio, the fugitive, who was kept busy fulfilling major public commissions.[93] For the moment it is not possible to solve this conundrum; we can, however, mention, although it is posthumous, the pencil portrait in the Darton collection in Avignon, published by Roberto Longhi with a correct attribution to Ottavio Leoni (fig. 7), which shows the painter with a large cross of Malta on his chest and the old inscription *fra michelagnolo merisio da Carauagio*.[94] This same drawing was worked up in a mediocre coloured copy as the anonymous portrait of Caravaggio with the knight's cross on his chest belonging to an 'ecclesiastical collection' in Malta, which Catherine Puglisi has recently published (fig. 8).[95] The engraving signed by Baudet (fig. 10) and the one published by Bellori in 1672 (fig. 9), both derived in reverse from the drawing by Leoni (a detail that does not seem to have been noticed up until now), also contain, hidden in the folds of the cloak, the knight's cross; it also features in the engraving of the artist published by Sandrart in 1675 (fig. 11). There were clearly plenty of people interested in perpetuating the news of the painter's decoration, even though he had been stripped of it in disgrace so soon afterwards.

The *Adoration of the Shepherds* entered the Museo Regionale in Messina from Santa Maria degli Angeli, the church for which it had been painted to a commission from the city Senate in the first half of 1609. There has been a tendency to disregard the fact that it was commissioned by a public institution, in favour of the case making Caravaggio out to be an observant of the new post-Tridentine devotional practices. This time emphasis is laid on the fact that both the *Adoration* in Messina and Caravaggio's next work, the *Adoration* stolen from the oratory of San Lorenzo in Palermo, which includes the figure of Saint Francis, were made for churches belonging to the most recent branch of the Franciscan order, the pauperist Capuchin friars. Certainly, the pauperism of the Capuchins and Caravaggio's own version of it do undeniably have something in common, but we must reject the thesis that this is proved by the adoption in these two paintings of the iconography of the Madonna of Humility, familiar in Palermo in Bartolomeo Pellerano da Camogli's *Nostra Domina de Humilitate*, one of the oldest and most authoritative examples of the theme.[96] As all students of iconography know, the oldest iconic formula of the Birth of Christ shows the Madonna lying on a rudimentary pallet, placed on the bare earth, raising herself to look at the infant sleeping in the manger or about to pick him up and hold him in her arms. We can merely cite the examples of Nicolas de Verdun in the famous altarpiece at Klosterneuburg (fig. 12), which dates back to 1183, and Giotto's Nativity in the Scrovegni Chapel in Padua, of about 1305; both precede the versions which introduce the Madonna seated with the Child in her arms, or kneeling in adoration of the newborn messiah.

We cannot rule out the possibility that Caravaggio had taken an interest in earlier iconographies. In the past I myself provided at least two examples, in the lost *Resurrection* painted for the Fenaroli in Sant'Anna dei Lombardi and in the *Saint Ursula* for Marcantonio Doria. But in these pictures the iconography was used not as metaphor or symbolism but as part of the artist's effort to give an almost etymological rendering of the sacred episode – as I sought to make clear – in the starkest form. In the pictures in Messina and Palermo, Caravaggio undoubtedly wanted to distance himself from the familiar formula; but, without departing from his intention of restoring to the Gospel narrative the actual circumstances in which it must have occurred, he avoided all symbols and metaphors, and concentrated on the particular tradition of iconographical representation which he believed most fitting to this overriding aim. Bellori made the telling remark that in Messina Caravaggio 'painted in the Cappuccini the scene of the Nativity, showing the Virgin and Child outside the derelict cattle shed, its beams falling to the ground'. Susinno highlighted 'the black background with rustic wooden beams constituting the cattle shed', and Longhi drew attention, amid broken and collapsing beams, to 'a sort of "peasant still life" – napkin, loaf and carpenter's plane in three tones, white, brown and black'. Convinced that, with the shed, this 'peasant still life' constituted the work's most expressive emblem, Longhi concluded that it 'is reduced to a forlorn quintessence'.

In Palermo, Caravaggio pursued the idea he had first developed in Messina, with inspired variations. Whereas in Messina the ox and ass are represented standing in the background, occupying the whole width of the paling beside the feeding trough, now we see only the long ass's head, almost vying with the extraordinary head of Saint Lawrence. The beams of the derelict shed are propped up obliquely to make room for the Lotti-style angel who, with arms flung wide and wings extended vertically, one lit up and the other in shadow, is flying beneath the beams like a gigantic moth against a windowpane: surely the only reason he does not fall to the ground is because he hangs on a cleverly concealed trapeze wire? Below, amid the three saints looking on with a mixture of wonder and perplexity, with the white-haired (or is it fair-haired?) stable-boy seen from behind, the young mother 'posing' as the Madonna is lifting herself up and leaning on a ledge to have a better view of the naked babe, lying on a sheet laid on a pile of straw. Saint Lawrence, his yellow and gold alb and dalmatic traversed by shadows like no other area of the picture, looms up in the blade of light with a blatancy that anticipates the youthful Velázquez of the *Adoration of the Magi* now in the Prado. Painted in Seville in 1617, some parts of this picture are so reminiscent of the Saint Lawrence in Palermo that one wonders whether the young Velázquez, whose father-in-law Pacheco records that he followed Caravaggio in keeping the model of nature constantly before him ('*y mi yerno, que sigue este camino, también se ve la diferencia que hace a los demás, por tener siempre delante el natural*'),[97] may not have been on a voyage through the islands of the southern Mediterranean, from Malta to Sicily. In Palermo he would have seen with his own eyes, as we are no longer able to, the picture *de aquel varon de la pintura* left in the oratory of the Compagnia di San Lorenzo just before Caravaggio's return to Naples.

As Giovan Pietro Bellori recorded, 'He sailed again for Naples, where he intended to stay until he received news of his pardon ... Seeking at the same time to placate the Grand Master, he sent him as a gift a half-length figure of Herodias with the head of Saint John in a basin'.[98] All agree that 'Herodias' must be a mistake, since it is obviously Salome, daughter of Herodias (Bellori, who had made the same mistake talking about the *Beheading of Saint John the Baptist* in Malta, goes on to discuss Honthorst and his *Martyrdom of Saint John the Baptist* for Santa Maria della Scala, and observes correctly: 'with the daughter of Herodias nearby ... the plate by her side').[99] There have been various attempts to identify this work with one of the two Salomes painted during those years: one formerly in the Casita del Príncipe in the Escorial, now in Palacio Real, Madrid; the other in the National Gallery, London. But these did not take into account the fact that both paintings feature three half-length figures, rather than one as Bellori specifies unequivocally ('*one* half-length figure of Herodias' etc.). Instead the picture that matches perfectly Bellori's description, and has the features one would expect to find in Caravaggio of this last period, is the half-length of Salome 'with the head of Saint John in a basin' from the Arditi di Castelvetere collection in Castello di Presicce near Lecce, now in Rome. I identified this picture more than twenty years ago, and since then confirmation has come from the painstaking work of restorers: not only is it undoubtedly an autograph work, but it is of the highest quality, in inverse proportion to its size, which is quite small. What is more, this Salome joins the ranks of the artist's most original achievements, not least for the interpretation given to the subject. True to his genius, Caravaggio presents the daughter of Herodias as a young girl who is rather too worldly wise, almost brazen, sporting a piece of refined jewellery in her ear, her head bound with ribbons which flutter down around her shoulders. She is performing the unprecedented gesture of carrying the trophy under her arm, for all the world as if it was a bundle of washing on the way to the mangle. Artistically and chronologically, the picture has telling similarities with the works Caravaggio painted in Malta, Sicily and Naples in the years 1608–9. If we look closely, we see that this is the same Salome as the one who, in the *Beheading* in Malta, bends over to receive the head of the saint; the charger, too, is the same as the one depicted in Malta, as if, in producing a gift for the Grand Master of the Hierosolymite Order, Caravaggio went out of his way to remind him of the work that could put him in the best possible light. On the other hand, the 'head of Saint John in a basin' is remarkably similar to the one featured in the Escorial picture which, in all probability, was painted in quick succession. The latter work in turn evokes the *Salome* in London, in which the affinity between the previous two works is projected forwards, to link up with the *Flagellation* in San Domenico Maggiore, to which we will now turn.

The *Flagellation* was recorded by Baldinucci as the first work Caravaggio did in Naples (perhaps on account of a misunderstanding of Bellori's reference to it, which was for a long time the only reference in the literature), and reassigned to the artist's first Neapolitan stay even after Roberto Longhi, who can claim the merit for discovering the existence of a second stay, proposed ascribing it to this subsequent period. Confirmation for a dating to

1607 seems to come from documents which, albeit for a work whose subject is not specified but whose identity with the picture we are dealing with has been unnecessarily questioned, record two payments made to Caravaggio by Tommaso di Franco: one of 100 ducats, on account for a sum of 250 ducats, on 11 May 1607, and the other of 49 ducats on 28 May. After some toing and froing, the earlier dating seems to have prevailed, to judge by the assertions of the most recent biographers and compilers of registers of documents.[100]

However, in addition to objections made in the past, others have come to the fore, and we can now summarise the situation as follows. First of all, it is clear that neither of the two payments were final payments; indeed for the larger figure it is explicitly stated that it was 'on account for the cost' of a work 'which is to be consigned'. In the second place, Caravaggio left for Malta just a month after these payments, and there are no grounds for thinking that he came back to Naples before his escape from Valletta. In the third place, X-ray analysis had already shown, beyond any doubt, the existence of a first version of the composition, left unfinished on the right-hand side, with the draft of a striking portrait, possibly of the person who commissioned the work, which was subsequently covered up. Finally, further analysis carried out during the recent restoration has revealed the existence of a large section of canvas added onto the right-hand side.[101] In my opinion, the only explanation is that Caravaggio began the work before leaving for Malta, and with characteristic rapidity had made considerable progress. Obliged to leave at short notice, he left it in draft form and returned to it more than a year later, on his return from Sicily. In the past I put forward the suggestion that the tormentor on the right, traversed by shadows in such an extraordinary manner to cover up the draft of the abandoned portrait, was the main outcome of Caravaggio's second intervention; and I also pointed out that the stature, pictorial construction and 'action' of this torturer were so reminiscent of the grave digger wielding the spade in the *Burial of Saint Lucy* in Syracuse as to be inconceivable without this precedent. The discovery that this part of the *Flagellation* is the result of a deliberate extension of the canvas leads me now to argue that Caravaggio, once it had been decided to suppress the donor's portrait – perhaps because it was deemed too assertive by the person himself, or because he considered it irreverent to appear in such proximity to the sacred figure of the scourged Christ – decided to reuse the figure of the grave digger and reinvent it in a new context. One could even argue, in fact, that it is precisely

the reutilisation and reinvention of the grave digger in the *Flagellation* in Naples which stands as the clearest proof that the latter was reworked following Caravaggio's return from Sicily. Moreover, he could hardly have reorganised the scene without carrying out a thorough recasting of the whole picture: from the figure of the scourger kneeling to knot the branches of his scourge, whose profile in shadow is attenuated in the brilliant light reflecting off the leg of Christ, to the figure of the torturer in action on the left, who in the styling of his garments shows affinities with the executioner in the *Salome* in London, who can be seen to have been painted from the same live model, thereby completing the chronology.

On the strength of the identification of a third representation of this same model, in the *Flagellation* in the Musée des Beaux-Arts, Rouen – another work whose conception, at least, can certainly be attributed to Caravaggio in these months – we can go on to illustrate another circumstance leading to the same circle of patrons which must have produced the commission for the *Saint Ursula* by the Genoese nobleman Marcantonio Doria.

Scholars in search of sources to reconstruct the iconographical genesis of the *Flagellation* have come up with images as wide-ranging as Sebastiano del Piombo's *Flagellation*, the 'Raphaelesque' picture in Santa Prassede, Rome (variously attributed to Giulio Romano, Simone Peterzano or even Peter de Kempner), and a *Flagellation* by Romanino recently presented by Keith Christiansen.[102] The reference to Romanino (and hence by implication to Baldung Grien and Dürer, although only Romanino himself can have been acquainted with these artists) does at least have the merit of taking us back to that area of Lombardy which was Caravaggio's stamping ground in his youth (Longhi proposed one analogy in the *Martyrdom of Saint Lawrence* by Antonio Campi in San Paolo, Milan). However, none of these links really gets to the heart of the matter, or gives due importance to the fact that Caravaggio was never interested in references which he could not remake in a realistic way. We can instead propose a very different source by recalling, firstly, that Caravaggio, who is known to have been in Genoa from after 24 July 1605 until almost 24 August, had dealings concerning artistic matters with members of the Doria family ('he had been sought by Prince Doria to paint a loggia for him' was how the Roman correspondent of the Duke of Modena put it in an unusually swift communication dated 24 August); secondly, that the man who was to commission the *Martyrdom of Saint Ursula*, Marcantonio Doria, could

12. Nicolas de Verdun,
Nativity. Vienna, Klosterneuburg

legitimately be referred to as a 'friend' of Caravaggio by the former's correspondent in Naples ('whom I know to be a friend of yours' as Lanfranco Massa wrote on 11 May 1610); and thirdly that the ships belonging to the Doria family regularly sailed into Naples, for even the Viceroy, the Count of Benavente, arrived in the city on board a ship 'of Prince [Giovanni Antonio] Doria in the company of Don Carlo, his son'.[103]

Among the various wills with which Caravaggio's friend, Marcantonio Doria, prepared the division of his property between his two sons on his death, the one dated 1645 stipulates that the first-born Niccolò should have the most valuable pictures in terms of both personal significance and monetary value, and first among these, before even Caravaggio's *Saint Ursula*, we find 'the Christ at the column by Titiano'. Since Marcantonio left to his younger son Giovan Francesco 'the pictures with portraits', including that of the 'quondam signor Giacomo, ancestor, by the hand of Tiziano', and we know this Giacomo Doria, Marcantonio's grandfather, to have been painted by Titiano 'by virtue of the financial services' rendered,[104] it is not difficult to deduce that the 'Christ at the column' too derived from the estate of Giacomo and had also originated from these 'financial services'. There is no doubt that, always bracketed with the *Saint Ursula*, this painting continued to be part of the inheritance of Marcantonio until 1832, when it was transferred to Palazzo Doria d'Angri in Naples, designed by Luigi Vanvitelli. Thereafter it became embroiled in the dubious dealings surrounding the sad dispersion of the inheritance during the following century. On 30 April 1903, one lot in a public judiciary auction held in Rome by the notary Filippo Delfini was 'an oil painting, 0.90 x 1.10, representing Christ at the Column – from the Galleria Angri in Naples, where it bore the indication – Tiziano – Cristo alla Colonna'. It was bought by the Roman artist Giuseppe Micocci, resident in Villa Stuart, via Trionfale 68, at Montemario.[105]

Fortunately this picture still exists, the property of Micocci's descendants (his sister being their maternal grandmother), and I am able to publish it thanks to their goodwill and also to the zeal of Dottoressa Mariella Utili, director of Capodimonte, who was good enough to put me onto this trail back in 1986, following my documentary research concerning the *Martyrdom of Saint Ursula*.

The painting is a masterpiece by Titian which can be dated before 1560 (fig. 13). It can be considered the earlier and more luminous version of the *Christ at the Column* which passed to the Aldobrandini family from the estate of Lucrezia Borgia and is now in the Galleria

Borghese in Rome. While the latter picture has by some been considered an autograph work of Titian, it seems more judicious to consider it only in part the work of the master.[106] On comparison, the Doria *Christ* has a degree of truthfulness which is as tragic as it is radiant, evident in the exquisite beauty of the splendid veined marble column and the astonishing sensuality of Christ's body and loincloth, worthy of Van Dyck.

I have no hesitation in affirming that, when Caravaggio conceived his *Flagellation* and wanted a different slant to the one he had adopted in the composition of which there is a copy in Palazzo Camuccini at Cantalupo in Sabina, his mind turned to Titian's extraordinary *Christ at the Column* which he had seen in Genoa in 1605, in the house of Giacomo Doria. He must have remembered first and foremost the extraordinary veined column to which Titian had tied his Christ, for at the heart of Caravaggio's picture is an even more majestic one, its volume evoked by the glimmers of light in the shadowy, crepuscular vastness of the chamber. He then introduced the massive body of the victim, recomposing the three-quarter-length figure of Titian in reverse, with the head thrown forward. He must in fact have been deeply perplexed by which direction to make Christ face, for when he was asked to paint the same subject again, in less monumental dimensions, he reproduced the torturer on the left of the picture for Tommaso de Franchi in the same pose, but he began by changing the position of the column with its blood-red veining, and then depicted the figure of Christ leaning forwards from right to left, exactly like the Christ of Titian: this time he came very close to making a quotation, or indeed an explicit acknowledgement of his indebtedness.

In illustrating an analogous case of 'Titianesque quotation in Caravaggio', perceived in the *Ecce Homo* painted for Prince Massimi, Roberto Longhi wrote that, even though it had been shown to be impossible that the young Caravaggio had made the journey to Venice, 'there remained intact, and indeed all the more comprehensible, the possibility that Caravaggio should have reapplied himself to the problem of the almost "pure painting" of the sixteenth-century Veneto artists and, *in primis*, that of Titian'.[107] The case we are considering involves the same problem but in different terms: it is in fact evident that Caravaggio's study of the Doria d'Angri *Christ at the Column* sought to revive the 'almost "pure painting"' of the master from Cadore which, on account of its intensity, rediscovers both an almost Phidian sense of the human figure and its vital carnality'.

After completing the *Flagellation*, Caravaggio seems to have worked on two large-scale pictures in Naples. One

is the *Annunciation* in Nancy, which he must have left unfinished, to be completed subsequently by others on various occasions, with the exception of the 'portentous' angel, as Longhi defined it, which is an obvious reprise of the angel which rends the darkness in the *Adoration of the Christ Child* formerly in San Lorenzo, Palermo.[108] The other is the *Resurrection of Christ* painted for the chapel of the Bergamask Alfonso Fenaroli in Sant'Anna dei Lombardi. Since the chapel was granted to Fenaroli on 24 December 1607, the work cannot have been completed before the end of 1609 – the hypothesis (based on

'emerges from the tomb almost in fear' – Bernardo De Dominici, 1745 – and '*passe en marchant au travers des gardes, ce ... qui le fait rassembler à un coupable qui s'échappe de ses gardes*' – Charles Nicolas Cochin, 1763).[109] I cannot pass over the fact, however, that in the collection of Giovan Carlo Doria in Genoa, c.1617, were to be found, at no. 276 'a resurrection of a Christ, copy of Caravaggio, Neapolitan manner', with walnut frame, and at no. 277 'a Christ bound at the column, large with full length figures, also with walnut frame'. The pair recurs in subsequent inventories: in one dating from not

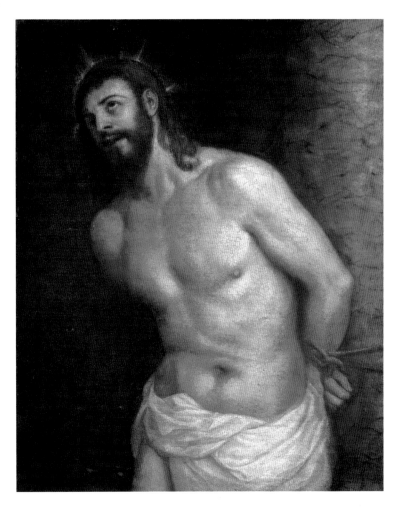

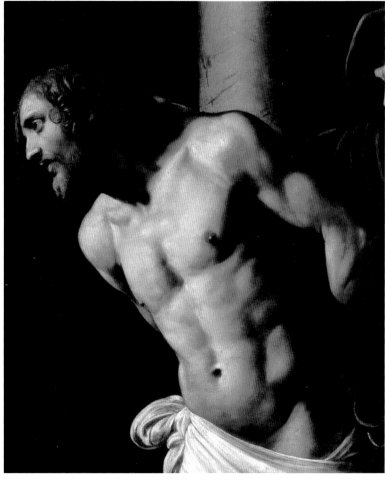

unreliable documents) of a return visit to Naples during the brief time he spent in Malta is absurd. For reasons of space I cannot here return to the complex arguments I set out twelve years ago concerning the work's genesis and iconography, or to the sources which describe it as inspired by a 'base and indecent idea of what was being represented' (it was qualified as 'Christ not as He is usually done, agile and triumphantly airborne; but with that most savage manner of painting he has, with one foot in the sepulchre and one foot on the ground' – Luigi Scaramuccia, 1674 – so that the resurgent Christ

later than the end of 1621, we find at nos 252 and 253 'a resurection of Our Lord and a flagellation at the column done in Naples', and in one of 12 June 1641, 'in the mezzanine down on the right as you go up to the room', at no. 287, there is 'a resurection of Christ', and 'in the mezzanine on the left as you mount the stairs', at no. 368, 'a Christ at the column, large'.[110] In addition to the fact that copies of two major works of Caravaggio were in Naples, which moreover are not recorded in the literature until many years after the mention in the Genoese inventories, it seems to me highly significant

that the two works were bracketed together so as to make a pendant. They were in effect considered as comparable and contemporaneous, with a substantial unity in both pictorial and iconographical intent. This surely is a solid contribution to the debate on chronology: given that the *Resurrection* cannot have been painted before the final months of 1609, the *Flagellation* too must have been completed – if not completely redone – in the same months.

What still remains to be said on the activity of Caravaggio up until the journey which ended in his death could fill a book, and can hardly be contained in the few lines available in an occasional essay such as this one. In the letter from Lanfranco Massa to Marcantonio Doria which speaks of the *Saint Ursula* we read: 'prepare another subject for Car[avaggio], whom I know to be a friend of yours, because he is already well on here … among these, who are in competition'. It is clear that, habitually a fast worker, following the attack at the Cerriglio he worked furiously, with great lucidity, making it legitimate for us to ascribe to these months the various works to be accounted for. Of course in vetting these works we must condemn the over-indulgent attitude to attribution which has been gaining ground for some time past. There is no place for *The Tooth-puller*, the alleged first versions of *David with the Head of Goliath* or the various specimens of the *Saint John the Baptist at the Spring* which have made their appearance in recent years. In fact, this section of the exhibition in Naples was dedicated specifically to copies and problematic works and was undoubtedly an excellent laboratory for comparisons and verification. We should, however, emphasise two points. In the first place, with respect to the pictures of Saint John the Baptist at the Spring, there is no doubt that there exists a prototype which will prove beyond all doubt to be by Caravaggio. It is still to be identified, and in my opinion the essential version remains the one which years ago was in Rome in the hands of Francesco Romano, and for which Longhi suggested an attribution to Battistello, and I to the early activity of Alonzo Rodríguez, for which there is some support.[111] In the second place, I must say something about the consequences of the recent restoration of the *Martyrdom of Saint Ursula*, which following the archive discoveries in 1980 and the other documents which have since come to light can be considered one of the best-documented paintings from the seventeenth century, and not only of Caravaggio.[112]

The beautifully executed hand of the man accompanying the Princess, which the excellent cleaning carried out by the restorer Giantomassi has retrieved from underneath old repaintings, has restored to the work and the moment it narrates an animation and an emotional immediacy which have never previously been noted, not even it seems by the most recent commentators. Clearly Caravaggio set out to exult in the commotion provoked by the flight of the arrow loosed at point-blank range, exploiting the culminating moment of the narrative. The hand fends off the posse of protagonists, giving more room to the distraught and repressed tension which is urging it forward. This also enables us to get a clearer idea of the problem posed by the picture's iconography. Caravaggio turned his back on the potential of the legend of the eleven thousand virgins and concentrated

13. Tiziano Vecellio, *Christ at the Column*. Private collection, formerly Genoa, Doria collection

14. Michelangelo Merisi da Caravaggio, *Flagellation*, detail. Rouen, Musée des Beaux Arts

15. Alonzo Rodriguez, *Saint John the Baptist at the Spring with a Lamb*. Formerly Rome, Romano collection

on the moment in which the Hun king shoots the defiant maiden who dares to refuse him. But in so doing – and recent commentators seem to have missed the point – Caravaggio turned to the iconographical tradition which combined the representation of the arrow being loosed with the protective hand being thrust out. Among the cases I am able to cite, there is first of all the shrine by Hans Memlinc in St John's Hospital in Bruges, where the panel featuring this martyrdom shows the saint in front of the camp of the Huns, with the king about to transfix her, while a man in armour intervenes, his left hand upraised to protect the shrinking Ursula.[113] Another concerns Ludovico Carracci, who in the second version

he painted of this episode, dating from 1600, in San Domenico, Imola, also introduced the motif of the warrior seen drawing his bow, with the arrow not yet loosed, and in the background two warriors, one who appears to want to dissuade the marksman and the other, a standard bearer, to protect the saint from the oncoming arrow.[114] Caravaggio set out to represent precisely this moment of the story, concentrating entirely on it, as the restored picture clearly shows.[115]

I can also note that, among the traces of a previous version which re-emerged in the Doria *Saint Ursula* during restoration, some bronze fringing appeared, presumably fragments of a helmet or coat of armour, which is identical to the fronds around the helmet of the man in the *Denial of Saint Peter* now in the Metropolitan Museum, New York, as is indeed the cuirass of the tyrant: this is surely an unmistakable sign that the two works were painted at the same time, even on two easels set up one next to the other.[116] Nor can we ignore the fact that the gesture of the executioner in the *Salome* in London,

thrusting his arm forward to place the Baptist's head in the basin, is a direct prefiguration of the gesture with which the Borghese *David* displays the bloody head of Goliath, also held by the hair. Here the tragic self portrait, with its desperate death cry, continues the tradition of self portraiture which Caravaggio had used in the *Saint Ursula*, where his face is disfigured by a look of anguish, in marked contrast to the self portrait in the *Taking of Christ*, now in Dublin, where he is still youthful and unlined.

'Whereupon, as soon as he could get aboard a felucca, full of bitter grief, he set off for Rome ... On reaching the beach, the Spanish guards who were awaiting another Knight [of Malta?], arrested him instead, and held him in prison. And although he was soon released, he did not find the felucca which with his things had given him passage... When he got to Porto Hercole he collapsed and ... died in a few days.'[117] In composing this account Bellori had certainly not read the letters which have recently been found by Pacelli;[118] but he does seem to be narrating the episode of the arrest at Palo, and even to know of the felucca which headed back to Naples, carrying Caravaggio's belongings with it.

1 Federico Borromeo, *De Delectu Ingeniorum*, Codice Ambrosiano F. 31 inf., ff. 204v–206r.

2 See T. Margetich, 'Per una rilettura critica del 'Musaeum' di Federico Borromeo', in *Arte Lombarda*, 1988, nn. 84–5, pp. 102–18, especially p. 108; B. Agosti, 'La Pinacoteca Ambrosiana. Aperture e chiusure', in *Prospettiva* n. 87–8, July–October 1997, pp. 177–8, 180 note 13 (with one important clarification, see below); M. Bona Castellotti, *Il paradosso di Caravaggio*, Biblioteca Universale Rizzoli ('I libri dello spirito cristiano'), Milan 1998, pp. 28–9, 40 note 24, 200; F. Bologna, 'Il Caravaggio al Pio Monte della Misericordia', in *Il Pio Monte della Misericordia di Napoli nel quarto centenario della fondazione*, ed. Mario Pisani Massamormile, Naples 2003, pp. 173–89 (republished with adaptations in *Confronto*, n. 2, January 2004, pp. 83–93). Edited by F. Bologna, it was also included in the brief anthology of documents and comments accompanying the various editions of the exhibition *L'opera d'arte nell'epoca della sua riproducibilità digitale: Tutta l'opera del Caravaggio: una mostra impossibile*, RAI e Regione Campania, Naples, April–June 2003, Salerno, July–September 2003, Rome, February–March 2004, Malta, summer 2004.

3 Karel van Mander, *Het Schilder-Boeck*, Harlem 1604, p. 191.

4 G.P. Bellori, *Le vite de' pittori, scultori e architetti moderni*, Rome 1672, ed. E. Borea, Einaudi, Turin 1976, p. 218.

5 Bellori 1672, cited in note 4, p. 223.

6 Bellori 1672, cited in note 4, pp. 230–1.

7 Bellori 1672, cited in note 4, p. 232. As confirmation of this assessment of the young Caravaggio, coinciding with the judgement of Federico Borromeo, we can add the report, dated 11 July 1597, of the questioning of the barber Luca son of Marco Romano. In saying he knew Caravaggio and that he was a painter, that he had attended and sometimes treated him, but maintaining he did not know his name, Luca gave the following description of him: 'this painter is a large youth, 20 or 25 years old, with a small black beard, rather large with heavy brows and dark eyes, who goes around dressed in black but not very smart, wearing a pair of black breeches rather the worse for wear, his hair long over his forehead' (with reference to text published by Corradini e Marini, republished in Bona Castellotti, see S. Macioce, *Michelangelo Merisi da Caravaggio. Fonti e documenti 1532–1724*, Ugo Bozzi editore s.r.l., Rome 2003, pp. 60–3, I DOC 64).

8 On Cardinal Ottavio Paravicino, the letter of 1603 to Paolo Gualdo containing the cited information and the discussion concerning the letter following its publication by Gaetano Cozzi, see F. Bologna, *L'incredulità del Caravaggio e l'esperienza delle 'cose naturali'*, Turin 1992, pp. 54–61.

9 F. Borromeo, *De pictura sacra*, 1624, libro I, cap. XI: Italian translation and ed. by Carlo Castiglioni, Sora 1932, p. 20 (Latin text), p. 76 (Italian).

10 F. Susinno, *Le vite de' pittori messinesi e di altri che fiorirono in Messina*, 1724, ed. V. Martinelli, Florence 1960, p. 114.

11 F. Bologna, 'Il Caravaggio al Pio Monte della Misericordia', in *Il Pio Monte della Misericordia di Napoli nel quarto centenario della fondazione*, cit, pp. 173–4, and in *Confronto*, n.2, cit., pp. 83–4.

12 S. Macioce, *Michelangelo Merisi da Caravaggio*, cited in note 7.

13 See note 2. The edition of the exhibition in question is Castel Sant'Angelo, Rome.

14 M. Calvesi, 'Il feticcio Caravaggio', in *L'Unità*, Saturday 27 March 2004, 'arte'. Here is the piece in full: 'The photographic exhibition on Caravaggio at Castel Sant'Angelo, which closed in mid March, has had a well-deserved success... The initiative was intelligent and well curated, opening up a new form of safeguarding for originals which are over-taxed by continuous exhibitions. However, among the accompanying material there is a passage by Cardinal Federico Borromeo in the guise of a portrait of Caravaggio, recalling that he had met in Rome a slovenly painter who wormed his way into the kitchens of rich households to lick the plates, and was only satisfied when he had painted scenes of taverns and tipplers. It is impossible that this can be the great Merisi, all the more so since he never painted either taverns or tipplers; the passage was merely included to revive the tired cliché of the *peintre maudit*, served up to the visitor as a historical record of Caravaggio'.

15 See B. Agosti, 'La Pinacoteca Ambrosiana. Aperture e chiusure', in *Prospettiva*, n. 87–8, July–October 1997, p. 80, note 13. Here is the note in full: 'This passage is in the vulgate version of the *De delectu ingeniorum* compiled by Federico (Milan, Biblioteca Ambrosiana, ms. F. 31 inf., ff. 118–19 [205v–206r]). The *De delectu ingeniorum*, in Latin, was published by the Biblioteca Ambrosiana in Milan in 1623, and Federico obviously planned – in keeping with his other works – a vulgate version; one of the printed copies in the Ambrosiana has a series of annotations in the Cardinal's hand duly incorporated in the translation – partially revised – contained in the manuscript (for this procedure, typical of Federico, see A. Martini, 'I tre libri delle laudi divine' di Federico Borromeo. Ricerca storico-stilistica*, Padua 1975, pp. 162–3). Tiziano Margetich had identified the 'painter' with Caravaggio (*Per una rilettura critica*, cit., p. 25), and it seems to me the passage would fit well in the celebrated 'anthology' of Caravaggesque criticism assembled by Roberto Longhi in *Paragone* in 1951. Confirmation for the identification, and for Borromeo's intention of giving a negative judgement on the artist, comes from the miscellany of preparatory notes for the composition of the *De delectu ingeniorum*, also in codice F 31 inf. The notes are in the same order as the subjects in the final text. In these preparatory papers, annotated hurriedly passing from Italian to Latin and viceversa, as we find in all his notebooks, Federico writes a note on the *vitia scriptorum* in which he contrasts with good books those, like Burchiello «diffettosi assai, imprudenti, sozzi», in which there is «vivacità», but also «multo peccato» (f. 30v). The Latin version of the passage cited in the text (*De delectu ingeniorum libri duo*, Mediolani 1623, pp. 51–2) is rather more detached: '*Dum Romae essemus, monstrabatur inter Pictores homo pravis moribus foedisque, qui lacera semper, et sordida veste Principum coquinas sectabatur, atque ibi inter mediastinos agebat aevum. Is homo nihil unquam*

in arte illa sua dignum laude fecit, nisi cum ganeones et ludiones, et aleatores pingeret. Aegytiae divinatrices, et garruli, baiulique, et strata nocturnis horis ebriorum corpora per fora, et vias tabulae ipsius erant; triumphabatque mirifice quoties cauponam unam, et in ea comessantem aliquem fecisset. Nimirum indigni mores hominis manum huc, penicillumque trahebant, et qualis illi animus obtigerat, talia etiam opera artificis cernebantur'.

[16] See Bologna 1992, cited in note 8, pp. 11–138; the section on 'Il Caravaggio e Federico Borromeo' is at pp. 112–37.

[17] The relevant bibliographical data and an analysis of the question are also in Bologna 1992, cited in note 8, pp. 129–37.

[18] See Bona Castellotti 1998, cited in note 2, p. 7.

[19] See B. Agosti, *Collezionismo e archeologia cristiana nel Seicento. Federico Borromeo e il medioevo artistico tra Roma e Milano*, Milan, Jaca Book, p. 34, note 73. In 'La Pinacoteca Ambrosiana' 1997, cited in note 2, p. 80, note 13, without repeating the citation of my work of 1992 recorded the year before, she writes: 'On the phantomatic ideological convergence between Borromeo and Caravaggio there has been a lucid intervention by G.D. Neri, 'Caravaggio e la scuola del silenzio', in *aut-aut*, pp. 280–1, 1997, above all pp. 147–9, 152–6'. There follow acknowledgements to 'Ippolita De Maio for informing me of this passage'.

[20] We can add one further reason for keeping Caravaggio quite distinct from Cardinal Borromeo's sphere of (political) influence. Following the murder of Tomassoni, in which Caravaggio's friend and mentor in Rome, the Lombard architect Onorio Longhi, played no little part, the latter took refuge in Milan, the see of Borromeo, while Caravaggio, a son of Lombardy and Milan, chose not to, but roamed instead through the estates of Southern Italy. Here is the letter which Longhi sent from Milan to the Pope, Paul V Borghese. Clearly opportunist, with special pleading and a hint of hypocritical disloyalty, it asks for pardon and the revocation of the ban on his return to Rome.
'Reverend Father, Honorio Lungo humbly informs you of how in 1606 he was banned from Rome, as appears in proceedings of the law courts of the city, since he had been present at the murder by Michelangelo da Caravaggio of Ranuccio Tomassoni, in which the supplicant had no blame, indeed he was accompanying Caravaggio as a good friend; so that there should be no disorders, and exhorting him to make peace: as God and his conscience are witness. Since he has always been fully conscious of his innocence, he has found peace, and during this time he has been in Milan in the service of M.a Cesarea; wishing to return with his wife and five children in order above all to serve the Church and Your Grace, in whatever You might deign to command him, he humbly supplicates You to lift the said ban, whereupon he shall live in perpetual obligation with his family to pray God for the long life and health of Your Holiness'.
Published by Bertolotti on pp. 75–6 of his celebrated collection of letters, it was republished with no further indications of chronology by W. Friedländer, *Caravaggio Studies*, Princeton 1955 (reprint Schocken, 1969), p. 287, but omitted, it would appear, by Macioce, in *Michelangelo Merisi da Caravaggio*, cited in note 7.

[21] R. Villari, 'Rivolte e coscienza rivoluzionaria nel secolo XVII', in *Studi storici*, 1971, reprinted in idem, *Ribelli e riformatori dal XVI al XVIII secolo*, Rome 1979, pp. 13–42 (p. 34). See by the same author, *Elogio della dissimulazione. La lotta politica nel Seicento*, Bari 1987, pp. 8–17, especially pp. 16–17.

[22] For an analysis of all the implications in Caravaggio's work, see Bologna 1992, cited in note 8, especially chapters 4 and 5 (pp. 138–234), and in general all the first part and *passim*; subsequently echoed (and in some cases amplified concerning the documentation) by R. Bassani-F. Bellini, *Caravaggio assassino, La carriera di un 'valenthuomo' fazioso nella Roma della Controriforma*, Donzelli editore, Rome 1994, pp. 105–7, 170–7.

[23] A. Bertolotti, *Artisti lombardi a Roma nei secoli XV, XVI e XVII, Studi e ricerche negli archivi romani*, Milan 1881, vol. II, pp. 74–5; M. Cinotti, in G.A. Dell'Acqua e M. Cinotti, *Il Caravaggio e le sue grandi opere da San Luigi dei Francesi*, Milan 1971, F.71, p. 159; M. Cinotti, *Michelangelo Merisi detto il Caravaggio*, Bergamo 1983, p. 244; Macioce 2003, cited in note 7, p. 180, II doc. 234.

[24] Letter of Gian Vittorio Rossi to Giovanni Castellini, 4 September 1620, included in Iani Nicii Erytraei, *Epistolae ad diversos*, Colonia [i.e. Amsterdam, Bertoldo Nihus] 1645, p. 62. On this see P. Della Pergola, 'Una testimonianza per Caravaggio', in *Paragone*, n. 105, September 1958, pp. 73–4; eadem, *Galleria Borghese, I, I dipinti*, vol. II, Rome 1959, pp. 221–2, doc. 79; Cinotti 1971, cited in note 23, F. 72, pp, 159–60; Cinotti 1983, cited in note 23, p. 244; Macioce 2003, cited in note 7, pp. 181–2, II doc. 237.

[25] I can refer in general to the bibliography and data assembled by Bassani and Bellini, cited in note 22, pp. 170–2. And previously, see in particular Bologna 1992, cited in note 8, *passim*.

[26] On the dependence of de Rossi's *Eudemia* on the *Argenis* by Barclay, and the two Barclays, see the relevant entries in *Enciclopedia Italiana*, respectively volumes XXX and VI.

[27] On Ottavio Costa and his purchase of the Brera *Emmaus*, recorded by Giulio Mancini, see Bologna 1992, cited in note 8, pp. 209–10, 214–15, 332, and *passim ad indicem*.

[28] Summary in Macioce 2003, cited in note 7, n. II doc. 326 e 327, pp. 219–20.

[29] See L. Gazzara, 'Fonti inedite sulla fondazione del Pio Monte della Misericordia: una lettura interpretativa', in *Il Pio Monte della Misericordia, nel quarto centenario*, ed. Mario Pisani Massamormile, Naples 2003, pp. 213–28, with a rich bibliography, valid for what follows.

[30] B. de Giovanni, 'Magia e scienza naturale nella Napoli seicentesca', in *Civiltà del Seicento a Napoli*, Naples 1984, p. 31.

[31] V. Spampanato, *Quattro filosofi napolitani nel carteggio di Galileo*, Portici 1907, p. 74.

[32] Moreover this patronage had turned into support and protection. In May 1598 Marino was arrested for immorality (he was accused of sodomy, and also seems to have forced a girl to abort); imprisoned in the Vicaria, he

was freed on the intercession of Conca (see F. Nicolini, 'Marino, Giovanni Battista', in *Enciclopedia Italiana*, vol. XXII, 1934, pp. 350ff, with ample bibliography).

33 See A.E. Denunzio, 'New data and some hypotheses on Caravaggio's stays in Naples', in this catalogue, note 57, specifying that the document is in Archivio Gonzaga, busta 824, and was published by I.M. Iasiello, 'Vincenzo I e il Regno di Napoli', in R. Morselli (ed.), *Gonzaga. La Celeste Galleria. L'esercizio del collezionismo*, Milan 2002, p. 361. I can add that the document is missing from Macioce's compendium.

34 On these dates and their documentation, see Denunzio's essay, cited in note 33.

35 On this episode, see Macioce 2003, cited in note 7, n. II doc. 332, pp. 219–21, with bibliography.

36 On the collection of Matteo di Capua, Prince of Conca, see A. Ferri, 'La collezione di Matteo Capua da palazzo d'Alarçón al castello di Vico Equense', in Morselli 2002, cited in note 33 ,pp. 361, 371–3.

37 For the cited documents, see now Macioce 2003, cited in note 7, nn. II doc. 354 & 355, pp. 230–1, with bibliography.

38 Bologna 1992, cited in note 8, pp. 189, 223–4, 445, note 84. On this subject, nonetheless, one should never ignore the old but ever useful M. Manfredi, *Gio. Battista Manso nella vita e nelle opere*, Naples 1919.

39 Bellori 1672, cited in note 4, pp. 225–6.

40 See M. Scaduto, 'Le carceri della Vicaria di Napoli agli inizi del Seicento', in *Redenzione umana. Rivista di studi giuridici e sociali*, n. 6, 1968, pp. 393–412. For further bibliography on the question, and other data, see V. Pacelli, *Caravaggio. La*

Sette Opere di Misericordia, Salerno 1984, pp. 109–10, notes 35–8.

41 On the social situation in Naples during the months Caravaggio spent there in 1606–7, see S. Causa, *Battistello Caracciolo*, Naples 2000, p. 361, for the year 1607: 'Year of serious famine in the territories of the Kingdom – as a correspondent of the Granduca di Toscana related – so that people flock into Naples and roam the city crying *pane, pane*, and so many paupers have died that please God plague will not strike, for then people will be dying in the streets'. On the same famine, see also Giuseppe Coniglio, *I Vicerè spagnoli di Napoli*, Fausto Fiorentino editore, Naples 1967, pp. 165–9, in the chapter dedicated to the reign of the Count of Benavente. We must point out, however, that on the basis of precise references, Coniglio dates the famine not to 1607 but to 1604–6.

42 On this picture, unusually painted on board – the only other one among Caravaggio's autograph works being the Odescalchi Colonna *Conversion of Saul* – see John T. Spike, *Caravaggio*, CD-ROM, Abbeville Press, New York 2001, no. 52, pp. 225ff. This work is the most complete recent study on Caravaggio, in terms of facts, bibliography and repertory of copies. Nonetheless it should be consulted together with the still unsurpassed Mia Cinotti, *Michelangelo Merisi detto il Caravaggio*, part of *I pittori bergamaschi. Il Seicento*, vol. I, Bolis editore, Bergamo 1983. In the case of the *David* in Vienna, it must be borne in mind that the Count of Villamediana, Don Juan de Tasis y Peralta, was never 'Viceroy of Naples', as stated in Spike's list, p. 226.

He was in fact a leading intellectual, inspiring in Tirso de Molina the character of Don Giovanni Tenorio, and invited to Naples by the Viceroy Don Pedro Fernández de Castro, Count of Lemos, from 13 July 1610. On Villamediana, and Lemos, see G. Coniglio, *I Vicerè spagnoli di Napoli*, cit., p. 178, with bibliography. In 1598 the Count of Lemos had Lope de Vega as his secretary, was later in correspondence with Galileo, and was protector of the Accademia degli Oziosi in Naples, founded on the instigation of Manso. Villamediana, who during his time in Naples tried to secure the large picture in the Pio Monte, contenting himself with a copy, was said by Bellori to possess another painting by Caravaggio, 'the portrait of a youth with a pomegranate flower in his hand', which has never been found and must have been an early work.

43 All the information concerning the picture, including copies and the story of its rediscovery (from the early intuition of Longhi concerning the copy in Toledo to the identification of the original by A. Tzeutschler Lurie and D. Mahon), as well as the bibliography and inventory references, is now in Spike 2001, cited in note 42, no. 55, pp. 238ff. For the document of July 1610, which Spike does not mention, see Macioce 2003, cited in note 7, n. II doc. 401, p. 263.

44 On Benavente as collector, see M. Burke and P. Cherry, *Collections of Painting in Madrid 1601–1755*, Los Angeles 1997, vol. I, p. 121, where he is defined as the most enlightened collector of any Viceroy in the seventeenth century, and the essay by A.E. Denunzio in this catalogue. On Benavente as

statesman and governor of Naples, dealing with the famine of 1604–6 mentioned in note 41 and accomplice of the 'astute Portuguese agent Michele Vaaz', see Coniglio 1967, cited in note 41, pp. 169–73. Coniglio paints a disastrous picture of Benavente as an immoral administrator; in November 1605 the Spanish Inspector General Gonzalo di Sotomayor denounced the situation, speaking explicitly in an official report now in the archive of Simancas of 'public embezzlement'.

45 See A. Tzeutschler Lurie and D. Mahon, 'Caravaggio's Crucifixion of Saint Andrea from Valladolid, in *The Bulletin of the Cleveland Museum of Art*, January 1977, pp. 12–15 (of which M. Gregori made a good résumé in entry n. 99 for the exhibition catalogue *Caravaggio e il suo tempo*, Italian edn, Naples 1985, p. 345).

46 See Iacopo da Varazze [Jacopo da Voragine], *Legenda Aurea*, ed. Alessandro e Lucetta Vitale Brovarone, Einaudi editore, Turin 1995, p. 23.

47 See Tzeutschler Lurie and Mahon 1977, cited in note 45, p. 13, fig. 23.

48 For both the Melfi image and that by Cavallini in San Domenico, Naples, see F. Bologna, *I pittori alla corte angioina di Napoli*, Rome 1969, chap. I, pp. 61 and 77, note 322, tav. I–40, fig. 80; and chap. III, pp. 115–26 [122], and 142, note 44, tavv. III–16 and 17, figs 17 and 18. Note 322 p. 77 gives an outline of the subject's iconographical history up to the start of the fourteenth century. It seems that the Melfi fresco is the first to feature the motif of the two executioners tying up (or perhaps untying) the saint with ropes.

49 Gregori 1985, cited in note 45, entry no. 99, p. 349, with bibliography.

50 Bologna 1992, cited in note 8, p. 333.

51 Catherine Puglisi, *Caravaggio*, London 2003, pp. 350ff.

52 Spike 2001, cited in note 42, entry no. 55, pp. 238ff.

53 The first to indicate the affinity, followed by many, was B. Nicholson, 'Caravaggio and the Caravaggesques. Some recent Research', in *The Burlington Magazine*, 1974, p. 608; for a dating of the Malaspina Saint Jerome to a Neapolitan period, see M. Levey, 'The Order of St John in Malta. Exhibition at Valletta', in *The Burlington Magazine*, 1971, p. 557.

54 On the problem of the 'Judith and Holofernes' which Pourbus saw in Naples, and the author of the copy (Louis Finson?), see the summary in Spike 2001, cited in note 42, no. 89, pp. 334–5. However, recalling that the identification using the Banco di Napoli copy was first proposed by Pierluigi Leone de Castris and confirmed by myself (see Bologna 1992, cited in note 8, n. 72, pp. 334–5, with bibliography), I must add that the earlier supposition of M. Marini, referred to by Cinotti 1983, cited in note 23, p. 453, that Pourbus mistakenly called Judith what was in reality a Salome, leading to the proposed identification with the Salome in London – see also V. Pacelli, *L'ultimo Caravaggio*, Todi 1994, p. 59 – ignored the document dated 19 September 1617 in which Louis Finson affirmed in Amsterdam to be co-owner, with Abraham Vinck, of a *Rosary* and a *Judith and Holofernes* by Michael Angel 'Crawats' – '*twee stucken schildereyen beyde con Michael Angel Crawats, d'een wesende een Rosarius en d'andere Judith en Holopharnis*' (Bredius 1918, in *Oud Holland*, 36, 1918, pp. 198–9, now in Macioce 2003, cited in note 7, n. II doc. 451, p. 284).
To give one final prop to the dating of the *Judith and Holofernes* copied in the Banco di Napoli picture to the period we have asserted, note how Holofernes, writhing on the bed, leans on the mattress in a manner closely resembling that of the angel 'supporting the cartwheel' in the *Works of Mercy*; who in turn (apart from the revolutionary idea of removing the support so as to turn a pose into the semblance of an acrobacy in the void) is an almost literal reprise of the corresponding gesture of Holofernes as shown in the first, Costa-Coppi version of the same composition.

55 I called attention to this – I believe for the first time – in Bologna 1992, cited in note 8, p. 334, n. 71; but it does not appear to have been noticed in the subsequent literature.

56 See the excellent recapitulations of the debate provided by M. Gregori on several occasions (1985, 1991–2 and 2000) and by W. Prohaska in *Caravaggio e i Giustiniani*, exhibition catalogue, ed. S. Danesi Squarzina, Milan 2001, n. D4, pp. 288–92.

57 See Puglisi 2003, cited in note 51, p. 402 ('undeniably Caravaggesque, the light and execution of the figures appear the work of another artist'); and Spike 2001, cited in note 42, entry no. 38, pp. 175–8 ('but the overall impression is curiously flat').

58 See R. Longhi, 'Battistello Caracciolo', in *L'Arte*, 1915, republished with notes in *Opere complete di R. Longhi, I–1, Scritti giovanili*, Florence 1961, p. 182.

59 See, in this catalogue, A.E. Denunzio, 'New data and some hypotheses on Caravaggio's stays in Naples'.

60 On the identification of the *Rosary*'s donor, and comparison with the portrait in Madrid, see also, duly cited by Denunzio, J. Brown, 'A new identification of the Donor in Caravaggio's Madonna del Rosario', in *Paragone*, 1984, and M. Simal López, *Los condes-duques de Benavente en el siglo XVII. Patrones y coleccionistas en su villa solariega*, Benavente 2002, pp. 35 and 44. It should, however, be noted that the signature of the portrait in Madrid does raise some doubts. The reading 'Pascual Cati' is certainly the 'Castilian' version of the Italian Pasquale Cati, the name of a master from Jesi mainly active in Rome, familiar with the works of Pellegrino Tibaldi in the Marches, and author of the frescoes in the Altemps Chapel in Santa Maria in Trastevere illustrating deeds of Pope Paul IV (on this artist see *Dizionario enciclopedico Bolaffi dei pittori e degli incisori italiani*, III, Turin 1972, p. 188, *ad vocem*, and *Dizionario biografico degli Italiani, ad vocem*). A.E. Pérez Sánchez, *Pintura Italiana del siglo XVII en España*, Madrid 1965, p. 252, referring to Sánchez Cantón, who a propos the portrait question '*piensa que pueda estar pintado en Valencia, donde estuvo el retratado de febrero a octubre*': '*Esto obligaría a admitir un viaje a España del pintor, desconocido en las fuentes*'. There is nothing in fact in our knowledge of Cati which hints at any contact with Spanish culture, whether Valencian or Castilian, and his constant presence in Rome hardly seems to allow for a period in Valencia.

61 I gave a specific photographic documentation in black and white of the sequence I am about to describe in Bologna 1992, cited in note 8, figs 34–40.

62 Drapery similar to the one in the *Judith* in Rome recurs in the second version of the *Judith* known from the copy in the collection of the Banco di Napoli; nonetheless the latter, from what can be made out in a copy, is more contracted and crushed, and closely resembles in its dynamic the sheet surrounding the divine group in the upper part of the *Works of Mercy*. Since the *Judith* of the copy can be identified with the one for sale in Naples in September 1607, which Caravaggio must presumably have painted in Naples (see above, note 54), this feature is useful for further excluding such a dating for the *Madonna of the Rosary*.

63 See the document published in 1998 by G. Marcolini and now republished in Macioce 2003, cited in note 7, I doc. 182, pp. 152–3.

64 See respectively Friedländer 1955, cited in note 20, pp. 198–202; R. Hinks, *Caravaggio's Death of the Virgin*, Oxford 1953; A. Chastel in *Critique*, November 1956; A. Berne-Joffroy, *Le dossier Caravage, psychologie des attributions et psychologie de l'Art*, Paris 1959, new but disappointing edition, A. Brejon de Lavergnée, Paris 1999, pp. 360–3, with complete bibliographical references.

65 See Bologna 1992, cited in note 8, nn. 58 and 59, pp. 325–9.

66 The passage comes from the document cited in note 63.

67 See Pacelli 1994, cited in note 54, pp. 56–8, with previous bibliography. Among Pacelli's arguments against

the hypothesis of a Roman origin for the Vienna altarpiece, I disagree that the commoners who fill the foreground as protagonists in the *Rosary* are 'very different from the Roman populace' (sic) and 'point unmistakably, as indeed does the devotional subject matter, to the Neapolitan environment'.

[68] See Friedländer 1955, cited in note 20, p. 200: 'the hooded monk in the background behind Peter Martyr may also be a portrait, perhaps of a Dominican prior'.

[69] The drawing belongs to the Prince of Teano, reproduced also in *Enciclopedia Italiana*, vol. VIII, Rome 1930, p. 568, at the entry *Campanella, Tommaso*. The painting in a private collection, wrongly attributed to the Calabrese painter (from Stilo, like Campanella) Francesco Cozza, derives from this drawing.

[70] In addition to the essay published here, see K. Sciberras, 'Riflessioni su Malta al tempo del Caravaggio', in *Paragone*, LIII, n. 629, third series n. 44, July 2002, pp. 3–19.

[71] See the letter sent by Wignacourt to Sforza in Macioce 2003, cited in note 7, II doc. 320, p. 213. Concerning the recommendation not to depart 'from the course of the instructions with which you are charged', we can recall that not long before Sforza Colonna had committed a crime; placed under investigation in May 1605, he was found not guilty in April 1606 following the intervention of his mother, both with Wignacourt and a number of cardinals, who all interceded for him, with greater or lesser conviction, with Pope Paul V, through the Secretary of State Scipione Borghese. As we see from the documents,

however, rather than an acquittal, the punishment was commuted to an obligation to remain under surveillance in Malta for three years, mitigated by the authority granted to the Grand Master to use Sforza Colonna in the fleet (see Macioce 2003, cited in note 7, II docs 190, 191, 225, 229, 247 and 265).

[72] The literature concerning these aspects of the problem now runs to many titles; for an overview of the bibliography then available, see Bologna 1992, cited in note 8, *passim*, especially pp. 215, 450, note 23. In addition to the exhibition catalogue *Caravaggio e i Giustiniani*, Milan 2001, see also Macioce 2003, cited in note 7, II doc. 348 e 349, pp. 227–8; A.E. Denunzio, 'New data and some hypotheses on Caravaggio's stays in Naples', in this catalogue, note 13, who refers above all to J. Hess, 'Caravaggio's Paintings in Malta: some notes', in *The Connoisseur*, 1958, pp. 175–81.

[73] See K. Sciberras, 'From Naples to Valletta: The Rise and Fall of a Painter-Knight' in this catalogue.

[74] See A.E. Denunzio, cited in note 72.

[75] See Macioce 2003, cited in note 7, II doc. 331, p. 219.

[76] See Macioce 2003, cited in note 7, II doc. 358ff, pp. 232–3, II doc. 365, p. 237: C. Puglisi, *Caravaggio*, cit., appendix VIII, p. 420. In this catalogue, see K. Sciberras, 'From Naples to Valletta: The Rise and Fall of a Painter-Knight'.

[77] See Macioce 2003, cited in note 7, II doc. 358 and 359, pp. 232–3.

[78] For the history and the bibliography see Spike 2001, cited in note 42, entry no. 64, pp. 267–71.

[79] It is likely that Caravaggio would have sought to enter

into the good graces of the Grand Master by painting his portrait. Giovanni Baglione records that Merisi, 'introduced to salute the Grand Master, did his portrait'. And Bellori specified later on: '... he was taken before the Grand Master Vignacourt, a Frenchman. He painted him standing, armed, and seated wearing the robes of the Grand Master, the former being kept in the armoury in Malta'. In general, scholars maintain that the first of the two portraits should be identified with the one in the Louvre, which on 1 March 1644 was already in Paris where it was seen by John Evelyn, who gave this description: 'Cavaliero di Malta, attended by his page', but added: 'said to be of Michael Angelo'. Not enough notice has been taken of the fact that Baglione, although he published his Life of Caravaggio some years previously, published the picture in 1642: if at this time the first portrait was 'in the armoury in Malta' (Bellori), it does seem unlikely that by 1 March 1644 it had left there and reached Paris; where we do not know how long the picture seen by Evelyn had been, nor was the attribution to Caravaggio considered certain, at least not by Evelyn. In fact, Longhi himself questioned the attribution of the Louvre picture, and we cannot but agree with him. Moreover, no conclusive research has been carried out into the various portraits of Vignacourt reported in Malta, which present important variants with respect to the Paris picture, and may point the way to the original recorded by Baglione, which for the time being, in my opinion, must be considered lost. On this picture, see Spike 2001, cited in note 42, entry no. 59,

pp. 252–6. Mina Gregori proposed as autograph the portrait of a *Cavaliere di Malta* in Palazzo Pitti, Florence, comparing it with the Louvre portrait, but it has since been shown that it cannot feature Wignacourt. I proposed its identification with Niccolò Caracciolo di San Vito (on the basis of an engraving published with this caption: see F. Bologna, *L'incredulità del Caravaggio*, cit., p. 478, note 23); more recently it has been identified with Fra Antonio Martelli, present in Malta in 1607–8. Nonetheless it has been observed that, 'formerly admiral of the order and prior of Messina, fra Martelli appears younger than his 74 years in Caravaggio's portrait' (see Spike 2001, cited in note 42, entry no. 62, pp. 260–4, with bibliography). What we must not lose sight of, however, is that the Palazzo Pitti painting is absolutely devoid of the qualities necessary for an attribution to Caravaggio, which Roberto Longhi himself cautioned against (as Mina Gregori has recently recalled). In any case, the work appears to date from the second half of the seventeenth century, which was indeed the sense of the old attribution to Niccolò Cassana.

[80] In the subsequent *bolla* of 14 July 1608 Wignacourt decrees the admission of Caravaggio into the Order as 'cavaliere di grazia': '*cumque magnificus Michael Angelus Carracha oppido vulgo de Caravaggio in Longobardis natus hanc urbem appellens, mox zelo religionis accensus, habitu ac insignibus militiae nostrae decorari valde cupere nobis significaverit, nos eximium pictura virum sui voti componere facere volentes ut tandem Melita nostra insula ac religio non minori iactantia illum*

adoptatum alumnum', going on to state that the island of Malta expects to derive the same glory from him as the island of Cos *'Apellem suum extollit'*, etc. (see the complete text in Macioce 2003, cited in note 7, II doc. 371, pp. 240–1).

81 For the reconstruction of these events see the essay of K. Sciberras, in this catalogue, with relevant bibliography. In contrast to what subsequently befell Caravaggio, we can recall that Fra Giovanni Pietro da Ponte, who was arrested with him, was also deprived of the habit on 1 December 1608, but was subsequently let out of prison and readmitted to the Order. Involved in a second tumult and arrested once again on 17 May 1610, he was readmitted as early as 13 August with a ceremony of *restitutio habitus*.

82 Gaspare Murtola, *Rime. Cioè gli occhi di Argo. Le lacrime. I baci. I pallori. Le Veneri. I nei. Gl'Amori*, Venice 1604, with dedication to Monsignor Alessandro Centurione, Archbishop of Genoa, 16 July 1603.

83 See Longhi 1915, cited in note 58, pp. 193–4.

84 Bologna 1992, cited in note 8, pp. 145–6, 151–2.

85 See Vincenzo Mirabella, *Dichiarazioni della pianta delle antiche Siracuse e d'alcune scelte medaglie d'esse, e de' Principi che quelle possedettero*, Naples, Scorriggio, 1613, p. 89. This rare passage (apart from the old citation by Sergio Samek Ludovici, *Vita del Caravaggio dalle testimonianze del suo tempo*, Milan 1956, p. 115) has even now not been fully incorporated into Caravaggesque literature, the first to draw attention to it being R. Longhi, *Quesiti caravaggeschi. Registro dei tempi*, 1928, now in *Opere*

complete di Roberto Longhi, cit., vol. IV, *'Me pinxit' e 'Quesiti caravaggeschi'. 1928–1934*, Florence 1969, pp. 140–1, note 19, although his comment itself requires a consideration (see below). Longhi himself, informed of the passage by Giuseppe Agnello, recorded just its contents in the documentary summary compiled for the catalogue of the 1951 Caravaggio exhibition (Florence 1951, p. 11, year 1608), but left it out of his 'rare pieces' of Caravaggesque criticism.

86 See, in chronological order: Francesco di Paola Avolio, *Memorie intorno al Cav. Mirabella e Alagona*, Palermo 1829; E. Mauceri, 'Vincenzo Mirabella', in *Aretusa*, a. I, n. 8, 26 September 1909; G. Gabrieli, 'Vincenzo Mirabella Linceo', in *Liceo Classico di Siracusa. Annuario del 1926–27*, pp. 67–91; S. Russo, 'Vincenzo Mirabella e il suo tempo', in *Archivio Storico Siracusano*, series III, X, 1996, pp. 87–112. We can add S. Russo, 'Vincenzo Mirabella e il suo tempo, II', in *Archivio storico siracusano*, s. III, XI, 1997, pp. 13–34, where he cites my book, but without bibliographical reference.

87 See Russo 1996, cited in note 86, pp. 90, 110, note 15, with reference to the documents of the notary Vincenzo Leone, in the Archivio di Stato, Syracuse.

88 On Colonna, a leading botanist, his relations with Cardinal Tarugi before April 1606, then with Caravaggio's old protector, Cardinal Francesco Del Monte, who on 6 April 1606 recommended him to Ferdinando I de' Medici, and on his exchanges with Galileo, see Z. Wazbinski, *Il Cardinale Francesco Maria Del Monte*, Florence 1994, t. II, pp. 444–5.

89 Letters nos 1027 and 1040

in *Le opere di Galileo Galilei*, Florence 1968, vol. XII.

90 See Russo 1996, cited in note 86, p. 108.

91 See in Macioce 2003, cited in note 7, II doc. 387, pp. 251–2.

92 See Macioce 2003, cited in note 7, p. 252.

93 See in this catalogue, the essay of K. Sciberras.

94 See R. Longhi, *Volti della Roma caravaggesca*, 1951, now in *Opere complete di Roberto Longhi, vol. XI, Studi caravaggeschi*, Florence 2000, tome II, p. 99, fig. 42. While the drawing is undoubtedly by Leoni, it appears to be a re-edition of the often reproduced drawing in the Biblioteca Marucelliana, Florence, which does not feature either the cross of Malta or the identificatory caption.

95 See Puglisi 2003, cited in note 51, p. 279, fig. 140, who, however, does not identify either the painting's derivation from the drawing in Avignon by Ottavio Leoni, nor the manifest iconographical affinity with the portrait in the Accademia di San Luca in Rome, and with the almost identical one in the Dell'Amore collection, also in Rome, also published by Longhi, cited in note 94, tome II, figs 71a and 7b. All three last-named versions feature the cross of Malta, although they do not preface the title 'Fra' to the subject's name.

96 On this thesis, see in this catalogue the contributions of Vincenzo Abbate, with previous bibliography.

97 See Francisco Pacheco, *Arte de la Pintura*, 1638, ed. Bonaventura Bassegoda i Hugas, *El Arte de la Pintura*, Cátedra Arte, Grandes temas, Madrid 1990, pp. 443–4, note 18.

98 Bellori 1672, cited in note 4 p. 228. On the problem of Caravaggio's second stay in

Naples, see the section in F. Bologna, 'Battistello e gli altri', in *Battistello Caracciolo e il primo naturalismo a Napoli*, Naples 1991.

99 Bellori 1672, cited in note 4, p. 236.

100 See, in particular, Puglisi 2003, cited in note 51, pp. 268–71; Spike 2001, cited in note 42, entry no. 54, pp. 233–7. For a good analysis, see *La Flagellazione di Caravaggio. Il restauro*, ed. Denise Maria Pagano, Naples 1999, especially pp. 11–28.

101 See B. Arciprete, 'Il restauro', in *La Flagellazione* 1999, cited in note 100, pp. 32–40, with an illustration of the extension, also seen from behind.

102 For a reliable summary of these indications, with the relevant bibliography, see D.M. Pagano, 'Il dipinto', in *La Flagellazione* 1999, cited in note 100, p. 20, which includes a reference to Michelangelo and Federico Zuccari.

103 For the first part of these details, see V. Pacelli and F. Bologna, 'Caravaggio 1610: la "Sant'Orsola confitta dal Tiranno" per Marcantonio Doria', in *Prospettiva*, n. 23, October 1980, pp. 26–7 and *passim*; for data on the visits of the Doria fleet to Naples, see A.E. Denunzio, 'New data and some hypotheses on Caravaggio's stays in Naples', in this catalogue, especially note 43.

104 See P. Boccardo, 'Un committente, un quadro, una collezione: vicende fra Napoli e Genova (e ritorno) della Sant'Orsola dipinta per Marcantonio Doria', in *L'ultimo Caravaggio. Il Martirio di Sant'Orsola restaurato*, exhibition catalogue, Milan 2004, p. 41, with sources and bibliography. For the relations between Giacomo Doria and Titian, see V. Farina, *Giovan Carlo Doria promotore delle*

arti a Genova nel primo Seicento, Florence 2002, p. 125, with reference to M. Hochmann, *Peintres et commandataires à Venise, 1540-1628*, Rome 1992, p. 38. Neither of these articles appears in the otherwise full bibliographies provided by Boccardo. Farina specifies that the portrait of Giacomo Doria by Titian, identified by Pallucchini with the one formerly in the Wernher collection at Luton Hoo and now in the Ashmolean Museum, Oxford, should be associated not with Giacomo's office as ambassador of the Republic of Venice, in Piacenza with Paul III Farnese in 1538, but as representative of Titian's personal interests in the Camera Imperiale.

[105] The notarial document, registered 8 May 1903 in the Ufficio atti pubblici in Rome, is conserved in legal copy by the heirs of the artist Micocci. We should note that the painting's dimensions, as given by the restorer in Zurich to whom it was consigned, are 99 x 85 cm.

[106] On this work, in addition to P. Della Pergola, *Galleria Borghese. I dipinti, vol. I*, Libreria dello Stato, Rome 1955, n. 236, pp. 132-3, still worth consulting although he favours its autograph status, see Harold E. Wethey, *The Paintings of Titian. Complete edition, I – The Religious Paintings*, London 1969, n. 41, pp. 93-4. I can add that some years ago a fine half-length of *Christ at the Column* appeared on the Rome art market, attributable to Palma il Giovane and still unpublished, which certainly derives from the prototype in the possession of Marcantonio Doria (photograph in my archive).

[107] See R. Longhi, *Una citazione tizianesca nel Caravaggio*, 1954, now in *Opere complete* cited in note 58, tome II, cit., p. 179.

[108] For the proposal that the work should be considered unfinished, see Bologna 1992, cited in note 8, n. 98, p. 345. There I also refer the verdict of H. Hibbard, *Caravaggio*, New York 1983, p. 338, on the hypothesis of M. Calvesi that the work was painted in Malta with the intervention of Federico Borromeo: 'correspondence between Cardinal Federico Borromeo and the former Bishop of Toul (not of Nancy, which became a bishopric in 1777), discovered by Calvesi, seems irrelevant'. For other information (this particular point is not treated in full), see Spike 2001, cited in note 42, entry no. 71, pp. 288-91.

[109] See Bologna 1992, cited in note 8, pp. 97-107, 394-412, notes 10-75.

[110] See Farina 2002, cited in note 104, pp. 196, 200, with note 29 pp. 236, 227 and 228.

[111] On the picture in the Swiss collection of the *Baptist* in question, and on other copies, see J. Spike 2001, cited in note 42, entry no. 65, pp. 271-3, with the information that the work was attributed to Caravaggio by Amadore Porcella in 1969, and that the Bonello picture attributed to Caravaggio by Longhi is only a partial copy, although important for the provenance from Malta which could reflect on a Maltese dating for the original. For the picture from the Romano collection which I republish here, and on the nice question of the Caravaggesque phase of the Sicilian painter Rodríguez, see Bologna 1991, cited in note 98, pp. 40 and 57, fig. 15 on p. 24.

[112] On this work see my entry in this catalogue. For other information see *L'ultimo Caravaggio* 2004, cited in note 104.

[113] Reproduction in M.J. Friedländer, *Early Netherlandish Painting, Hans Memlinc and Gerard David*, vol. VI, part I, with comment and notes by Nicole Veronee-Verhaegen, Leyden-Brussels 1971, n. 24, plate 75.

[114] Reproduction in *Ludovico Carracci*, exhibition catalogue ed. A. Emiliani, Bologna 1993, n. 55, pp. 118-19.

[115] To complete these iconographical remarks, and others on which a number of experts expatiated on the occasion of the work's sensational 'relaunch' as the major art treasure of Banca Intesa, we should note that although Saint Ursula is 'patron saint also of her own executioners, the archers' (see G. Ravasi, 'Sant'Orsola: storia, leggenda, iconografia', in *L'ultimo Caravaggio* 2004, cited in note 104, p. 20), the motif of the arrow or arrows, as her symbolic attribute, is not constant, nor is it invariably connected with the 'historical' representation of her martyrdom. For example, it is completely absent from the first of the two versions of the subject by Ludovico Carracci (Bologna, Pinacoteca Nazionale, formerly Santi Leonardo e Orsola, dated 1592), and there is only the arrow in the saint's throat in the version by a youthful Orazio Gentileschi (1598-9) in the Abazia di Farfa (see R. Ward Bissel, *Orazio Gentileschi and the Poetic Tradition in Caravaggesque Painting*, The Pennsylvania State University Press, Univerity Park and London 1981, n. 4, pp. 135-8, especially 4a, p. 136, fig. 4).

[116] For the New York painting, which came from Naples, see Spike 2001, cited in note 42, entry no. 57, pp. 248-50, with the unduly general dating 1607-10.

[117] See Bellori 1672, cited in note 4, p. 236.

[118] Now republished in Macioce 2003, cited in note 7, II docs 406 and 407, pp. 265-6. There is, however, a discrepancy between the points touched on in these letters (respectively 29 and 31 July 1610) and what we learn from the official document of 9 August, which can be attributed to the Viceroy Conte di Lemos in person (see ivi, II doc 409, pp. 266-7).

New data and some hypotheses on Caravaggio's stays in Naples

Antonio Ernesto Denunzio

We have all too little documentary evidence for the dates and circumstances of the periods Caravaggio spent in Southern Italy, and in Naples in particular. Nevertheless, the records we do possess have enabled scholars to establish, not without difficulty and some imprecision, the broad outlines of the artist's activities in those years, reinstating works for which his authorship had been forgotten or denied over a long period. From the information assembled it has also been possible to learn something about the milieu of prestigious protectors and patrons who on more than one occasion became closely involved with the artist's personal affairs, as well as lesser figures belonging to the local nobility, people of various standing who were united in being early admirers of Caravaggio's art. To give just one example to emerge from the documentation currently available, we can mention Niccolò Radolovich, member of a wealthy family of food merchants and money changers, the Marquises of Polignano. His commission for a *Madonna and Child with Saints*, registered at the Banco di Sant'Eligio on 6 October 1606, is the first evidence we have for the presence of Caravaggio in Naples.[1] Further evidence from records of transactions, also retrieved from the archives of old Neapolitan banking houses, refers to a commission entered into by Tommaso de Franchis, member of the King's Council. The payments registered for 11 and 28 May 1607 (both ascribed by virtually all scholars to *The Flagellation* of San Domenico Maggiore),[2] in addition to those of January 1607 for the *Seven Works of Mercy*,[3] have given us documentary reference points for the duration of Caravaggio's first stay in Naples.

Various hypotheses have been advanced concerning the circumstances and intermediaries which led Caravaggio to Naples following his flight from Rome and the period spent lying low in the fiefs of the Colonna family in Latium. The version recently put forward by Ferdinando Bologna is surely one of the most stimulating and rich in implications, not least because it provides an immediate link with the first Neapolitan commissions.[4] There is no doubt that the social and cultural milieu surrounding the figure of Andrea Ruffetti, in whose house the wounded Caravaggio found refuge in 1605, provides a trail leading directly to Naples and to Giovan Battista Manso, Marquis

of Villa, who is now more or less unanimously recognised as having played the greatest part in the assignment of the Pio Monte commission to the artist.[5] But another figure who may well have played a decisive role in directing the artist first to Naples and then to Malta is the Ligurian banker Ottavio Costa, responsible for some of Caravaggio's earliest commissions and member of that group of 'patrons of the maestro' who had in common 'entrepreneurial activities in the sphere of finance and commerce, or a professional commitment to the law'.[6] Costa in turn points to a more general 'Genoan connection' which seems to emerge quite tangibly at various points in Caravaggio's life. To cite just one other significant example, we can recall the painting he made in 1610 for Marcantonio Doria, *The Martyrdom of Saint Ursula*, a commission documented by the letters written by Doria's agent in Naples, preserved in the Naples State Archives.[7] Taking a different approach, it has been possible to reconstruct, on the basis of data contained in seventeenth-century records, the involvement, whether proven or highly probable, of leading members of the Carafa-Colonna family, and also the complex network of kinship linking them with the Dorias, the Sforza-Colonnas, Marquises of Caravaggio, and with other illustrious households of the Italian nobility, all for various reasons and in different circumstances – which we cannot go into here – associated with the affairs of Caravaggio.[8] In particular, support appears to have been given to the artist on various occasions by Costanza Colonna, sister of Cardinal Ascanio and wife of Francesco Sforza, Marquis of Caravaggio, and, on the latter's premature death in 1583, regent for their son and heir Muzio. Not only did Costanza Colonna give the artist hospitality and protection at the time of his escapades in Rome,[9] but she also played a fundamental part in covering his traces in her family fiefs in Latium and subsequently in his transfer to Naples, following close on his heels if not indeed accompanying him in person. It was again thanks to the good offices and powerful means of the Colonna family that Caravaggio was able to secure a passage to Malta in June/July 1607, the exact dates and circumstances of which are gradually emerging. We know that the artist was on the island by 13 July 1607,[10] and he appears to have made the voyage in the vessels of Fabrizio Sforza Colonna, one of Costanza Colonna's six children.[11] The activities of this nobleman, General of the galleys of Malta and Prior of Venice, an office he held jointly for some years with Cardinal Ascanio, seem to shed light on various episodes in the life of Caravaggio.[12] He may have been instrumental in securing a personal introduction for the

painter to the Grand Master Alof de Wignacourt, which led to his admission to the Order of Knighthood.[13] In terms of chronology it certainly seems significant that, after sailing from Marseilles with five galleys and calling at Genoa and Naples, he arrived in Malta on 12 July 1607.[14] An unpublished document found by the author in the Naples State Archives appears to give a more precise indication of the date of Caravaggio's probable departure from Naples on the ships of Fabrizio Sforza Colonna and, at the same time, to lead to an interesting series of further reflections on the episodes we have evoked thus far.

On 22 June 1607, Monsignor Alessandro Boccabarile, Bishop of Ortona and Campli[15] and agent in Naples for Duke Ranuccio Farnese, wrote to the court in Parma to report the arrival in Naples, 'eight days ago', of five galleys sailing down from Provence, part of the fleet of the Knights of Malta, under the command of Fabrizio Sforza Colonna. The nobleman disembarked in the company of his mother, the Marquise Costanza Colonna, who had been staying with the Prince of Stigliano at Torre del Greco and had come into the city to negotiate a proposed exchange of land involving the Marquisate of Caravaggio and a fief in Abruzzo, part of the Viceroyalty. The prelate adds that the galleys are to set sail again for Malta following the Feast of St John. The text of this letter is as follows: 'The Marquis of Santa Croce left today, the 22nd of the current month, with ten galleys, carrying nine companies of Spanish Infantry, and, it is said, will make for the Island of Sardinia, where there are many pirates, and he has taken provisions for two months. Eight days ago five galleys of the Religion of Malta arrived here, from Provence, under the command of the Prior of Venice, brother of the Marquis of Caravaggio. He brought his Mother who was staying at Torre del Greco with the Prince of Stigliano. It is said she has come to get information about the lands in the province of Abruzzo which these Ministers of the Crown are offering in permutation to her son the Marquis for the estate he owns in the state of Milan, and by all accounts they will offer terms which he will not be able to refuse. The aforesaid galleys will leave for Malta once the Feast of St John is over, taking with them two unequipped galleys newly made in Provence, and above all slaves, and most humbly I salute you and pray God for your every happiness. From Naples 22 June 1607'.[16]

I must first say something about the whereabouts of this letter. It is preserved in the Farnese deposit in the Naples State Archives, among the correspondence despatched from the capital of the Viceroyalty and the fiefs in Abruzzo to the court of Parma by the ducal agents and other figures with some competence in local affairs.

1. Michelangelo Merisi
da Caravaggio, *Madonna
of the Rosary*. Vienna,
Kunsthistorisches Museum

Unlike other specific archives in which the correspondence sent from Naples to various courts (notably Mantua and Modena) has been repeatedly and systematically examined in search of news and verifications of Caravaggio's activities in Naples, the Farnese deposit has escaped notice, presumably because it is kept far from its place of origin, and perhaps because the documentation in question is not ordered. Naturally, the most significant aspect of the letter's contents is the possibility of establishing the date of Caravaggio's departure from Naples: everything points to the fact that the ships due to sail once 24 June 'is over', that is, immediately after the Feast of St John, under the command of Fabrizio Sforza Colonna, were the ones which arrived in Malta on 12 July 1607, perhaps having spent one or more days in ports of call on the way. From the letter of Monsignor Boccabarile we learn, moreover, that Costanza Colonna, who had apparently been in Naples for some time, was in this period staying at Torre del Greco as guest of her affluent nephew Luigi Carafa Colonna, Prince of Stigliano, Duke of Mondragone and Count of Aliano, and the son of her sister Giovanna and Antonio Carafa, both dead,[17] and married to Isabella Gonzaga of Sabbioneta. On the strength of affirmations made by Deodato Gentile, papal nuncio at the Court of Naples, to Cardinal Scipione Borghese, in one of the letters related to the circumstances of Caravaggio's death and the legal disputes concerning some of his last pictures,[18] it has always been maintained that when she came to Naples the Marquise resided exclusively in the sixteenth-century Palazzo Cellamare, in via Chiaia, the property of the Carafas of Stigliano.[19] This is where Caravaggio himself was believed to have found hospitality and shelter, and from where he set out on the journey that ended in his death. It is now possible to state that the Marquise also stayed, perhaps on several occasions and for considerable periods of time, in the family residence at Torre del Greco. This in any case is what we can surmise from numerous elements suggesting that this locality on the outskirts of Naples, popular above all for its pleasing position and invigorating air,[20] was one of the favourite haunts of the Princes of Stigliano. The year 1610 saw the death, in circumstances that remain unclear but with a suspicion of poisoning, of Antonio Carafa Colonna, Duke of Mondragone, son of the Prince of Stigliano. His parents immediately returned to Torre del Greco[21] to spend the winter there and receive the official visits of condolences.[22] On learning of the tragedy Costanza Colonna, although 'currently on a journey' (to Rome?), made all haste back to Naples.[23] In February 1611 Olimpia

Aldobrandini, niece of Pope Clement VIII, also arrived in Naples and stayed in the city for several months, dividing her time between Palazzo Cellamare and the residence of the Carafa-Colonnas at Torre del Greco. She had come to take her daughter, Elena Aldobrandini, widow of the Duke of Mondragone,[24] back to Rome, after seeing her set up with a suitable income.[25] In the light of these details, the relations between the Carafa-Colonnas and the Aldobrandinis, to which attention has only recently been drawn,[26] can now be pursued as part of the more general investigation into Caravaggio's patrons and a more thorough reconstitution of the influential circle of the artist's protectors and admirers. It is common knowledge that Donna Olimpia, who took good care to build up a solid network of family alliances, giving another of her daughters, Margherita, in marriage to the Duke of Parma Ranuccio Farnese, owned, and may even have commissioned, at least two pictures by Caravaggio.[27] The residence of the Carafa-Colonnas at Torre del Greco can almost certainly be identified with the old baronial castle there, now almost entirely destroyed, although a few traces of the walls are still visible in what is now the Town Hall.[28]

At this point we might well ask whether Caravaggio himself did not stay at Torre del Greco, notably on his arrival, for it would surely have provided a more discreet haven for a notorious fugitive than anything to be found in the Naples, a hotbed of intrigue. What can be said for certain, in the light of Boccabarile's report, is that the Marquise was in Naples in June 1607, accompanied by her son, to see to an advantageous proposal for the exchange of the fief of Caravaggio (and once again we can only speculate whether the Maltese galleys put in first at the small port of Torre del Greco, to take on board Costanza and, in all likelihood, Caravaggio too). This negotiation, which was never concluded, was already known to scholars, but has generally been dated to 1610, when Costanza's eldest son, Muzio, Marquis of Caravaggio, stayed in Naples with his wife, Orsina Damasceni Peretti.[29] Now this whole matter has to be brought forward three years.

In addition to what has already been said about Olimpia Aldobrandini, and apropos of the complex tapestry of family and cultural relations which is a fundamental prerequisite for understanding many of the episodes in Caravaggio's life, there are some further conjectures regarding the concession of the papal pardon which should be taken into account. It is well known that the suit for obtaining a dispensation from Pope Paul V was conducted by Cardinal Ferdinando Gonzaga.[30] If seen in conjunction with this event, and if it is legitimate to

attribute a prominent role to the Marquise among Caravaggio's backers, there might be some significance in the letter sent by Costanza Colonna to Spinello Benci[31] on 28 July 1608 congratulating him on his appointment as secretary to Cardinal Gonzaga, a letter which might otherwise pass unnoticed.[32] The consequences of the relationship between the Marquise and the secretary on the decision to grant the papal waiver must be appropriately evaluated and, if possible, further elucidated, bearing in mind that Benci was also the cardinal's consultant in artistic maters. When a Roman residence had to be procured for the prelate, it was Benci who pursued the arduous negotiations for the lease of Palazzo Colonna ai Santi Apostoli.[33] Adopting a similar approach, Zygmunt Waźbiński reported the period of some months spent in Naples by Cardinal Del Monte together with Cardinal Montalto in September 1607, suggesting that it was part of a larger-scale operation to promote and organise Caravaggio's return to Rome.[34] Again there may be indirect confirmation for this hypothesis in a letter sent to the court of Mantua by Ottavio Gentili, Vincenzo Gonzaga's agent in Naples, in which Gentili alludes briefly to obscure motives which, following an illness that befell Cardinal Del Monte, also detained Cardinal Montalto in the city, 'and his going very often in secret to confer with His Eminence, arouses the suspicion that he is staying on here for more than just pleasure, but up until now nothing has been apprised'.[35] Research carried out in the Archives of Mantua seems to give grounds for returning to an unsolved question concerning the large altarpiece of the *Madonna of the Rosary* in Vienna (fig. 1), as well as shedding light on the Count of Benavente's patronage of Caravaggio during his term of office as Viceroy of Naples, from 1603 to 1610. Don Juan Alfonso Pimentel Enríquez, 8th Count and 5th Duke of Benavente, appointed in 1602 to succeed Fernando de Castro, Count of Lemos, entered Naples on 6 April 1603, following a long and costly journey, in the company of his wife and six of his children, to scenes of great enthusiasm on the part of the Neapolitan populace.[36] The Count, probably the first Viceroy with the stature of an important seventeenth-century art collector,[37] is known to have arrived in Naples after calling at Genoa, Gaeta and Pozzuoli,[38] where he waited for twenty days while his predecessor organised his departure and cleared up the outstanding business of his term of office. Since the Count did not visit Rome on this journey (only in 1608 do we have evidence of two of his sons paying an official visit to Paul V),[39] and granted that his attention would have been drawn to Caravaggio by the first prestigious Neapolitan commissions, we can nonetheless wonder whether he may not have received preliminary indications, if only by word of mouth, of the innovatory quality of Caravaggio's work during his stay in Genoa. It must not be forgotten that Ottavio Costa's first commissions date back to the last years of the sixteenth century (*Judith beheading Holofernes* in Palazzo Barberini), while he sent a copy of the *Saint John the Baptist* now in Kansas,[40] which Ferdinando Bologna believes to date from 1601, to his fief at Conscente, near Albenga (although some scholars believe that this transfer did not occur until 1615).[41] It must also be borne in mind that in 1579 Costa, whose probable role in urging Caravaggio to seek safety in Naples has already been mentioned, had entered into a flourishing banking enterprise with the family of Spanish bankers Enriquez de Herrera, with interests extending from Spain to the leading cities of Europe and Italy.[42] Perhaps more significant than any of these details is the unpublished evidence that the Viceroy arrived in Naples on board some Genoese galleys 'of the Prince Doria with Don Carlo his son',[43] meaning the Prince of Genoa Giovanni Andrea Doria, yet another figure closely associated with events in the life of Caravaggio.[44] This detail is of great interest in the effort to account for the favourable consideration extended to Caravaggio by the Spanish establishment, and in particular the immediate appreciation shown by the Count who, within a few months of the artist's arrival in Naples, secured at least three of his paintings: the *Crucifixion of Saint Andrew*,[45] now in Cleveland, duly recorded by Bellori, a *Saint Januarius with the Symbols of Martyrdom*, dispersed but of which the *Saint Januarius* in the Harris Collection, New York, some believe to be a copy,[46] and a *Washing of the Feet* which has never been traced.[47]

I believe that to this list of works commissioned by the Count it is now possible to add the *Madonna of the Rosary* of Vienna, taking up and reinforcing with new data a hypothesis which was advanced in 1984 by Jonathan Brown,[48] but which at the time, it must be said, made very little impression. This is not the place to go into the numerous and controversial questions concerning the dating, commissioning and original location of this work.[49] We can merely recall the widely held opinion that places it in the context of commissions from the Colonna family, identifying the man represented as donor as either Marzio or Marcantonio Colonna,[50] and also the various attempts to identify the painting either with the one commissioned by Radolovich[51] or that commissioned by Duke Cesare d'Este for a Lady Chapel in Modena.[52] Brown proposed that the donor (dressed in black with a ruff after the Spanish

manner) should be identified as the Count of Benavente, by comparison with what he believed to be the only portrait to have come down to us of the Viceroy, namely the engraving reproduced in the volume of Domenico Antonio Parrino dating from 1692 (fig. 2).[53] This proposal found no adherents, but more recently Mercedes Simal López returned to the subject with what was undoubtedly a more relevant comparison, and one which seems to put the matter beyond doubt: a portrait of the Count of Benavente, several years younger, painted by Pascual Catí in 1599, now in the Instituto Valencia de Don Juan, Madrid (fig. 3).[54] In fact, in their conclusions both Brown and Simal López admit to being baffled as to why such an influential figure as Don Juan Alfonso Pimentel, a keen admirer and collector of the works of Caravaggio, should have let go of a precious work, knowing how this would harm his own prestige. On the evidence of two well-known documents, the sale of the painting was in hand as early as September 1607, when presumably the work had not long been completed, and the Count's return to Spain was still a long way off. On 15 September 1607, Ottavio Gentili wrote to Duke Vincenzo Gonzaga in Mantua that the Flemish painter Frans Pourbus 'has however seen the portraits of some leading ladies done by this other Fleming who lives here, and says they would be good for the study of Your Highness' and again, referring presumably to the *Madonna of the Rosary*, 'has also seen something good by Michelangelo Caravaggio which he did here and which is to be sold'. At that time Pourbus was in fact in Naples, in the service of the Duke, to paint portraits of the splendid women whom Vincenzo I Gonzaga had met on the occasion of his visit in 1603,[55] and also to assess the collection of the Prince of Conca, Matteo di Capua, which the Duke of Mantua was very interested in acquiring.[56] Some months earlier Ottavio Gentili, who had been engaged to assess the value of the Prince's picture collection but felt he was not up to the task, had declared that he would seek the assistance of Caravaggio for this same purchase.[57] Shortly afterwards, on 25 September, Pourbus himself informed Vincenzo Gonzaga of the appearance on the market of two works by the artist: 'I have seen two most beautiful pictures by M[ichel]Angelo da Caravaggio: one is of a rosary and was done for an ancona and is 18 palms high and will not be got for less than 400 ducats; the other is a half-length room picture with half figures and is a Holofernes with Judith, and will not go for less than 300 ducats. I did not want to make any offer without knowing Your Highness's intentions, and they have promised me not to dispose of them until they shall learn of the will of Your Highness'.[58]

In a letter which has escaped scholars' attention, another agent of the court of Mantua in Naples, Gabriele Zinani, appears to go some way to explaining the reasons which may have spurred the Count of Benavente to dispose of his Caravaggio such a long time before the end of his term of office. On 26 October 1607 Zinani wrote to Vincenzo Gonzaga: 'Lightning has struck the baldaquin of H. E. the Viceroy, almost as if it were the harbinger of his change of post. ... It is said that H. E. the Viceroy has sent and is sending many things to Spain, and hence his departure is held to be much more certain ...'[59] In fact news of the possible departure of the Viceroy as early as 1607, although definite enough to figure several times in contemporary correspondence,[60] has long gone virtually unremarked.[61] This is not all, however, for according to Zinani's missive, confronted by the imminent prospect of having to leave Naples, the Viceroy sent back to Spain a large part of the collections he had built up during his years in office, and above all, it is surely legitimate to suppose, his precious picture collection. This circumstance finds a preliminary confirmation in the *cédulas de paso* which recorded the contents of consignments arriving from abroad on their entry into Spain. The records for the year 1607 have been almost entirely destroyed or dispersed, and when the Count did return to his homeland, the only objects that are recorded as being in his train were jewellery, tapestries and horses.[62] We can add that some inventories of his collections were drawn up in Naples in the year 1607,[63] presumably in view of an imminent removal, while the first inventories we know of for paintings and sculptures date from 1611. In them the works are ordered in a way which might reflect how they had been distributed in the fortress of Benavente.

I believe that the reasons which may have driven the Count to sell the painting by Caravaggio are to be sought not so much in any dissatisfaction with the outcome of the commission but rather in the serious economic difficulties in his personal household with which he had periodically to contend, in a situation which was in any case also critical on the more general level of governmental business.[64] It was in all probability such complications which forced him to have recourse to sporadic economies, including perhaps the sale of one or more items from his collections. He would naturally have selected works of immediate appeal which were sure to raise substantial sums of money with the minimum delay (in the case of the *Madonna of the Rosary*, 400 ducats). We know that prior to his departure for Spain, the Count was forced to make inroads into the income of his wife to pay off the debts he had accumulated and meet the

expenses of the move. Once back in his homeland he spent a few years away from the court in order to set his financial situation to rights, following the huge sums he had spent during his term of office in Naples. In 1614, in what was perhaps not his first such venture, he even sold off some of his pictures in an auction.[65]

Moving on from the question of the Viceroy's motives, the decision to sell led in the first place to the acquisition of the *Madonna of the Rosary* by the artist Louis Finson, although we do not yet know when or how, and hence its transfer to The Netherlands. In Finson's will, made in 1617, the large canvas, once again paired with a *Judith*, is recorded as being jointly owned with another artist, Abraham Vinck.[66] Thus it is possible that the painting was purchased by the two artists from the Count,[67] or else that when the latter made up his mind to dispose of it, he asked Finson, who had made various copies of works by Caravaggio, to see to its sale after duly producing a replica. A copy by Finson of the *Madonna of the Rosary*, now lost, is in fact on record as having been put up for sale in Amsterdam in February 1630.[68] Finson is known to have made copies of at least two other pictures by Caravaggio belonging to the Viceroy: *The Crucifixion of Saint Andrew*, the copy of which, known as the 'Black Vega', is now in a private Swiss collection,[69] and *Saint Januarius with the Symbols of Martyrdom*, known to us only from the replica in the Harris Collection.[70] Maurizio Marini, reaffirming the latter's provenance from 'an original by Caravaggio dating from 1607 in connection with the *Madonna of the Rosary*', advocated 'setting it alongside' *Judith beheading Holofernes* (now in the collection of the Banco di Napoli), 'another copy by Finson from a prototype by Caravaggio from 1607'.[71] On the strength of such stylistic considerations we are now confronted with the possibility that the *Judith* too[72] may have belonged to the Count of Benavente, and that the series of reproductions of works by Caravaggio may have been undertaken by the Flemish artist to a commission by the Viceroy. The latter, on the point of leaving Naples in 1607, may have decided, at least provisionally, to keep only copies with him, selling off two of the works and sending the others to Spain.

It is also perhaps not insignificant that such an interesting piece of news as the sale of two paintings by Caravaggio was communicated by the agents of Vincenzo Gonzaga (who in 1607, acting on information provided by Rubens, managed to buy the *Death of the Virgin*). The existence of a special channel of communications finds confirmation in the cordial relations between the Viceregal court and the Duke of Mantua established during Gonzaga's visit to Naples

from 25 April to 29 June 1603 and maintained thereafter.[73] The Duke's stay in Naples was marked by a magnificent welcome and all possible honours, the Royal Household bearing the entire expenses of his return journey to Mantua.[74] On that occasion too a leading role was played by a lady of the Colonna household, namely Geronima Colonna, of the Dukes of Paliano,[75] wife of Camillo Pignatelli, Duke of Monteleone, who occupied a pre-eminent position in all the official ceremonies. Geronima, sister of the great Marcantonio and thus the aunt of Costanza and Cardinal Ascanio, was to die at Gaeta in January 1609 on her return from a voyage to Barcelona.[76]

At this point we have to try to establish the *Rosary*'s original destination. That it was painted as an altarpiece ('*fatto per un'ancona*') has never been questioned, presumably for a major church belonging to the Dominican Order. From a strictly iconographical and compositional point of view, the Spanish birthplace of Saint Dominic and the importance given to the figure of Saint Peter Martyr, patron of the Inquisition, in a painting in which the details seem to allude to the context of a tribunal,[77] in an 'exceptional, yet indirect endorsement of Spanish policy of which the Dominicans (and the Tribunal of the Inquisition for which they were responsible) were one of the cornerstones',[78] seem once again to point to the Count of Benavente.[79] Simal argues that the picture may have been commissioned for the monastery of Santo Domingo at Benavente, which was under the Count's personal patronage and was granted numerous privileges and donations over the years. In the monastic church there is in fact an altar dedicated explicitly to Our Lady of the Rosary.[80] The Count maintained a special relationship with the Dominican Order, in which some key dates appear to be more than mere coincidences. Here we will merely recall that one of his sons, Don Rodrigo, abandoned a military career to enter the Dominican Order in the monastery of Santa Cruz la Real, Segovia, taking the name of Fra Domenico, the first step in an ecclesiastical career that culminated in the cardinalate.[81] Between 1607 and 1610 he visited his father in Naples, and on leaving the city he took with him some paintings, of which regrettably we know no details.[82] Simal's hypothesis concerning a Spanish destination for Caravaggio's work appears convincing and perfectly plausible, fully in keeping with the reconstruction we have sought to piece together thus far. If, on the other hand, one wished to identify a first, Neapolitan destination for the picture, various hypotheses are possible; faced with the prospect of leaving Naples, the Viceroy (among other

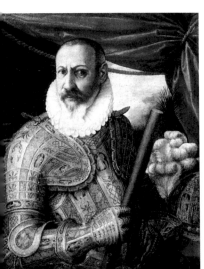

considerations) may have felt he could now do without the prestige and visibility afforded him by having the picture on display in a famous place with a well-established reputation. Scholars have suggested, for a variety of reasons, the churches of San Domenico Maggiore, San Pietro Martire, il Santissimo Rosario di Palazzo and Santa Maria della Sanità[83] as possible venues. I believe it is the latter which should be taken into serious consideration, while exercising all due caution and awaiting confirmation from further investigations. The church of Santa Maria della Sanità, which in those years was one of the richest convents in the city[84] and the headquarters for the reform of the Order in Naples, had a privileged standing in the eyes of the Spanish establishment.[85] Moreover, it was the recipient of one of the most generous donations (amounting to 1000 ducats) to be assigned by the Count of Benavente to local ecclesiastical institutions.[86] We need not perhaps give particular importance to the presence of the large painting by Giovan Bernardo Azzolino of 1612 showing the *Virgin of the Rosary* which, not unusually for a Dominican church, adorned the large chapel of the same name in the right nave. But there is a document, dated 26 December 1612, which also features the church of the Sanità and which may, although highly problematic, indicate the existence of contacts with Caravaggio in earlier years, perhaps through an authoritative and privileged intermediary.[87] In this document the Dominicans approved a payment of 150 *aurei* for the completion of an altarpiece depicting the *Circumcision*, begun some years earlier by Caravaggio himself.[88] In reality the picture in question, hanging in the large chapel opposite the one with the *Madonna of the Rosary*, is the work of Giovanni Vincenzo Forli, painted between 1610 and 1612. Basing his case on documentary evidence which is, it must be said, by no means unequivocal, and in consideration of the substantial sum paid over as a down payment on its execution (100 *aurei*), Raffaello Causa maintained that the painting was indeed commissioned from Caravaggio in 1607 or, at the latest, 1610. The picture, painted by Forli following Caravaggio's death, evokes, perhaps not coincidentally, 'in terms of some iconographic details (the Saint Dominic and the posture of some of the figures ...) the *Madonna of the Rosary* in the Kunsthistorisches Museum, Vienna'.[89]

Leaving aside some further aspects of a philological nature, we can conclude by pointing out how the document of 1612 brings to an end, once again amid discordant opinions,[90] the series of documents relating to the Neapolitan phase of Caravaggio's activity.

Abbreviations AHPM: Archivo Histórico de Protocolos de Madrid; AGS: Archivo General de Simancas; AHN: Archivo Histórico Nacional; ASMn: Archivio di Stato di Mantova; ASN: Archivio di Stato di Napoli; ASV: Archivio Segreto Vaticano; BNM: Biblioteca Nacional de Madrid; BNN: Biblioteca Nazionale di Napoli. In transcribing the documents we have chosen to maintain the original form and not complete the abbreviations.

[1] V. Pacelli, 'New documents concerning Caravaggio in Naples', in *The Burlington Magazine*, CXIX, 1977, pp. 819–829, esp. p. 819 note 1. For a complete transcription of all the documents published to date cited in this essay the reader is referred to the recent volume by S. Macioce, *Michelangelo Merisi da Caravaggio. Fonti e documenti 1532–1724*, Rome 2003. For the reconstruction of the activities and personalities of the Radolovich family see in particular V. Pacelli, *Caravaggio. Le Sette Opere di Misericordia*, Salerno 1984, p. 101. It is customary to associate the Radolovich commission with two other business documents found in the Historical Archives of the Banco di Napoli, dating from 25 October 1606 (V. Pacelli, op. cit., p. 102). On attempts to identify the picture with the *Madonna of the Rosary* in Vienna see M. Marini, *Caravaggio 'pictor praestantissimus'*, Rome 2001, pp. 516–17.

[2] V. Pacelli 1977, p. 280; idem, 'Nuovi documenti sull'attività di Caravaggio a Napoli', in *Napoli Nobilissima*, XVII, 2, 1978, pp. 57–67; M. Marini 2001, cit., p. 530.

[3] F. Nicolini, 'Notizie storiche tratte dai giornali copia-polizze dell'Antico Banco della Pietà', exhibition catalogue, in *Bollettino dell'Archivio Storico*, Banco di Napoli, 1, 1950, p. 10; G.A. Dell'Acqua-M. Cinotti, *Il Caravaggio e le sue grandi opere da San Luigi dei Francesi*, Milan 1971, p. 160; Pacelli 1984, pp. 102–103; M. Marini 2001, p. 509.

[4] In addition to the essay written for this occasion, we must mention F. Bologna's other treatments of this topic, including *Il Caravaggio al Pio Monte della Misericordia*, in M. Pisani Massamormile (ed.), *Il Pio Monte della Misericordia nel quarto centenario*, Naples 2003, pp. 173–190 and above all the fundamental work *L'incredulità del Caravaggio*, Turin 1992.

[5] It was F. Bologna 1992, pp. 223–224, who first recognised the 'strictly lay' origin of the institution of the Pio Monte. See also L. Gazzarra, *Fonti inedite sulla fondazione del Pio Monte: una lettura interpretativa*, in M. Pisani Massamormile (ed.), op. cit., pp. 215–227, esp. p. 218, for the circumstances of a contact between Manso and Marzio Colonna.

[6] F. Bologna 1992, p. 214. On Ottavio Costa and his dealings with Caravaggio see also L. Spezzaferro, *Ottavio Costa e Caravaggio: certezze e problemi*, in M. Cinotti (ed.), *Novità sul Caravaggio. Saggi e contributi*, Milan 1975, pp. 103–118; A. Vannugli, 'Enigmi caravaggeschi: i quadri di Ottavio Costa', in *Storia dell'Arte*, XCIX, 2000, pp. 55–83; J. Costa Restagno, *Ottavio Costa (1554–1639) le sue case e i suoi quadri*, Bordighera-Albenga 2004. We can recall that the Alfonso Fenaroli who commissioned Caravaggio to paint the works for Sant'Anna dei Lombardi, now lost, was also a merchant from Bergamo.

7 The letters conserved in ASN, Archivio Doria d'Angri, buste 290 & 293 are published by V. Pacelli-F. Bologna, 'Caravaggio 1610: la «Sant'Orsola confitta dal tiranno» per Marcantonio Doria', in *Prospettiva*, XXIII, 1980 pp. 24-45.

8 M. Calvesi, *Le realtà del Caravaggio*, Turin 1990, pp. 105-164; M. Marini 2001, pp. 68-72 and relative notes.

9 The Marquise, who arrived in Rome in 1600 for the jubilee, stayed on for several years (M. Calvesi 1990 pp. 123-125). See also, again by M. Calvesi, 'Le residenze romane di Caravaggio: l'ospite inquieto', in *Art e dossier*, XLII, 1999, pp. 8-9.

10 J. Spike, 'The Church of St. John in Valletta 1578-1978 and the earliest record of Caravaggio in Malta: an exhibition and its catalogue', in *The Burlington Magazine*, CXX, 1978, pp. 626-628.

11 M. Calvesi 1990, p. 133.

12 Ivi, pp. 131-134; S. Macioce, 'Caravaggio a Malta e i suoi referenti: notizie d'archivio', in *Storia dell'Arte*, LXXXI, 1994, pp. 207-228.

13 On the probable role in Caravaggio's visit to Malta of Fra Ippolito Malaspina, of the marquisate of Fosdinovo, influential member of the Order, Knight Commander in Naples and counsellor to Wignacourt, see J. Hess, 'Caravaggio's Paintings in Malta: some notes', in *The Connoisseur*, CXLII, 1958, pp. 142-147; S. Macioce, 'Caravaggio a Malta: il «S. Girolamo» e lo stemma Malaspina', in *L'ultimo Caravaggio e la cultura artistica a Napoli, in Sicilia e a Malta*, conference proceedings, Syracuse 1987, pp. 175-181; S. Macioce 1994, cited in previous note, pp. 216-216. Malaspina owned at least one picture by Caravaggio, the *Saint Jerome*. To what is already known

about this figure, related to Ottavio Costa and to the Medici and Doria, we can add the data found in the documentation examined for this occasion, showing him to have been the beneficiary of some properties in the Farnese Dukedom of Parma and Piacenza and in the territory of Lodi. His brothers were in the service of Alessandro Farnese in the Low Countries (ASN, Archivio Farnesiano, fascio 1196 II, Ippolito Malaspina al duca di Parma Ranuccio Farnese, Malta, 10 April 1616; henceforward, unless otherwise stated, the papers are given as unnumbered). There are frequent references to Malaspina in Malta during 1609 (letters of 12 May and 1 September).

14 M. Calvesi 1990, cited in note 8, pp. 131-134. The author believes that Caravaggio may have decided to go to Naples to wait for Fabrizio to arrive from Marseilles and set out for Malta.

15 Alessandro Boccabarile, bishop of Ortona from 1596, was agent for the Duke of Parma in Naples from September 1602, an appointment made by Cardinal Odoardo Farnese (ASN, Archivio Farnesiano, fascio 1945, Alessandro Boccabarile al duca di Parma, Rome, 28 September 1602). There do not seem to have been dealings of any kind between Caravaggio and Cardinal Odoardo, nor is there any record of even the slightest interest on the part of the nobleman, who appears to have been wholly taken up with his passion for Emilian art (A.E. Denunzio, 'Una nota di pagamento per Guido Reni e qualche aggiunta per Domenichino, Carlo Saraceni e Lanfranco al servizio del cardinale Odoardo Farnese', in *Aurea*

Parma, LXXXIV, 2000, pp. 365-386; idem, 'Acquisti del cardinale Odoardo Farnese: due note per stampe e disegni', in *Arte, collezionismo, conservazione. Scritti in onore di Marco Chiarini*, Florence 2004, pp. 126-129). We can however recall the clear relationship, already referred to by Roberto Longhi, linking the *Boy bitten by a Lizard* of the Fondazione Longhi to a drawing by Sofonisba Anguissola featuring a *Boy bitten by a Lobster*, now at Capodimonte. The drawing belonged to the collection of Fulvio Orsini, secretary to Cardinal Odoardo, and would presumably have been seen by Caravaggio at Palazzo Farnese (see the entries relating to the drawing compiled by B. de Clerck, in *Sofonisba Anguissola e le sue sorelle*, exhibition catalogue, Milan 1994, pp. 274-277, and R. Muzii in *Museo e Gallerie Nazionali di Capodimonte. La collezione Farnese. La scuola emiliana: i dipinti. I disegni*, Naples 1994, p. 287). On the existence of strained relations between the Farnese court in Rome and the marquises of Caravaggio see A. Zuccari, 'Un carteggio di Francesco M. Del Monte e alcune annotazioni sul «Martirio di San Matteo» del Caravaggio', in *Storia dell'Arte*, XCII-XCIV, 1998-1999, pp. 292-302, and M. Marini 2001, p. 68.

16 ASN, Archivio Farnesiano, fascio 1945, Alessandro Boccabarile, bishop of Ortona e Campli, to the Duke of Parma, Naples, 22 June 1607. The Marquis of Santa Croce was General of the Neapolitan fleet. Part of the information contained in the letter is confirmed and expanded in the account of B. Dal Pozzo, *Historia della Sacra Religione di Malta*, II, Verona 1715, p. 521: shortly after being appointed

General of the fleet of Malta, Fabrizio Sforza Colonna 'made his first voyage to Barcelona, where he was sent with the four Galleys towards the end of October [1606] to take delivery of the Flagship built in that shipyard at the expense of the Fondatione Claramonte; and having returned to Marseilles, he spent the whole winter there, expediting the construction of another Galley being built on behalf of the Religion; and since the Flagship built in Barcelona had not proved well built, he exchanged it for this one, which gave excellent service. Setting out at last from that Port with five Galleys, having embarked a large number of Convicts donated by the Most Christian Sovereign, and calling at Genoa, and Naples, where he also took on board many Convicts donated by His Catholic Majesty, he did not return to Malta until the 12 July of the following year.' This passage is also published in M. Calvesi 1990, cited in note 8, p. 160. See also the letter from Alof de Wignacourt to Fabrizio Sforza Colonna in Marseilles, dated 15 December 1606 (S. Macioce 1987, cited in note 13, p. 225; S. Macioce 2003, pp. 214-215).

17 In 1574 Luigi Carafa della Marra, Prince of Stigliano, purchased the estate of Torre del Greco from Giovan Francesco de Sangro, Duke of Torremaggiore (F. Balzano, *L'antica Ercolano ovvero la Torre del Greco tolta all'oblio*, Naples 1688; G. e F. Castaldi, *Storia di Torre del Greco*, Torre del Greco 1890).

18 'The sloop returned bearing the effects of his which were left in the house of the Marquise of Caravaggio, who lives at Chiaia, from whence Caravaggio had set out', ASV, Nunziatura di Napoli, Segreteria di Stato, 20 A, cc.

222 *r-v*, published, like the other letters, by V. Pacelli, *L'ultimo Caravaggio dalla Maddalena a mezza figura ai due san Giovanni (1606-1610)*, Todi 1994 (3rd ed. revised and expanded, 2002), pp. 120-132. The letters found by Pacelli can be integrated with one dated 19 August 1610, sent presumably by the Viceroy of Naples, Count of Lemos, to the military judge of the Garrisons of Tuscany, claiming the effects of Caravaggio left in Porto Ercole (O.H. Green-D. Mahon, 'Caravaggio's Death: a New Document', in *The Burlington Magazine*, XCIII, 579, 1951, pp. 202-204).

19 The identification of the residence of the Marquise of Caravaggio with Palazzo Cellamare is due to M. Calvesi, 'Novità e conferme', in *Art e Dossier*, 66, 1992, pp. 12-14.

20 F. Balzano 1688, cited in note 17.

21 The Princes of Stigliano usually took up residence also at Teano and Pozzuoli. On 4 January 1603 the Princess of Stigliano is known to have been in Rome, a fact which should not be passed over in a reconstruction of the episodes in question (BNN, Sezione Manoscritti, Fondo San Martino, ms. 389, Letters of Luigi Carafa Colonna and Isabella Gonzaga to P. Don Andrea Avellino il vecchio).

22 ASN, Archivio Farnesiano, fascio 1959, Alessandro Boccabarile to the Duke of Parma, Naples, 10 December 1610: 'The Prince and Princess of Stigliano with the Duchess of Mondragone are expected in two days' time at Torre del Grecho, where they will spend this winter. They still entertain suspicions that poison was given to their son the Duke of Mondragone, and the Officer set on the

case has put several of their servants in prison, in particular his secretary and others in the service of the Prince ...'; 24 December 1610: '... Four days ago I was at Torre del Grecho, and presented the condolences of Your Excellency to the Princess and Duchess of Mondragone. ...' Again on 27 December 1610, the Princess of Stigliano wrote 'from la Torre' to the Duke of Parma concerning the death of her son (ASN, Archivio Farnesiano, fascio 1960). The documents that have come to light (see also the letters in BNN, Sezione Manoscritti, Fondo San Martino, ms. 389, Letters of Luigi Carafa Colonna and Isabella Gonzaga to P. Don Andrea Avellino il vecchio) clarify the dates and circumstances surrounding the death of Antonio Carafa, an episode which in the past has given rise to more than one misleading interpretation (see R. Raimondo, *Uomini e fatti dell'antica Torre del Greco*, Ercolano 1985, pp. 307–321).

23 ASN, Archivio Farnesiano, fascio 1959, Alessandro Boccabarile to the Duke of Parma, Naples, 26 November 1610: '...The Princess of Stigliano has been so smitten by grief at the death of her son the Duke of Mondragone that she has thought of and done something which was not altogether proper; being unable to believe that this gentleman died a natural death, but rather that he was assisted and poisoned since he had crossed many people of all stations, including important personages, on account of his means, and above all his estates, including Sabioneta, and being on a journey when she received news of the gentleman's death, she made the Marquise of Caravaggio,

whom she had taken with her, go back to entreat the Viceroy to send an Officer to get information and do everything in his powers to ascertain the truth of the matter, and immediately the order was given to Ottavio Piciolelli, Judge of the Great Court of the Vicaria ...'

24 The title of Duke of Mondragone was ceded to Antonio Carafa by his parents (B. Aldimari, *Historia genealogica della Famiglia Carafa*, Naples 1691, vol. II, pp. 396–397).

25 ASN, Archivio Farnesiano, fascio 1959, Alessandro Boccabarile to the Duke of Parma, Naples, 11 February 1611: 'Donna Olimpia Aldobrandina arrived in good health at Torre del Grecho the 11th of this month with a retinue numbering, it is said, eighty mouths, and on passing by the city walls sent the Prior of Rome to present her compliments to His Excellency and the Vicereine, being invited to lunch by H.E. that morning, after meeting and being accompanied by a large number of the Neapolitan nobility, and after lunch Donna Olimpia left immediately to arrive at her destination, and was invited by H.E. to return for the three remaining days of Carnival in Naples, and so she returned on Sunday morning, and was presented by H.E. to Martio Colonna, who hosted and accompanied her for the three days, as he has done for many nobles...'; 18 February 1611: 'On the Monday of Carnival I went to Torre del Grecho to salute and visit Donna Olimpia on the part of Your Excellency and the Duchess ... I also visited the Prior in the house of Martio Colonna and used all the courtesies required of me...'; 27 May 1611: 'Donna Olimpia Aldobrandina is to leave tomorrow, the 28th of

the month, for Torre del Grecho to take her leave and return to Rome with the Duchess of Mondragone... The aforesaid Lady presented the Vicereine with a fine reliquary, said to be worth two or three thousand *scudi*, and gifts to many members of the Viceroy's family, and was received with great ceremony, her visit being returned by the Viceroy and Vicereine, and is leaving most content with her reception...'; 3 June 1611: 'Donna Olimpia Aldobrandina with the Duchess of Mondragone left here for Rome on 30 May just past...' We can also mention a letter dated 29 April 1611 in which Olimpia Aldobrandini, staying in the Palazzo di Chiaia, negotiates an income to be assigned to her daughter.

26 V. Pacelli, *L'ultimo Caravaggio 1606–1610. Il giallo della morte: omicidio di stato?*, Todi ed. 2002, p. 221. Another figure who recurs in the life of Caravaggio, Giovan Battista Marino (F. Bologna 2003, cited in note 4, p. 185), composed the epithalamium entitled *Imeneo* for the marriage of Antonio Carafa and Elena Aldobrandini. In 1628 another sister of Elena, Maria, married the Marquis of Caravaggio Giampaolo Sforza, son of Muzio, Costanza Colonna's eldest son. There is a copy of Maria Aldobrandini's will, dated 1657, in ASN, Archivio Farnesiano, fascio 1818 I. In it the Marquise, nominating the Duke of Parma as executor, leaves among other things to 'Padre Maestro Frà Teodoro Muggiano di San Giovanni la Conca' of Milan 'the painting I was given by Cardinal Monte, of blessed memory, of the Madonna which I keep near the tester'.

27 On 20 October 1604 Caravaggio, imprisoned for insulting some constables,

lost no time in informing Cardinal Del Monte and Donna Olimpia Aldobrandini (M. Cinotti-A.G. Dell'Acqua 1971, cited in note 3, pp. 157–158). The two paintings by Caravaggio which belonged to the Aldobrandini are *The Rest on the Flight into Egypt* and *Penitent Magdalen* in the Galleria Doria Pamphilij (F. Bologna 1992, cited in note 4, pp. 301–302; M. Marini 2001, cited in note 1, pp. 406–410). On the Aldobrandini as collectors and patrons of Caravaggio see also M. Calvesi 1990, cited in note 8, p. 324.

28 In 1621 Isabella Gonzaga wrote from the baronial castle at Torre del Greco to her daughter-in-law, who had been back in Rome for some years (BNN, Sezione Manoscritti, Fondo San Martino, ms. 213, letters of Isabella Gonzaga). See also V. Di Donna, *Vocabolarietto delle denominazioni locali di Torre del Greco*, Torre del Greco 1925, p. 27: 'in 1620 and 1621 many improvements were made to our castle ... by the Princess of Stigliano'.

29 This detail, due to S. Corradini, is reported by both M. Calvesi 1990, cited in note 8, p. 13, and M. Marini 2001, cited in note 1, pp. 70, 118. In fact in February 1610 we know that Muzio Sforza stayed in Parma on his way to Naples (BNN, Sezione Manoscritti, Fondo Nazionale, ms. X E 52 : «Trattamenti diversi fatti da Ser.mi S.ri Padroni à Personaggi venuti ò inviati à questa corte dal giorno 14 aprile 1595 sino alli 7 ottobre 1646», c. 72r. 'On... February 1610 in Parma. Having been advised from Piacenza by Conte Oracio Scotto that the Marquis of Caravaggio, who had been staying there in San Sisto, intended to come to Parma, to go on to Naples, and was

travelling in a carriage with very few attendants, H.E. sent Padre Don Carlo Bosso in a six-horse carriage to meet him on the other side of the Tarro...'

30 G. Baglione, *Le Vite de' pittori, scultori et architetti*, Rome 1642, ed. V. Mariani, Rome 1935, p. 138; G.P. Bellori, *Le Vite de' Pittori, Scultori et Architetti moderni*, Rome 1672, ed. A. Borea, Turin 1976, p. 228. According to M. Calvesi 1990, cited in note 8, p. 147, the person responsible for securing the Pope's pardon for Caravaggio was a namesake of the Cardinal, Ferdinando Gonzaga, Duke of Molfetta, related to the Carafa-Colonna family, who had donated to de Franchis the chapel in San Domenico Maggiore which was to house the *Flagellation*.

31 On Spinello Benci see N. Vian, 'Spinello Benci', in *Dizionario Biografico degli Italiani*, Rome 1996, vol. VIII, pp. 200–201. Benci had dealings with San Filippo Neri and frequented the court of Cardinal Agostino Cusani, a cultured milieu also frequented by Tarugi and Baronio, among others.

32 ASMn, Archivio Gonzaga, busta 825, Costanza Sforza Colonna to Spinello Benci, secretary of Cardinal Gonzaga at Mantua, Naples, 28 July 1808. 'Dear Sir, the Duke of Mantua could not have chosen a better Secretary for his son the Cardinal, of greater kindness and value, than yourself, nor chosen anyone else that would have given me such pleasure, because I know that you will serve that worthy Household with honour and satisfaction. I thank you for the news, which is a sure sign of your affection towards me; and I trust that your merits of kindness and valour will lead you in the paths of

the goodness and greatness of such Princes. And I pray you to bear in mind wheresoever you may be that you can count on me, who love you and desire your prosperity; I declare and recommend the same with all my soul. From Naples 28 July 1608.'

33 D.S. Chambers, The *bellissimo ingegno* of Ferdinando Gonzaga (1587–1626), Cardinal and Duke of Mantua', in *Journal of the Warburg and Courtauld Institutes*, L, 1987, pp. 113–147, partic. p. 114; R. Piccinelli, *Le collezioni Gonzaga. Il carteggio tra Firenze e Mantova (1554–1626)*, Cinisello Balsamo 2000, pp. 248–249; B. Furlotti, *Le collezioni Gonzaga. Il carteggio tra Roma e Mantova (1587–1612)*, Cinisello Balsamo 2003, pp. 531, 577. We can recall that Costanza Colonna lived in palazzo Colonna ai Santi Apostoli during her years in Rome.

34 Z. Ważbiński, *Il cardinale Francesco Maria Del Monte 1549–1626,* Florence 1994, vol. I, pp. 192–193.

35 ASMn, Archivio Gonzaga, busta 825, Ottavio Gentili to the Duke of Mantua, Naples, 1 January 1608: '... Since the doctors have advised Cardinal del Monte not to move from here during the winter, and since the Prince Pereti leaves tomorrow for Venafro, and from there to Rome, it is taken for certain that Cardinal Montalto will also stay on; his worthiness takes great pleasure in going about incognito, and his going very often in secret to confer with H.E. arouses the suspicion that he is staying on here for more than just pleasure, but up until now nothing has been apprised ...' Prince Peretti is Michele Damasceni Peretti, brother of Cardinal Montalto: in 1605

Filippo III granted him the favour of elevating to the dignity of princedom the fief of Venafro which Peretti had inherited from his great-aunt Camilla. On 4 December 1607 Cardinal Montalto also wrote to the Duke of Mantua to inform him he was prolonging his stay in Naples (ASMn, Archivio Gonzaga, busta 824). The prelate was related to both the Colonna and the Sforza-Colonna families (Calvesi 1990, cited in note 8, pp. 133, 256) and was on terms of cordial friendship and collaboration with Ottavio Costa (J. Costa Restagno 2004, cited in note 6, pp. 24–56). Other details, some very colourful, concerning the period spent in Naples by the two cardinals, can be found in the correspondence of Gentili (see for example the letters of 22 January 1608).

36 The fundamental work on the Count of Benavente is the volume by M. Simal López, *Los condes-duques de Benavente en el siglo XVII. Patronos y colleccionistas en su villa solariega*, Benavente 2002, which includes a complete and detailed bibliography. On the Viceroy's passion for collecting see *Vita Iohannis Alfonsi Pimentelli Benaventanorum Comitis* by his contemporary Giulio Cesare Capaccio (copy in Biblioteca Apostolica Vaticana, Urb. Lat. 971, ff. 148–161v). I owe this and other indications to Mercedes Simal, whom I wish to thank both for her precious suggestions and for the chance to talk over many of the topics dealt with in this essay.

37 M. Burke-P. Cherry, *Collections of Paintings in Madrid 1601–1755*, Los Angeles 1997, vol. I, p. 121.

38 G.C. Capaccio, *Il Forestiero...*, Naples 1634, ed. F. Strazzullo, Naples 1993, pp. 510–511.

39 M. Simal López 2002, cited in note 36, p. 53.

40 F. Bologna 1992, cited in note 4, p. 318.

41 M. Marini 2001, p. 484.

42 J. Costa Restagno 2004, cited in note 6, pp. 17–31. Costa maintained, moreover, a cordial collaboration with Marquis Vincenzo Giustiniani, a member of the pro-Spanish clique in Rome. We can mention that the wedding of the daughter of Ottavio Costa, Luisa, and Pietro Herrera was attended by the Spanish ambassador Francesco di Castro, Cardinal Antonio Zapata, Archbishop of Burgos, Cardinal Montalto, Cardinal Giustiniani and some of the leading families of the nobility, including the Doria, Peretti, Orsini, Malaspina, etc. (J. Costa Restagno 2004, pp. 51–52, to which we refer also for Costa's business and cultural dealings with Cardinal Del Monte).

43 ASV, Segreteria di Stato, Spagna, vol. 55, fol. 98v, letter of Monsignor Domenico Ginnasio, Nuncio in Spain, to the Cardinal Pietro Aldobrandini, Valladolid, 10 March 1602: '... We shall go first to Rome, and then to Naples, to bring back the Countess of Lemos, and it seems quite likely that within a few months Don Francesco too will leave, since it is given as certain that the Count of Benevento is already destined for that post, not having accepted the offer of Chamberlain to the Queen. I believe that Don Alonso and the others will embark on the galley of Prince Doria with Don Carlo his son...'; IVI, fol. 431, letter of Monsignor Domenico Ginnasio, Nuncio in Spain, to Cardinal Pietro Aldobrandini, Valladolid, Valladolid 2 December 1602: '...The Count of Benevento left Valenza for Binaros on the 29th of last

month, to embark on the galleys of Count Doria ...' The documents examined for this occasion contain numerous references to the presence in those years in Naples of Don Carlo Doria, son of Giovanni Andrea, as commander of the Genoese fleet (e.g. ASN, Archivio Farnesiano, fascio 1956, Monsignor Alessandro Boccabarile to the Duke of Parma, Naples, 5 January 1605). News of a gift made by Carlo Doria to the wife of the Viceroy is in ASMn, Archivio Gonzaga, busta 823, letter of Gabriele Zinani to Vincenzo Gonzaga, Duke of Mantua, 3 September 1606: '... Don Carlo Doria has given the Vicereine a cross in rock crystal and two chandeliers, said to be of excellent craftsmanship, and of the value of two thousand ducats. Since the Viceroy obliged him to ask for something in exchange, with a great effort Don Carlo, for it seems he was most reluctant, asked H.E. to nominate his Agent in Naples as criminal judge ...' On Carlo Doria see the entry compiled by M. Capanna Ciappina in *Dizionario Biografico degli Italiani*, Rome 1992, vol. XLI, pp. 310–314. On the relations of the Spanish political authorities with the Doria family see M. Calvesi 1990, cited in note 8, pp. 131–132, 149.

44 Ivi, pp. 124–126, 131–133, 149, 157.

45 For the inventory references of the three pictures in the collection of the Count of Benavente see M. Simal López 2002, cited in note 36, pp. 44, 92–93, 105, and M. Marini 2001, pp. 526–527, 533–536, 565–566, 581. On *The Crucifixion of Saint Andrew* see above all A. Tzeutschler Lurie and D. Mahon, 'Caravaggio's Crucifixion of Saint Andrew from Valladolid', in *The*

Bulletin of the Cleveland Museum of Art, LXIV, 1977, pp. 3–24.

46 F. Bologna 1992, cited in note 4, p. 351, however, believes that the Harris picture is not a copy of the lost Caravaggio. We should also recall the attempt to identify the picture referred to in the inventory of 1653 in the palace of the Counts of Benavente at Valladolid ('*otro lienço de un santo obispo la cabeza degollada con moldura negra de pino original de Carabacho*') with the *Saint January Beheaded* (or *Sant'Agapito*) from Palestrina, in deposit at the Galleria Nazionale d'Arte Antica, Palazzo Barberini (M. Marini 2001, pp. 565–566).

47 An echo of the painting could be detected in the picture on the same subject done by Battistello Caracciolo for the transept of the Certosa di San Martino (M. Marini 2001, p.581).

48 J. Brown, 'A new identification of the Donor in Caravaggio's Madonna of the Rosary', in *Paragone*, CCCCVII, 1984, pp. 15–21.

49 For a comprehensive analysis of these questions see M. Marini 2001, pp. 513–517.

50 J. Hess, 'Modelle e modelli del Caravaggio', in *Commentarii*, V, 6, 1954, pp. 271–289; M. Calvesi 1990, cited in note 8, pp. 352–355.

51 On this possibility see most recently M. Marini 2001, pp. 513–517.

52 F. Bologna 1992 subscribes to this opinion, cited in note 4, pp. 326–329, and, moreover, on stylistic grounds, places the work in the years 1605–6, among the last Roman paintings. On the commission of the Duke of Modena see G. Marcolini, 'Cesare d'Este, Caravaggio e Annibale Carracci: un duca, due pittori e una committenza «a mal termine»', in J. Bentini

(ed.), *Sovrane passioni. Studi sul collezionismo estense*, Milan 1998, pp. 209–236. R. Hinks, *Michelangelo Merisi da Caravaggio. His life. His legend. His work*, London 1953, went so far as to identify the donor with the ambassador of the Duke of Modena in Rome, Fabio Masetti.

53 D.A. Parrino, *Teatro eroico e politico de' Viceré del Regno di Napoli*, Naples 1692.

54 M. Simal López, 2002, cited in note 36, pp. 35,44. On the portrait see also F.J. Sánchez Cantón, *Catálogo de las pinturas del Istituto de Valencia de Don Juan*, Madrid 1923, pp. 76–78, and A.E. Pérez Sánchez, *Pintura italiana del siglo XVII en España*, Madrid 1965, p. 252.

55 G. Pontari-G. Aita, 'Vincenzo Gonzaga e il viaggio a Napoli del 1603' in R. Morselli (ed.), *Gonzaga. La Celeste Galleria. L'esercizio del collezionismo*, Milan 2002, pp. 363–370.

56 I.M. Iasiello, 'Vincenzo I e il Regno di Napoli' and A. Ferri, 'La collezione di Matteo Capua da palazzo d'Alarcón al castello di Vico Equense' both in R. Morselli 2002, cited in previous note, pp. 357–362, 371–373. The collection of the Prince of Conca passed to the prince's son, not least as a result of pressure from the Viceroy, who was opposed to a sale in separate lots. Subsequently heavy debts forced the heirs to sell the family residences with all their contents (A. Ferri, op. cit., 2002, p. 373). In reality parts of the celebrated collection must have been sold off as early as 1610 if Alessandro Boccabarile was able to write to Ranuccio Farnese: 'The gold coins which I bought for this purpose from the Wardrobe of the Prince of Conca weigh one hundred *onze* of Portuguese marks; among them, there is one of 200

doubles, or rather ducats, with the effigy of the Monarchs; the others are of 50 and 60 ducats; and wishing to sell them, we would lose on the price paid, on account of the fact that gold then was in short supply here, so that I shall await your orders as to what I should do.' (ASN, Archivio Farnesiano, fascio 1961, copy of part of a letter of Mons. Vescovo Boccabarile scritta a S.A. di Napoli, 2 July 1610). The coins and medals of Matteo di Capua had been one of the most prestigious features of his collection for both their quality and number.

57 ASMn, Archivio Gonzaga, busta 824, Ottavio Gentili to the Duke of Mantua, Naples, 3 July 1607: '... but since this is a matter of evaluating paintings, which is not my line, and not knowing whom I can trust in this city ... I shall go and see them taking with me Michael Angelo Caravaggio, who did that large picture Your Excellency bought recently in Rome, and shall ask his opinion ...' (published in R. Morselli 2002, cited in note 55, p. 361).

58 The letters of Gentili and Pourbus referred to, in the Archivio di Stato di Mantova, are given here transcribed from the version contained in S. Macioce 2003, cited in note 1, pp. 230–231, to which the reader is referred also for the preceding bibliography.

59 ASMn, Archivio Gonzaga, busta 824, Gabriele Zinani to the Duke of Mantua, Naples, 26 October 1607.

60 ASMn, Archivio Gonzaga, busta 824.

61 A brief note on the subject is in A. Feros, *Kingship and Favoritism in the Spain of Philip III, 1598–1621*, Cambridge 2000. Feros recalls that it was in 1607 that the Duke of Lerma lobbied insistently for the

candidature of his nephew, Pedro Fernández de Castro, Count of Lemos, as Viceroy of Naples. The detail has recently been recalled in M. Simal López, *Don Juan Alfonso Pimentel, VIII conde-duque de Benavente, y el collezionismo de antigüedades: inquietudes de un virrey de Nápoles (1603–1610)*, in press in 'Reales Sitios'.

62 M. Simal López, 2002, cited in note 36, p. 88: '*Respecto al contenido del equipaje que el VIII conde-duque trajo a su regreso de Nápoles tan sólo sabemos, gracias a una cédula de paso fechada el 9 de julio de 1611, que contenía 'algunas joyas de oro perlas piedras y plata labrada de serviçio, vestidos y ropa blanca, camas, colgaduras de oro y seda, tapicerías y otros aderezos de su persona casa y criados. Y treinta y dos cavallos napolitanos' que se registraron en el puerto de Cartagena. Los derechos de todos estos bienes, que estaban exentos gracias a la cédula que había emitido la Cámara de Castilla, ascendían a 285.804 maravedíes por las 'joyas, platas y otras cosas' y 120 ducados por los caballos (AGS, Cámara de Castilla, Cédulas, libro 367). En este mismo sentido se pronuncia la petición de la cédula de paso (solicitada el 20 de mayo de 1610 y otorgada el 7 de junio), en la que sólo se menciona 'ropa de su cassa y serviçio y que mucha della la sacó destos reynos quando fue a serbir [...]' y los ya mencionados 32 caballos (AGS, Cámara de Castilla, leg. 973, exp. 25). Entre la plata labrada, probablemente se encontraban los 'dos blandones de plata de peso de hasta setenta marcos de poco mas o menos' que el conde-duque llevó consigo cuando*

partió hacia Nápoles (AGS, Cámara de Castilla, Cédulas, libro 365, fol. 62).'

63 M. Simal López, 2002, cited in note 36, pp. 88, 178–182.

64 G. Coniglio, *I viceré spagnoli di Napoli*, Naples 1968, pp. 163–173. I intend to produce a brief account of the years of the Count of Benavente's term as Viceroy in which I shall illustrate all the documentary material assembled for this occasion and used only in part in this essay.

65 M. Simal López, 2002, cited in note 36, pp. 45–46: 'AHPM, prot. 4.429, f. 302v y BNM, mss. 11.569, fol. 161r (*'se bolvió a su casa con más honrra que hazienda pues de Nápoles salió con más de cinquenta mill ducados de deuda y los hubo de pagar de la hazienda de la condesa su mujer, por no tener con que pagarlos de la suya, y si no le llevaran de su Casa veinte mill ducados a la lengua del agua, no le fuera posible llegar a Benavente'*). *Antes de desembarcar en Valencia, el conde-duque tuvo que pedir una licencia para que un criado de su Casa le llevara hasta allí 15.000 ducados en moneda de oro o plata 'para ayuda a los gastos de su jornada desde Nápoles de donde viene a su casa' (AGS, Cámara de Castilla, leg. 970, exp. 106), concediéndole la Cámara de Castilla el 9 de agosto de 1610 permiso para que Bernardo de Herbó le llevara tan sólo 8.000 ducados (AGS, Cámara de Castilla, leg. 972, exp. 39). Los gastos ocasionados por el virreinato napolitano, sumados a los generados por sus anteriores obligaciones cortesanas, las deudas heredadas de su padre y las acarreadas por las dotes de sus hijas hicieron que en 1611 el conde tuviera que vender algunos lugares de su estado para sanear su comprometida*

economía (AGS, Cámara de Castilla, leg. 982, exp. 85) y en 1614 celebrar una almoneda, en la que se vendieron distintas pinturas (AHN, Nobleza, Osuna, leg. 430–41).' A. Ottino Della Chiesa, *L'opera completa del Caravaggio*, Milan 1967, p. 75, believed that the failure to deliver the painting may 'have been due not only to "decorum" but also to other factors, including financial considerations'.

66 For the last episodes concerning the picture see M. Marini 2001, pp. 512–517. On the relations of Finson and Vinck with Caravaggio see pre-eminently S. Causa, 'Gli amici nordici del Caravaggio a Napoli', in *Prospettiva*, XCII–XCIV, 1999, pp. 142–157.

67 W. Prohaska, 'Untersuchungen zur Rosenkrantz Madonna Caravaggios', in *Jahrbuch der Kunsthistorischen Sammlungen in Wien*, LXXVI, 1980, pp. 111–132, esp. p. 112. In the opinion of F. Bologna 1992, cited in note 4, p. 328, it was Caravaggio himself who 'decided to sell or to have the picture sold by the two Flemings, who then saw to the matter'.

68 D. Bodart, *Louis Finson*, Brussels 1970, pp. 13–14, 132–136.

69 It is not without implications for our reconstruction that the copy of *The Crucifixion of Saint Andrew* has been identified with the one sold at Amsterdam in 1619 by the heirs of Abraham Vinck, deriving from the legacy of Finson (M. Marini 2001, p. 536).

70 This is, however, strictly conjecture, since for example F. Bologna 1992, cited in note 4, p. 351, maintains that the painting cannot be 'either a copy taken from another Caravaggio, since lost, or the work of Louis Finson. It seems rather to be a copy by

59

a modest artist from a picture by Antonio Tanzio da Varallo, to be linked with the latter's visit to Naples'.

[71] M. Marini 2001, p. 526.

[72] For the picture in question see once again M. Marini 2001, pp. 517–518. For this copy too F. Bologna 1992, p. 355, affirms that the attribution to Finson is problematic, although he recognises the 'substantial contemporaneity with the St Andrew'.

[73] G. Pontari and G. Aita, Vincenzo Gonzaga e il viaggio a Napoli del 1603, cit.

[74] Ivi, p. 369.

[75] Ivi, pp. 364, 366–367.

[76] ASN, Archivio Farnesiano, fascio 1949, Alessandro Boccabarile to the Duke of Parma, Naples, 23 January 1609: '... Donna Gironima Colonna has passed away, while at Gaeta on her return from Barcelona where her son the Duke of Montelione was awaiting a shipment of something valuable from the Court ..'.

[77] M. Marini 2001, p. 517.

[78] Ivi, p. 515. However, in his efforts to identify the picture in Vienna with the one commissioned by Radolovich, the scholar asserts that the donor could be a portrait post-mortem of Traiano Radolovich, lawyer, who died in 1606.

[79] For J. Brown 1984, cited in note 48, p. 18, 'The iconography has what might be called a "Spanish" flavor. St Dominic was Spanish-born and St Peter Martyr was the patron of the Inquisition'.

[80] M. Simal López, 2002, cited in note 36, pp. 44, 154.

[81] Ivi, p. 50.

[82] On his departure from Naples Fra Domenico took with him « seis u ocho pinturas y avendo traido muchas y excelentes de Nápoles hizo con licenzia de sus superiores dispuso de ellas » (J. Bernstock, 'La tumba del Cardenal Domingo Pimentel, de Bernini', in Archivo Español de Arte, 237, 1987, pp. 1–15, esp. p. 5 note 15).

[83] M. Marini 2001, p. 516.

[84] E. Nappi, 'Santa Maria della Sanità. Inediti e precisazioni' in Ricerche sul '600 napoletano. Saggi e documenti, 1999, pp. 61–69. I am grateful to Eduardo Nappi for his valuable suggestions and the great courtesy he has shown me on various occasions.

[85] A. Spinosa and N. Ciavolino, Santa Maria della Sanità. La Chiesa e le Catacombe, Naples 1981.

[86] This detail in AGS, Secretarías Provinciales, leg. 10 e 11 (the church was « tan sumptuosa que con haver gastado en ella hasta oy más de veynte mill dos no se ha hecho más que la tercia parte de la fabrica, y que asi para acavarla han menester otros quarentamill ducados, y mas ») is reported by M. Simal López 2002, cited in note 36, p. 42, to which the reader is referred, also for a list of other churches to receive donations.

[87] The document in ASN, Monasteri soppressi, fascio 1008, c. 180, was published by F.G. D'Andrea, 'Il Caravaggio morì veramente nel 1610?', in Il Rievocatore, XXII, 1971, pp. 1–5. See also M. Marini 2001, pp. 566–567.

[88] In reality the annotation referring to Caravaggio appears to have been added to the document subsequently, in another hand.

[89] R. Causa, I. La pittura del Seicento a Napoli dal naturalismo al Barocco. II. La natura morta a Napoli nel Sei e nel Settecento, in Storia di Napoli, Naples 1972, vol. V, tome II, p. 963.

[90] To cite just one, in the authoritative opinion of F. Bologna 1992, cited in note 4, p. 453, the idea that the commission was ever given to Caravaggio is 'completely groundless' while the 'record itself has no semblance of authenticity on either historical or philological grounds'.

Caravaggio in black and white:
art, knighthood, and the Order of Malta
(1607-1608)
Keith Sciberras and David M. Stone

Standing in front of Caravaggio's *Seven Works of Mercy*, the *Crucifixion of Saint Andrew*, or the *Flagellation* – altarpieces that revolutionised Neapolitan painting, blazing a path for such artists as Caracciolo and Ribera – it is hard to understand why the Lombard artist would have suddenly felt the need to leave Naples for Malta, a small island in the middle of the Mediterranean. Since 1530, Malta had been the headquarters or 'convento' of the Knights Hospitaller of St John of Jerusalem, an international military-religious order of Catholic nobles founded in Jerusalem during the First Crusade. The 'Sacra Religione', as the Knights of Malta were frequently called, had previously occupied Cyprus and Rhodes. Caravaggio's interest in coming to Malta can be deduced from a network of sources and circumstances. The first part of this essay deals with the documentary evidence for his Maltese sojourn, raising questions about his motives for coming to the island, the identity of his protectors and patrons, the complications of his knighthood (fig. 1), and the nature of the crime that ultimately led to his daring escape to Sicily. Caravaggio painted some of the greatest works of his career for the Knights of St John, including the magnificent *Beheading of Saint John the Baptist*. The second section is devoted to examining this crucial moment of Caravaggio's stylistic development, when he was painting to please patrons who in many ways held the keys to his liberation from exile.

From Naples to Valletta:
The Rise and Fall of a Painter-Knight

In June 1607, Caravaggio left Naples heading south for the small island of Malta, a military outpost of the Roman Catholic faith entrusted to the Knights of the Order of St John.[1] There, Caravaggio probably believed that powerful patrons and good fortune would bring him politically closer to Rome and to papal pardon. It is still not clear what was really in the artist's mind, whether it was the search for greater protection and security, or the dream of knighthood. Yet, it may also be possible that he was attracted to the island because the ruling Grand Master, Alof de Wignacourt, was desirous for a painter to serve his court. In Malta, Caravaggio's fortune was initially great and his first year was probably even better than he had expected. His outstanding pictures from this period are testimony of his well-being, and also of his emotional stability. Life seemed too good to be true, until all went so suddenly wrong.

Caravaggio's Maltese period is largely concerned with his knighthood, that is, his ambition for it, his arming, and disrobing. Before arriving in Malta he certainly knew about honorific knighthoods and knighthood may well have been one of his ambitions. He should also have known, however, that the Statutes of the Order of St John prohibited the reception of anyone guilty of murder, and certainly he would have realised that this was a great obstacle. The fact that Caravaggio had committed murder was not, however, the only hurdle that the artist needed to overcome had he really wanted to be armed with the habit of Magistral Obedience. Reserved for valorous men who did not possess noble lineage, this was the only honorific knighthood for which

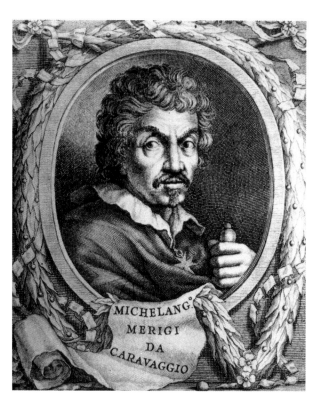

1. Albert Clouwet, attrib., *Portrait of Caravaggio*, engraving from G.P. Bellori, *Vite de' pittori*, Rome 1672

62

he would have been eligible. There had, however, been some very recent changes in their conferment and when Caravaggio set sail for Malta, the ruling Grand Master had not, since his election in 1601, been favourably inclined to bestow such knighthoods.[2] It is possible that Caravaggio was not aware of Wignacourt's policy on the matter; it is even probable that he did not care and that it became the Grand Master's concern when, in turn, he wanted to invest Caravaggio with the habit of Magistral Obedience. This was no easy task, and certainly not something that a Grand Master could officially promise to a fugitive from papal Rome. Thus, when Caravaggio left Naples for Malta there was probably no prior, formal, agreement with the Magistry for his election to the

knighthood. Wignacourt's admiration for Caravaggio matured in Malta, after the artist had proved his worth.[3] Caravaggio travelled to Malta on the galleys of the Order; the fact that he embarked on these galleys, and not on one of the many private or mercantile vessels, indicates that he was no mere tourist. He was certainly enjoying considerable protection.[4] It should be remembered that these galleys, five of them, were under the command of General Fabrizio Sforza Colonna, who certainly knew the artist well.[5] In the Order's strict military code, all the persons taken aboard had to be notified to the General; Sforza Colonna thereafter instructed on which of the galleys such persons were to sail.[6] On this occasion, the galleys' stop in Naples had been short; they came from the North and were only passing through the city to gather provisions. In such circumstances, it is difficult to maintain that it was Fabrizio himself who had managed to convince Caravaggio to abruptly abandon Naples and travel with him to Malta. Everything would have been well orchestrated and Caravaggio was probably keenly awaiting the galleys' arrival, with all his belongings.[7] In Naples, Caravaggio's papers would have been prepared by Fra Giovanni Andrea Capeci who, as Receiver, was responsible for the provisions for the galleys. That Capeci was somehow involved in Caravaggio's passage to Malta can also be proposed on account of his earlier involvement in the failed transfer of a painter to Malta. In the early months of 1606, Wignacourt was seeking to obtain the services, from Florence, of a painter (unfortunately unnamed). Wignacourt's correspondence of March 1606 shows that negotiations were reaching a conclusion, so much so that he made provisions for the painter's voyage to Malta. The unnamed painter had to pass through Naples, and there Capeci had to assist him in buying the necessary pigments and provisions and secure his safe passage to Malta through Messina.[8] For some unknown reason, the painter did not make it to Malta; he probably did not even leave Florence to take up the position. But Capeci now knew how eager Wignacourt was to have a painter in his service. Caravaggio's voyage to Malta on these galleys was, as was his whole life, an adventure. This voyage was a dangerous one, because seven large enemy vessels from Barbary had just been sighted off the coast of Gozo, Malta's sister island. Wignacourt had every reason to believe that they were waiting to engage the galleys of Sforza Colonna. Five of these enemy vessels had, on 25 June, disembarked soldiers and attacked, unsuccessfully, the Order's guards on Gozo. On seeing this, Wignacourt immediately warned Sforza Colonna of 'the advantage that the enemy has because of the larger number of

vessels and because our galleys are burdened and with provisions in tow'.[9] Wignacourt's concern grew when, by early July, the enemy vessels were still in Maltese waters. For this reason he sent a frigate to accompany his galleys' return; he could do little more. It can be safely presumed that, in their voyage from Sicily to Malta, all men on board, including Caravaggio, were in a state of alert and armed for combat. The artist thus probably commenced his Maltese sojourn grasping a sword firmly in hand. The naval encounter did not, however, materialise and the galleys of the Order arrived in Malta around 12 July.[10] This was Caravaggio's first view of Valletta (fig. 2). Against a backdrop of glowing limestone, Caravaggio would have also noted the macabre sight of the gallows, so prominently exposed to greet the visitors on the first promontory on the left of the harbour; this was a daunting reminder of the Order's rule of law. Within the harbour, on the third promontory on the left was Fort St Angelo, where many glorious episodes of the Great Siege of 1565 had unfolded; it was now, among other things, a prison for unruly knights.

In the corridors of power within the palace of the Grand Master in Valletta, Caravaggio's former patrons in Rome were frequently mentioned; the Mattei, Costa, Giustiniani and Sforza Colonna had established intimate ties with Wignacourt and were in correspondence with him. The Borghese papal family was obviously much revered. News that Caravaggio was in Malta would have spread fast. Many probably did not even know who the artist was; but a select few were distinguished 'cognoscenti' and were powerful enough to canvass in his favour with the Grand Master. The Grand Master was probably expecting him, perhaps as a replacement for the artist who should have arrived through Naples in 1606. Caravaggio attracted around him prominent personalities, and his circle of protectors grew to include new patrons, among whom were Francesco dell'Antella[11] and Ippolito Malaspina,[12] for whom he painted the easel pictures of *Sleeping Cupid* and *Saint Jerome*, and Antonio Martelli, of whom he is likely to have painted a portrait now in the Pitti.[13] A Florentine, dell'Antella was personal assistant and secretary to Wignacourt. Erudite and a man of culture, he moved within the innermost circles of the Grand Master, also apparently occupying the role of what can be called the 'consultant for culture and the arts'. Malaspina was a political heavyweight of the older generation and the former General of the Papal Galleys under Clement VIII. Related to Ottavio Costa through the latter's marriage, he had lived in Rome precisely at the time Caravaggio achieved public recognition there. He had, moreover, travelled to Malta on the very same galleys that had brought the artist.[14] To these patrons should be added the

members of the Lorraine family. Charles of Lorraine, Conte de Brie, was in Malta, amid initial controversy, throughout 1608[15] while Francis of Lorraine was on the island with great pomp for a short spell late in July 1608.[16] This was likely the most appropriate opportunity for the Lorraine family to commission the *Annunciation*, shortly afterwards donated by Henry II to the primatial church of Nancy.[17] It is not known where Caravaggio resided in Malta; he may have stayed with one of his protectors or in one of the inns at Valletta.[18]

The first reference to Caravaggio in Malta is a chance reference from the Inquisitors' Archives.[19] On 14 July,

2. Francesco Villamena after Fra Francesco dell'Antella, *Map of Valletta*, engraving from Bosio, *Istoria della Sacra Religione*, vol. 3, Rome 1602; second state with the arms of Grand Master Caraffa, Naples 1684

3. *Fort St Angelo*, reconstruction by S. Spiteri, 2004

that is, immediately following his arrival, Caravaggio attended a welcome party given by Giacomo Marchese, a Sicilian knight who had embarked on the galleys during their stop at Messina. At the party Marchese was overheard talking about a Greek painter who kept two wives. This attracted the attention of Judge Paolo Cassar, who was also present and who conscientiously reported the matter to the Inquisitor Leonetto Corbiaro. The latter opened an enquiry and Caravaggio was summoned before his court on 26 July. At the Inquisitor's questioning the artist responded evasively, saying that he did not know anything about what had been said.

Giacomo Marchese was called to testify weeks later, on 18 September. He also said that he did not know anything about the matter and declared that the entire situation had arisen out of an innocent joke. The enquiry failed to reach any conclusion, but it does at least provide evidence that Caravaggio was in Malta.

The weeks that followed Caravaggio's arrival in Malta are still biographically hazy, but the artist was beginning to gain considerable prestige. Wignacourt gradually came to realise his good fortune; perhaps he heard stories of how Italian princes, cardinals and bankers sought to have him in their service. Around this time Wignacourt had himself portrayed in full armour, accompanied by a page, a picture that now hangs in the Louvre.[20] The Grand Master and his close collaborators recognised the benefits that the Order could reap from Caravaggio's presence and began planning how to keep him in Malta or permanently associated with the Order. The Grand Master had a number of alternatives. The simplest was to elect Caravaggio as a member of the palace household, giving him all the privileges that it carried.[21] Wignacourt, however, wanted an even more intimate connection and opted for a bold move, that of making Caravaggio a knight. This was an honour that was to the advantage of both artist and patron.

However, as noted earlier, Wignacourt himself had abolished the Knighthood of Magistral Obedience, the knighthood to which Caravaggio would have been eligible. In the Order's ranking, the Knighthood of Magistral Obedience was primarily an honorific conferment and had little political stature. Such knights, however, still had to wear the black and white habit, enjoyed a small pension, and food and accommodation when in residence in the convent. Even though socially prestigious, the knighthood was of less importance than the Knighthood of Grace, where a degree of nobility was required, and obviously much less important than that of Justice. The latter was reserved for true noble knights. Knights of Magistral Obedience, however, still required to be regularly professed 'in Convent' and normally had to spend a full year in residence as novices.

Wignacourt's desire to keep the artist was considerable; determined to make him a knight he had to ask for two papal dispensations, one for investing a man who had committed murder, and the other for making him a Knight of Magistral Obedience. In a letter of 29 December 1607, Wignacourt wrote to his Ambassador in Rome, Fra Francesco Lomellini, and briefed him on this request, which was in turn to be addressed to the papal court. He did not mention Caravaggio by name, but referred to him as a 'person of great virtues, honourable, and respectful, and whom we particularly respect as our servitor'.[22] Moreover, he explains his desire by his wish 'not to lose' him (per non perderlo). And it is precisely this fear of losing him that would have been the principal motive for Caravaggio's arming as a knight. Once a knight, Caravaggio could not leave Malta without the Grand Master's consent. To assist Lomellini in his request to the papacy, Wignacourt enrolled the help of Giacomo Bosio, who was similarly informed by a letter of 29 December.[23] Lomellini and Bosio acted immediately and papal authority was granted on 7 February 1608.[24] This was, remarkably, a mere three weeks or so after receipt of the Grand Master's letter in Rome. The full document of the authorisation, as released by the papacy, is dated 15 February 1608.[25]

In other words, by the end of February, the Grand Master would have received the news from his Ambassador. The news spread fast within the palace corridors. Caravaggio himself would have been summoned by the Grand Master and informed that there were no longer any difficulties with his admission into the Order. His only remaining obligation was that of fulfilling the requirements of a year's residence 'in Convent' as a novice prior to his arming. Wignacourt was obviously desirous for a speedy outcome. It can be inferred, from the date of Caravaggio's admission, that the Grand Master gave instructions to have his year counted immediately after his arrival in Malta. He could thus be armed in mid-July 1608. Caravaggio's thoughts would, at this stage, certainly have turned to Rome. Paul V, from whose authority he was fleeing, had granted a major concession in his favour and it would have been logical to interpret this as a major step towards pardon. In Malta, Caravaggio thus found himself building a strong foundation for his eventual return to Rome; a return that certainly could not have been foreseen had he, a fugitive for the crime of murder, reappeared 'triumphantly' as a knight of the Order of Malta, armed and wearing the black habit with the white eight-pointed cross proudly exhibited on his chest.

The reception ceremony at which Caravaggio was invested with the habit of a Knight of Magistral Obedience was held on 14 July 1608. The Grand Master thus fulfilled his wish 'to gratify the desire of this excellent painter, so that our island of Malta, and our Order may at last glory in this adopted disciple and citizen with no less pride than the island of Kos (also within our jurisdiction) extols her Apelles; and that, should we compare him to more recent artists of our age, we may not afterwards be envious of the artistic excellence of some other man, outstanding in his art, whose name and brush are equally important'.[26] Admiration for Caravaggio's work is deliberately spelled out, as are the expectations that his art was to be a vehicle for the

4. Michelangelo Merisi da Caravaggio, *Beheading of Saint John the Baptist*, detail. Valletta, St John's Co-Cathedral, Oratory of San Giovanni Decollato

Order's glorification. At his first opportunity, Caravaggio proudly signed his name as Fra Michael Angelo, painted in the blood oozing from Saint John's head in the *Beheading of Saint John the Baptist* (fig. 4).

As a Knight of Malta, Caravaggio's social life took on an entirely new dimension; he was now bound by obedience, respect for his superiors, and by the strict observance of the Statutes of the Order. Long hours in taverns, brawls, blasphemy, gaming, the colourful aspects of street life and consorting with prostitutes were to become a thing of the past. He was now obliged to be decorous in his demeanour and to wear his habit with dignity and composure. But Valletta was a cosmopolitan city and temptations were around every corner;[27] Caravaggio's turbulent nature could not be contained for too long. A brawl was to lead to his disgrace.

It happened in Valletta on the night of 18 August 1608.[28] The circumstances emerge with some clarity, even if it is still difficult to explain what led up to it. A fight broke out in the house of the organist of the Conventual Church of St John, Fra Prospero Coppini, who, however, does not seem to have taken an active part. The fight was no small affair and seven knights, all Italians, were involved. Arms were used, and a shot was fired. The front door of Coppini's residence was smashed and broken open and one of the knights, Fra Giovanni Rodomonte Roero, Conte della Vezza di Asti, was seriously wounded. The Venerable Council was immediately notified and an investigation was set up the following day. Caravaggio and Fra Giovanni Pietro de Ponte, a deacon of the Conventual Church, were the first among the perpetrators to be identified, on 27 August 1608,[29] by the Criminal Commission. Both men would have been put in detention in Fort St Angelo immediately afterwards.[30]

This was only two days before the feast of San Giovanni Decollato, when Caravaggio's monumental picture was probably to be unveiled in the Oratory of the Decollato.[31] Caravaggio seems to have spent September 1608, or the greater part of it, detained in Fort St Angelo (fig. 3).[32] This was a large and now somewhat derelict fort, but it had had a glorious past, holding the Order's standard during the memorable months of the Great Siege. Its military significance had diminished with the building of Valletta, but nonetheless it still presented an imposing sight in the harbour. In St Angelo, unable to paint, the artist's inventiveness was kept alive by planning his incredible escape. This took place in early October and must have been the result of an elaborate plot.

On 6 October 1608, the Venerable Council was informed that the Knight Fra Michelangelo Merisi da Caravaggio, while detained in Fort St Angelo, had escaped and secretly fled from the island. By this flight Caravaggio had seriously breached the Order's Statutes and one of its central points of honour and discipline.[33] It eventually led to the *privatio habitus* ceremony of 1 December 1608 (nearly two months after his escape) during which the artist was deprived of his habit and expelled from the Order *in absentia*.[34] He had, through his flight, indirectly admitted his guilt for the brawl and was thus removed from the list of knights eventually tried for the affray.[35] There has been much speculation on how Caravaggio escaped; what is known is that he used a rope. It is, however, difficult to establish the exact sequence of events partly because it is not clear where he was being kept within the fort. It is improbable that Caravaggio was detained, as traditionally held, in the rock-cut *guva* within the fort. He was on preventative custody and not yet condemned, thus he possibly enjoyed a certain degree of liberty within the fort's perimeter,[36] making escape easier. The main difficulty lay in getting out of Malta. At this stage, Caravaggio was certainly helped to arrive speedily in Sicily. He must somehow have secretly boarded a boat, possibly the *speronara* of a daring and corruptible boatman. Sailing through the narrow opening of the Grand Harbour would have been too much of a risk and he was probably picked up from one of the island's many bays after spending some hours, or even days, in hiding.[37] That there was an 'arrangement' to help Caravaggio escape is clear but it is difficult to ascertain who helped him. In an island of informers and of rewards for information, it is significant that nothing came of the investigations carried out by the Criminal Commission. Escaping from the Convent was, as already noted, a dishonourable deed, and a dangerous one too. Moreover, everyone in Malta knew that, in such circumstances, even the fugitive's accomplices risked a great deal, as was the case in a similar incident that happened less than a month before Caravaggio's escape. Caravaggio's accomplices, therefore, knew what they were risking.[38] If they were knights, they risked the *privatio habitus* themselves. If secular, they were also in great trouble, and liable for punishment.

But, dramatic as it was, Caravaggio's escape was not an isolated episode. During Wignacourt's Magistry, other knights had fled the island or left without authorisation. In some instances, Wignacourt's furious reaction is documented. What usually happened in such cases was that the Grand Master promptly wrote to all his Receivers in the major European cities and ordered the immediate recapture and detainment of the fugitive knight.[39] It clearly emerges that the Grand Master wanted fugitives back in Malta. This would have been the situation which faced Caravaggio after his escape, and Bellori himself records that Caravaggio feared that the knights were after him.[40]

Unfortunately, specific documents confirming that Caravaggio was being pursued do not exist (though this is hinted at by biographers). But in view of the manner in which he was expelled from the Order, it does not appear that he would have been given preferential treatment and simply let go. The Order's Receivers in Sicily would have been informed about his escape, but made no move to apprehend him. Perhaps this was because Caravaggio had managed to obtain protection immediately upon his arrival on that island. It is obvious that he had important contacts and that, for the Order, his apprehension could have become an embarrassing affair. It should also be noted that, during the same period, the Order was in litigation with the Senate of Messina. In such circumstances it seems that it would have been difficult for the Order to expect official help from that city. That Caravaggio truly feared that he was being pursued, as suggested by his biographers, should not be excluded, because he certainly knew how Wignacourt treated those who contravened the Statutes. Moreover, throughout his first weeks in Sicily, the galleys of the Order were sailing off the harbours of that island, and he would probably have seen them from the ports where he took refuge, a veritable reminder of the Order's vengeance and also an indirect threat. First under Sforza Colonna and later, after November 1608, under Francesco Moletti, the galleys were known to have been in the waters of Messina. Meanwhile, some time before 4 November, Fra Antonio Martelli arrived in Messina to take up residence as prior of the city.[41] With his presence in Messina, certainly till late summer 1609 (thus running parallel to Caravaggio's own stay), there was undoubtedly a strange and awkward situation. Martelli was one of the most powerful and deeply respected knights within the Order and, if he is to be identified with the *Knight of Malta* at the Pitti (cat. no. 9),[42] he was also one of Caravaggio's protectors in Malta.

The most crucial period for the apprehension of Caravaggio by the knights in Sicily was when the Order was compiling evidence for his trial in Malta. It is during this period that the Order would have concentrated its resources on his recapture and forced return to the Convent.[43] When on 27 November 1608, during Caravaggio's trial, the Venerable Council heard details of how Caravaggio had escaped from the fort using a rope and decided that it should proceed with his defrocking,[44] it also heard and judged the criminal case for the August brawl. The Council condemned another four knights to imprisonment and de Ponte and Caravaggio to be expelled from the Order.[45]

The expulsion and defrocking of Caravaggio and de Ponte took place immediately afterwards on 1 December 1608.

Both ceremonies were held in the Oratory, ironically in front of the *Beheading of Saint John the Baptist* and in the presence of the members of the Venerable Council that included most of Caravaggio's former protectors (fig. 5). The first to be expelled *tanquam membrum putridum et foetidum* and defrocked, *in absentia* and after a unanimous vote against him, was Fra Michelangelo Merisi da Caravaggio.[46] [k.s.]

Caravaggio's Paintings for the 'Sacra Religione'

If Giorgione's and Titian's paintings, as is often said, respond to the dappled light and watery brew of colours emanating from Venice's palace-lined canals, Caravaggio's Maltese works have an austerity and tectonic rigour that match the character of this rocky island, with its cubist panorama and stalwart military commanders.[47] In the summer of 1607, Valletta's new buildings – behemoths designed by the engineer who planned its fortifications – contained some important paintings by such artists as Matteo Perez d'Aleccio and Filippo Paladini.[48] But huge expanses in the Grand Master's palace and St John's church were still relatively bare.[49] The Oratory of San Giovanni Decollato annexed to the church, which had only been completed a couple of years earlier, was similarly incomplete in its decoration. The Order, no doubt, was counting on Caravaggio to lend prestige and beauty to these new sites. Indeed, it is likely that Caravaggio was invited to the island specifically to provide meritorious service to the Order by serving – for the first time in his career – as court painter.

The pictures Caravaggio painted during his fifteen-month sojourn on the island demonstrate his sensitivity to his surroundings – not only to the topography but also to the visual and spiritual culture of his knightly audience. His canvases are experimental in many ways, taking standard themes and reinventing them. Caravaggio's Maltese works have a distinctive look. They are noticeably 'harder', more spartan and subdued than anything that came before them. It was here – more than in Naples – that he began to paint very economically, putting in the 'treble' highlights in a few rapid strokes and using the reddish ground, not only as a kind of 'basso continuo' for the entire composition, but also as part of the actual substance (part of the melody, as it were) of individual forms. The half-tones in the figures turn out in many instances to be no more than plain background surrounded by a deft highlight. While Caravaggio's figures retain their old force of three-dimensionality and *rilievo*, the balance between lights and darks has become more subtle. The canvases have a porosity that absorbs light with such force that the figures seem virtually imprisoned by their surroundings.

Caravaggio's minimalism also extends to his range of colour – a restricted spectrum of browns and greys with a single splash of red serving as his only strong chromatic element – and to his new habit of leaving large areas of the canvas bare.

Minimal too were the number of works Caravaggio produced in this long and – until August 1608 – strangely peaceful period. This, in fact, was the longest stretch in a single locale of his post-Roman career. Given how few paintings Caravaggio is known to have created on the island, his seemingly rapid technique would appear to have little or nothing to do with time constraints. His daring brushwork and new economy of means, which in certain cases test the limits of what could be considered a 'finished' work, are instead signs of a new confidence in his approach to painting.

Our knowledge of what Caravaggio painted on the island is based on the rather patchy evidence provided by a handful of biographies,[50] two documents,[51] and a smattering of observations penned by Seicento travellers.[52] Since it is likely that one of Caravaggio's primary motives for going to Malta was to obtain a knighthood, it follows that the artist may have donated some of his pictures to the Order. This may explain why no financial transactions for Caravaggio in Malta have been discovered.

The most important source for the 1607–8 period is unquestionably Bellori. In the *Vite de' pittori* (Rome 1672), he says Caravaggio made the following works during his Maltese sojourn: two portraits of Grand Master Alof de Wignacourt – one showing him standing dressed in armour (located, according to the author, in the Knights' Armoury) and another showing him seated without armour;[53] and three works for St John's – the *Beheading of Saint John the Baptist* (the Oratory is not mentioned) and two paintings, a *Magdalen* and a *Saint Jerome Writing*, each half-length, situated above the two doors of the Chapel of the Italian Langue.[54] According to Bellori, Caravaggio made another *Saint Jerome*, this one located in the palace, which shows the saint with a skull, 'meditating on death'. Since the first image was a depiction of the saint 'writing', the implication is that the work in the palace had a different composition.[55]

With the notable exception of the second *Saint Jerome*, about which nothing further is known,[56] all the pictures described by Bellori are traceable, though at least three of them, as will be demonstrated, are almost certainly cases of mistaken identity. Bellori, it turns out, probably never visited Malta.[57] Obvious errors of attribution in his text lead to the conclusion that he relied on a poorly informed correspondent for this section of the biography.[58] Bellori's predecessor Baglione (1642) was the first to

mention that Caravaggio had painted a portrait of the Grand Master. It so pleased the prince, Baglione writes, that he rewarded the artist with the habit of the Order.[59] The author does not describe the picture, but it is likely that he is referring to one of Caravaggio's most intriguing paintings, the *Portrait of Grand Master Alof de Wignacourt and a Page*, now in the Louvre (fig. 6).[60] There are no early documents for this work, which, based on style and context (paying tribute to the Grand Master), was probably done in late 1607, soon after Caravaggio arrived on the island. The second person to cite the work was the English traveller and diarist John Evelyn, who in 1644 observed the portrait hanging in Paris in the rue de Seine palace of Roger de Plessis, duc de la Rocheguyon et de Liancourt (1598–1674), a major collector of Italian baroque pictures, who, so far as I have been able to ascertain, was neither a member of the Order of St John nor a relative of Wignacourt.[61] By 1670 the picture is recorded in the collection of Louis XIV.[62] It is not known where the picture was kept on the island (though the Grand Master's palace would have been an obvious place). Since no contemporary copies of the work have been identified other than an extremely mediocre derivation at the Verdala Palace that carries an inscription based on Wignacourt's death date of 14 September 1622 (fig. 7),[63] it is possible that Caravaggio's portrait of the Grand Master left Malta relatively early. Elected for life to the chief position of the Order in 1601,[64] Alof de Wignacourt almost at once proved to be a great military leader. Much of his magistry was devoted to protecting the islands from attacks. But he also organised numerous military campaigns against the Turks in the Eastern Mediterranean, successfully recapturing islands that had for years been in Ottoman possession. Many engraved frontispieces bearing his likeness contain references to his victories at Patras, Lepanto, Lango, and the city of Mahomet in Barbary.[65] Caravaggio shows the ageing Grand Master as a proud, feisty warrior with a look of sublime confidence on his face. In a format based on Titian but made both more flexible and more austere, he steps towards the left but turns his head towards the right, looking over his shoulder as if to inspect his troops, making sure 'these youngsters' keep up with him.[66] Wearing a classic suit of Milanese armour of c.1565–80, Wignacourt holds a commander's baton with both of his gauntleted hands. The poise and glowing face of the Grand Master suggest that this scene might be no more than a moment excerpted from a drill or parade. But the firm grip of his fingered gauntlets on the baton, by contrast, is a poignant metaphor of his tight rule over his Order and a warning to the enemy not to test his readiness to engage.[67]

5. Wolfgang Kilian, *The Criminal Tribunal of the Knights of Malta in the Oratory of San Giovanni Decollato*, engraving from C. von Osterhausen, *Eigentlicher und gründlicher Bericht ...*, Augsburg 1650. Washington, D.C., Catholic University of America

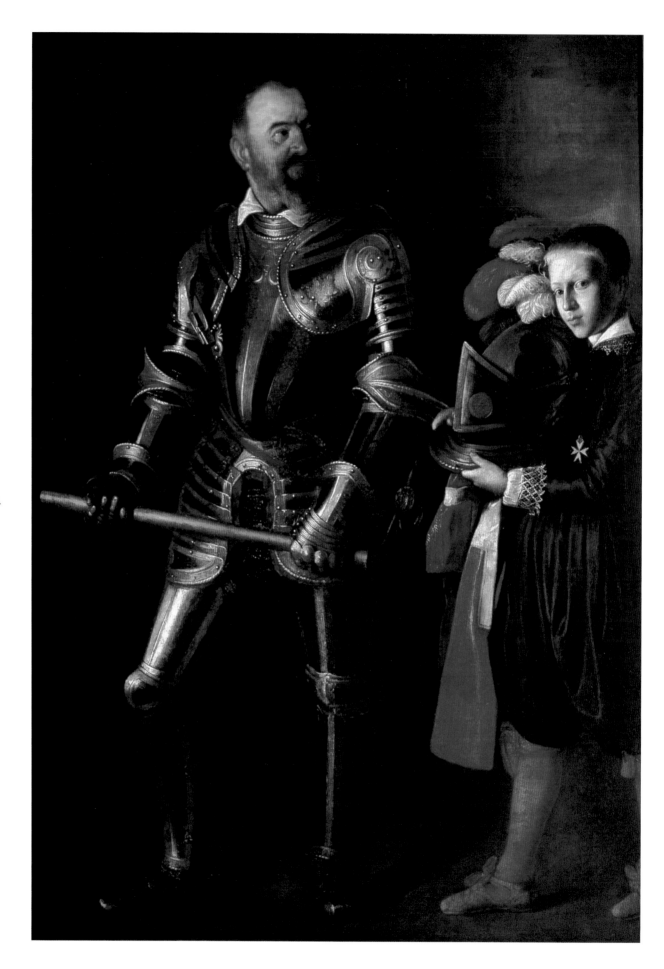

6. Michelangelo Merisi
da Caravaggio, *Portrait
of Grand Master Alof
de Wignacourt with a Page*.
Paris, Musée du Louvre

68

At his side, the enchanting young page holds the Grand Master's helmet and red-and-white surcoat while moving in the opposite direction to Wignacourt's glance. A wonderful intersection of axes is thereby created, knitting the two figures together more by action and gaze than by placement. Perhaps the best-preserved part of the picture, the page, one of twelve who served the Grand Master,[68] looks out at the viewer, making sure we recognise his good fortune in being favoured by this powerful prince.[69]

Bellori's description of a full-length portrait of Wignacourt, which he locates in the Armoury, does not mention the page, and is unlikely to be identical with the Louvre picture (which, it should be remembered, had already left the island and was seen in Paris by 1644). It corresponds instead to a *Portrait of Wignacourt in Armour* (fig. 8) formerly in the Armoury showing the Grand Master alone and *in piedi armato* (standing in armour).[70] This modest, anonymous work is now in the National Museum of Fine Arts, Valletta.[71]

Bellori's informant made yet another blunder, if we are right in thinking that his *seduto e disarmato* (seated without armour) portrait of the Grand Master is comparable to (or identical with) a *Portrait of Wignacourt* in the Collegio Wignacourt Museum, Rabat (fig. 9).[72] This stiff work, which follows a worn-out, late-Cinquecento formula used for earlier Grand Master portraits, carries two inscriptions, one stating Wignacourt's age as 70, and another indicating that the picture was made for Fra Louis Perrin du Bus in 1617.[73] Neither of these two portraits has even the slightest hint of Caravaggism. They are not copies of Caravaggios mentioned by Bellori that have gone missing; rather, they are almost certainly the very same works Bellori's informant mistakenly identified as paintings by Caravaggio.

On the basis of style and the age of the sitter, the National Museum portrait (fig. 8) can be plausibly dated to *c.*1612–15. It is particularly interesting in that it shows the Grand Master wearing an entirely different suit of armour than the one depicted by Caravaggio in the Louvre portrait. Both suits survive and are preserved in the Armoury in Valletta.

Unlike the heavy, old-fashioned harness of *c.*1565–80 painted by Caravaggio (fig. 10),[74] the armour shown in the National Museum portrait (fig. 11), also of Milanese manufacture, is light and extremely ornate; it is obviously from the early Baroque period. This work, among the great pieces of Italian armour of the early Seicento, is traditionally dated to 1610–20.[75] The presumption has always been that Caravaggio never had the opportunity to paint the second harness, since its date of manufacture was subsequent to the artist's flight from Malta.[76]

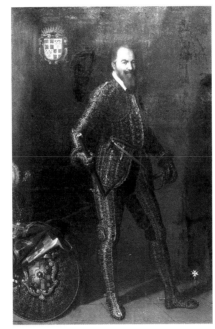

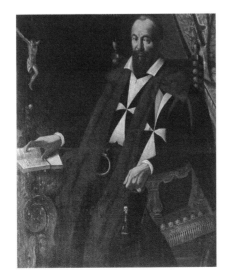

7. Anonymous, *Portrait of Wignacourt.* Malta, Verdala Palace

8. Anonymous, *Portrait of Wignacourt standing in armour.* Valletta, National Museum of Fine Arts

9. Anonymous, *Portrait of Wignacourt seated without armour*, 1617. Rabat, Museum of the Collegiate Church of St Paul, Collegio Wignacourt

When the two suits are seen side by side in the Armoury, it is immediately noticeable that the earlier armour, depicted by Caravaggio, would never have fit the Grand Master, who was a shorter, thinner man. Moreover, unlike the more modern harness, which is covered with Wignacourt's coat of arms, the earlier suit has no marks or inscriptions that would link it to Caravaggio's patron. In all likelihood, then, the earlier suit was simply used by Caravaggio as a studio prop, which would help explain why there is a slight awkwardness in the handling of the relationship in the portrait between the head and the armour.[77]

The discovery of a series of documents forces a redating of Wignacourt's personal armour and throws new light on the Grand Master as a patron, one concerned with how he would appear in public and with the quality of objects associated with his person. On 19 February 1601, a mere nine days after his election, Wignacourt sat down with his secretary to pen one of the very first letters of his magistry. This missive, and the score of related dispatches that followed until the armour finally arrived on 12 August 1602, show an impatient Wignacourt obsessed with this full (and no doubt extremely expensive) suit of armour he ordered from Milan.[78] This rare letter, and the several others that followed it, despite referring to a suit Caravaggio did not paint, provide invaluable insights into how Wignacourt would have instructed the artist when the portrait now in the Louvre was first contemplated. At the same time, the letters also complicate matters, since they demonstrate – contrary to generally held opinion – that the more modern armour was made in 1601 and not ten or twenty years later.[79] Consequently, it was in Wignacourt's possession long before, rather than long after, Caravaggio made this stunning effigy of his patron.

It is a mystery why Wignacourt and Caravaggio decided that the old-fashioned armour, which had belonged to another knight, would serve them better than the flashy (*vistosa*) new suit Wignacourt had worried about for eighteen months and which carried his coat of arms. A proper, if still speculative, answer goes beyond the scope of this general essay.[80]

Caravaggio was an accomplished portraitist (since his earliest days in Milan, according to Bellori). And it is not surprising to learn that he painted Wignacourt a second time in what was probably a bust-length image in an oval format (*in aovato*), which the Florentine knight Francesco dell'Antella took back to Florence. The picture, not mentioned by Bellori and now lost, is specifically listed as a Caravaggio in an early and highly reliable description of 1622 of the Priory church of San Jacopo in Campo Corbolini,[81] a *commenda* given to Fra Francesco on 27 April 1611. Francesco left Malta in July of that

same year, soon after he murdered the Grand Master's nephew (in self-defence).[82] He probably took the portrait home with him at this time. Two years before the incident, dell'Antella, a member of the Accademia del Disegno in Florence and a learned man,[83] sent home a little jewel of a painting (his *gioia*, as his fellow Florentine knight Francesco Buonarotti put it in a 1609 letter to his brother Michelangelo Buonarotti the Younger).[84] The work is Caravaggio's *Sleeping Cupid* now in the Pitti Palace (cat. no. 8), the only mythological painting Caravaggio is known to have created on the island and perhaps his last essay in this genre.[85] We know from dell'Antella's letter of 24 April 1610 to Michelangelo the Younger that the latter, a famous poet and playwright, enjoyed this witty painting,[86] which was no doubt inspired by his great uncle's long-lost marble of this subject. Legend has it that Michelangelo's statue was deceptively sold in Rome as a true antique. Michelangelo da Caravaggio's excessively naturalistic counterfeit of an ugly baby in a sexy, pseudo-antique pose was no doubt meant as a clever challenge to Michelangelo's ultra-classicising original.[87] Something of the old satirical Caravaggio – painter of the Berlin *Amore Vincitore* and a self-styled 'Michelangelo moderno' – suddenly reappears in Malta to make a final curtain call.[88] But, of course, this was a painting that he must have known was destined for dell'Antella's palace in Piazza Santa Croce in Florence, not public display in Malta, where Caravaggio seems to have presented himself as nothing less than the most polite and pious of court artists.[89] Portraiture and Florentine patronage are not unique to dell'Antella's involvement with Caravaggio. Another senior Florentine knight, Fra Antonio Martelli, Prior of Messina, is the likely subject of a beautiful portrait, also in the Pitti (cat. no. 9).[90] Like the *Sleeping Cupid*, this work is not mentioned by the biographers. Assuming Martelli is the subject, the 74-year-old *cavaliere* appears as a weary but nonetheless resolute old warrior – the kind of man who made the Order function even during times of diplomatic and military upheaval. If the Louvre *Wignacourt* is likely Caravaggio's first work on the island, the *Portrait of Martelli* is probably one of his last (though the *Sleeping Cupid* is also clearly a very late Maltese picture). The monochromatic character of this canvas and its loose, unfinished-looking brushstrokes,[91] which barely cover the reddish ground, anticipate more than any of the other works associated with the Malta period a new chapter in Caravaggio's development. Here we see the kind of abstraction – where the brushstrokes are beginning to detach themselves from descriptive functions – that is the hallmark of pictures done in Sicily and the second Naples period. A comparison with the heads of the older male figures in the *Burial of Saint Lucy*

10. Milanese armourer of the late Cinquecento, *Armour*, c.1565–80. Valletta, National Armoury

11. Milanese armourer of the early Seicento, *Armour belonging to Alof de Wignacourt*, 1601–2. Valletta, National Armoury

on the following pages
12. Michelangelo Merisi da Caravaggio, *Beheading of Saint John the Baptist*, detail

(cat. no. 10) is instructive in this regard. One cannot help but think that Caravaggio observed Martelli on many occasions before painting this picture,[92] which has a compelling combination of movement and *gravitas*. One further work of private patronage is recorded for Caravaggio in Malta. Probably painted around the middle of his visit, the *Saint Jerome Writing* (cat. no. 7), as mentioned earlier, was described by Bellori as hanging above the passageway in the Chapel of the Italian Langue. The picture is now in the Oratory. Bellori was also told that a *Magdalen* situated above the other doorway was by Caravaggio. It is almost certain that this second work is identical with a competent late sixteenth-century copy after Correggio still in the chapel, a canvas Caravaggio did not execute. The confusion of Bellori's informant was no doubt fostered by the fact that in addition to their similarity in size and symmetrical hanging, both works carry the arms of Fra Ippolito Malaspina, Prior of Naples. The treatment of perspective in the *Saint Jerome*, which works best when hung at eye level (as it currently is), speaks against the commonly held notion that the picture was made for the Chapel of Italy, where, until several years before the picture's recent theft (and recovery), it had hung for centuries, from as early as 1629, perhaps even before.[93]

Caravaggio's Saint Jerome, a miracle of wrinkles, grey hair and loose skin that would have pleased the young Rembrandt, seems to be speaking the words as he writes them. Employing a much bolder *contrapposto* than he had in the *Portrait of Wignacourt*, Caravaggio ingeniously draws our attention to the writing hand – the divinely inspired instrument – by covering up the left forearm with red drapery. The verticals and horizontals created by the table and the wooden post (or door) provide a rigorous structure seldom seen in Caravaggio's earlier works. Such classical restraint would be put to good use in another picture he began for the knights around this time. Arguably the masterpiece of his career and one of the most gripping images in all of Baroque art, the *Beheading of Saint John the Baptist* (figs. 12–13) is Caravaggio's largest painting[94] and the only extant work by him that bears his signature.[95] The letters 'f. MichelAn . . .' are formed out of the blood spewing from the freshly cut neck of the Baptist (fig. 4).

Painted as the altarpiece for the Oratory of San Giovanni Decollato, the recently restored picture[96] was probably started soon after March 1608, that is, after Caravaggio learned that the Pope had sent a waiver to make him a knight. It has been suggested that the work was given to the Order in lieu of a proper *passaggio*, the gift – usually money – knights presented to the Religione upon being admitted as a member.[97] Because the signature, 'f[ra]

Michelan[gelo]', makes reference to Caravaggio's new status as a knight (his installation was on 14 July 1608), the canvas must have been completed after that date. It is likely that it was unveiled on 29 August, the feast of St John's Decollation, the Oratory's titular.[98]

The function of the Oratory and its architectural, pictorial and sculptural development over the course of the seventeenth century have been the focus of two recent studies, so only brief mention needs be made here.[99] Before Mattia Preti (another Italian artist who became a Knight of Malta) turned the hall into a Baroque spectacle in the 1680s, the room was quite simple, giving much greater force and resonance to the taut design of Caravaggio's painting, which would have dominated the space much more than it presently does.

An engraving of 1650 representing the knights' tribunal or Squardio, which met in the Oratory, gives a general idea of what the hall looked like before Preti's intervention (fig. 5).[100] Built in 1602–5 over the cemetery where knights, including those martyred by the Turks, were interred, the Oratory owes its origins to a petition from several knights who wanted to move their Confraternity of the Misericordia to St John's. This organisation, like its more famous counterpart of San Giovanni Decollato in Rome, accompanied prisoners to the gallows. Caravaggio was no doubt familiar with the traditions of this Roman brotherhood and the imposing paintings of the *Beheading* by Giorgio Vasari and Roviale Spagnuolo (attrib.) in its church and oratory respectively. In addition to hosting elections, installation ceremonies, tribunals, and defrockings, the Knights' Oratory was also used for the training and devotions of the novices, who had their own special commissioners and theologian. Although the Oratory, the showplace of his defrocking, has come to symbolise Caravaggio's defeat – his difficulty in controlling his violent temper – the *Beheading* by contrast stands as a memorial to how brilliantly he controlled violence in his art. Nowhere has an artist better balanced extremes of emotion and savagery with order and stillness. Discipline of a classical nature is everywhere apparent in the *Beheading*, whose setting is an austere prison courtyard, unyielding in its geometry, cold and unfeeling in its stony surfaces.[101] Nicely described by Bellori,[102] who noted that the artist had put everything he had into this work (*usò ogni potere del suo pennello*),[103] Caravaggio's *Beheading* is a theatre of voids, displacements, and arrested actions. It is easy to kill a man, but the world remains permanently askew as a result.

The drama takes place wholly on the left side of the composition, where a human arch of four figures, mocked by the titanic architecture behind it, presides

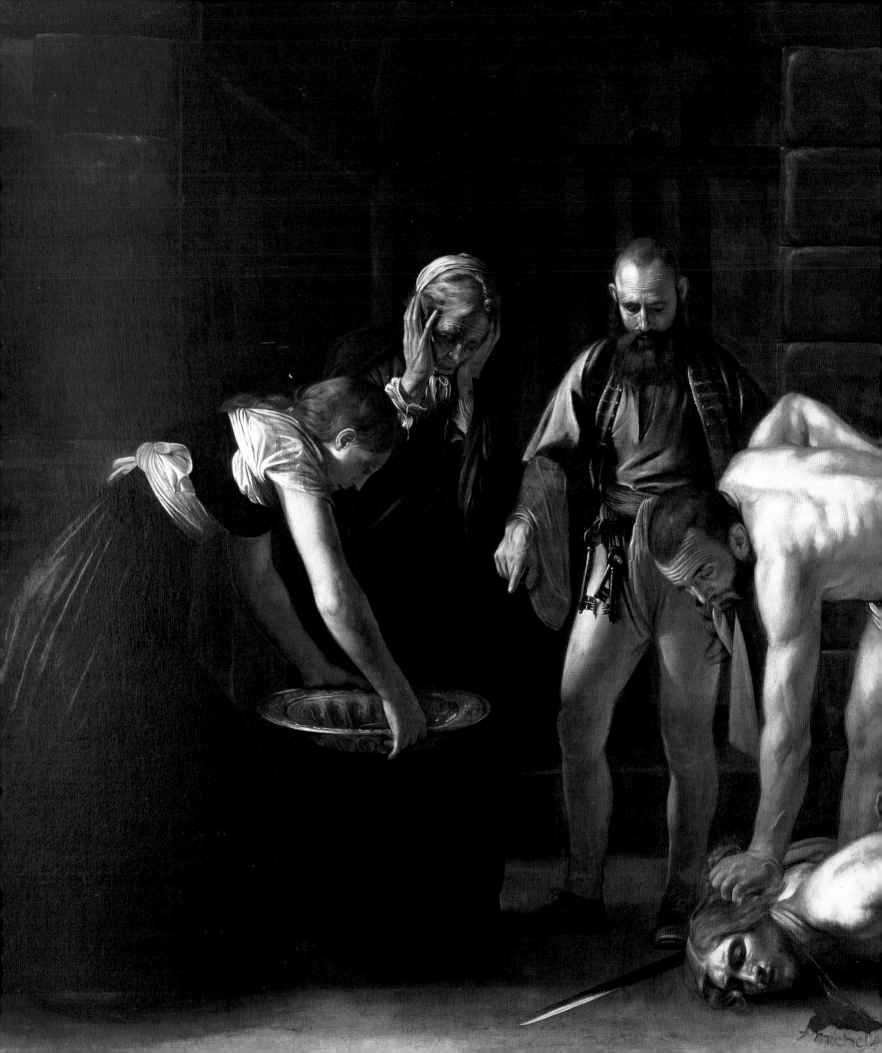

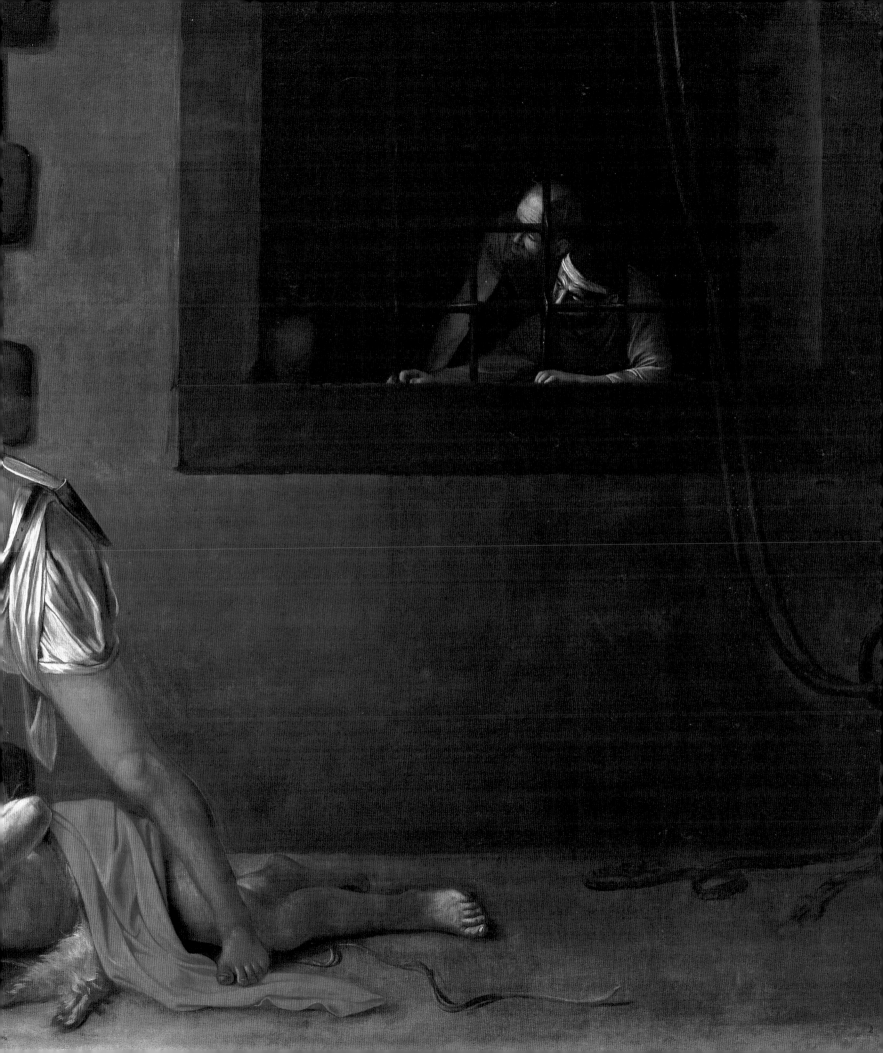

over the slaughter of John, the Holy Precursor, who is placed flat on the floor like a sacrificial lamb. Caravaggio situates the woolly hooves of John's garment strategically near the saint's head to reinforce this idea of the Baptist's martyrdom paving the way for Christ's own sacrifice on the cross.[104] The executioner, whom Herod has appointed to cut off the Baptist's head, is terrifying in the way he stands astride his prey, grasping John's hair so that he can gain better access to the neck.

composition is so utterly static that we know the knife will never fully emerge from its sheath. Time and action are forever frozen in this picture whose starkness and simplicity recall the great murals of Giotto and Masaccio. The girl, whose common clothes and apron define her as a servant rather than Salome (Bellori calls her Herodias),[107] stands ready with her golden basin to receive the human trophy, the product of a rash oath taken by Herod. But her timing is not synchronised with

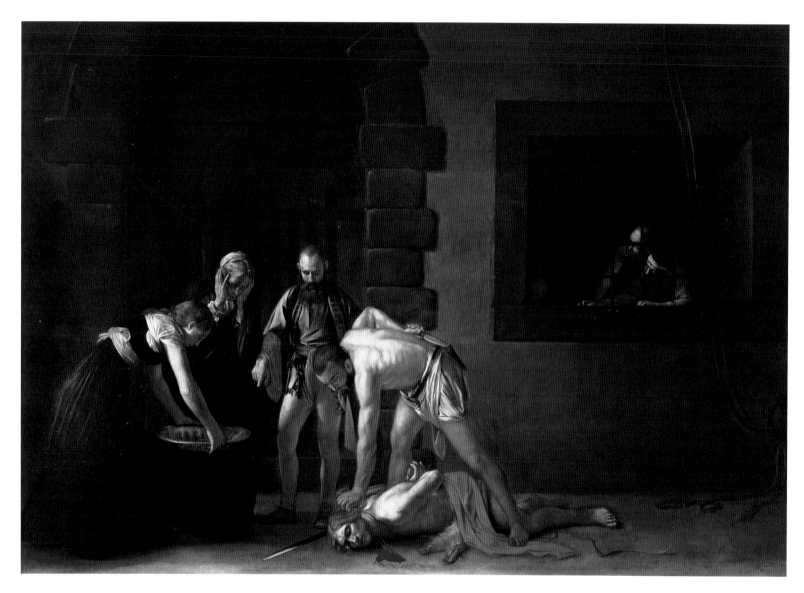

He steps on a strip of John's blood-red drapery, a seemingly arbitrary act that reinforces the realism of the scene. The brute has already killed John with his sword, but now reaches back for a small knife, the *misericordia*,[105] to cleave the head from the body. Dressed in a dark turquoise (not Turkish)[106] jacket and weighed down by a set of huge keys, the jailer points impassively to the basin as if to hurry the executioner along. Yet the narrative remains frustratingly incomplete: Caravaggio's

the movements of the executioner; indeed, her arms seem to grow longer as she, like the audience to Caravaggio's drama, must remain patient.
The huge rectangle framing the low prison window[108] challenges the quoined arch at left for prominence. Two forlorn prisoners watch with quiet sadness. They have seen this scene from their front-row seats many times before. Perhaps they know this is a rehearsal for their own punishment.

Only one figure in this picture is demonstrably horrified by what she witnesses. The old woman, perhaps a companion to the girl or a prison nurse, uniquely displays the signs of compassion and grief such a scene should elicit. With her closed eyes and stopped ears, she reaffirms our inability to prevent this atrocity, to change the course of divinely ordered history. Her single gesture of humanity is nearly lost in the dead calm of the picture's cavernous spaces, which absorb all emotion, all action. She cannot hear that John's screams have ceased. In the interminable seconds dividing sword from knife, death and dismemberment, silence itself has been silenced.

Given the inclusion of the Fra in the signature, the date of Caravaggio's installation, and his imprisonment a month later, the *Beheading* was probably his final work in Malta. But a powerfully composed altarpiece of the *Annunciation,* formerly in Nancy's primatial church and now in that city's Musée des Beaux-Arts, may be a product of the last months of the Maltese period, as several scholars have suggested (see cat. no. 15).[109] As noted above, members of the Lorraine family were in Malta during Caravaggio's stay; they could have been patrons of the canvas, perhaps even the conduit for its transport to Nancy.[110]

The picture's poor state of conservation hampers stylistic analysis and the quest for a secure dating.[111] Damaged early on, the canvas has severe losses and abrasions, though the basic composition remains intact. The best-preserved passages are the shoulder and right arm of the angel and a few folds in the white drapery over the thigh. Only in the latter can one appreciate the range of whites, greys, and ash blacks that Caravaggio used to shape and model the forms. Despite damage, the underlying brushwork and design of the angel's drapery are breathtaking. The retouched face of the Madonna is closer to Jacques-Louis David than to Caravaggio and gives a false impression of what the Lombard painter intended.

There are solid points of comparison between the *Annunciation* and the securely attributed works of Caravaggio's Maltese sojourn. The treatment of the furniture recalls elements of the *Saint Jerome* – especially the chair, which has the raw classical geometry and rustic texture of the table and beam in the Malaspina canvas. The picture's overall design, taut yet graceful, emphasises the exact middle of the canvas through a horizontal axis created by the right leg of the angel, the head of the Virgin, and the mattress of the bed. It is but a more compact and slightly more flexible expression of the spartan aesthetic found in the *Beheading.* The steep diagonal that flows from upper left – across the horizontal – to lower right, electro-charged

along the way by the angel's gesture as it penetrates the void above Mary's head, conveys the meaning of the story all by itself.

The Nancy altarpiece, much like the *Beheading,* is given a nearly barren, stage-like space in the foreground. Nothing but Mary's sewing basket – the still-life equivalent of the Baptist's severed head in the Oratory canvas – establishes the picture plane and a sense of scale. The basket is treated with such psychological force that we would not be wrong to read it as a third character in this drama. It is no doubt meant to allude, proleptically, to the crib of the Christ Child at the Nativity.

The Virgin's mantle is coloured with a blue-green pigment rarely seen in Caravaggio's oeuvre. The best comparison is the costume of the jailor in the *Beheading.* The lower sweep of the angel's drapery, which falls forward of the knee, seems to echo the serving girl's apron in the larger work, which may have been painted just weeks before. It is the *disegno* of the girl's overly long arm and exposed elbow that seems most obviously reborn in the annunciate angel, whose head similarly is pushed up against the right shoulder.

If the *Annunciation* is a Malta picture, as its patronage and style seem to suggest, it joins the *Saint Jerome* and the *Beheading of Saint John* as testaments to the creative strides made by Caravaggio during his fifteen months on the island. It would also moot a frequently debated observation that Caravaggio made surprisingly few works during his relatively long service to the knights. This distinguished service (before a fatal error in judgement brought it to a sudden halt) did not go unnoticed by the person who had championed the artist and proclaimed him the Apelles of Malta. According to Bellori, in recompense for the *Beheading,* Grand Master Wignacourt put a rich gold chain around Caravaggio's neck and awarded him two slaves.[112] An engraving in Bellori's book (fig. 1) shows Caravaggio as a proud *cavaliere.*[113] He wears the black-and-white habit of the Order – clearly recognisable by the white eight-pointed cross embroidered across the breast – and holds a sword, a key attribute for a knight. Poking up from the folds of drapery over his chest, a second Maltese cross, this one probably made of gold, hangs from a chain (no doubt an allusion to Wignacourt's gift). Though Bellori obviously knew a fair amount about Caravaggio's misfortunes in Malta, the fact that he had him depicted in 1672 as a Knight of St John suggests that he may have been unaware that the artist had been defrocked in December 1608. Or perhaps Bellori was being charitable, in a biography quick to point out artistic and human shortcomings, in portraying Fra Michelangelo da Caravaggio in his moment of greatest achievement.[114] [d.m.s.]

13. Michelangelo Merisi da Caravaggio, *Beheading of Saint John the Baptist.* Valletta, St John's Co-Cathedral, Oratory of San Giovanni Decollato

The authors thank Nicola Spinosa, Dawson Carr and Keith Christiansen for their support. In Malta, thanks are due to John Azzopardi, Daniela Apap Bologna and to many other scholars, librarians and curators for their assistance.

From Naples to Valletta (Sciberras)

[1] For Caravaggio in Malta see: Farrugia Randon 1989, esp. Azzopardi 1989[1] and 1989[2], Cutajar 1989; Calvesi 1990; Macioce 1994; Gash 1997; Stone 1997[1]; Stone 1997[2]; Gregori and Bonsanti 1999; Langdon 1999; Pacelli 1999; Macioce 2001; Marini 2001; Sciberras 2002[1]; Sciberras 2002[2]. I thank David M. Stone for several useful suggestions in the preparation of this text.

[2] The Knighthood of Magistral Obedience was abolished during the 1603 a.i. [1604] Chapter General. Sciberras 2002[2], p. 16; *Le Ordinationi del Capitolo Generale celebrato nell'anno MDCIII*, Rome 1609, p. 23: De Receptione Fratrum, 10. Wignacourt himself had spoken about the numerous requests concerning this knighthood in his letter requesting a papal decree in favour of Caravaggio, and had explained how 'si fusse troppo allargata la mano massime in tempo dell'Illustrissimo Verdala, fu ne suddetto Capitolo Generale fatta l'Ordinatione e confermata dal nostro tenore dell'alligata copia, la quale per essere veramente utile, e necessaria, non habbiamo mai voluto, che si deroghi, ancor'che cene sieno state fatte molte instanze'. Letter dated 29 December 1607, in Macioce 1994, p. 207. There are similar references in the Apostolic Brief published in Azzopardi 1989[2], pp. 49–56.

[3] In order to invest Caravaggio, the Grand Master required two concessions from Paul V. He needed a concession in arming a person who had committed murder and a concession in arming a Knight of Magistral Obedience. See Sciberras 2002[2], pp. 16–17. An indication of this is the date when Wignacourt sent his first request for such concessions to the pope. This was in December 1607. Had there been prior agreement, Wignacourt would no doubt have commenced the entire mechanism much earlier. Instead he waited for more than five months before putting pen to paper.

[4] Sciberras 2002[2], p. 15.

[5] The son of Costanza Colonna (Marchesa di Caravaggio), Fra Fabrizio, Prior of Venice and General of the Order's Galleys, had great political power. He had lived a controversial life and had been sent in 'privileged exile' to Malta by papal order in 1602. See Calvesi 1990, pp. 131–4; Macioce 1999.

[6] Sciberras 2002[2], p. 14. *Gli Statuti della Sac. Religione di S.Giovanni Gierosolimitano*, Rome 1609, p. 251: De Triremibus, 83.

[7] The circle of Neapolitan personages who could have instilled in Caravaggio a desire for the Order of Malta should not be restricted to the Carafas and Colonnas but can be enlarged to a number of aristocratic families who had a close and intimate contact with the Order. Mention should be here made of families associated with the Pio Monte della Misericordia whom Caravaggio knew, such as the Sersale, d'Alessandro and Piscicello. Another important family was that of the Capeci, who had a long-standing tradition of being the Order's Receivers in Naples, and they counted numerous knights. See Sciberras 2002[2], pp. 14–15.

[8] '... non mancherete d'assistere per essere egli nuovo in cotesto Paese, come per assicurarvi, che ci farete piacere acuttisimo ad aiutarlo, e consigliarlo in tutto quello, che gli potesse occorrere, particolarmente per fargli godere buon' passaggio fino a Messina ...', in Stone 1997[2], p. 170.

[9] '... vantaggio che mostrano i nimici con più numero di vasselli che quelli della Religione come anco per presupporre che le Galere sieno assai imbarazzati, et con il remorchio', in Sciberras 2002[2], pp. 15–16.

[10] The date of the galleys' return to Malta is not precisely documented but it would have been in those days. Sforza Colonna's galleys would have entered the Grand Harbour amid fanfare and celebrations. They had been long awaited and were laden with provisions.

[11] He was the patron of Caravaggio's Pitti *Sleeping Cupid*. See Sebregondi Fiorentini 1982; Stone 1997[2]. See below and cat. no. 8.

[12] He was the patron of the *Saint Jerome* (Oratory of S. Giovanni Decollato, Valletta). See below and cat. no. 7.

[13] Gash 1977. The Florentine Antonio Martelli, Prior of Messina, was another elderly heavyweight and very close to the Grand Master. For Martelli, see below and the entry on the Pitti *Portrait of a Knight* (cat. no. 9).

[14] Macioce 1994, p. 225.

[15] He has been identified by Calvesi 1990, p. 375, and Macioce 1994, pp. 208–12, as the second prospective knight nominated in Paul V's Brief granted in favour of Caravaggio and another person. The present writers believe that the assumption does not hold ground and is, almost, impossible for two reasons: 1) documents show that Charles of Lorraine was invested, as Knight of Justice, within the Langue of France; 2) he had also initially requested to be promoted to the dignity of a Grand Cross. Charles remained in Malta until mid-1610. AOM, Arch. 457, Liber Bullarum 1610–12, f. 36r. For a proposal for the identity of the 'seconda persona', see Sciberras, article to appear in *The Burlington Magazine* (January 2005).

[16] Calvesi 1990, p. 375; Macioce 1994, p. 220. AOM, Arch 102, Liber Conciliorum, f. 122v.

[17] Macioce 1994; Marini 2001, pp. 557–8.

[18] Sforza Colonna had his own residence as documented through a hitherto unpublished notarial document (Notarial Archives Valletta, R.309 Not. Lorenzo Grima V.10 (1605–6), ff.175v–180r); Marc'Aurelio Giustiniani, cousin of Marchese Vincenzo Giustiniani and of Cardinal Benedetto, was also on the island. See Macioce 1994, p. 217.

[19] The documents for this case were discovered by Azzopardi. For a full transcription see Azzopardi 1978, pp. 16–20; Azzopardi 1989[1], pp. 25–31.

[20] See below.

[21] Some twelve years earlier Grand Master Martino Garzes had done the same with the Florentine painter Filippo Paladini, who was a convicted criminal and who had arrived in Malta as a galley slave. See Sciberras and Stone 2001.

[22] '... una persona virtuosissima e di honoratissime qualità, e costumi e che tenghiamo per servitore nostro particolare', in Macioce 1994, pp. 207–8.

[23] Macioce 1994, p. 208.

[24] Azzopardi 1989[2], pp. 45–56.

25 Azzopardi 1989², p. 56.
26 For the documents see Azzopardi 1989¹, pp. 32–3.
27 Valletta itself, named after the hero of the Great Siege, was still something of a building site, but it had largely taken shape and many of the residences and small palaces were completed. It was a small place, but extraordinarily cosmopolitan and fascinating. In it, the sons of the great nobility of Europe lived as 'brothers' in a chivalric embrace of different languages. This embrace was, nonetheless, marked by nationalism and political rivalry. Valletta was also a violent city, full of young nobles from various Langues, arrogant and difficult to contain. Duels and violence were the order of the day. 'È impossibile', wrote Wignacourt to the pope, 'che in un luogo dove si fa tanta professione d'arme, e si sta tanto in sul'punto dell'honore come qui non manchino delle volte, anzi spesso, delle risse' (see Sciberras 2002², p. 5). For a man of such a tumultuous nature as Caravaggio, Malta was thus a dangerous place.
28 Sciberras 2002¹, p. 229.
29 Sciberras 2002¹, p. 229.
30 The fact that Caravaggio was detained indicates that his participation in the brawl was serious enough to be subject to a privatio habitus case, and that he thus risked expulsion from the Order. If it was not so, Caravaggio would have been allowed to roam free in Malta while awaiting the criminal proceedings and trial.
31 Sciberras 2002¹, p. 231. It is probable, however, that instead of participating in the colourful pageantry associated with the celebration of the feast, Caravaggio was facing imminent arrest (if not already under arrest). Meanwhile, on 9 September, for the first

time, a privatio habitus ceremony was held in the Oratory of the Decollato, in front of Caravaggio's painting. The knight in question was being deprived of his habit because he had escaped from Malta without the Grand Master's permission. Caravaggio probably heard of this, and thought that the same could happen to him. AOM, Arch. 210, Decreta Concilio, p. 351.
32 Azzopardi 1989¹, p. 36.
33 The flight of a knight from Malta – or even unauthorised leave from the island – was a forbidden act, contravening Statute 13 of the chapter Prohibitions and Penalties. In these circumstances, the Venerable Council had to be immediately informed and a Criminal Commission was then nominated to investigate the events. This, as is well known, is what happened in Caravaggio's case on 6 October.
34 Azzopardi 1989², pp. 38–9.
35 Sciberras 2002¹, p. 229.
36 See Sciberras 2002², p. 7.
37 Sciberras 2002², pp. 7–8.
38 Sciberras 2002², pp. 8–10.
39 It is significant how, in these circumstances, Wignacourt usually asked his Receivers to capture fugitives with the greatest secrecy. This procedure was also noted in the Statute 12 of Prohibitions and Penalties which exhorted all knights to capture and detain in the prisons of their priories those knights who were wandering in that land without specific authorisation (i.e. fugitives). Even more specific are the Statutes referring to the manner of celebrating the privatio habitus in absentia which refer to particular occasions when the fugitive 'could not be apprehended'. This statutory reference specifically implies that attempts should have been made to apprehend the

fugitive. See Sciberras 2002², pp. 8–10.
40 'Ma la disgrazia di Michele non l'abbandonava, e 'l timore lo scacciava di luogo in luogo'. See Hibbard 1983, p. 370.
41 Sciberras 2002², pp. 10–14.
42 See below and the entry on Martelli (cat. no. 9).
43 The fact that, after his expulsion from the Order, he seems to have lived with relative tranquillity at Messina, indicates that probably there was not a civil case pending against him in Malta. Thus, after the privatio habitus, his juridical case could have been considered concluded. The victim, Fra Giovanni Rodomonte Roero, had left the island. AOM, Arch. 456, Liber Bullarum, f. 156r.
44 Azzopardi 1989¹, p. 36.
45 De Ponte was later identified as the ringleader; he was armed at night and carried a pistol. De Ponte was also identified as the person who inflicted serious wounds on Fra Giovanni Rodomonte Roero. Because of the gravity of his actions, de Ponte was deprived of his habit, alongside Caravaggio, on 1 December 1608, following the trial held on 27 November. In the same trial, two novices, the Noble Giovanni Pecci and the Noble Francesco Benzo were condemned to four and two years imprisonment respectively, while the knights Fra Giulio Accarigi and Fra Giovanni Battista Scaravello were each sentenced to six months imprisonment for their involvement in the brawl. Sciberras 2002¹, pp. 230–1.
46 See Azzopardi 1989¹, pp. 38–9. See also Sammut 1978.

Bonsanti 1999; Langdon 1999; Spike 2001; Marini 2001; and many other studies. For the bibliography, see Cinotti 1983; for more recent publications, see Spike 2001 (CD-Rom). I thank Keith Sciberras for several useful suggestions and for his hospitality in Malta.
48 For the earlier history of painting in Malta, see Buhagiar 1987; and Gash 1993. For Paladini, see most recently Stone 1997²; and Sciberras and Stone 2001.
49 For the palace see Ganado 2001. For the church see Scicluna 1955; and Cutajar 1999.
50 G. Mancini (ms. of c.1617–21) simply says that he made 'alcune opere con gusto del Gran Maestro' (Hibbard 1983, p. 348). G. Baglione, Vite de' pittori, Rome 1642, is not much more helpful, naming only the portrait of Wignacourt: 'Poscia andossene a Malta, & introdotto a far riverenza al gran Maestro, fecegli il ritratto; onde quel Principe in segno di merito, dell'habito di s. Giovanni il regalò, e creallo Cavaliere di gratia' (Hibbard 1983, p. 355). F. Scannelli (Il Microcosmo della pittura, Cesena 1657) does not mention the Malta episode. G.P. Bellori (1672), who wrote the most detailed life of Caravaggio, is discussed below. L. Scaramuccia (Le finezze de' pennelli italiani, Pavia 1674) refers only to Caravaggio's 'passaggio à Malta' (Hibbard 1983, p. 374). J. von Sandrart, in his Academie der Bau-, Bild-, und Mahlery-Künste von 1675 (Nuremberg 1675), states that 'he painted the Beheading of St. John the Baptist in the church at Malta, which is marvelous because of its truth to nature, as well as some other paintings' (trans. Hibbard 1983, p. 379). On Sandrart's

visit to Malta, see Freller 2002. F. Susinno, Vite de' pittori messinesi (ms. dated 1724), repeats only some of Bellori's list: the Beheading and the two portraits of the Grand Master, one 'in pie' armato' and the other 'vestito in abito signorile di pompa' (see Hibbard 1983, pp. 380–1).
51 See Sebregondi Fiorentini 1982; and Stone 1997². See below.
52 See Balsamo 1996; and Stone 1997¹, p. 164, n. 22.
53 'Era il Caravaggio desideroso di ricevere la croce di Malta, solita darsi per grazia ad uomini riguardevoli per merito e per virtù; fece però risoluzione di trasferirsi in quell'isola, dove giunto fu introdotto avanti il Gran Maestro Vignacourt, signore francese. Lo ritrasse in piedi armato ed a sedere disarmato nell'abito di Gran Maestro, conservandosi il primo ritratto nell'armeria di Malta' (Bellori, in Hibbard 1983, p. 368).
54 'Per la Chiesa medesima di San Giovanni, entro la cappella della nazione Italiana dipinse due mezze figure sopra due porte' (Hibbard 1983, p. 369).
55 'Fece un altro San Girolamo con un teschio nella meditazione della morte, il quale tuttavia resta nel palazzo' (Hibbard 1983, p. 369).
56 A Caravaggesque Saint Jerome in the Grand Master's palace in Valletta, attributed to Van Somer, is a prime candidate for being Bellori's second painting. See our forthcoming article in Paragone on Caravaggio's Saint Jerome Writing.
57 Hibbard 1983, pp. 235, 327, is incorrect in stating that the biographer travelled to the island. Cinotti 1983, p. 487, notes that Bellori was in Naples in 1661.
58 See our entry on the Saint Jerome (cat. no. 7) for the problem of assigning a date

Caravaggio's Paintings for the 'Sacra Religione' (Stone)

47 This essay is much indebted to overviews of the period in Hibbard 1983; Cutajar 1989; Gash 1993; Puglisi 1998; Gregori and

for Bellori's contact with his Malta correspondent (probably after 1661).

59 Hibbard 1983, p. 355. Bellori repeats the same information in relation to the two portraits he describes: 'Laonde questo signore gli donò in premio la croce' (Hibbard 1983, p. 368).

60 The 195 x 134 cm canvas, already in poor condition in the eighteenth century, is quite compromised and in need of restoration. For this reason it could not be loaned to the exhibition. The painting's condition, and the fact that, as an official portrait, this is an uncharacteristic subject for the master, have no doubt weighed in the deliberations of those scholars who question the attribution. However, today, nearly all experts assign the work to Caravaggio. (For those few who continue to raise doubts, it should be borne in mind that no painter exhibiting this quality of invention and execution – other than Caravaggio – is known to have been resident in Malta during the period when, judging from Wignacourt's age in the picture, this work was completed.) The present author has recently completed a broad study of this portrait, with special attention to the culture and politics of the pages of the Order. See Stone, 'The Apelles of Malta: Caravaggio and his Grand Master', forthcoming.

61 For the Conte de Liancourt as a collector, see Schnapper 1994, pp. 159–64. He owned such masterpieces as the *Diana as Huntress* by Orazio Gentileschi, now in Nantes.

62 For provenance and bibliography, see Cinotti 1983, pp. 487–9.

63 Inv. 5815. 195 x 134.5 cm. The Verdala picture shows the Grand Master without the page and with his arms in

a different position with respect to the Louvre canvas. The picture is cited by Marini 2001, p. 539, as being in Santa Maria della Vittoria in Valletta. However, some years ago it was transferred.

64 Born in Picardy in 1547, he took the habit on 25 August 1566. See Galea 2002.

65 For various engraved portraits of Wignacourt, see Gregori 1974.

66 Caravaggio's idea of having the Grand Master looking over his left shoulder was probably sparked, as has been noted many times, by the fact he had a large mole on the left side of his nose.

67 While the left hand holds the baton with the palm down and would seem to be the hand to actually use the weapon, the right hand is held palm up so the baton can be quickly released. Gregori, in *Age of Caravaggio* 1985, p. 330, notes the unusualness of this gesture: 'This detail underscores Caravaggio's independence toward traditional iconographic conventions and probably accounts for the presence of pentimenti in this part of the picture'. The pilgrim in the *Seven Works* holds his staff in a similar gesture, as C. Puglisi recently suggested to me.

68 The maximum number used to be eight, but in the Chapter General of 1603 a.i. [1604], it was raised to twelve.

69 It has been suggested by several scholars that the young boy is Alessandro Costa, Ottavio Costa's son. See Spike 2001, p. 206, and notes 682–3, with previous bibliography. For Costa's nomination as a page, see Macioce 1994, p. 227. In 1608, he would have been eleven years old. The identification of the page as Costa is a possibility, but is undocumented. There are eleven other contenders for the sitter.

70 Inv. 199. 232 x 152 cm. Restored in 1987–8.

71 The picture has been attributed to Leonello Spada as well as to Cassarino, though without consensus. A slightly varied copy, of lesser quality, still hangs in the Ambassadors' room in the palace. There are numerous other replicas and variants of the picture, which was obviously Wignacourt's official portrait in Malta.

72 136 x 113 cm.; Azzopardi 1990, cat. no. 1, ill. on p. 265 (entry by A. Espinosa). In the same Collegio is another portrait of Wignacourt 'seduto e disarmato', probably painted around the same time (200 x 135 cm; cat. no. 58; ill. on p. 404; entry by Espinosa on p. 405; inscribed with the Grand Master's death date of 1622).

73 A third inscription on the canvas, the famous G.N.F.D.C. monogram, awaits further study. The *Ruolo Generale* (1886) at NLM gives the date of admission of Fra Louis Le Parain, known as de Bus, as 25 December 1602.

74 Laking 1903, no. 139, pl. XI (as School of Lucio Picinino, Milan, c.1580).

75 Laking 1903, no. 413, pl. XXV (as Milanese, probably by Geronimo Spacini, c.1610–20). I thank Donald J. LaRocca and Stuart W. Pyhrr of the Department of European Arms and Armor, Metropolitan Museum of Art, New York, for discussing these two pieces of armour with me. Further technical details are examined in Stone, 'Apelles' (forthcoming).

76 The earliest study of the Louvre painting, by Maindron 1908, is mostly concerned with the two suits of armour discussed here. More recently, Rossi 2000, pp. 84–5, suggested that the second suit of armour was a gift from the pope to Wignacourt, and that this

gift did not arrive until 1608, after Caravaggio had been forced to use the old-fashioned suit of armour as a substitute. However, as new documents show (see below), the situation was quite different. No documents substantiate the idea that the pope sent Wignacourt a suit of armour in 1608.

77 It is doubtful that Caravaggio cajoled the Grand Master into modelling this armour for him – and, as just mentioned, it probably did not fit. Typical studio practice would begin with a simple sitting in which the painter worked out the position and form of the head and the basic pose of the body. Only later would the tedious rendering of the armour – perhaps modelled by an assistant – be done. Caravaggio's 'del naturale' methods perhaps got the better of him here, because the proportions he so faithfully rendered in each of the two elements do not quite go together.

78 'Quartieri [in Milan], 19 February [1601]: Being aware of the great care and diligence with which you served this Religion in the time of our Predecessors and of the experience you have in Milan, where they make beautiful and excellent armour, we decided to take advantage of your services, and thus we commission you to have a suit of armour manufactured for our person, using the measurements that will be sent to you from Genoa by our Procurator Torreglia. We wish to be armed from head to foot, and the armour should not only be of fine and perfect temper, but of showy and beautiful craftsmanship, and with all those gold embellishments that can properly be fit on it. Similarly, provide us with a weapon, such that on those

occasions when one has to rush out at night in armour, we could carry the weapon in our hand. Not only must the weapon be light, noble, and strong, but if necessary it should injure. And thus, select an invention that has all the above qualities in order that it be worthy of being seen in the hands . . .'. Translation author. AOM, Arch. 1380 (1601), f. 50v. See also the Italian edition of this essay (Naples 2004, p. 78, n. 78), for a transcription of the original text. For the armour's arrival, see Wignacourt's letter in AOM, Arch. 1381 (1602), ff. 204r–v. The present author discovered these documents and presented them in public lectures at Columbia University and Emory University in 1999. For a more complete treatment, with full transcriptions, see Stone, 'Apelles' (forthcoming).

79 For an excellent discussion of the armour and the development of the Malta Armoury, see Spiteri 2003, pp. 229–38, who recently also found the documents.

80 No doubt the idea of alluding to the Battle of Lepanto (or even to the 1565 Siege) through a veteran's suit was part of the scheme (Calvesi 1990, pp. 364–5). However, I suspect stylistic issues raised by Caravaggio were also a major factor. It is hard to imagine Caravaggio painting such frilly armour. It would have taken all the drama and sobriety away from this classic portrait, which was greatly admired by Ingres. See also Puglisi 1998, p. 293, for Venetian and Lombard sources for the work.

81 See Sebregondi Fiorentini 1982, pp. 108, 117, and notes 15–16.

82 Stone 1997², pp. 171–2, with docs.

83 He is the designer of the

78

magnificent bird's-eye view of Valletta illustrated in this essay (fig. 2). For dell'Antella as a map-maker, see Ganado 2003, pp. 330–42.

84 Sebregondi Fiorentini 1982, p. 122.

85 71 x 105 cm. The picture has an old inscription on the reverse: 'Opera del Sr. Michelangelo Maresi da Caravaggio in Malta 1608'.

86 See Stone 1997², pp. 167–8.

87 For further interpretations, see also Posèq 1987; Cropper 1991, pp. 199–201; and Puglisi 1998, pp. 294–7.

88 On Caravaggio's satirical character, see Stone 2002.

89 For further discussion of the Sleeping Cupid and dell'Antella, see cat. no. 8.

90 118.5 x 95 cm. See Chiarini 1989; and Gash 1997.

91 Marini 2001, p. 318, seems to think it is 'parzialmente non finito', an idea I do not share. I think the picture is finished, in a style that anticipates the great Sicilian works.

92 For further discussion, including the problem of the sitter's identity, see cat. no. 9.

93 See also cat. no. 7.

94 The picture, which is best seen from the end of the hall, where its figures seem literally to inhabit the space above the altar, measures 3.61 x 5.20 metres.

95 Though I think it is likely that the sword in the Borghese David (cat. no. 16) bears Caravaggio's initials (a conceit imitated, I now realise, by Orazio Gentileschi in his Executioner with the Head of John the Baptist, Madrid, Prado, c.1612–13). See Stone 2002, p. 33 and n. 66.

96 See Gregori and Bonsanti 1999 for a technical report.

97 See Cutajar 1989.

98 It must have been completed before 27 August, the date Caravaggio was named as an accomplice in the tumulto. See Sciberras, above.

99 See Stone 1997¹; and Sciberras 1999. I would, however, like to make one correction. I later found that there was, in fact, a large passageway connecting the church to the Oratory, as AOM, Arch. 105 (Lib. Conc. 1613–16), f. 42v, makes clear: [4 March 1614 new style; 1613 ab incarnat.], 'Die eadem. Monsignor Illustrissimo et il Venerando Consiglio hanno concesso che il molto Reverendo Signor Prior della Chiesa fra Pietro Urrea Camarasa possi erigere un'Altare ad honor di San Carlo Borromeo nella Capella della Chiesa posta avanti l'intrata grande dell'Oratorio di San Giovanni Decollato'.

100 See Stone 1997¹, who also discusses the lunette painting shown in the print. The actual lunette still exists in Rabat, where it was identified by Mons. J. Azzopardi. The painting, which I attribute to Bartolomeo Garagona, was probably inserted above the Beheading in c.1620–30.

101 For the suggestion that the architectural setting is inspired by a print from the knights' statute book illustrating the punishment for capital crimes, see Stone 1997¹.

102 '. . . e per la Chiesa di San Giovanni gli fece dipingere la Decollazione del Santo caduto a terra, mentre il carnefice, quasi non l'abbia colpito alla prima con la spada, prende il coltello dal fianco, afferrandolo ne' capelli per distaccargli la testa dal busto. Riguarda intenta Erodiade, ed una vecchia seco inorridisce allo spettacolo, mentre il guardiano della prigione in abito turco addita l'atroce scempio. In quest'opera il Caravaggio usò ogni potere del suo pennello, avendovi lavorato con tanta fierezza che lasciò in mezze tinte l'imprimitura della tela . . .' Hibbard 1983, pp. 368–9.

103 He also remarked, quite accurately, on how thinly painted the work is (see the previous note). By the 1660s, when it is likely Bellori wrote this section of the biography, there may have been painted copies of the Beheading in Italy he could have seen. But only a confrontation with the actual canvas or a description by a careful observer would have yielded such detailed information about Caravaggio's technique. Could there have been more than one informant who helped Bellori?

104 For a broad iconographic investigation of Caravaggio's treatment of the Baptist in his art, see Treffers 2000.

105 Calvesi 1990, p. 367.

106 The greenish-blue jacket called an 'abito turco' by Bellori is not an Ottoman costume. The very idea that anything Turkish would be represented in an altarpiece depicting the tragic death of the patron saint of the Order – in their conventual church no less – is too fantastic to entertain. It is much more likely, I think, that Bellori's informant meant to imply that the costume was painted in turquoise colour, that is, 'turchino'. A true 'abito turco' would include a turban as part of an entirely different costume.

107 Because Salome is not named in the Bible, writers frequently referred to her, erroneously, by her mother's name, Herodias. The recent restoration of the picture has made it much easier to see that the girl has a large apron tied to her waist that swings forward as she stoops to receive the head. Thus, she is probably a servant in Herod's palace.

108 A type known as a misericordia. This was pointed out to me by John Beldon Scott.

109 The 'Maltese' character of the Annunciation came into sharp focus for me for the first time when seeing the work in the context of the Naples exhibition. I thank K. Sciberras, who recently examined the picture in Nancy, for sharing his observations with me. He also supports a Malta-period dating. We both thank Sophie Harent, curator at Nancy, for her assistance.

110 It seems unlikely that Caravaggio began the Annunciation in Malta and then completed it in Sicily, since we have no reason to suspect that his personal items were shipped to him, let alone taken by him personally as he escaped from Fort St Angelo. If he painted the work during one or more of his brief stays in Syracuse, Messina, Palermo and Naples, he would have had difficulty corresponding with his patrons and arranging for the picture to be shipped to Lorraine. Malta, therefore, remains the most likely place for the commission and its execution.

111 At the time of the Naples exhibition opening, I was fortunate to discuss the picture's state of conservation with K. Christiansen and D. Carr. I thank K. Christiansen and D. Carr for comments on the picture's state of preservation. According to a 1970 report supplied by S. Harent, in 1968-9, ICR in Rome relined the canvas and removed the extensive nineteenth-century overpaint except in two areas, the upper part of the angel's wings and the central part of the basket. Probably repainted before 1800, these areas have no original pigment underlying them. Inpainting by ICR was done in watercolour; some of the Virgin's face is reconstructed in tratteggio.

112 '. . . si che, oltre l'onore della croce, il Gran Maestro gli pose al collo una ricca collana d'oro e gli fece dono di due schiavi, con altre dimostrazioni della stima e compiacimento dell'operar suo'. Hibbard 1983, p. 369.

113 Probably engraved by Albert Clouwet, a French printmaker active in Rome in 1644–67 in the workshop of C. Bloemaert. See Bellori 1672 (ed. 1976), p. 89, n. 2.

114 In some recent studies, other pictures, such as the Saint John at the Spring (Rome, Private Collection), have been assigned to the Malta period with varying degrees of plausibility. The Saint John is best known through the version in Malta (Private Collection), and some have jumped to the conclusion that this composition must therefore originate in the Malta period. But to the best of my knowledge, the Malta picture, which has a vertical format, was imported. Secondly, despite the fact that the Rome picture's subject is the patron saint of the Knights of Malta, the work's style and composition are wholly out of character with Caravaggio's Maltese paintings. The Sleeping Cupid, which is really the only point of comparison, has a monumentality and sense of space that make the Rome Saint John seem superficial. Leaving aside the question of the Rome version's autograph status (I personally have significant reservations after seeing it in the context of the Naples exhibition), its style seems more consonant with the Seven Works of Mercy of late 1606 and earlier works. I would not be surprised to learn that this was a variant (in a dark style) of a lost Roman period painting by Caravaggio.

From the *Burial of Saint Lucy* to the *Scenes of the Passion*: Caravaggio in Syracuse and Messina

Gioacchino Barbera and Donatella Spagnolo

The premise for Caravaggio's stay in Sicily[1] is the visit to Malta which ended in his imprisonment and escape by sea towards the southern shores of the neighbouring island. It is, however, possible that he had been planning to spend a period in Sicily, and the visit may have been prepared through contacts with Sicilians or other persons in some way associated with Sicily in the years 1608 and 1609. These contacts, inferred by scholars or suggested by documentary sources, range from Caravaggio's friend from his years in Rome, Mario Minniti,[2] to his long-standing protector, Costanza Colonna, Marquise of Caravaggio;[3] the Florentine Knight of Malta Antonio Martelli, in charge of the Grand Priory of Messina in precisely the months of the artist's stay and resident in Messina from November 1608 to the summer of 1609,[4] whose portrait Caravaggio may have painted;[5] and leading figures in the Franciscan community, such as the then Provincial of the Franciscan order Gerolamo Errante[6] or Bonaventura Secusio, Archbishop of Messina from 1605 to 1609 and native of Caltagirone and Observant Minor,[7] or again the General Minister of the Observant Minor friars from 1606 to 1612, Arcangelo Gualtiero,[8] native of Messina. Caravaggio's imprisonment in Fort St Angelo on Malta, as has been mentioned, was the upshot of a brawl on 18 August 1608 in the house of Fra Prospero Coppini, involving seven Italian knights, including Caravaggio, who was then a Knight of Obedience.[9] He was probably remanded in prison on 27 August and spent the month of September behind bars, managing to escape, apparently with the aid of ropes, at the beginning of October. He must have been helped or at least protected by someone, both for the escape and for the sea crossing, and this protection must have continued in Sicily, for in spite of being a wanted man he was never arrested or hindered in his work. Indeed, in the document which attests delivery of *The Raising of Lazarus* to the Padri Crociferi (dated 10 June 1609), he still employed the title of Knight of Malta,[10] even though he had been sentenced, on 1 December 1608, to the *privatio habitus*, and the Hierosolymite community in Messina must have been informed of this.

It is not certain that the artist landed first at Syracuse. It has been suggested that, for reasons of safety, the landing may have been made at a port less frequented by Maltese galleys, such as Pozzallo or Scicli in the south of the island, and that he would have reached Syracuse, or possibly Caltagirone, from there.[11] The tradition that he visited Caltagirone – before or after Syracuse – is preserved in an eighteenth century document recently brought to light. The story goes that Caravaggio, visiting the church of Santa Maria di Gesù, praised a Madonna by Antonello Gagini with the words 'whoever wants her more beautiful should go to Heaven'. However, the note of civic pride in this anecdote, and the lack of any other evidence, are bound to leave doubts as to the episode's veracity.[12]

As to the brief stay in Syracuse, which has recently received fascinating treatment in more than one work of fiction,[13] we possess some reliable historical records, although we still have no documentary evidence concerning *The Burial of Saint Lucy* (Syracuse, Galleria Regionale di Palazzo Bellomo, in deposit from the church of Santa Lucia al sepolcro), which Susinno declares to have been commissioned from Caravaggio. In his words, the municipal Senate was 'entreated' by Mario Minniti 'to employ Caravaggio on some project, so that he [Minniti] could have the chance to enjoy the company of his friend for a period and also to demonstrate what a degree of excellence Michelagnolo had attained, since he was much spoken of and said to be the foremost painter in Italy'.[14] In fact there is no evidence for the presence in Syracuse of Minniti in 1608, although we do know he was back in Sicily by 1606.[15] It is difficult to believe that he had achieved such standing as to be able to help or protect Caravaggio, unless his family, well-to-do and 'esteemed'[16] but not belonging to the nobility, can be assumed to have wielded particular influence.

Up until 1617 the church of Santa Lucia *extra moenia*, for which the picture was painted, and the adjacent monastery, originally a Benedectine foundation, were administered by Cappellani Reginali. The Minorite friars (Conventual and Observant) had tried repeatedly to take over the premises, but it was not until 1618 that church and monastery were assigned to the Reformed Minors.[17] The Franciscans may also have played a part in the award of the commission: in this case the idea (or fact) presented by Susinno concerning the agency of Minniti may merit greater credit, considering the large number of Franciscan commissions he carried out over the following years, indicating a privileged relationship with the Order, together with the fact that his sister Maria was a Capuchin tertiary.[18]

Capodieci's account of a commission from Bishop Orosco II was promptly refuted by scholars on chronological grounds, since Orosco died in 1602 and was replaced by Giuseppe Saladino, in office from 1604 to 1611.[19] However, there is some justification for Capodieci's error in that Orosco's term as bishop introduced a new climate of goodwill between the religious authorities and the municipal Senate[20] – which in those years undertook to finance the silver simulacrum of Saint Lucy – and initiated a programme of re-evaluating local devotional practices, including the cult of the site traditionally identified with the saint's martyrdom and burial. The presence in the picture of a bishop giving his blessing – whether Orosco or Saladino – is in part inspired by the episode in the *Golden Legend* which tells of priests taking the eucharist to the dying saint,[21] but it can also be seen as a grateful tribute on the part of the artist for receiving the commission, as supposed by Maurizio Marini.[22] At the same time, given the encouragement of traditional cults associated with the Roman persecutions and hence with the sites and buildings of Christian archaeology – in which the studies of Vincenzo Mirabella, scholar of antiquity, played a key role – we cannot exclude the possibility that there is a reference to the first Bishop of Syracuse, Saint Martian, who also suffered martyrdom and whose crypt may have inspired Caravaggio's setting for the burial of Saint Lucy.[23]

In 1608 Vincenzo Mirabella (fig. 1) is known to have been engaged in the research and archaeological explorations which culminated in what is probably his best known work, *Dichiarazioni della pianta delle Antiche Siracuse*, published in 1613. He is one of the contacts, and perhaps the best documented one, which can corroborate Caravaggio's stay in Syracuse.[24] Mirabella recorded going with the artist to visit the cave once known as the 'prison of Dionysius' or the 'speaking cave' on account of its acoustic effects which amplified voices and sounds and thus allowed the tyrant Dionysius to hear every word uttered by his prisoners.

Caravaggio is said to have made the following reflections on the cave's acoustic phenomenon: 'Do you not see how the Tyrant, in order to fashion a vessel that would make things audible, looked no further for a model than to that which nature herself had formed for the self same purpose? Thus he made this cell in the likeness of an ear. The which, for not being noticed at first and then realised and studied thereafter, has produced a two-fold amazement in the most enquiring minds',[25] so much so that the cave was called the 'ear of Dionysius', the name by which it is still known. In his study of Caravaggio's naturalism, Ferdinando Bologna recognises in the

reflections of the artist – which struck Longhi as having 'a tone altogether too academic and … anatomical' – further proof of and key to the '"optical" nature of the pictorial "observations" of Caravaggio' and goes on: 'it must not escape us, what's more, that … Caravaggio gave an essentially experimental, or indeed functional, explanation of the phenomenon … a reflection which is already "Galileian" … paying attention without qualms to "what experience and sense tell us"; to such an extent, moreover, as to provide a patent explanation of what in Caravaggio's method can be really meant by the "observation of the thing" and the cognitive processes on which this observation was based'.[26] [g.b.]

Caravaggio may already have been in Messina in December 1608. In an agreement dated 6 December, in which the painter's name does not figure, Giovan Battista de' Lazzari undertook to build the central chapel in the church of the Padri Crociferi, and provide a picture depicting a Madonna with Child and Saints including Saint John the Baptist.[27] The subject was subsequently changed to the Raising of Lazarus, according to Susinno as a tribute to the family name of the donor and on the suggestion of Caravaggio,[28] whose name only appears in the document concerning the picture's consignment, on 10 June 1609.[29] In 1755 Caio Domenico Gallo mentions a Saint John the Baptist by Caravaggio allegedly hanging above The Raising of Lazarus.[30] The Saint John does not appear at all in the most authoritative nineteenth-century critical tradition, while Virgilio Saccà, in the course of research into the question as part of his studies on Caravaggio in Messina, found evidence of its existence but was not able to verify it as an original by Caravaggio.[31]

The Lazzari (or de' Lazzari) were a family of merchants from Genoa, originally from Castelnuovo di Scrivia in the Duchy of Milan,[32] known only from the occasional reference in the volumes of the Tavola Pecuniaria and in documents concerning business dealings with Fra Orazio Torriglia, Receiver of the Order in Messina.[33]

Susinno places considerable emphasis on the complete liberty enjoyed by the painter not only in the composition of the scene but also in the choice of subject; the latter seems highly unlikely, but reflects the painting's originality in the milieu of Messina. It continued to amaze throughout the following century, particularly in the eyes of a classicist such as Susinno. The extravagant prose which Susinno employs in his account of The Raising of Lazarus (Messina, Museo Regionale)[34] is among the most vivid in his oeuvre. As examples we can mention the setting in the great hall of

the 'spedale' with extempore actors and a 'corpse which had been high for some days', the outbursts of the painter, brandishing a dagger – Susinno maintains that he was 'always armed, so that he looked more like a mercenary than a painter'[35] – and the slashing to pieces of the picture shortly after it was unveiled only for it to be immediately replaced by a second version.

Susinno repeatedly describes Caravaggio as 'mad and demented', a 'lunatic', and this insistence finds confirmation in a comment by di Giacomo – as we shall see in more detail below – concerning the painter's unhinged mind. Everything points to the fact that, during his months in Messina, Caravaggio felt that his life was in imminent danger. The threat seems to have become reality in the violent attack he suffered at the Cerriglio, in Naples, as soon as he left Sicily.

As we have noted, the Lazarus was delivered in June 1609, several months after the presumed date of Caravaggio's arrival in Messina in the previous December. It is quite likely that he made other paintings during this period, including perhaps, as many scholars have maintained, The Adoration of the Shepherds (Messina, Museo Regionale), painted for the church of Santa Maria la Concezione of the Capuchin friars (where it adorned the high altar).[36] Aside from the difference in subject and the virtuosity of the conception, this picture is characterised by a less agitated style than The Raising of Lazarus, as well as a more reflective elaboration of the iconography, probably based on traditional images of the Madonna of Humility or the Madonna del Parto. There is no consensus at the moment as to which of the two was painted first, although most scholars tend to place The Adoration of the Shepherds after The Raising of Lazarus.[37] The 'dolorous' and concentrated tone, the profound adhesion to the values of simplicity and humility, the poetry of the 'peasant still life' and the extraordinary pictorial qualities of its luminism, have given rise to some of the most inspired passages in art criticism – from Longhi to Brandi – while in historical terms they confirm the hypotheses concerning the artist's contact with Capuchin and Minorite communities during his stay in Sicily.

Susinno suggests that his preference for the Adoration over the other works Caravaggio painted while in Sicily ('to my mind this is indeed the best, because in its [figures] this great naturalist avoided that clever outlining with shadows but showed himself natural without recourse to his virtuosity in shading') found wide consensus. In fact, to judge from both the literature and the recollections of the local works the picture inspired which were subsequently lost, Caravaggio's

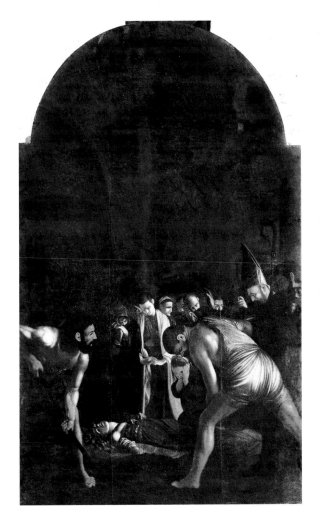

2. Raffaele Politi, *The Burial of Saint Lucy* (copy after Caravaggio). Syracuse, church of San Giuseppe

3. *Burial of Saint Lucy*, engraving from *Siracusa per i viaggiatori*, Syracuse 1835

on the following pages
4. Anonymous, early 17th century, *Panel showing the Burial of Saint Lucy* (from Caravaggio), detail of the *Silver coffret of Saint Lucia*. Syracuse, Cathedral

5. Alonzo Rodriguez, *The Leave-taking of Saint Peter and Saint Paul*, detail. Messina, Museo Regionale

'Nativity' represented for Sicilian artists the most profound and enduring touchstone of the master's realism, in spite of the fact that its extraordinary unity and completeness virtually ruled out any imitation or quotation.

Among the pictures painted in Messina a *Saint Jerome Writing*, also in the church of the Capuchins, is recorded by Bellori,[38] and two other *Saint Jeromes* are cited by Susinno in the collection of Count Adonnino – 'one in excellent taste, in the act of writing with a pen in his hand, in a most natural pose; the other in the spare manner, holding a skull in his hands and meditating on it.'[39] Apart from these three, Susinno mentions no other paintings belonging to private individuals, although he seems to acknowledge their existence.

The chronicler Gallo, on the other hand, in addition to

the *Saint John the Baptist* in the church of the Crociferi, also places on record a *Beheading of the Baptist* in the church of San Giovanni Decollato (now in the Museo Regionale, Messina), subsequently identified as the work of Minniti[40] – and already recorded as such in Susinno's biography of Minniti – and an *Ecce Homo* in the church of Sant'Andrea Avellino (now in the Museum of Messina), a copy of the *Ecce Homo* by Caravaggio now in Genoa (Galleria di Palazzo Bianco), and attributed by Enrico Mauceri to Alonzo Rodriguez.[41] The other local eighteenth- and nineteenth-century sources generally follow Gallo's attributions,[42] except for the *Saint John the Baptist* of the Crociferi.

There was first-hand evidence for four *Scenes of the Passion* in a private document (lost probably in 1908) concerning Baron Niccolò di Giacomo, found in the

family archives by Baroness Flavia Arau di Giampaolo and published by Virgilio Saccà in 1907: 'Note of the four pictures which I, Nicolao di Giacomo, have had done: I gave the commission to Signor Michiel'Angiolo Morigi da Caravaggio to do for me the following pictures: Four stories of the Passion of Jesus Christ to be done at the fancy of the painter, of which he finished one showing Christ with the Cross on his shoulders, the Lady of Sorrows and two soldiers, one playing the trumpet, which proved to be a truly excellent work, and paid 46 *oz.*, and the other three the Painter has undertaken to bring me in the month of August, the payment for them to be agreed with this painter who has his mind unhinged.'[43]

Thus we know for certain that Caravaggio delivered at least one painting, the *Road to Calvary*, in which the detail of the soldier playing the trumpet recalls the picture of the same subject by Polidoro Caldara, then in the church of the Annunziata dei Catalani in Messina (now in Naples, Museum of Capodimonte). There can be no doubt that Caravaggio would have seen it, on account of its fame and because of the great esteem in which his compatriot was held in Messina. Making one more leap in time, but forwards rather than backwards, there may well be an echo of Caravaggio's trumpeter in the figure on the far right in Alonzo Rodriguez's *The Leave-taking of Saint Peter and Saint Paul* (fig. 5). It is highly likely that the picture featured three-quarter-length figures, a format frequently used by Caravaggio.[44]

As for the other Passion scenes, the *Ecce Homo* – probably but not necessarily part of the cycle – has been hypothetically identified with two versions, one in a private collection and the other in Genoa (Arenzano, Santuario del Bambino Gesù di Praga) or with an original that has gone missing, on account of the presumed dating of the prototype to the Messina period and by analogy with the *Road to Calvary* in the inclusion of four figures.[45]

In the Palermo collection of Don Andrea Valdina, Marquis of La Rocca – and hence originally from Roccavaldina, in the province of Messina – there is a record dating from 1659 of a *Christ carrying the Cross* by Caravaggio, with the same dimensions (5 palms by 4) as an *Ecce Homo* recorded as the previous item in the inventory,[46] and as such also considered to be by Caravaggio.[47]

The painting has been hypothetically identified, on the basis of a common origin in Messina, with the *Road to Calvary* from the 'di Giacomo cycle', which must have found its way, by means of legacies or transactions, to the Princes of Valdina and their castle at Roccavaldina, and thence to Palermo.[48] Maurizio Marini has postulated

the same itinerary for the *Ecce Homo*, which he links to the Cortes version in New York.[49] However, since we have as yet no firm evidence for the sequence of ownership, it is more prudent to suppose that the Valdina *Christ carrying the Cross* is a different picture, whose only bearing on the 'di Giacomo cycle' is the common subject. We know from documentary sources that the Princes of Valdina and Marquises of La Rocca had commercial and financial dealings with the Genoese colony in Sicily, and indeed with Genoa.[50] Thus it is quite likely that they were also in contact with the Genoese family of Lazzari, who commissioned the first work from Caravaggio in Messina. It also appears that a member of the Valdina family had a specific interest in naturalistic painting. In his *Life* of Alonzo Rodriguez, Susinno states that 'having heard that Rodriguez was resolved to go to Rome, the Prince Carlo di Valdina, enamoured of his paintings, got him to travel to the nearby estate of la Rocca, and thereupon diverted him with various painting projects'.[51]

Carlo was the second son of Andrea, and thus too young in 1640 or so to be the Carlo in Susinno's account. Nonetheless we find confirmation for the episode in a letter written by the heir to the title and patrimony of Valdina, Giovanni. He speaks of his intention of taking with him to Rome various paintings, all by 'Alonso, the old Messinese artist, whose works enjoy today some consideration',[52] paintings which in all likelihood, from chronological considerations, were commissioned by his father Andrea or by another member of the family called Carlo – as Susinno suggests – of whom there is now no trace.

There may be an allusion to the Valdina *Christ carrying the Cross* in the picture of the same subject by Minniti owned by the Fondazione Lucifero (Milazzo), which has very pronounced iconographic and formal analogies with the detail of Christ and Simon of Cyrene in the *Road to Calvary* (Syracuse, Seminario Arcivescovile), a work produced by Minniti's workshop.[53] It therefore seems plausible to postulate an authoritative prototype which could not have been the one in the 'di Giacomo cycle', since the close formal link between the two figures of Christ and Simon of Cyrene – or torturer in the Milazzo painting – rules out *a priori* the possibility of including any other major figure, such as the Madonna (who is present in Nicolò di Giacomo's picture), whom Christ would presumably have had to look at, turning his head. See, for example, Raphael's *Spasimo di Sicilia* or, to cite a work which was very close to the Roman Caravaggio, the *Ascent to Calvary* by Orazio Gentileschi (Vienna, Kunsthistorisches Museum).

The other published works attributed to Caravaggio that have been hypothetically dated to the period he spent in

Messina, although it must be said that some are critical *causes célèbres*, in which there is no general consensus as to either dating or, for the last three, attribution are: *Salome with the Head of Saint John the Baptist* (Madrid, Palacio Real);[54] *The Annunciation* (Nancy, Musée des Beaux-Arts);[55] *Salome receives the Head of Saint John the Baptist* (London, National Gallery);[56] *Portrait of a Knight of Malta*[57] and *The Tooth-puller*[58] (both in Florence, Palazzo Pitti); *The Vision of Saint Jerome* (Worcester, Museum of Fine Arts);[59] *Christ and the Adultress* (private collection).[60]

Susinno concludes his account of Caravaggio's stay in Messina with a highly colourful story of a dispute involving the teacher Don Carlo Pepe: 'On holidays [Caravaggio] would set off in pursuit of a certain grammarian by the name of Don Carlo Pepe, who took his pupils to the shipyards for recreation ... In that place Michele busied himself observing the movements of the boys at play so as to model his pictorial fantasies on them. Made suspicious by such behaviour, the teacher asked him why he was always lurking round them. This question made the painter wild, and drove him into such a state of fury that, so as not to disown the name of madman, he wounded the good man in the head; for the which he was obliged to quit Messina.'

We do not know whether the artist was still in Messina in August 1609, when he was due to deliver the three missing *Passion* scenes to Nicolò di Giacomo; he may already have arrived in Palermo, where in any case he must have stayed long enough to paint the *Nativity with Saints Francis and Lawrence*. With our current knowledge, the next certain date concerning the termination of his stay in Sicily is 24 October 1609, the date of the notification of the violent affray in which he was involved in Naples. [*d.s.*]

This essay is the product of joint research: Gioacchino Barbera wrote the section on Caravaggio in Syracuse, while Donatella Spagnolo was responsible for the section on the artist's stay in Messina.

1 On Caravaggio's stay in Sicily, in addition of course to the most recent monographs by F. Bologna, M. Calvesi, M. Cinotti, M. Marini and V. Pacelli, see: *Caravaggio in Sicilia: il suo tempo, il suo influsso*, exhibition catalogue (Syracuse), Palermo 1984 (in particular the essay by F. Campagna Cicala, 'Intorno all'attività di Caravaggio in Sicilia. Due momenti del caravaggismo siciliano: Mario Minniti e Alonzo Rodriguez', pp. 101–44); *L'ultimo Caravaggio e la cultura artistica a Napoli in Sicilia e a Malta*, ed. M. Calvesi, coordinated by L. Trigilia, Syracuse 1987; *Sulle orme di Caravaggio tra Roma e la Sicilia*, exhibition catalogue (Palermo) eds. V. Abbate, G. Barbera, C. Strinati and R. Vodret, Venice 2001 (in particular the essay by M. Marini, 'Michelangelo da Caravaggio in Sicilia', pp. 3–23). Important data have been revealed by the recent X-ray analysis of Caravaggio's Sicilian paintings: see *Come dipingeva il Caravaggio. le opere messinesi* (*Quaderni dell'attività didattica del Museo Regionale di Messina*, 4), Messina 1994 (see in particular the essay by R. Lapucci, 'Documentazione tecnica sulle opere messinesi del Caravaggio', pp. 17–67); *Il Seppellimento di santa Lucia del Caravaggio. Indagini radiografiche e riflettografiche*, ed. G. Barbera and R. Lapucci, Syracuse 1996.

2 See F. Susinno, *Le vite de' pittori messinesi*, ms. 1724, ed. V. Martinelli, Florence 1960, p. 110. On the relations between Caravaggio and Minniti in general see the catalogue of the exhibition in Syracuse, *Mario Minniti. L'eredità di Caravaggio a Syracuse*, Naples 2004.

3 See above all M. Calvesi, *Le realtà del Caravaggio*, Turin 1990, *passim*. For his influence concerning an introduction into the milieu of Malta and the Order see also S. Macioce, *Precisazioni sulla biografia del Caravaggio a Malta*, in *Sulle orme di Caravaggio...*, cited in note 1, p. 29.

4 K. Sciberras, 'Riflessioni su Malta al tempo del Caravaggio', in *Paragone*, LIII, n. 629, III series, 44, 2002, pp. 11–12 *et passim*.

5 On the *Portrait of a Knight of Malta*, which according to Sciberras (2002, cited in note 4, pp. 11–12) was painted in Malta, where Martelli stayed until at least October 1608, see M. Gregori, 'A new Painting and some observations on Caravaggio's Journey to Malta', in *The Burlington Magazine*, CXVI, 859, 1974, pp. 594–603; M. Chiarini, 'La probabile identità del "Cavaliere di Malta" di Pitti', in *Antichità viva*, XXVIII, 1989, 4, pp. 15–16; M. Gregori, signed entry in *Michelangelo Merisi da Caravaggio. Come nascono i capolavori*, exhibition catalogue (Florence), ed. M. Gregori, Milan 1991, pp. 318–23; J. Gash, 'The Identity of Caravaggio's "Knight of Malta"', in *The Burlington Magazine*, CXXXIX, 1128, 1997, pp. 156–60.

6 On the mileu of the Minorites in Sicily, the figure of Errante and the possible relations with Caravaggio see V. Abbate, 'I tempi del Caravaggio: situazione della pittura in Sicilia (1580–1625)', in *Caravaggio in Sicilia...*, cited in note 1, esp. pp. 48–52; he affirms that Errante may have commissioned the lost *Saint Jerome* of the Capuchins in Messina (see above in this essay).

7 The figure of Secusio in relation to Caravaggio was illustrated by A. Spadaro, 'Proseguendo l'indagine sul soggiorno siciliano del Caravaggio', in *Foglio d'Arte*, VII, 12 December 1984, pp. 12–13, 16–17. See also E. Natoli, 'I luoghi di Caravaggio a Messina', in *L'ultimo Caravaggio...*, cited in note 1, p. 219; A. Spadaro, *Note sulla permanenza di Caravaggio in Sicilia*, ibid., p. 291.

8 Ivi, p. 290.

9 On these and subsequent indications on Caravaggio's imprisonment and escape from Malta, see K. Sciberras 2002, cited in note 4, pp. 3–20, *passim* and the essay in this catalogue.

10 First published in V. Saccà, 'Michelangelo da Caravaggio pittore. Studi e ricerche', in *Archivio Storico Messinese*, VIII, 1907, pp. 67–9.

11 S. Macioce in *Sulle orme di Caravaggio...*, cited in note 1, p. 34.

12 The episode was published by A. Spadaro, 'Il percorso smarrito e l'importante inedito: la presenza del pittore a Caltagirone', in *Foglio d'Arte*, VIII, II, 1984–5, pp. 6–7; idem, *Note...*, cit., p. 289. The manuscript referred to is *Notizie sacre di Caltagirone* (Biblioteca Comunale, Caltagirone) by Francesco Aprile, dating from before 1710.

13 See in particular: V. Consolo, *L'olivo e l'olivastro*, Milan 1994, pp. 93–5; P. Di Silvestro, *La fuga, la sosta. Caravaggio a Syracuse*, Milan 2002; V. Consolo, 'Caravaggio in Sicilia. Le orme del maestro', in *FMR*, new series, 1, June–July 2004, pp. 18–24.

14 F. Susinno 1724, cited in note 2, p. 110.

15 On 21 May 1606 a commission was given for a *Madonna del Soccorso* for the church of San Giovanni Battista di Vizzini (Catania), and the work was delivered on 7 November (see A. Ragona, 'Un documento del periodo oscuro della vita del pittore Mario Minniti', in *Archivio Storico Siracusano*, n. s. I, 1971, pp. 60–1).

16 F. Susinno 1724, cited in note 2, p. 116.

17 See N. Agnello, *Il monachismo in Siracusa. Cenni storici degli ordini religiosi soppressi dalla legge 7 luglio 1866*, Syracuse 1891, p. 57 *et passim*.

18 See G. Agnello, 'Un caravaggesco: Mario Minniti', in *Archivi*, VIII, 1941, doc. 13.

19 G.M. Capodieci, *Annali di Syracuse*, vol. VIII, early 19thC ms., Biblioteca Arcivescovile Alagoniana di Syracuse, p. 456; V. Saccà, 'Michelangelo da Caravaggio pittore. Studi e ricerche', in *Archivio Storico Messinese*, 1906, VII, p. 58, 1907, VIII, p. 78; H. Hibbard, *Caravaggio*, London 1983, pp. 327–8; see also O. Garana, *I Vescovi di Syracuse*, Syracuse 1969, facsimile reprint, Syracuse 1994, pp. 144–8.

20 On 6 May 1586 Orosco signed a 'bond of peace and goodwill' with the members of the Senate of Syracuse: see O. Garana 1969, cited in previous note, p. 145.

21 Jacopo da Varazze [Voragine], *Legenda Aurea*, ed. A. and L. Brovarone, Turin 1995, p. 37.

22 M. Marini, *Io Michelangelo da Caravaggio*, Rome 1974, p. 45.

23 A. Zuccari, 'La pala di Siracusa e il tema della sepoltura in Caravaggio', in *L'ultimo Caravaggio...*, cited in note 1, pp. 156–7. For previous hypotheses relating to the identification of the scene of the burial, see the entry on *The Burial of Saint Lucy* by G. Barbera in this catalogue.

24 On Vincenzo Mirabella see most recently S. Russo, *Vincenzo Mirabella Cavaliere siracusano*, Palermo-Syracuse 2000.

25 V. Mirabella, *Dichiarazioni della Pianta delle antiche Siracuse, e d'alcune scelte medaglie d'esse, e de' Principi che quelle possedettero*, Naples 1613, p. 89.

26 F. Bologna, *L'incredulità del Caravaggio e l'esperienza delle 'cose naturali'*, Turin 1992, pp. 144–54, esp. pp. 145–6, 151–2. The quotation from R. Longhi is taken from *Opere complete di Roberto Longhi*, vol. IV, '"Me pinxit" e Quesiti caravaggeschi'. *1928–1934*, Florence 1968, pp. 140–1, note 19.

27 The document, probably lost in 1908, is published in V. Saccà 1906–7, cited in note 19, pp. 67–9.

28 For this and subsequent references to the biography of Caravaggio in Susinno's work, relating to the main works painted in Messina and the anecdotes, see F. Susinno 1724, cited in note 2, pp. 106–16; see also E.S. Natoli, 'Michelangelo da Caravaggio nell'interpretazione di Francesco Susinno', in *Archivio Storico Messinese*, LXVI-LXVIII, III series, vol. XVII-XIX, Messina 1968, pp. 193–202.

29 See note 10.

30 C.D. Gallo, *Apparato agli Annali della città di Messina Capitale del Regno di Sicilia*, Naples 1755, facsimile reprint, ed. G. Molonia, Messina 1985, p. 233.

31 V. Saccà 1906–7, cited in note 19, p. 69, note 2: 'In the record of the acquisition and composition of an inventory of the property belonging to the monastery of the Crociferi under the name of the Ministers to the Sick drawn up on 27 October 1866 ... under Picture No. 20 there is the indication: "Another small (painting) of Saint John". It is highly likely

that the picture is now either in the Civic Museum or in one of the municipal churches: but I have not been lucky enough to trace it, since in museum catalogues there is all too often no indication of provenance'.

[32] A. Spadaro, *La 'Resurrezione di Lazzaro' e la famiglia di Giovanni Battista Lazzari patrizio di Castelnuovo signore del castello di Alfano committente messinese del Caravaggio*, San Giovanni La Punta (Catania) 1995, p. 6.

[33] V. Saccà 1906-7, cited in note 19, pp. 66, 69. The volumes of the Tavola Pecuniaria were almost certainly lost in the 1908 earthquake.

[34] In addition to Susinno, on *The Raising of Lazarus* see M. Pupillo, signed entry (*The Raising of Lazarus*), in *Sulle orme di Caravaggio*, cited in note 1, pp. 109-11; G. Barbera, entry on *The Raising of Lazarus* in this catalogue.

[35] F. Susinno 1724, cited in note 2, esp. p. 114.

[36] See G. Papi, entry (*The Adoration of the Shepherds*), in *Michelangelo Merisi da Caravaggio. Come nascono i capolavori*, exhibition catalogue (Rome), Milan 1991, pp. 386-90; G. Barbera, entry on *The Adoration of the Shepherds* in this catalogue.

[37] On the critical history of the two pictures, in addition to the entries cited in the previous note see: M. Cinotti, *Michelangelo Merisi detto il Caravaggio. Tutte le opere*, introductory essay by G.A. Dell'Acqua, Bergamo 1983, pp. 457-62; M. Marini, *Caravaggio "pictor praestantissimus"*, III ed., Rome 2001, pp. 85-8 and entries 97-8, pp. 549-53.

[38] G.P. Bellori, *Le vite de' pittori, scultori e architetti moderni*, Rome 1672, ed. E. Borea, with introduction by G. Previtali, Turin 1976, p. 227.

[39] F. Susinno 1724, cited in note 2, esp. p. 114. Originally from Florence, it is not known when the Counts Adonnino moved to Messina. They were also Dukes of la Catena and Barons of Sittafari. There are supposed to have been Knights of Malta among the family members, but nothing definite is known (see V. Palizzolo Gravina, *Il Blasone in Sicilia*, Palermo 1871-5, pp. 52-3; G. Galluppi, *Nobiliario della città di Messina*, Naples 1877, p. 192; V. Spreti, *Enciclopedia storico-nobiliare italiana*, vol. I, Milan 1928, p. 317).

[40] On Minniti's *Beheading of the Baptist* see D. Spagnolo's entry (*Beheading of Saint John the Baptist*) in *Mario Minniti. L'eredità di Caravaggio a Siracusa*, exhibition catalogue (Syracuse), Naples 2004, p. 70.

[41] On the copy in Messina see F. Campagna Cicala's entry (*Ecce Homo*) in *Sulle orme...*, cited in note 1, pp. 128-9.

[42] See F. Hackert-G. Grano, *Memorie de' pittori messinesi*, Naples 1792, ed. G. Molonia, Messina 2000, pp. 105-8; G. Grosso Cacopardo, *Memorie de' pittori messinesi e degli esteri che in Messina fiorirono dal secolo XII sino al secolo XIX*, Messina 1821, facsimile reprint Bologna 1972, pp. 77-81; G. La Farina, *Messina ed i suoi monumenti*, Messina 1840, facsimile reprint Messina 1976, pp. 104, 121-2, 128, 139; see also A. Salinas-G.M. Columba, *Terremoto di Messina (28 dicembre 1908). Opere d'arte recuperate*, Palermo 1915, facsimile reprint eds. F. Campagna Cicala and G. Molonia (*Quaderni dell'attività didattica del Museo Regionale di Messina*, 8), Messina 1988, pp. 115, 132-3.

[43] V. Saccà 1906-7, cited in note 19, p. 64.

[44] See M. Gregori, 'Sulla traccia di un altro 'Ecce Homo' del Caravaggio', in *Paragone*, XLI, n.s., 24 November 1990, p. 24. At the beginning of the twentieth century, before the 1908 earthquake, a *Road to Calvary* with half-length figures had been found in Messina, believed to be by Caravaggio by local scholars such as Gaetano La Corte Cailler and Virgilio Saccà. From the collection of Gaetano La Corte Alessi, purchased in about 1905 by Prince Castellaci Marullo, it was described as follows in the diary of La Corte Cailler (nephew of the previous owner): 'This picture measures 1.48 x 1.20 m., horizontally, and shows in half-length a Christ carrying the Cross with three figures, plus Pilate with his hand outstretched, which is a portrait of Caravaggio. The style is altogether of this painter, and the picture has always been considered one of his works' (G. La Corte Cailler, *Il mio Diario. Vol. II. 1903-1906*, ed. G. Molonia, Messina 2002, p. 561). At first it was thought that this may have been the *Road to Calvary* from the 'di Giacomo cycle', but as Saccà rightly pointed out the trumpet player is lacking. Nonetheless he affirmed: 'the picture has all the marks of Caravaggio and among the works believed to be by him, this could indeed be authentic' (V. Saccà 1906-7, cited in note 19, p. 74).

[45] For the copy in a private collection see M. Gregori 1990, cited in note 44, pp. 19-27, with the previous bibliography; M. Marini, entry (*Ecce Homo*) in *Sulle orme...*, cited in note 1, pp. 114-17, with the previous bibliography. For the version of Arenzano see G. Papi, 'Un nuovo 'Ecce Homo' del Caravaggio', in *Paragone*, XLI, n.s., 24, November 1990 pp. 28-48.

[46] V. Abbate, 'La città aperta. Pittura e società a Palermo tra Cinque e Seicento', in *Porto di mare 1570-1670. Pittori e pittura a Palermo tra memoria e recupero*, exhibition catalogue (Palermo), ed. V. Abbate, Naples 1999, p. 38.

[47] M. Marini, *Michelangelo da Caravaggio in Sicilia*, in *Sulle orme...*, cited in note 1, p. 14; idem, entry (*Ecce Homo*), in *Sulle orme...*, pp. 114-17.

[48] V. Abbate, *La città...*, in *Porto di mare*, cited in note 46, p. 38.

[49] See above note 47.

[50] L. Salamone, 'L'archivio privato gentilizio Papé di Valdina', in *Archivio Storico Messinese*, vol. 79, Messina 1999, pp. 46-7.

[51] F. Susinno 1724, cited in note 2, p. 139.

[52] L. Salamone 1999, cited in note 50, p. 60 and *passim*.

[53] See D. Spagnolo, entry (Mario Minniti, *Flagellation* and *Christ carrying the Cross*; Bottega di Mario Minniti, *Christ in the garden*, *Flagellation*, *The Crown of Thorns*, *Road to Calvary*), in *Mario Minniti...*, cited in note 40, pp. 75-81.

[54] See M. Marini 2001, cited in note 37, p. 326, entry 99 pp. 553-5, with critical history and previous bibliography; see M. Cinotti 1983, cited in note 37, p. 458, who finds affinities with *The Adoration of the Shepherds*.

[55] See M. Marini 2001, cited in note 37, p. 330, entry 101 pp. 557-8, with critical history and previous bibliography.

[56] See F. Campagna Cicala, cited in note 1, pp. 104-6.

[57] See note 5. See also M. Gregori, 'Significato delle mostre caravaggesche dal 1951 ad oggi', in *Novità sul Caravaggio*, Bergamo 1975, pp. 33-52; M. Calvesi 1990, cited in note 3, pp. 366, 426; M. Marini 2001, cited in note 37, p. 318, entry 95 pp. 545-7, with critical history and previous bibliography.

[58] See M. Gregori, signed entry (*The Tooth-puller*), in *Michelangelo Merisi da Caravaggio. Come nascono i capolavori*, cit., pp. 328-47, with critical history and previous bibliography; K. Christiansen, signed entry (*The Tooth-puller*), in *Pittori della realtà. Le ragioni di una Rivoluzione. Da Foppa e Leonardo a Caravaggio e Ceruti*, exhibition catalogue (Cremona), eds. M. Gregori and A. Bayer, Milan 2004, pp. 250-1.

[59] See M. Marini 2001, cited in note 37, p. 328, entry 100 pp. 555-7, with critical history and previous bibliography.

[60] See M. Marini 2001, cited in note 37, p. 334, entry 103 p. 560.

Caravaggio in Palermo
Vincenzo Abbate

In 1609 Michelangelo da Caravaggio, then living in Sicily, painted two works for Franciscan patrons featuring the Nativity. The first was done for the church dei Cappuccini in Messina, and was commissioned by the city Senate itself for the princely figure – according to Hackert[1] – of 1000 *scudi*; the second (fig. 1) was for the Venerabile Compagnia di San Francesco known as dei Bardigli or delli Cordiggeri, which was based in the Oratorio di San Lorenzo, next to the monastery buildings of the Minor Conventual friars in Palermo.[2]

The Nativity was of course a favourite Franciscan theme, but Friedlander[3] emphasises the fact that the two Sicilian pictures both present the iconography of the Madonna as the Madonna del Parto, lying in the straw. This is clearly linked to older medieval representations, such as the Madonna of Humility, where the Virgin was depicted seated on the bare earth: *humus = humilitas*, a tradition in Sicily going back to the Byzantine mosaics in the Cappella Palatina and the Martorana, and to a fourteenth-century Ligurian picture signed and dated (1346) by Bartolomeo da Camogli (fig. 4) in Palermo in the monastery of San Francesco d'Assisi next to the Oratory.

Without entering into the merit of Caravaggio's choice of subject and model in the Messina altarpiece, which Susinno considered among his best works 'because in it this [great] naturalist avoided that clever outlining with shadows but showed himself natural without recourse to virtuosity in shading',[4] or indeed of the one (stolen, alas) in Palermo, which has been considered an earlier work, 'misunderstanding the reprise of certain iconographical and stylistic motifs, in this case pre-eminently from Lombard art, which do nonetheless express the richness of Caravaggio's artistic culture',[5] I believe that Caravaggio's decision to represent the Virgin in a 'humble' attitude should be stressed because in my opinion it is not in the least fortuitous.

It is certainly not fortuitous in relation to a work which in those years was fundamental for the Minorite Rule (and the Capuchins in particular), the *Expositio ... in Regulam Seraphici Patriarchae S. Francisci* by Fra Geronimo Errante, Sicilian Capuchin and General of the Order in Rome from 1587 to 1593.[6]

We have spoken elsewhere[7] of this strong-willed Minorite friar, 'seraphice paupertatis custos observantissimus' – in 1579, as Provincial of the Capuchins in Palermo, he even crossed swords with the Viceroy Marcantonio Colonna, 'devotissimo della Religione'. He spoke out against the lavishness of the monastery being constructed for the Order in Palermo under the aegis of the Viceroy, insisting that the buildings should respect the rigour and poverty preached by a mendicant Order. This same rigour comes out in his Expositio, completed in 1593. The work was fundamental in promoting a stricter application of the Franciscan Rule in the wake of the Reform, but we also know it to have met with opposition. Some of its intransigent positions diverged from the Church in Rome and were openly antagonistic towards the Cardinal who oversaw the Order, Giulio Antonio Santori known as the Santaseverina.

Attempts to resolve the controversy came to nothing, in spite of the efforts of Cardinal Marco Sitico Altemps, Michele Bonelli, Cardinal Alessandrino and Federico Borromeo, who gave their personal support to Fra Errante: his treatise, fresh off the press, was placed on the Index on 27 November 1595, and he himself was exiled to Calabria.

Such blatant persecution caused no little scandal in ecclesiastical circles, and this persisted until his complete rehabilitation, effected in 1603 by Saint Lawrence of Brindisi, who was then General of the Order. However, the real turning point in the affair came only on 9 June 1604 with the election to the purple of the Capuchin friar Anselmo Marzato of Monopoli, known as the Monopolitan. On 27 August 1605 the Plenary Council of the Sacred Congregation, on the basis of the opinions of its advisers, gave the imprimatur to Errante's work, which was duly published in Naples the following year, albeit in an expurgated version, by Gian Giacomo Carlino.[8]

The Council, in addition to the Monopolitan, also included the cardinals Girolamo Bermerio (the Ausculano), Olivario Razario, the Serafino, Pier Benedetto Miriano, the Camerino, Girolamo Pamphily, Roberto Bellarmino, Cesare Baronio and Ascanio Colonna. The latter had only returned from Spain the previous May, and was 'linked', one might say, by long-standing disagreements with the Santaseverina, who in the meantime had died in 1602.[9] The three last-named cardinals all figured in the circle of Caravaggio's patrons and supporters.[10]

When Caravaggio arrived in Sicily from Malta, Errante had been back there for several years. After being appointed commissary and general visitor for the three Capuchin provinces of Palermo, Messina and Syracuse in 1603, he was elected Provincial of the Capuchins in the province of Messina the following year, and in May 1605 in Rome he was once again appointed General until 1608. He was to die in Trapani on 28 January 1611 at the age of 67, after 45 years in the habit. It is plausible to think that the two men, both at the centre of events which were equally turbulent although of a different nature, may have met, but this is not supported by documentary evidence. Many years ago – recalling Bellori's report[11] of the painting done by Caravaggio for the Capuchins of Messina, showing Saint Jerome Writing (a belated tribute perhaps on the part of the Order to Geronimo Errante?) – we were taken with the idea that the learned friar may have been instrumental in introducing the painter into the milieu of the Minorites, leading on to various commissions, by the fact that the Franciscan houses in Malta were administered from Sicily.[12]

Studies concerning Caravaggio have given due importance to his endorsement, over many years, of the work of the Minorite friars, perhaps through the influence of Federico Borromeo, cousin of Saint Carlo Borromeo, protector of all Franciscans and related to the Colonna family. Some scholars have attributed a particular role to Fra Bonaventura Secusio of Caltagirone, who had been General of the Minor Observant friars,[13] and was Archbishop of Messina when Geronimo Errante was confirmed Provincial for the second time.[14] Furthermore we should not forget that from 1605 to 1608, the year of his death (on 17 May), Ascanio Colonna – 'consilio, probitate, scientia & morum gravitate ornatissimus', formerly 'Archipresbyter Lateranensis, S. Joannis Hierosolimitanus Venetiae Prior, ... ac demum Episcopus Prenestinus', son of Marcantonio, brother-in-law of Anna Borromeo, sister of Saint Carlo, protector of Caravaggio, and supporter of Errante – was Commendatory Abbot of no less than three ancient and very wealthy Cistercian and Benedictine foundations in Sicily: Santa Maria di Novaluce near Catania, Santa Maria la Nohara in the diocese of Messina and Santa Maria di Altofonte seu de Parco on the outskirts of Palermo.[15] Ten years later the last named was in turn assigned to Scipione Borghese.[16]

But to go back to our starting-point, in Caravaggio's two Nativities we find the same spirit that imbues Errante's Expositio. Against the 'Heroic virtues' or civil virtues (Justitia, Temperantia, Magnanimitas, Fortitudo), which represent the only path to glory in this world, Errante returns to the Gospels and proclaims the Paupertas Spiritu as the only way to elude Cupiditas, the root of all

1. Michelangelo Merisi
da Caravaggio, *Nativity with
Saints Francis and Lawrence*,
1609. Formerly Palermo,
Oratorio di San Francesco

2. Michelangelo Merisi
da Caravaggio, *Nativity with
Saints Francis and Lawrence*,
1609, detail. Formerly Palermo,
Oratorio di San Francesco

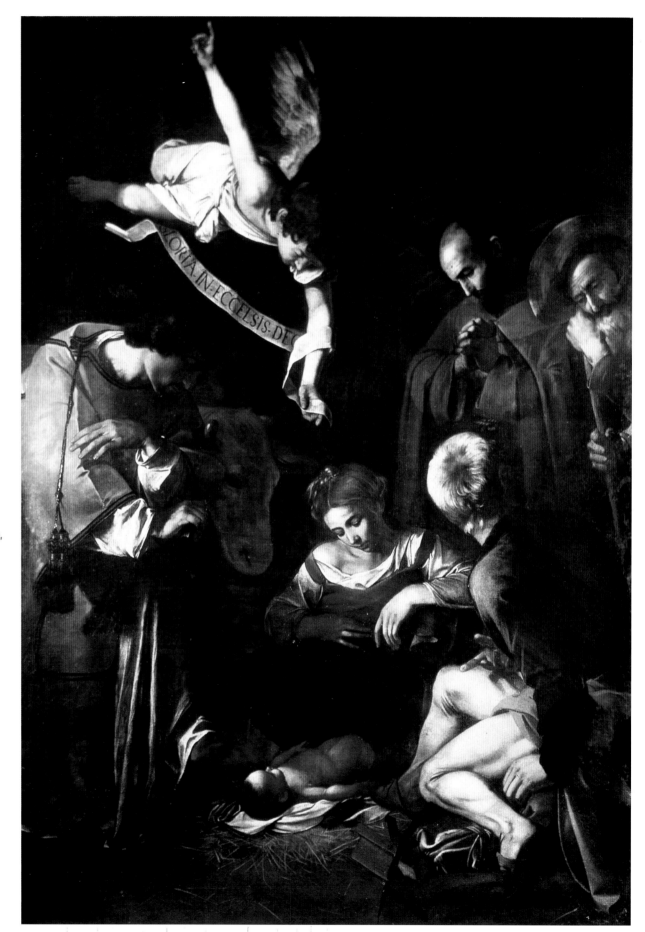

vices and of love for earthly things (chap. 6,1 02, p. 557). Only from poverty '*gignitur et nutritur* Humilitas', and from this derives *Oboedentia*, which in turn gives rise to and nurtures *Castitas*, because through poverty and humility the flesh yields to the spirit and is vanquished. The same goes for *Pax*, because it is generated only in the absence of greed, and when united to humility generates in its turn *Fortitudo* (ivi, p. 558).

If we probe further into other passages, such as the one dedicated to *Vilitas vestimentorum Fratrum Minorum*, where it is stated that '*vestes repetiare possint de sacco et aliis petijs; et hoc vel amore paupertatis, vel humilitatis*', we find an even more significant and pertinent reference in the *Saint Francis in Meditation* in Carpineto Romano, a metaphor for the humanistic theme of Melancholy and the Capuchins' affinity with Jesuit mysticism. This work is now confirmed as an autograph work by the Lombard artist. On the basis of technical evidence, revealed during the picture's very recent restoration,[17] of the handling of light and shadow, which has certainly more in common with the works of his last years, Marini recently assigned it once again to the artist's period in Palermo,[18] and related it to a profoundly Capuchin milieu.

It is above all in chapter 10.109 – the *summa* of the whole work – that we find all the poetry that comes from the intimate meditation on the new-born Child, which Longhi defined as typically Lombard.[19] '*Orare semper ad Deum puro corde et habere humilitatem, et patientiam im persecutione, et infirmitate et diligere eos qui nos persequuntur, reprhendunt et arguunt: quia dicit Dominus, diligite inimicos vestros, et orate pro persequentibus et calumniantibus vos*'; adding that pure oration '*ad humilitatem, patientiam et charitatem hortatur*'.

In both *Nativities* the onlookers are depicted in the act of praying and meditating in a 'humble' attitude, head bowed (fig. 2). For the picture in Messina, Marini[20] is undoubtedly correct in drawing attention to 'the character of *Natività dolente*, akin to the funereal meditations of the Capuchins; a joyous subject which in Caravaggio's outlook takes on the perspective of sacrifice'. In Palermo the message, based directly on the Gospels, emerges all the more clearly in connection with the devotions and pious exercises observed by the brotherhoods and the *exempla vitae* offered by Saints Lawrence and Francis, titular saints of the *Societas*. For the Compagnia di San Francesco in San Lorenzo, founded in 1569, Malignaggi has shown the significance of the pictures on the walls, three on each side, illustrating well-known episodes from the lives of the

two saints. They provided examples of moral edification such as the temptation and chastity of Saint Francis, the martyrdom of Saint Lawrence on the rack, and the sharing of goods with the poor. The same topics were pedantically reproduced about a century later by Giacomo Serpotta in his spectacular 'stage sets' which replaced the old paintings. This throws further light on the iconographical formulation of the altarpiece: 'the presence of Saint Francis and Saint Lawrence, flanking and focusing attention on the central group, is fully justified by the conceptual significance of the lost paintings which once hung on either side.'[21]

The adhesion to the Roman confraternity of the Girdle of

Saint Francis, the name given by Sixtus V to replace the erstwhile '*de' Bardigli o delli Cordiggeri*', fostered a greater spirit of co-operation in the Franciscan community in Palermo. This found visual expression in the woodcut showing the *Bolla dell'Istituzione*, 1588 (fig. 3). The motto *Funiculus triplex dificile rumpitur* is accompanied by *exempla* in the form of medallions showing the Franciscan Virtues, *Oboedentia*, *Castitas*, *Paupertas*, of the three families of the Order jointly (Conventuals, Observants, Capuchins) and other Virtues.[22] At the top two angels are offering the emblems of the Order to the brethren, seen kneeling in an attitude of humility: the habit of rough sackcloth and girdle being a

typically medieval legacy of the flagellant confraternities. In practical terms – times having changed, with Catholic reform under way – such *exempla* were only realised in good works, helping the needy and practising charity (it must not be forgotten that the association was founded in 1564 with the provision of burial for the paupers of the Kalsa district as its primary institutional function) and in the devout performance of processions, above all the one known as '*delli Cordiggeri*', guided by the Conventual friars, in which the brethren were required to take part wearing sackcloth with the emblems of Saint Francis – the standard, small crosses, torches – as specified in the *Capitula* of the *Societas.* [23]

At this point it may be appropriate to identify the connections which, in terms of contents, link the Company of Saint Lawrence, Caravaggio's altarpiece and the medieval picture of the *Madonna of Humility* by Bartolomeo da Camogli (fig. 4). The most striking feature is the presence 'of the suppliants and flagellants in the act of praying, clothed in sackcloth', who 'humble themselves' by kneeling to ensure that their prayers will be answered.[24] This is no straightforward revival of medieval artistic traditions in glorification of the Tridentine ideology which, outside Sicily, has numerous counterparts in the climate in Rome at the end of the sixteenth century, and unmistakable echoes in the cultural policy of Baronio and Federico Borromeo, whom we know to have been particularly associated with Caravaggio.[25] All the more so if, as now seems beyond doubt, the picture by Camogli was originally intended for the older *Capela mercatorum januensium* inside the monastery of St Francis of Assisi, and was only later installed in the alcove of the cloister[26] where one can still see the fine marble doorway leading into the new chapel, erected in the second half of the fifteenth century under the auspices of Sixtus IV della Rovere *januensis*. Inside, thanks to the concession of the Viceroy Gaspare de Spes granted in Palermo on 23 March 1480, the '*Honorabiles Januenses in hac felici urbe Panhormi commorantes, devotione impulsi*' were given licence to '*ordinare inter se ... et facere confratriam disciplinantium*'.[27]

Although modern rebuilding work has made it difficult to establish the original layout, it seems clear that the Genoan structure erected next to the Minorite monastery of St Francis was truly vast, and must have included all the area surrounding the first cloister and hence the two oratories still in existence, those of St Lawrence and the Immacolatella. We know moreover that the Company of the Immacolata, founded in 1575 by Fra Giuseppe Mandria, who had been a slave in Barbary, was originally located in the 'cappella dei Genovesi', subsequently moving next to the Oratory of St Lawrence following the purchase of some adjacent houses.[28]

The Genoese connection which played a part in Caravaggio's commissions in Palermo was perceptively pointed out by Calvesi and Malignaggi.[29] It depended in part on the appointment of Cardinal Giannettino Doria (1572–1642) as Archbishop on 6 May 1609,[30] shortly before the presumed date of Caravaggio's arrival in the city. This connection is amply borne out by the fact that the painting was intended for an oratorio which, in the context of the buildings of the Franciscan monastery of Palermo, stood in an area which continued well after 1609 to be under the control and administration of the Genoese, in spite of the fact that as early as 1576 work was in hand on the church of the Genoese Nation named after Saint George (1576–1591). It is no coincidence that on 15 November 1622 the '*Capitaneus Laurentius Isola januensis*' specified in his will that '*die sui obitus, cadauer sepelliri, et humari ... in Ecclesia conventus Sancti Francisci de Assisi huius urbis Panormi et in sepoltura januensium*'.[31]

While Villabianca was certainly correct in describing St Lawrence as a church and company of 'people in trade',[32] it is only now that we can be sure of the substantial Genoese element in this institution, since we have unexpectedly brought to light the '*Roll of the brethren of the Venerable Company of St Francis of Assisi founded in the church of St Lawrence in this city of Palermo in the year of our Lord 1564, confirmed thereafter by His Excellence Don Ottaviano Precone Archbishop of the same Blessed City on 21 March 1566*'.[33]

The first item of note is that 'the founder of Our Company' is Genoese by birth, Antonio Massa, who 'died on 9 February 1574 and was buried in our Oratory'. More interesting still is to see how at the end of the sixteenth century and through the first decade of the seventeenth, among the lay and religious brethren who can be identified, there were some whose surnames show clearly that they came from Genoa, providing a network of acquaintances and introductions leading up to the award of the commission to Caravaggio: Giovanni Borgise (or Borgese), Mariano Maringo, Battista Costa, Antonino Pozzo, Filippo Brignone, Bartolomeo Maino, Raffaello Scattino, Tommaso Costa, Francesco Grimaldi, Alessandro Brignale, Santo Pernice; the M.R.P. Fra Filippo Gesualdo, a Neapolitan Conventual Minor, enrolled in 1590 and subsequently appointed bishop in the Kingdom of Naples; Padre maestro Clemente, a Milanese Conventual, enrolled in 1605 and buried in the monastery St Francis in Milan; Padre maestro Santo Sala, Conventual, who died in Naples in 1637; Padre maestro

Mario Trayna, Conventual, who died in 1625; a certain Filippo Maltisi; Fra Mariano d'Alcamo, Capuchin, enrolled in 1607 who died in 1620; Don Vincenzo Capua, possibly from the family of the Princes of Conca, linked to Cardinal Giannettino Doria on account of a debt of 1538 ducats owed to his father, Prince Gian Andrea, and still outstanding in 1612;[34] and finally Andrea Bramè, whose family is known to have come from Genoa, enrolled in 1608 undoubtedly on the strength of the trade he practised in the family workshop in Calata di San Lorenzo, next to the Oratory, who died in 1615. It seems certain that he was related to the painter Paolo Bramè, responsible for the miniature in the frontispiece of the volume of the Chapters of the Company (fig. 5). Indeed I should not be surprised if the six pictures in the Oratory showing episodes from the lives of the two titular saints were not his work, for in view of the period he spent in Rome and his activity as engraver – as we have recently documented[35] – he must have been acquainted with the prints by Philip Galle featuring the life of Saint Francis published in Antwerp in 1582 and again, revised and corrected, in 1587.[36]

Trasselli and Braudel have shown clearly that the secret behind the power of Genoa, above all in the sixteenth and seventeenth centuries, and not only in Sicily, lay in the large number of male sons born to Genoese families, with of course innumerable ramifications. This led to a close cohesion, as in a clan, since the strength of a family – acting on its own or in association with others – lies, as Trasselli affirmed, in its widespread presence from north to south, particularly in the nodes of commerce and power, making it to all intents and purposes 'like a multinational or supranational financial enterprise'.[37]

I am particularly intrigued by the real identity of the *Thomas Costa januensis* named in the documents, enrolled in the Company; how significant was his business, and was he related to the Costa families of Genoa, Rome and Naples, and in particular with the banker and collector of Caravaggio Ottavio Costa?[38] And also by Ippolito Malaspina, '*mercator januensis*' (a namesake of the Grand Prior of Naples and Grand Cross of Malta of the Marchesi di Fosdinovo), continually present in Palermo from at least 1611 to 1623 when, in partnership with Nicolò Bozolo, 'merchant' of the Genoese Nation of Palermo, he was trading in cloth (Majorca twill weave, Genoese serge, Barcelona linen, Neapolitan linen, ribbed cloth, Roman linen, Florentine serge, Garbo twill weave, Reo twill weave, canvas, Sangallo canvas).[39]

Pursuing our list of people linked with Caravaggio, it is interesting to learn from documents that in 1623 Don

Antoniotto Costa, '*eques Hierosolimitanus et filius Octavii Costa habitatoris urbis Romae*', was in Palermo, and named as his agent, '*actorem, factorem Thomam Crapi in urbe Messane ... et pro eo recipiendum et recuperandum*' what he was owed by '*Thoma et Jo. Bactista Lazzari Messane*', in other words, the two Genoese merchants who commissioned *The Raising of* Lazarus.[40] Two other figures who were closely linked to the Genoese community from 1612 to 1613 were Don Gaspare Orioles, Baron of Fontanafredda,[41] a Marinist poet who from 1615 had contacts with Marco Gezio, from a Milanese merchant family,[42] chaplain in the Cathedral of Palermo and a great collector, and Orazio Giancardo whom we know to have held the office, which was more lucrative than prestigious, of '*Arrendatarius omnium gabellarum Secretiae huius Regni Siciliae*'.[43]

Quite early on, in 1627, Orioles is known to have asked the painter Paolo Geraci to make a copy of Caravaggio's *Nativity* in Palermo.[44] Then there is a recently found document which throws light on the presence in Palermo of another work known to be by Caravaggio. This would appear to be the lost *Road to Calvary* ('showing Christ with the Cross on his shoulders, the Lady of Sorrows and two rogues, one playing the trumpet ... paid 46 oz.', the only picture he completed of the four commissioned by the Messinese nobleman Nicolò di Giacomo prior to August 1609.

In 1659, on the death of Don Andrea Valdina, Marquis of La Rocca, the picture was in Palermo in his house in the Kalsa, figuring as no. 8 in his picture collection: 'a Christ with the Cross on his shoulders by Caravaggio, same size as above, frame gold and black'. The size above – meaning 5 palms by 4 (125 x 100 cm circa) – refers to an *Ecce Homo*, without attribution.

Both paintings, with other pictures and furniture, were moved a few years later to the castle of La Rocca (now Roccavaldina in the province of Messina), which makes it all the more likely that they were originally painted in Messina.

In 1672 the two works were again described as being in 'the second room of the old part' of the castle, after which all trace of them is lost.[45]

This essay, with modifications and updated bibliography, is taken from my article La città aperta. Pittura e società a Palermo tra Cinque e Seicento, *in* Porto di mare 1570-1670. Pittori e Pittura a Palermo tra memoria e recupero, *exhibition catalogue (Palermo, San Giorgio dei Genovesi, 30 May – 31 October 1999), ed. V. Abbate, Naples 1999.*

[1] F. Hackert, *Memorie de' Pittori Messinesi*, Naples 1792, ed. S. Bottari, Messina 1932.

[2] For a complete bibliography for the two works see the catalogue *Caravaggio in Sicilia, il suo tempo, il suo influsso* (Syracuse, Palazzo Bellomo, 1 December 1984-28 February 1985), Palermo 1984, esp. pp. 158-61, 162-4; M. Calvesi (ed.), *L'ultimo Caravaggio e la cultura artistica a Napoli, in Sicilia e a Malta*, Conference Proceedings, Syracuse 1987, and M. Marini, *Michelangelo Merisi da Caravaggio «pictor praestantissimus»*, Rome 1987.

[3] W. Friedlander, *Caravaggio Studies*, Princeton 1955 (repub. 1969), cited by M. Marini 1987, see previous note, p. 540.

[4] F. Susinno, *Le vite de' pittori messinesi* (1724), ed. V. Martinelli, Florence 1961, pp. 109-16.

[5] V. Pacelli, *L'ultimo Caravaggio, dalla Maddalena a mezza figura ai due San Giovanni*, Todi 1994, pp. 92 and 221, note 104.

[6] For the figure and activity of Fra Geronimo Errante di Polizzi see P. Antonino da Castellammare, *Il Padre fra Girolamo da Polizzi della Provincia di Palermo*, Palermo 1935; idem, *Della venuta dei Cappuccini in Sicilia*, Palermo 1937, in part. pp. 184-193.

[7] V. Abbate, 'I tempi del Caravaggio. Situazione della pittura in Sicilia (1580-1625)', in *Caravaggio in Sicilia*, cited in note 2, esp. pp. 49-52.

[8] A. Da Castellammare 1937, cited in note 6, pp. 35ff.

[9] Petrucci, *ad vocem*, in D.B.I. During the conclave in which Clement VIII was elected, Colonna caused a sensation by declaring his opposition to Cardinal Giulio Antonio Santori, the Spanish candidate.

[10] M. Calvesi, 'Le realtà del Caravaggio. Prima parte (vicende)', in *Storia dell'Arte*, 53, 1985, pp. 51-85, esp. pp. 64ff.; A. Zuccari, 'La politica culturale dell'Oratorio Romano nelle imprese artistiche promosse di Cesare Baronio', in *Storia dell'Arte*, 42, 1981, pp.171-93; idem, *Arte e committenza nella Roma di Caravaggio*, Rome 1984, *passim*.

[11] G.B. Bellori, *Le vite de' pittori, scultori et architetti moderni*, Rome 1672 (ed. E. Borea, Turin 1976), p. 210; V. Abbate, *I tempi del Caravaggio*, cited in note 2, pp. 51-2.

[12] S. Cucinotta, *Popolo e clero in Sicilia nella dialettica socio-religiosa fra Cinque e Seicento*, Messina 1986, esp. p. 514.

[13] A. Spadaro, *Note sulla permanenza di Caravaggio in Sicilia*, in M. Calvesi (ed.) 1987, cited in note 2, pp. 289-92.

[14] A. Da Castellammare 1937, cited in note 6, p. 192.

[15] See R. Pirro, *Sicilia Sacra* (with additions by V.M. Amico), Palermo 1733, facsimile reprint, Bologna 1987, t. II, pp. 1194, 1303, 1328; for Cardinal Ascanio Colonna see also M. Calvesi 1985, cited in note 10, esp. pp. 64ff.; idem, 'Nascita e morte di Caravaggio', in M. Calvesi (ed.) 1987, cited in note 2, pp. 13-41, esp. pp. 18-19, with previous bibliography.

[16] V. Abbate, 'La città aperta. Pittura e società a Palermo tra Cinque e Seicento', in *Porto di mare 1570-1670*, Naples 1999, pp. 11-56, esp. pp. 18, 34, 53, note 55; V. Abbate, 'Contesti e momenti del primo caravaggismo a Palermo', in *Sulle orme di Caravaggio tra Roma e la Sicilia*, exhibition catalogue (Palermo, Palazzo Ziino, 4 March – 2 May 2001), eds V. Abbate, G. Barbera, C. Strinati and R. Vodret, Venice 2001, p. 85.

[17] See R. Vodret, entry 5 in *Sulle orme di Caravaggio tra Roma e la Sicilia*, cited in previous note, pp. 118-19, with previous bibliography.

[18] M. Marini, 'Michelangelo da Caravaggio in Sicilia', in *Sulle orme di Caravaggio tra Roma e la Sicilia*, cited in note 16, pp. 3-23, esp. pp. 16-17, with previous bibliography.

[19] R. Longhi, *Il Caravaggio*, Milan 1952, cit. by M. Marini 1987, cited in note 2, p. 548.

[20] M. Marini 1987, cited in note 2, p. 540.

[21] D. Malignaggi, 'L'altare gaginiano di S. Giorgio e gli episodi artistici a Palermo nel terzo decennio del Cinquecento', in Atti del III Incontro 'Genova e i Genovesi a Palermo' (Palermo 21-23 March 1980), Palermo 1982, pp. 278-88. The scholar has pointed out that these images probably derive from the series of engravings published by Philip Galle in Antwerp in 1582 and again 1587, based on the life of Saint Francis (published also by Prosperi Valenti Rodinò in *L'immagine di S. Francesco nella Controriforma*, exhibition catalogue, Rome, Calcografia, 9 December 1982-13 February 1983, Rome 1982, pp. 179ff.).

[22] *L'immagine di S. Francesco nella Controriforma*, cited in previous note, entry 122, p. 188.

[23] See ASPa, Fondo S. Francesco, *Capitoli...*, esp. c. 227v.

[24] De Floriani, *Bartolomeo da Camogli*, Genoa 1979, p. 19.

[25] For these aspects see Zuccari 1984 cited in note 10, and B. Agosti, *Collezionismo e archeologia cristiana del Seicento. Federico Borromeo e il Medioevo artistico tra Roma e Milano*, Milan 1995.

[26] It was seen here by Cannizzaro and Mongitore; but see De Floriani 1979, cited in note 24, p. 23 note 3. For the hypothesis concerning another arrangement inside the church, leading to a different account of the work's commission and intermediary, see F. Rotolo, 'Le cappelle pisane nella Basilica di San Francesco e l'arco di S. Rainieri nella Cappella dei Lombardi', in *Immagine di Pisa a Palermo*, Atti del Convegno (Palermo, Agrigento, Sciacca, 9-12 June 1982), Palermo 1983, pp. 335-55, esp. pp. 344-5.

[27] See in this respect R. Patricolo, 'La Cappella dei mercanti genovesi nel chiostro della Basilica di S. Francesco d'Assisi in Palermo', in Atti del III Incontro 'Genova e i Genovesi a Palermo' (Palermo 21-23 March 1980), Palermo 1982, pp. 85-110, esp. p. 91; idem, *S. Giorgio dei Genovesi e le sue epigrafi*, Palermo 1980, esp. pp. 9-13. The new chapel was adorned with the splendid altar of St George commissioned from Antonello Gagini by the *Societas Nobilium Mercatorum* in February 1520 and installed in 1526 during the consulship of Giacomo Negrono (Patricolo *S. Giorgio dei Genovesi*, cit., p. 92; D. Malignaggi, *L'altare gaginiano di S. Giorgio*, cit., pp. 52-61).

[28] D. Malignaggi, *La Natività del Caravaggio e la Compagnia di S. Francesco nell'Oratorio di S. Lorenzo*, in M. Calvesi (ed.) 1987, cited in note 2, pp. 280-1.

[29] M. Calvesi (ed.) 1987, cited

on the previous pages

3. *Bolla dell'Istituzione della Confraternita del cordone di San Francesco*, woodcut on parchment, 1588

4. Bartolomeo da Camogli, *Madonna of Humility*, 1346. Palermo, Galleria Regionale della Sicilia

5. Paolo Bramé, *Saint Francis and Saint Lawrence*, miniature. Rome, Volpe collection

in note 2, p. 19; Malignaggi, ibid., p. 287.

30 For Cardinal Giannettino Doria see S. Pedone, 'Il Cardinale Giannettino Doria Arcivescovo di Palermo e Presidente del Regno di Sicilia', in Atti del III Incontro 'Genova e i Genovesi a Palermo', cited in note 21, pp. 111–25.

31 ASPa, Not. F. Comito, Minute, vol. 921 (aa. 1619–23), part III, c. 7r.

32 F.M. Emanuele and Gaetani di Villabianca, Il Palermo d'Oggigiorno (m.s. Biblioteca Comunale di Palermo, Qg E 91-92), in Biblioteca Storica e Letteraria di Sicilia, ed. G. Di Marzo, vols II and IV, Palermo 1873 (facsimile reprint Sala Bolognese 1974), p. 387.

33 Rollo di fratelli della Venerabile Compagnia di San Francesco d'Assisi fundata nella Chiesa dim S. Lorenzo di questa Città di Palermo l' anno del Signore MDLXIIII, confirmata doppo dall'Ill.mo et Reuerend.mo Sign. D. Ottaviano Precone Arcivescovo dell'istessa Felicissima Città a 27 di marzo MDLXVI, ridotto in questa forma nel MDCLIX, 17th century ms., Palermo, private library.

34 The loan made by Gianandrea Doria to quondam Don Matteo Capua olim Prince of Conca went back to 1598; in a notarial act dated 22 August 1612 the cardinal, as heir, appointed the Neapolitan Francesco Roberto as his procurator to recoup the sum; cfr. ASPa, Not. F. Comito, Minute, vol. 910 (aa. 1611–12), c. 871r e c. 873r; idem, Registri, vol. 928 (aa. 1611–12), c. 886v.

35 See on this topic V. Abbate, La città aperta. Pittura e società a Palermo, cited in footnore to article, esp. pp. 23–32; Andrea Bramè and his brother Agostino, sons of Giovanni, are known to have been cousins of Paolo, and connected with the Franciscans; on 1 March 1607 they donated to the monastery 250 onze 'for the building ... new refectories and dormitories' and for daily masses; see F. Meli, 'Nuovi documenti relativi a dipinti di Palermo dei secoli XVI e XVII', in Atti dell'Accademia di Scienze, Lettere e Arti di Palermo, s. IV, XVI, fasc. I, part II, 1955–6, p. 203.

36 D. Malignaggi, 'La Natività...' cited in note 28, p. 283; Prosperi Valenti Rodinò, in L'immagine di S. Francesco nella Controriforma, cited in note 21, esp. entry 15, pp. 179–84.

37 See C. Trasselli, 'I rapporti tra Genova e la Sicilia: dai Normanni al '900' in Genova e I Genovesi a Palermo. Genova, 13 dicembre 1978 – 13 gennaio 1979, Conference Proceedings, Genoa 1980, pp. 13–37, who gives further bibliography.

38 For Ottavio Costa see L Spezzaferro, 'Ottavio Costa e Caravaggio: certezze e problemi' in Novità sul Caravaggio. Saggi e contributi. Bergamo 1974, Conference Proceedings, ed. M. Cinotti, Milan 1975, pp. 103–18, with further bibliography; M. Calvesi 1985, cited in note 10, esp. p. 72, with bibliography.

39 ASPa, Not. F. Comito, Minute, vol. 922 (aa. 1623–24), act of 22/9/VII Ind. 1623, cc. 51r et seq.

40 Ivi, act of 9/11/VII Ind. 1623, c. 133r.

41 On Orioles Marinist poet see D. Malignaggi, 'La Natività', cited in note 28, esp. pp. 286–7; and also ASPa, Not. F. Comito, Minute, vol. 913 (aa. 1614–15), c. 692r, act of 5/6, XIII Ind., 1615; Don Marco Gezio chaplain of the Cathedral of Palermo rented to Orioles a fine house 'sita et posita in quarterio cassari jn strada tollera in frontispicio peani eiusdem Maioris Ecclesie', see V. Abbate, 'Contesti e ...', cited in note 16, esp. p. 77.

42 On Gezio and the trading interests of his family see V. Abbate, 'Contesti e ...', cited in note 16, esp. pp. 78–9.

43 ASPa, Not. F. Comito, Minute, vol. 910 (aa. 1611–12), c. 645r; Minute, vol. 911 (aa. 1612–13), c. 393r.

44 See F. Meli, 'Nuovi documenti ...' cited in note 35, esp. p. 219; V. Abbate, 'Contesti e ...', cited in note 16, p. 77, and entry by M. Marini in Sulle orme di Caravaggio tra Roma e la Sicilia, cited in note 16, pp. 132–4.

45 See L. Salamone, 'L'Archivio privato gentilizio Papé di Valdina', in Archivio Storico Messinese, vol. 79, Messina 1999, esp. p. 50. For Caravaggio's lost work, first referred to by V. Saccà ('Michelangelo da Caravaggio pittore. Studi e ricerche', in Archivio Storico Messinese, 1907, VIII, pp. 64–5), see the essays and studies of F. Campagna Cicala, 'Intorno all'attività di Caravaggio in Sicilia. Due momenti del caravaggismo siciliano: Mario Minniti e Alonzo Rodriguez', in Caravaggio in Sicilia, il suo tempo, il suo influsso, exhibition catalogue (Syracuse, Palazzo Bellomo, 1 December 1984 – 28 February 1985), Palermo 1984, pp. 101–44, esp. pp. 117ff., and M. Marini 1987, cited in note 2, esp. p. 568.

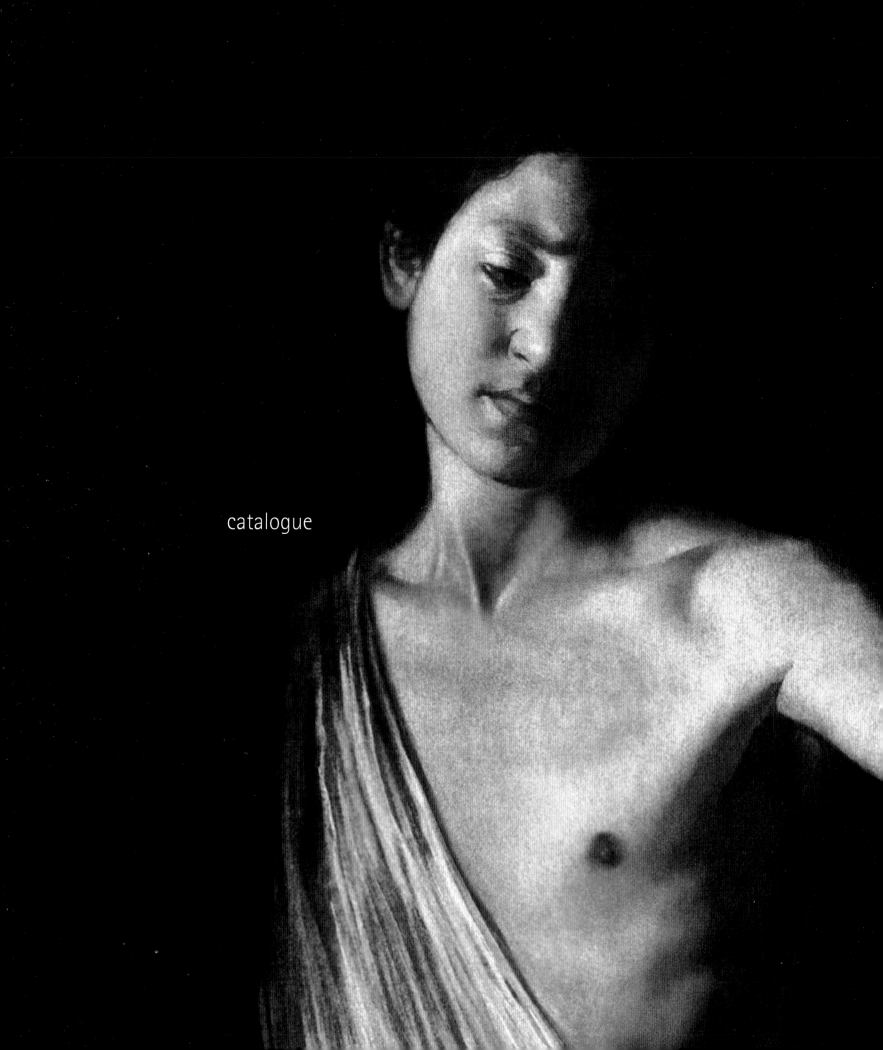

catalogue

autograph works

Caravaggio portrayed the Supper at Emmaus in two compositions that virtually span the greatest years of his Roman career. This forceful demonstration of his ability at naturalistic representation was painted in 1601 as he was becoming famous for his innovative, powerful pictures. The other painting (cat. no. 2) was made soon after he fled the city in 1606 and thus initiates the period that is the subject of this exhibition. The juxtaposition of these two paintings, so similar in scale and composition, but so very different in mood and realisation, will demonstrate the profound and rapid development of Caravaggio's style and artistic personality from youthful bravura to the mature and grave sensibility of his later works.

Caravaggio captures the climactic moment in the story of Christ's appearance to the apostles at Emmaus on Easter day. Luke 24:13–32 tells that Cleophas and another disciple walked from Jerusalem to the village of Emmaus after learning of the Resurrection. Along the road they were joined by Christ, though his identity was hidden from them. When they expressed sorrow and doubt, he chided them for their lack of faith. While they were warmed by his works, they remained oblivious to his identity. Once they reached Emmaus, they welcomed the stranger to supper and it was only when he blessed the bread that 'their eyes were opened, and they recognised him; and he vanished out of their sight'.

The basic composition of figures around a table with Christ in the centre was traditional in the depiction of this scene in Renaissance Venice and Lombardy, as were naturalistic still-life elements and tablecloths spread over carpets (Potterton 1975, p. 6). Using standard formulas, Caravaggio created a scene of extraordinary actuality in which the viewer is swept up in the surprise and astonishment of the apostles. For this subject the artist pushed his exploration of rhetorical gestures to the extreme. The painting is roughly contemporary with the Cerasi Chapel commission in Santa Maria del Popolo in Rome awarded to Caravaggio and Annibale Carracci and Carracci's example is evident in the gestures even if thoroughly assimilated into Caravaggio's own idiom.

Caravaggio depicts the moment of recognition with explosive force. Christ reveals himself with a bold gesture of blessing as his other hand signifies the bread being consecrated. The apostles express more than surprise. Their reactions imply that they fully realise the significance of his appearance: that he is truly risen, that he is the Messiah, and that his promise of life after death is real. The one at left instinctively rises in the presence of the divine and the one at right throws out his arms, making the form of the cross, his hands bridging darkness and light, our world and the picture's. The chair is cunningly cropped to break the picture plane and the basket of fruit is suspended over the edge of the table, all lending to the impressive sense of immediacy. The unnaturally strong light raking down into the evening interior is a compelling metaphor of recognition. The light also gives the forms a potent sense of presence even if it is not applied consistently. Some see Christ's symbol, the fish, in the shadow cast by the fruit and the innkeeper's shadow on the wall serves as a dark halo emphasising Christ's presence.

The apostle rising from the Savonarola chair is usually identified as Cleophas, a disciple known only from the Emmaus narrative. The other apostle is not named in the Gospel, but he

is most often identified as Peter, who might be alluded to in the cruciform pose. He wears the scallop shell of a pilgrim as was traditional in Emmaus scenes, which suggests that his pilgrimage finds fulfilment in this event. The innkeeper serves as a foil, his expression, gesture and covered head indicating his lack of understanding of what is taking place, but also his recognition that something significant is happening. The strongly tangible items on the table include the elements of the Eucharist, bread, wine and water, and a basket containing fruits that allude to the Eucharist and to the Resurrection (Warma 1990).

Bellori questioned the decorum of Caravaggio's unprecedented characterisation of the Emmaus Christ as young and beardless. Luke never precisely explained why the apostles failed to recognise Christ, so divine intervention was presumed until 'their eyes were opened'. Scribner pointed out that Caravaggio was concerned with the visual logic of this lack of recognition and turned to Mark 16:12, which states that Christ appeared to the disciples 'in another likeness (*in alia effigie*)' (Scribner 1977, p. 378). Caravaggio shows Christ not as he appeared at the end of his life, but as young and unmarked by the Passion, which gives credibility to the apostles' recognition only through the gesture used at the Last Supper and serves to involve the viewer in the realisation because we also would not readily recognise Christ without the gesture. Caravaggio's portrayal of the risen Christ as literally rejuvenated is a typically simple, audacious and powerful metaphor of rebirth.

This canvas is almost certainly the 'painting of Our Lord breaking bread' ('quadro de N[ostro] S[ignore] in fractione panis') for which Ciriaco Mattei paid Caravaggio 150 scudi on 7 January 1602 (Cappelletti and Testa 1994, pp. 104–5, 139, no. A31). Baglione's identification of the Mattei subject as Christ going to Emmaus ('N. Signore andò in Emmaus') long caused controversy, but the discovery of the payment confirms the Mattei subject as the Supper. Similar contradictory evidence exists regarding the Emmaus scene that Caravaggio made at Zagarolo in 1606 (see cat. no. 2). The discovery of the payment confirmed the date long proposed by scholars based on its close relationships with the *Amor* (Berlin, Gemäldegalerie) and the first version of the Contarelli Chapel *Saint Matthew Inspired* (formerly Berlin, Kaiser Friedrich Museum), in which the same chair is utilised. The painting was no longer in the Mattei collection by 1616, when it fails to appear in the inventory of Giovanni Battista Mattei, Ciriaco's son and heir (ibid., pp. 173–6). It would seem likely that Scipione Borghese acquired the painting from the Mattei before 1616 because the National Gallery *Supper* is certainly the painting in the Borghese collection mentioned by Manilli (1650, p. 88) and Bellori (1672, p. 208). The 'No. 1' in the lower right-hand corner is noted in the 1693 inventory of the Palazzo Borghese in Campo Marzio (Della Pergola 1964, p. 453, no. 261).

1. The Supper at Emmaus

oil and egg on canvas,
141 x 196 cm
London, The National Gallery,
NG 172

This painting is one of Caravaggio's most highly finished works. The composition was carefully established on the canvas prior to painting as generally the forms do not overlap, but there are few signs of Caravaggio's preparation

Although Caravaggio had long employed the Lombard technique of using the ground in middle tones, here the flesh is strongly modelled, extending the tonal range for an especially potent sense of presence. [d.c.]

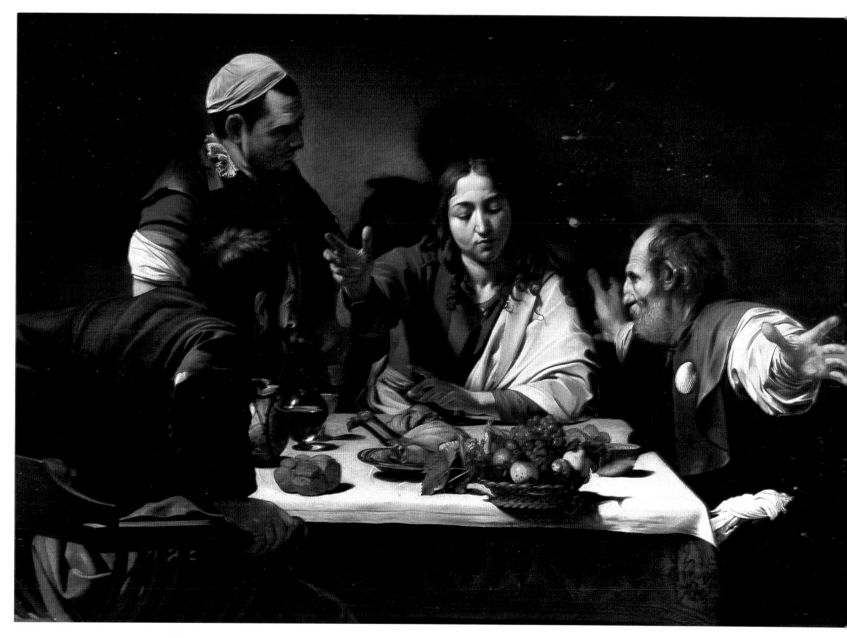

(Keith 1998, pp. 42–5). The translucent, red-brown ground is extensively covered by paint, more than most contemporary works, and especially in contrast with the Brera version's thin application and extensive use of the ground colour.

Bibliography: Levey 1971, pp. 49–53; Gregori in New York 1985, no. 78, pp. 271–6; Varriano 1986, pp. 218–24; Bell 1995, pp. 139–70; Testa 1995, cat. no. 1, pp. 118–19.

Caravaggio employed basically the same composition as the London *Supper at Emmaus* (cat. no. 1) and a canvas of the exactly the same height, but the Brera version shows a striking change in mood and execution. Bellori was the first to comment on the difference between the two, particularly noting that the Brera version was 'più tinta' or darker. Not only has the illumination been dimmed, but all ambient light has been banished to isolate the main action in a dark void. Concomitant with the lower light, colour is muted and forms are softened and more summarily indicated in comparison with the crisp solidity and sharp distinctions in the London painting. A unifying atmosphere contrasts with the crystal clarity of the London version, but the scene retains a profound sense of presence. The varying intensity of the light endows this representation with a vibrant emotional tenor as well as stressing its immediacy.

In this new probing of the subject, the composition is simplified and drawn inward. The chain of hands around the table is completed by the bread and wine, evoking the eternal presence of the risen Christ in the Eucharist, the essential message of the Emmaus narrative. The eucharistic elements are here emphasised and made humble in comparison with the London version. The massing of the figures to the right creates an expressive emptiness, a motif that would be developed further in the *Flagellation* (no. 6) and further still in Malta and Sicily. The exuberant theatricality and bold illusionism of the London painting convey an excited, triumphant mood, while the Milan version is quieter, deeper, and more meditative. Its power depends on restraint, which is especially evident in the earthy colour range, and in gestures that are contained and focused inward. Even though the apostles are given essentially the same gestures as their London counterparts, their response is not explosive astonishment, but awestruck recognition. They are overwhelmed by the presence of the divine, which Caravaggio perhaps grew to feel was a more natural and truer emotive response to the presence of the risen Christ and its implications. The open hands of the apostle in the foreground are tremulous with light flickering around them. Caravaggio assumes a lower viewpoint and avoids breaking the picture plane to enhance the intimacy of the confrontation around the table. This sense of intimate connection is enhanced by the orchestration of the light and particularly by the head of the foreground apostle lit from behind, a motif that would be developed in the Naples *Flagellation* (cat. no. 6).

2. The Supper at Emmaus

100

oil on canvas, 141 x 175 cm
Milan, Pinacoteca di Brera,
inv. 2296

Christ is immediately recognisable as the mature man crucified three days earlier. He becomes the eternal, blessing Christ only by the omission of any sign of his suffering. Caravaggio's audaciously inventive portrayal of the risen Christ as youthful in the London version is rejected here, reflecting a more mature vision. As with the depiction of the still life, all compositional elements are restrained and balanced, revealing his growing classicism.

The robust characters of the London *Emmaus* are transformed and endowed with humility. The innkeeper is no longer boldly incredulous, but leans back pensively. Sensing the sacred moment, the old woman respectfully waits to serve the rack of lamb. They function as witnesses, a supporting chorus, and establish the meditative mood that is tinged with sadness (Gregori 1995, p. 306).

Bellori criticised Caravaggio's depiction of the disciples as vulgar. While Caravaggio consistently used ordinary people as models, it is worth noting that it was particularly appropriate for this subject because the *Golden Legend* associated Christ's appearance at Emmaus with Christ's poor and meek (Voragine 1993, vol. 1, p. 220). Here, the proletarian apostles illustrate the significance of the miracle for all people, but especially the meek, and perhaps they reveal a humbler Caravaggio as well. This painting is probably the Emmaus scene that Mancini and Bellori mention among the first works created by Caravaggio after his flight from Rome in 1606. Painted while under the protection of the Colonna family at Zagarolo, it was identified as a 'Christ going to Emmaus' ('Christo che va in Emaus') by Mancini, who goes on to say that it was 'taken to Rome' and 'sold to Costa' (Mancini 1956–7, I, p. 225). Bellori described a 'Christ at Emmaus between the two apostles' ('Christo in Emaus frà li due Apostoli') that might signify a Supper or a Road to Emmaus (Bellori 1672, p. 208). In a separate passage Bellori precisely described the Brera *Supper at Emmaus*, which he saw in the collection of the Marchese Patrizi, without connecting it to the Zagarolo composition (ibid.). This might indicate that the Brera painting is a different Emmaus scene or, more likely, that Bellori did not correlate the sketchy information on Zagarolo with the painting in the Palazzo Patrizi. The Brera *Supper* was first recorded in a Patrizi inventory of 1624 and remained with the family until acquired by the Amici di Brera for the Pinacoteca in 1939. As a viable candidate for a late Road to Emmaus composition has not been identified, it is assumed that the Brera painting is the Zagarolo *Emmaus* even if the supporting documentation is inconsistent. Similar confusion exists over the subject of the Mattei Emmaus scene (see cat. no. 1). If the Brera painting is the one made at Zagarolo, Ottavio Costa presumably sold it to the Patrizi before 1624, and there is the possibility that he acted as an intermediary in 1606 (Gregori 1992, p. 227–8).

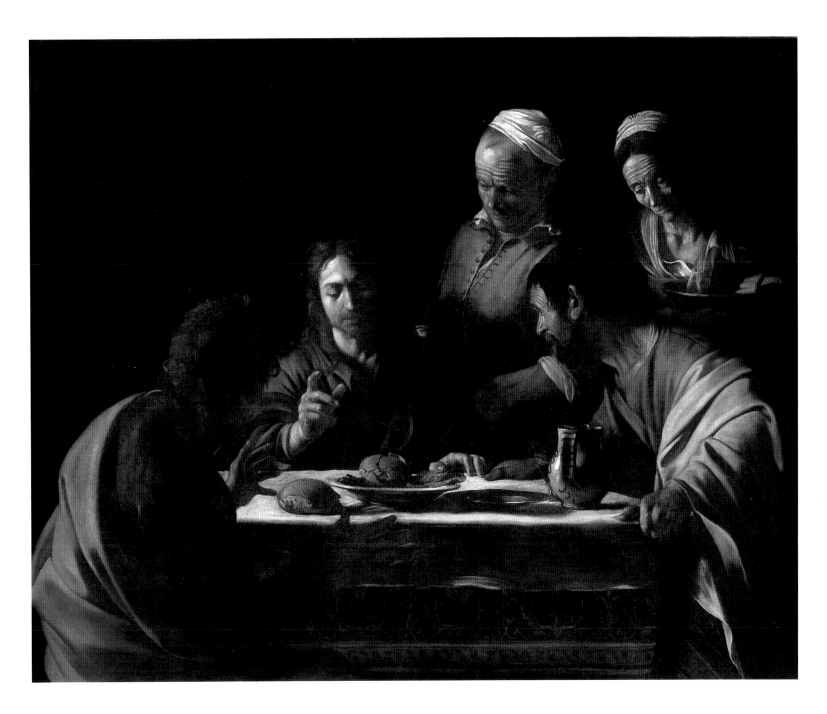

The *Supper at Emmaus* is universally acknowledged in modern scholarship as the work of Caravaggio and there is consensus that the painting dates to 1605–6, as it clearly develops trends evident in the *Death of the Virgin* and the *Madonna dei Palafrenieri*. Doubts about the Zagarolo subject have led to the suggestion that this work was made in Rome in the period immediately before Caravaggio's flight, but most scholars identify it with the composition made at Zagarolo in the summer of 1606 (survey of opinions in Marini 2001, no. 75, pp. 505–7).

Christiansen has plausibly suggested that this is one of the first paintings in which the fresh study of each figure from the model was supplanted by types (Christiansen 1986, p. 440). The visage of the old woman is similar to that of Saint Anne in the *Madonna dei Palafrenieri*, suggesting that the same model was used, which would be unlikely owing to Caravaggio's flight from Rome. This old woman type would set the emotional tone in many of Caravaggio's late depictions of martyrdom.

The technique follows the grave mood of the Brera *Supper* and contributes to it. The paint is laid on very thinly and tersely, especially in comparison with the London version, one of Caravaggio's most highly finished works. Here, the ground and canvas weave are evident and the relatively dilute paint was seemingly applied rapidly and, in parts, with a cursory use of the brush on the ground colour. While this trend was evident in the late Roman pictures, this painting represents a giant step in Caravaggio's desire to achieve powerful physical and psychological presence with a magisterial economy of means. In keeping with his treatment of the subject, the technique is reduced to essentials. [*d.c.*]

Bibliography: Gregori in New York 1985, no. 87, pp. 306–10; Gregori in Milan 1992, no. 94, pp. 227–31; Marini 2001, no. 75, pp. 505–7.

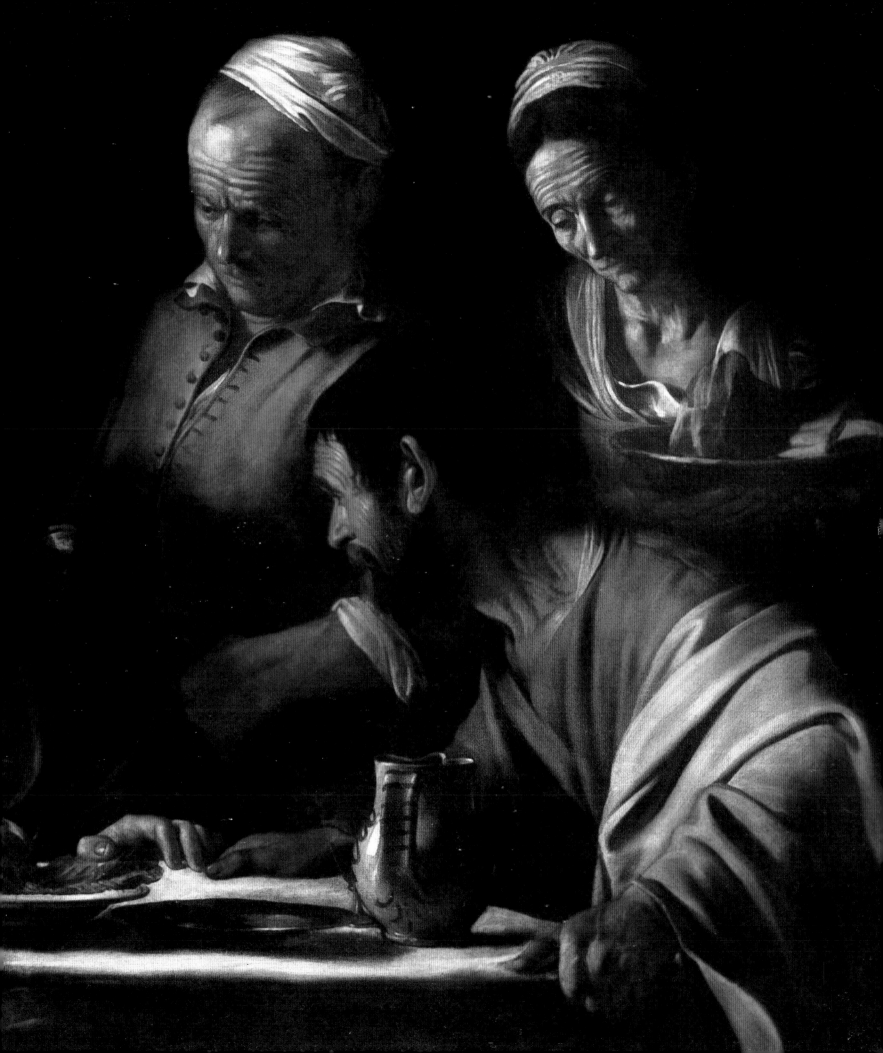

3. Saint Francis in Meditation

104

oil on canvas, 130 x 90 cm
Cremona, Museo Civico
Ala Ponzone, Pinacoteca,
inv. 234

This marvellous, psychologically intense portrayal of Saint Francis – 'in disperata meditazione sul Crocefisso' (Longhi 1943, p. 17) – was introduced into the Caravaggio literature by Longhi in 1943. Although he considered it a copy, in his inimitable fashion he framed future discussion of the picture: 'l'originale, ove è forse un pensiero tragicamente autobiografico, dové toccare all'ultimo e più affannato tratto della vita del maestro'. Following its exhibition in the 1951 *Mostra di Caravaggio* in Milan (p. 41, cat. 60) – as a copy – Denis Mahon (1951, p. 234, n. 125) asserted its claim to being considered an autograph work of c.1607, that is, during Caravaggio's first Neapolitan period, and in 1952 (p. 42) Longhi, modifying slightly his views ('in originale consunto o copia fedele'), dated it to the period immediately following Caravaggio's flight from Rome in 1606. Since then, the picture has gradually gained widespread acceptance as a work painted by Caravaggio after his flight from Rome to Naples in 1606. Initial doubts regarding its status (among them, Wagner 1958, pp. 155–6, 223, notes 666–8, and Friedlander 1955, p. 224: for a full account, see Cinotti 1983, p. 423, cat. 9; and Spike 2001, pp. 208–9, cat. 61) have largely subsided following its cleaning in 1986. The most extreme position is that of Hibbard (1983, p. 287), who, doubting its connection with Caravaggio, rather surprisingly proposed that it was the work of an independent North Italian follower. Despite its exceptional quality – and it is, to my way of thinking, a pivotal work by the artist – the picture continues to occupy only a marginal position in many studies: it is not mentioned by Langdon and is merely listed among attributed works by Puglisi (1998, p. 405, cat. 59).

Nothing is known about the painting prior to 1836, when Marchese Filippo Ala Ponzone left it to the Comune di Cremona. A copy is in the Museo della Collegiata di Castell'Arquato (Piacenza). Gregori (1987, p. 56) conjectured that this might suggest that the Cremona picture originated in a Franciscan convent in Rome or Naples and was subsequently sent to Piacenza, where it was substituted with a copy. Marini (1987, pp. 467–8, cat. 53) has attempted to identify it with an item in the 1639 inventory of Ottavio Costa in Rome ('E più un altro quadro di S. Francesco fatto dall'istesso Caravaggio'), while Azzopardi (1997, pp. 197–201) has proposed that it belonged to Paul Alpheran de Bussan (1686–1757), a member of the Order of the Knights of Malta who bequeathed a 'quadro di S. Francesco d'Assisi dipinto dal Caravaggio' to Fra Christoph Sebastian, Barone di Remshingen. There is no way of confirming any of these hypotheses, which, in any case, have no necessary bearing on the date or place of execution of the picture. Marini has implausibly argued for a date of c.1603, while Azzopardi prefers one of 1608, when Caravaggio was in

Malta (his view is followed by Spike); Bologna believes it to date from Caravaggio's second Neapolitan period. The matter of inventory references to images of Saint Francis is complicated by the fact that a *Saint Francis in Meditation* – a work of c.1602–4 – seems to have been well known and copied (the two primary versions are in the Chiesa dei Cappuccini, Rome, and at Carpinetto Romano; I continue to favour the Cappuccini version and consider the technical evidence adduced in favour of the Carpinetto Romano painting to be ambivalent, at best: but see Vodret in Madrid–Bilbao 1999–2000, pp. 118–20, and in Palermo 2001, p. 118, cat. 5. I have examined one copy of this composition in Malta.) To my mind, Mahon's initial proposal to date the picture to Caravaggio's first Neapolitan period pointed in the right direction, though the most thorough – and convincing – discussion of the painting remains the various interventions of Gregori (New York–Naples 1985, pp. 311–12, cat. 88; Cremona 1987, pp. 52–6, cat. 1; Florence 1991, pp. 290–8, cat. 17, with a technical report by Roberta Lapucci based on the findings following its cleaning and restoration in 1986; in Madrid–Bilbao 1999–2000, p. 116; Bergamo 2000, p. 215, cat. 41). She rightly emphasises the importance of Annibale Carracci's etching of 1585 for Caravaggio's conception of the saint and, following Longhi's indication, convincingly dates Caravaggio's picture to the period immediately following his flight from Rome in May 1606. Moreover, she draws convincing comparisons of style with the *Agony in the Garden* (destroyed, formerly Berlin) and the *Saint John the Baptist* (Rome, Galleria Corsini), and also emphasises points of similarity with the *Supper at Emmaus*, which we know was painted on the Colonna estates in the Alban Hills. I cannot but concur with her arguments: the assured, but already summary, way of describing the head, with the deeply furrowed brow and the beard added over the chin and hands, as well as the manner of constructing the folds of the drapery with long, form-describing brushstrokes, finds close parallels in the Brera *Supper at Emmaus*—especially the innkeeper and his wife. Caravaggio had begun to move in this direction in his last Roman paintings: the *Madonna dei Palafrenieri* and the *Saint Jerome* (both Rome, Galleria Borghese), but the *Saint Francis* takes the technique much farther. The cool dark tonality also signals what will become Caravaggio's post-Roman palette (modified, however, in the Sicilian paintings, with their reddish tonality). The background tree trunk and foliage—much sunk and visible only in strong light—is a further extension of what is found in the Galleria Corsini *Saint John the Baptist* (another late Roman painting), in which nature itself seems to participate in the psychological unrest of the figure (the gaping hollow in the trunk has a haunting, not to say threatening, quality). The devotional still life in the *Saint Francis* – dramatically lit and, like the saint's halo, brilliantly foreshortened so as to affirm its physical reality – is the middle term between the *Saint Jerome* in the Galleria Borghese and the *Saint Jerome* in Malta, of 1608. There is no justification for confusing the psychological intensity of this work, heightened by the sharp contrasts of light and dark and a new emphasis on the figure projected against the hushed expanse of a space engulfed in darkness, with Caravaggio's far more serene and contemplative *Saint Francis in Meditation*, of some three to four years earlier. At the same time, the technique of the

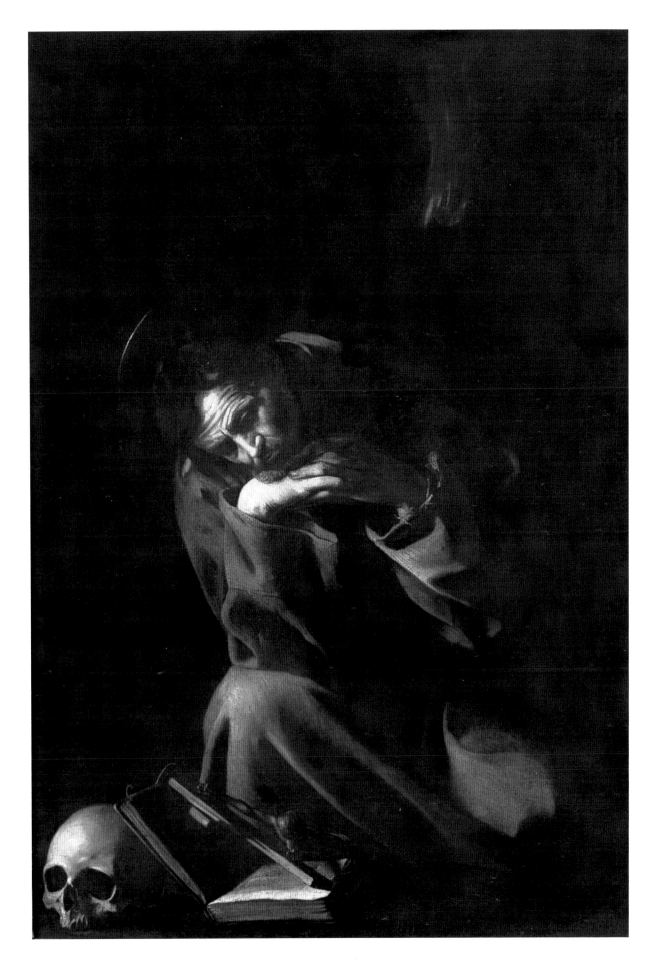

Cremona *Saint Francis* has not yet attained that staccato, *abbozzo*-like brushwork of Caravaggio's latest paintings. Nonetheless, with the *Saint Francis* we have crossed the boundary that separates Caravaggio's Roman and post-Roman production. As in all of Caravaggio's late works, style seems increasingly to grow out of the psychological or expressive mood of the painting: the descriptive beauty of a work such as the London *Supper at Emmaus* is rejected in favour of an emotionally charged brushwork. It is this subordination of style to expressivity that constitutes the modernity of Caravaggio's post-Roman work.

Longhi's suggestion that the saint is, in some sense, a self portrait has significant implications in understanding the character of Caravaggio's stylistic revolution—of enormous importance for the nature of Baroque art (and paralleled, we might add, by Annibale Carracci's emphasis on an increasingly abstracted figure style after c.1601). In his 1642 biography Baglione records that during his first years in Rome Caravaggio could not afford models and therefore worked from a mirror—a practice that a number of his Lombard forebears, including Sofonisba Anguissola, had made central to their art. The so-called *Sick Bacchus* (Rome, Galleria Borghese) would have been done in this fashion. Caravaggio later introduced himself into a number of his paintings—playing a cornetto in the *Musicians* (New York, Metropolitan Museum), fleeing the scene in the *Martyrdom of Saint Matthew* (Rome, San Luigi dei Francesi), as the victim in *David with the Head of Goliath* (cat. no. 6), and – at the very end of his career – as a spectator in the *Martyrdom of Saint Ursula* (cat. no. 7). There are numerous analogies for this sort of self-inclusion in narrative painting, usually as a passive spectator, as recommended by Leon Battista Alberti in his 1435 treatise on painting. What distinguishes the Cremona *Saint Francis* is the way self-inclusion has become self-identification: the way Caravaggio's insistence on painting as an imitation of reality ('Professavasi egli inoltre tanto ubbidiente al modello che non si faceva propria né meno una pennellata, la quale diceva non essere sua ma della natura', writes Bellori 1672, p. 212) seems to have acquired an intensely personal dimension. There is the temptation to read works such as this one in terms of autobiography. As Gregori (New York–Naples 1985, p. 312) has written, 'e sembra...quasi abbia voluto trasferirvi il proprio senso di colpa e il proprio desiderio di penitenza e di espiazione.' (For a more psychological approach, see Röttgen 1974, p. 208.) Although a vein of tragedy and guilt runs through all of Caravaggio's post-Roman paintings and poses the central problem of interpretation for his religious art, it would be wrong to attempt to link these traits with presumed feelings of remorse over the killing of Ranuccio Tomassoni in May 1606 (on this event, see Corradini 1993, pp. 70–81, and Langdon 1999, pp. 309–10). Personal experience certainly enriched Caravaggio's painting, but as part of his quest to endow his pictures with the urgency of actuality, not as an element of self-confession. In works such as the *Entombment* (Pinacoteca Vaticana) and the *Madonna of the Rosary* (Vienna, Kunsthistorisches Museum), Caravaggio explored the rhetorical conventions of classical, Raphaelesque painting by which experience is transformed into formal drama – and thereby externalised. But increasingly, in his post-Roman paintings, he aimed at an imitation of the psychological reality of an event rather than its mere dramatic and physical contingency. It is in this sense that his biography becomes an important source. The Cremona *Saint Francis* is one of the paintings that inaugurates this new phase in his art, of enormous consequence for the subsequent history of painting. We should probably understand it as having its basis in the intersection of a specifically Lombard/Leonardesque notion of art as mimesis with the renewed emphasis on self-examination promoted by the religious orders of the Counter Reformation. [*k.c.*]

Bibliography: Longhi 1943, p. 17; Mahon 1951, p. 234, note 125; Cinotti 1971, pp. 132, 197, notes 480–1; Marini 1974, pp. 186, 401–2, cat. 50; Cinotti 1983, p. 423, cat. no. 9; Gregori in New York–Naples, 1985, pp. 310–12, cat. no. 88; Christiansen 1986, p. 436; Marini 1987, pp. 467–8, cat. 53; Bologna 1992, pp. 239, 243, 342; Azzopardi 1997, pp. 197–201; Puglisi 1998, p. 405, cat. 59; Spike 2001, pp. 208–9, cat. no. 61; Pacelli 1994 (ed. 2002), pp. 95, 97.

4. The Seven Works of Mercy

oil on canvas, 390 x 260 cm
Naples, church of Pio Monte
della Misericordia

The painting is not exhibited

For the commission and payments, the historical and artistic background, and the state of conservation (the painting was restored for this exhibition), see my introductory essay, with the essential bibliography, including the most recent additions.
A fundamental work for Caravaggio's whole artistic development, this painting is a key to the reconstruction of the first phase of his activity in Naples, in September–October 1606. The iconography is based on the works of corporal mercy as they were practised in the Naples of that day and age. In fact the traditional title, alluding to the seven works prescribed in the catechism of Cardinal Roberto Bellarmino, is misleading, although it recurs in the sources and was taken at face value for many years out of mere critical conformism. There is a subtle 'transposition', with variations, of the Madonna and Child in the upper part of the altarpiece realised by Luca Giordano in the early years of his career. Some time ago this picture was on the market in Rome, and the present author illustrated it in Naples on two occasions: in a course of lectures at the university and in a public lecture, both given in 1983. Notwithstanding, the picture was published by others in 1984 without any reference to my exposition. [f.b.]

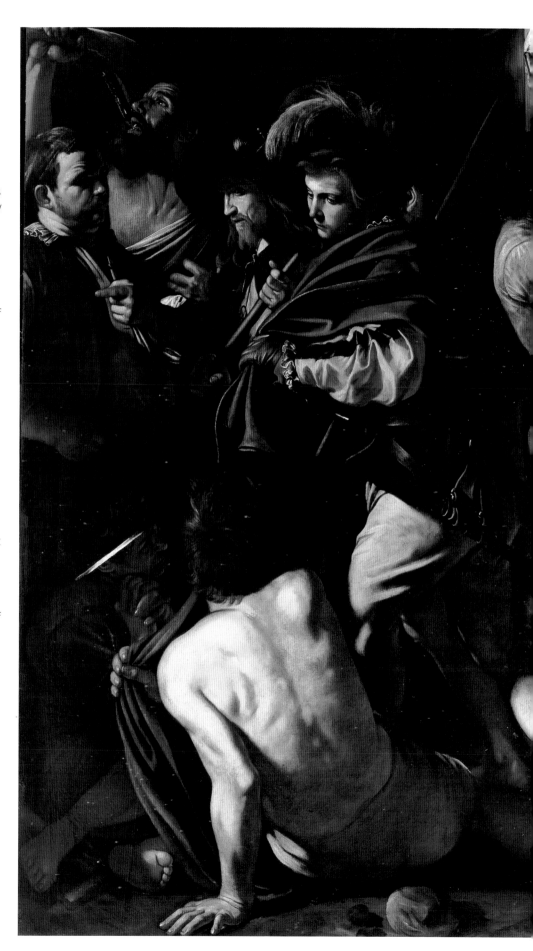

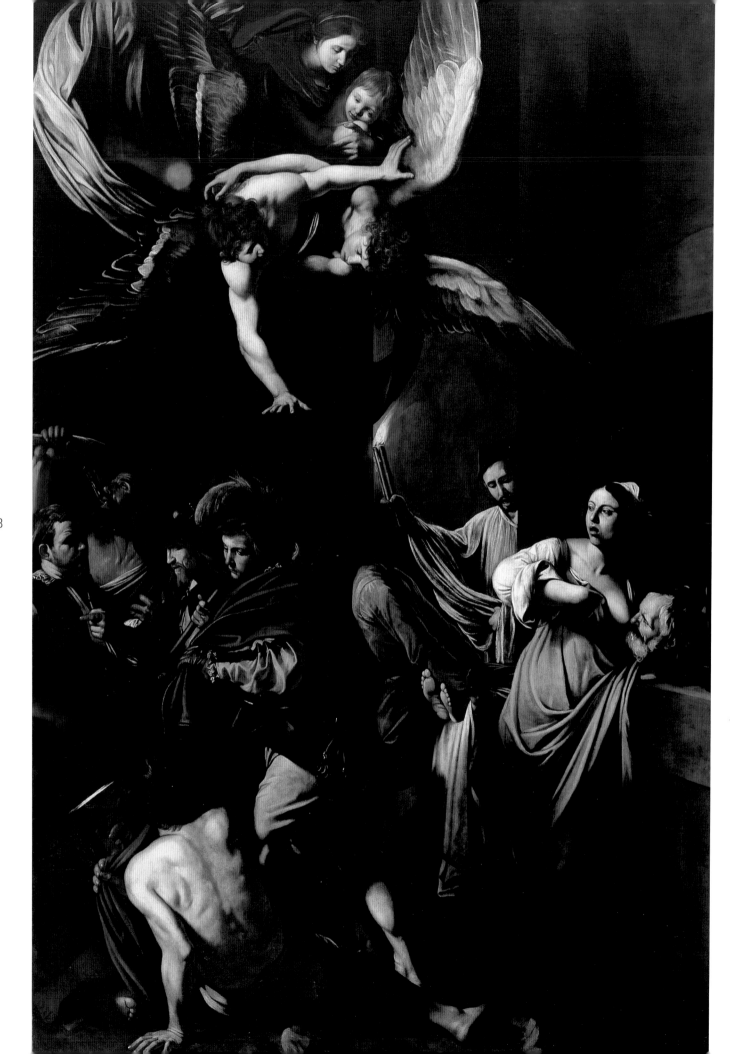

5. The Crucifixion of Saint Andrew

oil on canvas, 202.5 x 152.7 cm
Cleveland, The Cleveland
Museum of Art, Leonard
C. Hanna Jr. Bequest,
inv. 1976.2

The picture, which was acquired by the Cleveland Museum in 1976, had previously been known only from three copies: Musée des Beaux-Arts, Dijon; Museo Provincial de Santa Cruz, Toledo; and a private Swiss collection, formerly in the Back-Vega collection, Vienna (the latter is probably the copy by Louis Finson known to have been in Amsterdam in 1617–19). Following its restoration and acquisition, Anne Tzeutschler Lurie and Denis Mahon (1977, pp. 3–24) published the work, with full documentation of its history, iconography and conservation. Today it is universally accepted as the picture described in the following terms by Bellori (1672, p. 214): 'Il conte di Benavente, che fu viceré di Napoli, portò ancora in Ispagna la Crocifissione di Santo Andrea'. Don Juan Alonso Pimentel y Herrera, the eighth Conde de Benavente, was Viceroy of Naples between 1603 and 1610 (he left Naples for Spain on 11 July 11 1610). He had a particular devotion to Saint Andrew, having played a part in completing the renovations of the crypt of Saint Andrew in the cathedral of Amalfi. Indeed, in 1610 the viceroy is recorded to have visited Amalfi, 'mosso ... dalla divozione di visitare la tomba di S. Andrea' (see the sources brought together by Tzeutschler Lurie and Mahon 1977, pp. 18–20). Whether the Conde de Benavente intended the painting as an altarpiece for his private chapel is not known, but it seems probable. Upon his return to Spain he hung the picture in his palace at Valladolid, where it is recorded in three inventories, of 1652 and 1653, the latter two drawn up after the death of his grandson: 'Iten, un lienco muy grande de pintura de san Andres desnudo quando le estan poniendo en la cruz con tres sayones y una muger con moldura de ebano todo lo tasaron en mil y quinientos ducados. Es de micael anjel caravacho orijinal' (see Spike 2001 and Tzeutschler Lurie 1977). The mention in this description of only four, rather than five, assistants has been explained variously: either the reference is to the figures at the foot of the cross – three men and one woman – or the figure only partially visible was overlooked. The Cleveland picture first came to scholarly attention when it was exhibited in Seville in 1973 (cat. 4: lent by José Manuel Arnaiz, Madrid). In the catalogue for that exhibition Pérez Sánchez was misled by the unusual iconography of the painting and rejected the possibility that it showed the crucifixion of Saint Andrew, who, in fact, is shown crucified on an upright Latin cross rather than on the more traditional X-shaped one associated with this saint. This detail turns out not to be an anomaly: merely a less-frequently encountered alternative (in the late sixteenth century the theologian Joannes Molanus went so far as to declare the crux decussata

to be an error). Mahon was able to demonstrate that the picture shows not the crucifixion of Saint Andrew, but his attempted release, as told in several contemporary versions of the Golden Legend. The Proconsul of Patra, upset at his wife having been baptised by Saint Andrew, ordered that the apostle should be bound to a cross. For two days Saint Andrew continued to preach from the cross to the gathered crowds, who pressed the proconsul to have him taken down. Remarkably, the attempted rescue of the apostle was thwarted when the soldiers who tried to untie him found their arms paralysed, for the saint had prayed to be allowed to die on the cross; he was surrounded by a dazzling light before expiring. It is this episode that Caravaggio depicts: the figure on the ladder is shown frozen in his action while those gathered around the cross look on in rapt astonishment. The old woman was originally shown with her hands clasped beneath her chin – a gesture Caravaggio employed in the London Salome with the Head of John the Baptist. By eliminating this feature Caravaggio at once called attention to her goitre – a common ailment among the poor in the mountainous regions near Naples – and gave her a less conventionally devout expression. As Tzeutschler Lurie writes, 'For Caravaggio, who recognised the potential for drama in suddenly arrested motion, the miraculous moment in which life itself comes to a halt must have been an intriguing challenge'. We might further observe that few subjects lent itself so perfectly to the artist's preference for working from posed models. Caravaggio emphasised the popular character of the story by the inclusion of ordinary types, most memorably by the woman with a goitre. By showing these figures half-length, grouped around the base of the cross – the soldier shown with his bent arm projecting from the picture plane – the artist skilfully includes the viewer as one of the witnesses to the miracle. Together with the Madonna di Loreto in Sant'Agostino, Rome, in which we find similarly vivid peasant types, this is one of Caravaggio's most successful attempts actively to involve the viewer-worshipper in the action. The convention on which he drew for this depiction was the late sixteenth-century, Counter-Reformation fashion of including bust- or half-length donor portraits in the foreground of a religious scene. These portraits act as mediators between the fictive, imaginary realm of the painting and that of the viewer-worshipper. Caravaggio has completely transformed this tradition by using the half-length figures, grouped in an open circle, to break down the pictorial fiction. He insists on the depicted action as an event contiguous with the viewer's experience. It should also be noted that in his description of the old woman and the sagging skin of the apostle, Caravaggio has moved beyond the naturalism of his Roman paintings to explore a realistic style that will be taken up by Ribera (Longhi recounts that when he first saw the Toledo copy it was ascribed to the Spaniard). That the picture was painted in Naples goes without saying, but there has been some discussion as to whether it was painted during Caravaggio's first stay in the city or during his second. The matter is of more than academic interest in that if this painting dates from the second Neapolitan period, it is the last surviving altarpiece by the artist and thus a key document in the direction of his notion of religious painting. Longhi (1943, pp. 8, 17–18), basing his opinion on the copy in Toldeo, had suggested a date of 1607, whereas Mahon (1952, p. 19)

109

and Gregori (1975, pp. 43–4) judged the (then) lost original to be a work of c.1609–10 (earlier, Mahon (1951, p. 234), had placed it in the first Neapolitan period). The reappearance of the original has not resolved the matter. Tzeutschler Lurie and Mahon argued for a date in close proximity to the *Seven Works of Mercy* and the *Flagellation* (followed by Cinotti, Marini, Hibbard, Bologna, Pacelli and Spike, *inter alios*), while Gregori (in London–Washington and New York–Naples) has argued for the later period. Noting that Caravaggio used the same literary source for the *Martyrdom of Saint Ursula*, Calvesi (1990, p. 163 note 146) has suggested that only in 1610 was the relevant translation of Jacopo da Voragine's *Legenda Aurea* given to Caravaggio. He considers a date of c.1609–10 'assolutamente indubitabile' (see also Bona Castellotti and Puglisi). The only time the painting has been shown with a group of works encompassing Caravaggio's post-Roman output was in the New York–Naples exhibition of 1985. At New York the picture was hung between the London version of *Salome with the Head of John the Baptist* and the *Martyrdom of Saint Ursula* and near the *Denial of Saint Peter*. The comparison with these three works – carried out in Caravaggio's most extreme, summary style – was not altogether favourable. My own view at the time was that 'the execution [of the *Saint Andrew*] relates closely to that of the Borghese *David* and the Naples *Flagellation*, and…differs considerably from the abbreviated technique of the pictures of the documented Sicilian and second Neapolitan periods' (Christiansen 1986, p. 436). It was 'per l'intermittenza della luce e delle forme e per l'abbreviata libertà dell'esecuzione' that Gregori considered the picture late. In order to clear the field for proper consideration of the many problems that surround an understanding of Caravaggio's first and second Neapolitan periods it may be useful to explain that my own view differs in several controversial respects from the one commonly accepted. I consider the Borghese *David* to be a late Roman work – not a painting of Caravaggio's second Neapolitan period (see Christiansen 1990, p. 52 note 88). As far as I can see, its point of comparison is with the *Madonna di Loreto* rather than with the Borghese *Saint John the Baptist*, and I do not believe the biographical subtext would make sense if it was painted in Naples (Manili 1650, p. 67, reports that the David is 'Caravaggino', that is, Cecco di Caravaggio). I also believe it highly unlikely that the *Madonna of the Rosary* (Vienna, Kunsthistorisches Museum) was painted later than c.1602/3. I would explain its presence in Naples in 1607 by the hypothesis that it was painted for a Dominican establishment outside Rome (hence the apparent lack of knowledge of the work there), rejected, and then acquired by the painter-merchants Abraham Vinck and Louis Finson for future sale. We know that from Naples it was shipped to Amsterdam. It seems to me that the removal from consideration of these pictures gives far greater consistency to Caravaggio's first and second Neapolitan periods. However, it cannot be too strongly stressed that we still lack a key work for a proper understanding of Caravaggio's art in his very last years of life, namely the *Nativity, with Saints Lawrence and Francis*, painted in 1609 for the Oratorio di San Lorenzo in Palermo and stolen in 1969. To judge from reproductions, in that work Caravaggio showed a renewed interest in painting directly from posed models and he employed a more descriptive technique than is found in his other Sicilian altarpieces. In particular, the angel is the obvious,

undisguised result of a youth posing on a table with his left arm hanging over the edge – much as in the *Martyrdom of Saint Matthew* in San Luigi dei Francesi. Each figure registers as an individual and the tendency towards abstraction found in Caravaggio's late paintings – a movement towards the creation of types rather than individuals – is reversed. This should warn against being overly schematic in our interpretation of the artist. The 1985 exhibition included no Sicilian altarpieces. In this respect, the Neapolitan venue of the present exhibition offered an ideal opportunity to rethink the direction of Caravaggio's art during the last months of his life, and the variations in style as he travelled from place to place, as well as those that distinguish a prestigious commission with the subject and scale of an altarpiece from such modest-sized and summarily painted gallery pictures as the London *Salome receives the Head of John the Baptist* (cat. no. 14), the *Denial of Saint Peter* (cat. no. 17) and the *Martyrdom of Saint Ursula* (cat. no. 18). My view is that the *Saint Andrew* has little in common with Caravaggio's last works – either in its cool, steely tonality or its emphasis on physical density – and that it was, indeed, painted during the artist's first Neapolitan period.

The impact of the picture on Neapolitan painters has been seen in Carracciolo's *Crucifixion* (Museo Civico di Castelnuovo: see Bologna in Naples 1991, p. 213) and Carlo Sellitto's *Crucifixion* in Santa Maria in Cosmedin, Naples. Even more interesting is the obvious debt of Zurbarán to this picture in his *Crucifixion with a Painter* in the Prado (Gregori in New York–Naples 1985, p. 349). [k.c.]

Bibliography: Pérez Sánchez, in Seville 1973, cat. 4; Gregori 1975, pp. 43–4; Tzeutschler Lurie and Mahon 1977, pp. 3–24; Cinottii 1983, pp. 420–3, cat. 8; Gregori in London–Washington 1982–3, pp. 128–9, cat. 17; Hibbard 1983, pp. 219–23; Gregori in New York–Napoli 1985, pp. 345–9, cat. 99; Christiansen 1986, p. 436; Marini 1987, pp. 272, 520–4, cat. 80; Calvesi 1990, pp. 144–5, 149, 163 note 146, 373, 381; Bologna 1992, pp. 333–4; Pacelli 1994, ed. 2002, pp. 39–40; Gregori 1994, pp. 23, 153 no. 69; Bona Castellotti 1998 (ed. 2001), pp. 132–3; Puglisi 1998, pp. 342, 350, 410, cat. 82; Langdon 1998, pp. 383, 386; Spike 2001, pp. 200–1, cat. 55.

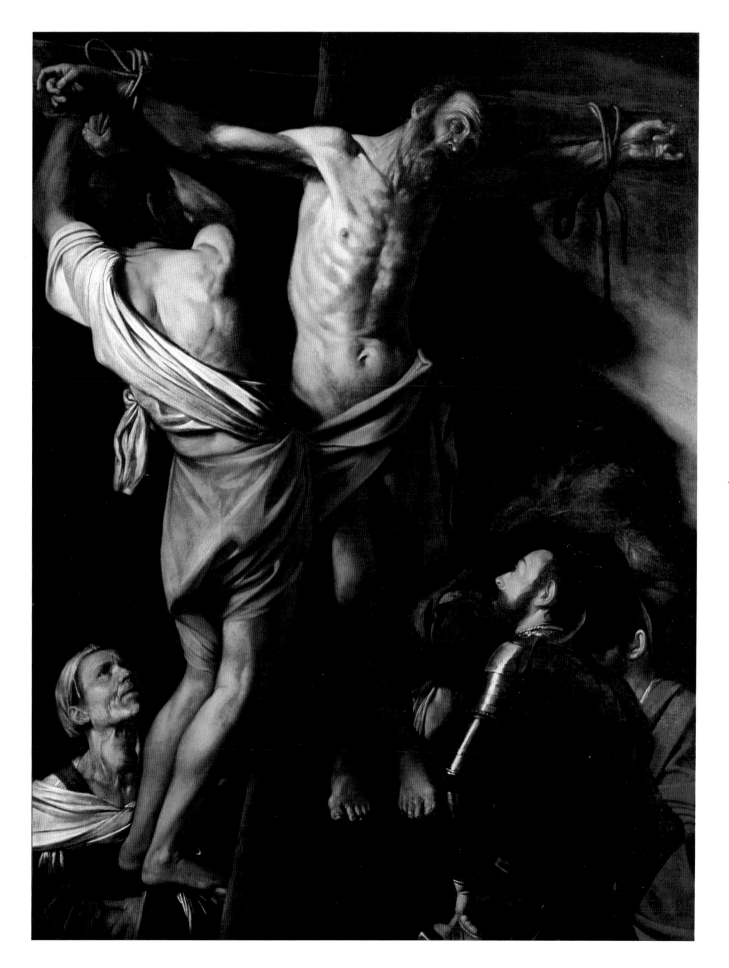

6. The Flagellation

oil on canvas, 286 x 213 cm
Naples, Museo di
Capodimonte (from the
church of San Domenico
Maggiore, property
of the Fondo Edifici di Culto)

See the text and notes of my introductory essay, with the suggestion that a preliminary inspiration for this work came from the *Christ at the Column* in the collection of Marcantonio Doria in Genoa. Caravaggio would have been able to see this picture in 1605 during a brief visit to the city, when there was talk of a commission from the Doria family for some frescoes in one of their palaces. However, we would do well to recall that the X-ray analysis commissioned by A. Brejon de Lavergnée and V. Pacelli (see Pacelli-Brejon de Lavergnée 1985, pp. 209–18) revealed such a stratification of interventions and reworkings that Caravaggio would seem to have worked on the painting in two different periods: the first, in May–June 1607, when two payments were made, both interim payments rather than final settlements; the second, following his return from Sicily, in 1609–10. Taking a new look at the pictures which can be associated with this one, there are clearly two orientations for the stylistic developments at work: we can recognise preparation for it in the copies of a lost *Flagellation* to be found in the Pinacoteca Civica of Macerata and the Museo Civico of Catania, the original apparently dating from after *The Works of Mercy* but which must have been done by the end of Caravaggio's stay in Malta; whereas it is continued and developed above all in the *Flagellation* in Rouen, whose execution we know was connected with the *Saint Ursula*, dated May 1610.

I feel I should reiterate the remark made in the introductory essay concerning a copy of this Neapolitan *Flagellation*, on record as early as 1615–20 in the collection of another Doria, Giovan Carlo, in Genoa. It is surely significant that it formed a pair with a copy of the lost *Resurrection of Christ* which Caravaggio had painted in Naples, for the Fenaroli chapel in Sant'Anna dei Lombardi, during his second stay in the city between October 1609 and June–July 1610. The pairing of these copies may well be an indication that the people who commissioned them knew that the two masterpieces had been painted at about the same time. [*f.b.*]

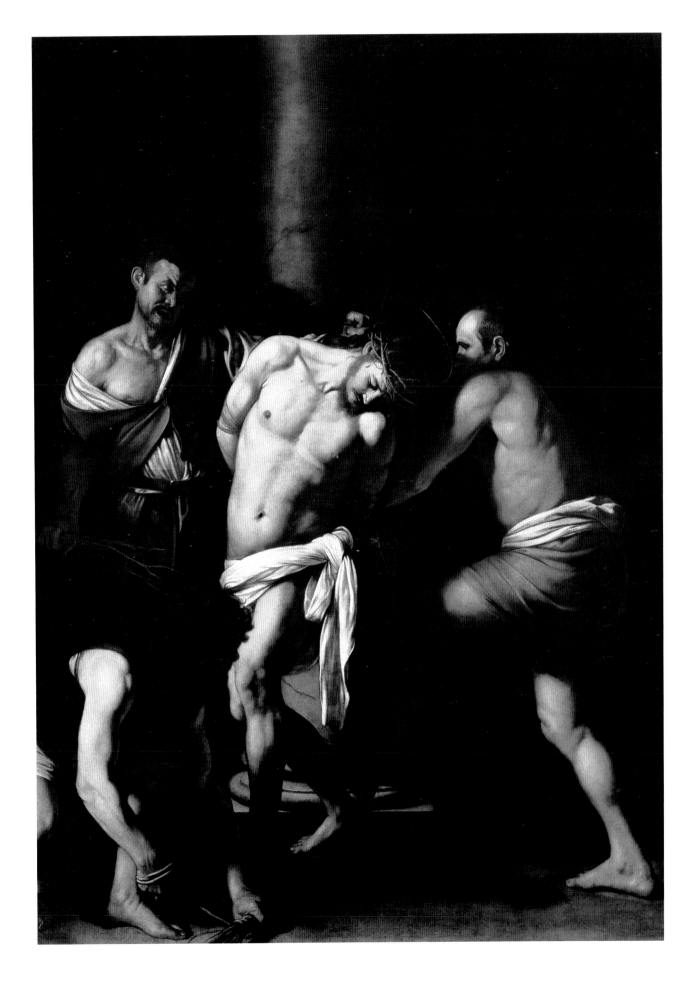

7. Saint Jerome Writing

oil on canvas, 117 x 157 cm
Valletta (Malta), Museum
of St John's Co-Cathedral

The painting is not exhibited

114

Secluded in his cell-like room, cardinal's hat hung on the wall, Jerome sits on the edge of the bed with his right leg positioned towards the left side of the composition. In a beautiful *contrapposto*, his head and torso are both turned in the opposite direction, towards the right. The torsion is a metaphor of the spiritual current suddenly pulsing through the saint's body. The design of the figure – basically a large triangle whose focal point is the writing hand of the saint – is given energy by the intense contrast between the reds, whites, greys, and flesh tones that make up the centre of the picture, and also by the complex outline and interior movement of the draperies. The weathered and craggy topography of the saint's anatomy and face, brought into high relief by the strong light entering the room from the upper left, is itself a masterpiece. The triangle, which is cut dramatically in half by a black shadow running diagonally across the chest like a sash, is framed by the strong verticals and horizontals established by the wooden post (or door) and the rustic-looking table. Such rigorous geometry (though fashioned out of elements that are themselves flexible) is a central feature of Caravaggio's Maltese style.

The *Saint Jerome*, which was first attributed in modern times to Caravaggio by Vincenzo Bonello (see Marangoni 1922, p. 41), was restored by the Istituto Centrale di Restauro in Rome in 1956 (Carità 1957). The picture was badly damaged when it was stolen from St John's Museum on 29 December 1985. After being recovered in August 1987, it was again restored by ICR. The tension on the canvas, even after relining, is somewhat compromised because the picture had been cut out of its frame, leaving behind those areas of the canvas covering the sides of the stretcher (see ICR 1991).

In a strong light it is possible to see that the background area, now substantially abraded, originally contained more description of the interior of the room. A well-preserved contemporary copy of the picture (private collection) may reflect these now nearly invisible elements, including a scarf beneath the cardinal's hat. The copy, whose faithfulness to the original is difficult to gauge, shows an arched opening at the extreme left, with the corner of a wall positioned just to the left of the saint's head. Thus, it would not be wrong to hypothesise that the imaginative use of deep space and architectural scenography displayed by Caravaggio in the *Beheading of Saint John the Baptist*, which was probably painted a few months later (that is, in mid-1608), is anticipated here, in a more restrained manner, in the *Saint Jerome Writing*, which we date to the end of 1607 (or the first months of 1608). It is not known why Caravaggio painted this subject or for what location the canvas was originally intended. There is relative certainty, however, on the question of the picture's patron, thanks to the coat of arms painted prominently in the lower right corner of the canvas. The arms belong to one of the most important members of the Order of St John, Fra Ippolito Malaspina, Marchese di Fosdinovo and Prior of Naples (Hess 1958; Macioce 1987).

A Conventual Bailiff and intimate adviser to Grand Master Wignacourt, as well as a knight with a glorious military career, Malaspina had been away from Malta for some four years before returning, in July 1607, on the very same galleys commanded by Fra Fabrizio Sforza Colonna on which Caravaggio travelled for the first time to the island (Macioce 1994, p. 215). Fra Ippolito was a relative of the Roman banker Ottavio Costa who owned Caravaggio's Palazzo Barberini *Judith beheading Holofernes* and several other important Roman period works (Spezzaferro 1974, p. 585, n. 49); thus, Malaspina may have already heard of the famous painter before their presumed encounter on board the galleys. The Marchese was great uncle to Costa's sons Alessandro and Antonio Costa, both Knights of St John, who were responsible for the beautiful tomb slab dedicated to Malaspina in the centre of the floor of the Chapel of the Italian Langue in St John's church, Valletta.

Indeed, it was to this Chapel, as a document of 1629 shows (Macioce 1994, pp. 217, 228), that Malaspina, who died five years earlier in 1624, had left an important group of paintings. This group almost certainly included Caravaggio's *Saint Jerome*, a copy by an unidentified artist of a famous *Magdalen* by Correggio (which also contains Malaspina's coat of arms), and two other works which have recently been identified as part of the Prior of Naples' donation to the Chapel.

As a forthcoming article on Malaspina by the present authors will demonstrate, it was probably not until 1661, when some of the pictures in the Chapel were transferred to another church, that the *Jerome* and *Magdalen* were placed over the arches of the passageways leading to the adjacent chapels. Bellori (see our essay in the catalogue) describes the pictures – both of which he ascribes to Caravaggio – in this exact location. Since the pictures both contain Malaspina's coat of arms and were hung as a symmetrical pair, Bellori's hypothetical informant, who likely viewed the Chapel after 1661, probably jumped to the conclusion that the *Magdalen* was also a work by Caravaggio. It is unlikely that any of the works Malaspina bequeathed to the Chapel of the Italian Langue – a Langue he once presided over as *pilier* (or head) – were made specifically for the Chapel. Caravaggio's *Saint Jerome* hung for centuries in its new position above the passageway until late in the twentieth century, when it was removed to St John's Museum. The canvas was recently transferred to the Oratory of San Giovanni Decollato. Here, hung at eye-level (a position for which Caravaggio clearly designed this powerful image), it is possible to appreciate the subtlety of his brushwork and the intensity of expression that animates Jerome's face as he commences writing. [*k.s., d.m.s.*]

Bibliography: Bellori 1672; Marangoni 1922, p. 41, pl. XXXIX; Hess 1958; Cinotti 1983; Macioce 1987; Gash 1997; Marini 2001; Spike 2001 (with previous bibliog.); Sciberras and Stone (forthcoming).

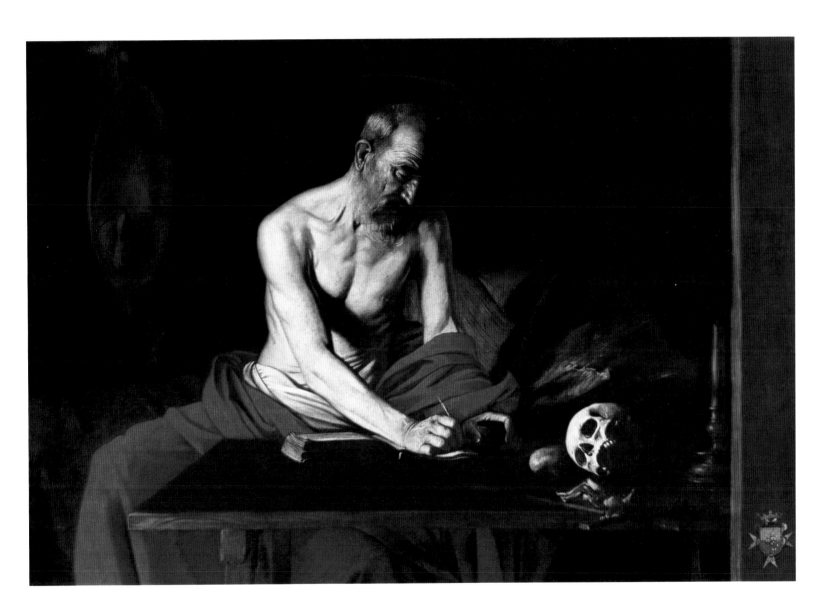

8. Sleeping Cupid

oil on canvas, 72 x 105 cm
inscribed on the back of the
canvas: OPERA (?) DEL SR
MICHEL ANGELO / MARESI DA
CARAVAGGIO / I[N] MALTA 1608
Florence, Galleria Palatina,
Sala dell'Educazione
di Giove, inv. 1912 n. 183

Cupid lies on the bare earth, his wings apart as if to create a structure encompassing and supporting the small body, with his head propped up on a quiver full of darts and the left hand resting on a dart and his bow.

The picture's authorship (given to Caravaggio as early as Baldinucci 1728, ed. 1846, IV, p. 206), date and place of execution are based on the inscription on the back (Giglioli 1909, p. 151). We know it to have been commissioned by a Florentine knight, Fra Francesco dell'Antella, from a letter written by Fra Francesco Buonarroti in Malta to his brother Michelangelo the Younger: 'For your information let me tell you that on two or three occasions I have been in conversation with Signor Antella, who tells me that he has sent there a picture by Michelangelo da Caravaggio, showing a Cupid sleeping, to the house of his brother Signor Niccolò; the Commendatore is delighted with it, and is very happy for people to go and look at it, so he can hear others' opinions on it, and also that somebody has written sonnets after seeing it, which he has shown me, so I imagine that he would appreciate your going to see it' (ABF, Filza 104, f. 145r; Sebregondi, 1982, p. 122). Thus by 20 July 1609 Antella had already sent Caravaggio's painting showing a Sleeping Cupid to his brother's house in Florence. Francesco Buonarroti believed that the knight would appreciate having the opinion of Michelangelo the Younger, man of letters and connoisseur, on the picture, although at the same time he did not wish to inconvenience his brother: 'up until now I have pretended not to understand, nor have I mentioned you in this matter, so that you can do as you like if you decide to go and see it' (ABF, Filza 104, f. 145r). We learn more about the picture from the letters that passed between the two brothers and Antella: the admission into the Order of a Buonarroti nephew with the backing of the highly influential Antella prompted Francesco Buonarroti to urge Michelangelo the Younger to thank him (ibid., f. 164bis r), which Michelangelo must have done, to judge by the reply of Francesco dell'Antella dated 24 July: 'Now I hold my Cupid in much higher regard than before, since it has been praised by Your Lordship' (ABF, Filza 46, f. 756r; Stone 1997, p. 168). Antella returned to Florence in the summer of 1611, where the picture had been sent to his residence in Piazza Santa Croce. The presence of a work by Caravaggio was considered so significant that Giovanni da San Giovanni reproduced it on the façade of the building, in the lower section of the frieze commissioned by Niccolò dell'Antella, completed in May 1620.

Baldinucci gives a description of it and praises the fresco, also mentioning the original on canvas from which it was taken (1728, ed. 1846, IV, p. 206). After the death of Francesco dell'Antella in 1624 and of his brother Niccolò in 1630, the painting passed to the latter's son, Donato, who died on 10 January 1667. In his unpublished will, which shows him to have been aware of possessing some important works of art, he stipulated the drawing up 'without delay of an Inventory ... to proceed as soon as possible ... to the sale of all the furnishings in the residence in Florence of Piazza di Santa Croce, so that, once they are detailed ... capital is realised, to be spent thereafter as shall be decided' (ASF, Notarile Moderno 16758, cc. 45r, 54r). His administrators seem to have lost no time, for on 15 March Annibale Ranuzzi, writing to Cardinal Leopoldo de' Medici, was rejoicing 'at the fine purchase made by Your Lordship of that picture by Caravaggio which belonged to the Prior Antella' (ASF, Carteggio d'Artisti 12, f. 200r; Meloni, 1977, p. 47).

On the death of the cardinal an inventory was drawn up in which the painting was described as 'A picture on canvas measuring 1 1/8 braccia in height and 2 1/2 braccia in width, showing a Cupid sleeping with quiver and arrows by Caravaggio with a similar frame [carved, gilded and fretted]' (ASF, Guardaroba Medicea 826, f. 61r, n. 107). The publication of this passage contained errors both in the measurements and in the misreading of 'carcasso', or quiver, as 'l'arcano', the arcanum. Only the height given in the passage corresponds to that of the picture, which was completed with a carved gilt frame featuring bows and arrows, alluding to the attributes of the god of love (Mosco 1982, p. 77 n. 2).

The inscription on the back has been variously transcribed. The unclear script does not refer to the person who commissioned the picture, but is undoubtedly old, the form 'Maresi' being also used on the occasion of Caravaggio's expulsion from the Order (Gregori in Caravaggio 1996, p. 20).

The Commendatore Antella played a significant part in securing papal authorisation for Caravaggio's knighthood (Macioce 1994, p. 208), and the Cupid has been seen as a gesture of gratitude for his admission to the Order (Gregori in Caravaggio 1996, p. 40). It could, however, have been the result of a request on the part of Francesco dell'Antella, discerning connoisseur and patron, who had also been responsible for commissioning from Caravaggio a lost portrait of Wignacourt (see Sebregondi 1982).

The complex iconography of the Cupid was probably suggested by Antella himself. Stone argues that there may have been an explicit reference to the legendary Cupid by the young Buonarroti, as if Antella, prompted by the name they had in common, saw Caravaggio as the new Michelangelo (1997, p. 168). The scheme of the composition seems to have been taken from an engraving by Giovan Battista Scultori dating from 1538 (Calvesi 1990, p. 232), although a number of versions of this subject were known in ancient art (Posèq 1987; Puglisi 1998, pp. 296-7).

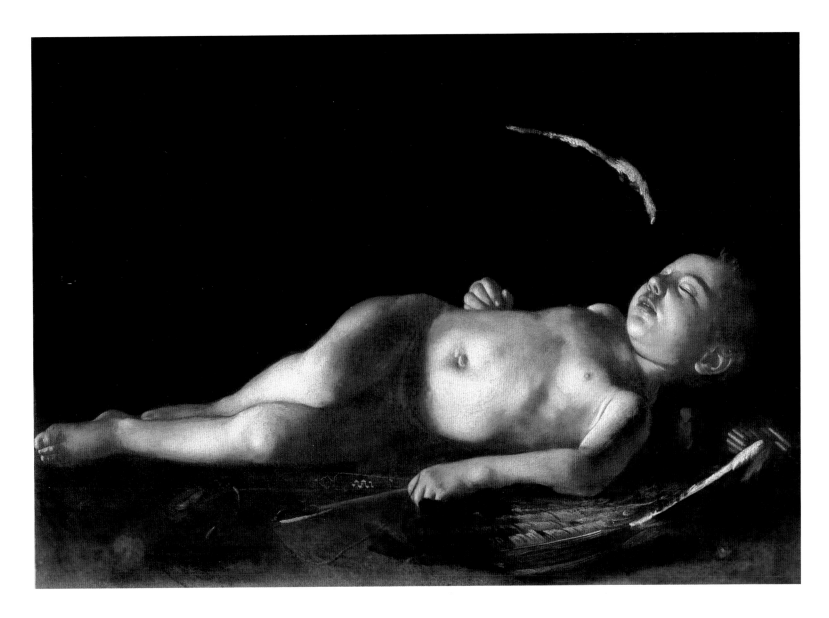

The picture has given rise to various enigmatic hypotheses and contrasting interpretations. The sleeping Cupid has been seen as symbolising blind love, not least because in 1603 Gaspare Murtola dedicated a madrigal to a painting by Caravaggio, since lost, featuring Cupid both asleep and blind (Salerno 1970, p. 241), or alternatively as an allusion to sensual love, in the abandonment to sleep (Calvesi 1971, p. 109). On the other hand, it has been argued that the work symbolises 'delivery from enslavement to the senses', since it was conceived for a Hierosolymite who had taken the vow of chastity (Marini 1974, p. 440). Pizzorusso (1983, pp. 52–5) has shown that the image of Cupid was chosen to represent Tranquillity among the allegorical figures on the façade of Palazzo dell'Antella, and noted how the scene may be illuminated by a lamp held by Psyche, for in Apuleius's account it is she who discovers the god asleep.

Love sleeping is clearly a mythological and allegorical topos, but here it is expressed by Caravaggio in all the crudeness of extreme naturalism. In fact a physician (Espinel 1994, p. 1751) has drawn attention to the jaundiced skin, oedematous cheek, cyanotic lips, swollen abdomen and other clinical symptoms, and diagnosed juvenile rheumatoid arthritis, in such an advanced state that the child we see may be moribund or even dead. It is difficult to imagine that the artist could have produced such an exact representation unless he was working from a live model, and in fact some critics have preferred the title 'Love dead' (Giglioli 1949, p. 34; Anna Banti 1977, p. 10 and Hibbard 1983, p. 331), in keeping with a predominating theme of Caravaggio's final years.

The light illuminating the figure from below points up the most unsavoury anatomical details: this dwelling on physical decay can be interpreted either as a memento mori requested by Antella or as a choice on the part of the artist who felt acutely that his end was nigh.

The picture probably dates from the end of Caravaggio's stay in Malta: the use of colours here coincides with that in contemporary works, predominantly shades of brown and ochre, with red being used to enliven the odd detail.

A version with very similar dimensions (65.5 x 105.5 cm), now in the Indianapolis Museum of Art, was published by Friedlaender in 1955 as an original by Caravaggio predating the Florence picture (p. 112), but it is not generally held to be autograph. [l.s.]

Provenance: Malta; Florence, Palazzo dell'Antella (ante July 1609); Florence, collection of Cardinal Leopoldo de' Medici (ante March 1667); Florence, Grand-Ducal collections (1675).
Exhibitions: Florence 1922 (not in catalogue); Milan 1951, n. 40; Florence 1970, n. 2; Florence 1972, Sala XXX, n. 5; Florence 1982–1983, p. 77 n. 2; Tokyo 1987, n. 75; Florence-Rome 1991–1992, n. 19; Florence 1996.
Documentary sources: ABF, Filza 104, f. 145r; ABF, Filza 46, f. 756r; ASF, Notarile Moderno 16758, cc. 45r, 54r; ASF, Carteggio d'Artisti 12, f. 200r; ASF, Guardaroba Medicea 826, f. 61r, n. 107.

Bibliography: Inghirami 1834, p. 38; Baldinucci 1728, ed. 1846, IV, p. 206; Chiavacci 1860, p. 90 n. 183; Giglioli 1909, pp. 151–2; Marangoni 1922[1], pp. 223–4; Marangoni 1922[2], pp. 41–2; Marangoni 1927, pp. 156–7; Giglioli 1949, p. 34; Longhi 1951, p. 34; Mahon 1951, p. 234; Mostra del Caravaggio 1951, pp. 32–3; Longhi 1952, p. 44; Mahon 1952, p. 19; Friedlaender 1955, p. 212 n. 38; Berne Joffroy 1959, p. 341; Jullian 1961, p. 186; Ottino Della Chiesa 1967, p. 105 n. 87; Longhi 1968, p. 43; Borea in Caravaggio e caravaggeschi 1970, pp. VI, 5–7 n. 2; Dal Poggetto in Caravaggio e caravaggeschi 1970, p. 122; Salerno 1970, p. 241; Calvesi 1971, p. 109; Pérez Sánchez 1971, p. 85; Firenze restaura 1972, p. 83 n. 5; Immagine del Caravaggio 1973, pp. 103–4 n. 64; Marini 1973, p. 440; Moir 1976, pp. 102, 133 n. 222; Banti 1977, p. 10; Meloni Trkulja 1977, pp. 46–50; Mosco 1982, p. 77 n. 2; Sebregondi Fiorentini 1982, pp. 108–9, 122; Pizzorusso 1983, pp. 50–9; Cinotti 1983, pp. 433–4; Hibbard 1983, pp. 234, 331 n. 172; Gregori in Caravaggio e il suo tempo 1985, p. 334; Sebregondi Fiorentini 1986, p. 78; Marini 1987, pp. 530–2; Posèq 1987, pp. 27–31; Calvesi 1990, pp. 22, 232; Gregori in Michelangelo Merisi 1991, pp. 310–11; Lapucci in Michelangelo Merisi 1991, pp. 311–16; Papi in Michelangelo Merisi 1991, p. 82; Espinel 1994, pp. 1750–2; Macioce 1994, pp. 208–9; Pacelli 1994, pp. 78–80; Gregori in Caravaggio da Malta 1996, pp. 20–1, 40–1; Gash 1997, p. 156; Stone 1997, pp. 165–77; Puglisi 1998, pp. 294–7, 409 n. 73; Bandera 2000, pp. 188, 191–2, 196; Sebregondi in Lungo il tragitto 2000, p. 163; Marini 2001, pp. 314–15, 542–4; Sebregondi 2001, p. 602; Spike 2001, p. 208; Macioce 2002, pp. 158–9; Navarro 2003, pp. 220–1; Chiarini in La Galleria Palatina 2003, p. 110 n. 155; Macioce 2003, pp. 253–4, doc. 390.

118

9. Portrait of a Knight of Malta (Fra Antonio Martelli?)

oil on canvas, 118.5 x 95.5 cm
Florence, Pitti Palace,
inv. Oggetti d'arte 1911,
no. 717

The knight is shown in a nearly three-quarter-length format wearing a black monastic habit with a large white eight-pointed cross of the Order of St John on his chest. This habit was primarily the privilege of the Grand Crosses of the Order – the Grand Master, the Conventual Bailiffs, and the Capitular Bailiffs. Conventual Bailiffs were the heads of the various Langues or nations (plus the Grand Prior) residing 'in convento' at Malta. They formed, together with the Grand Master, the governing body of the Order. Capitular Bailiffs had bailiwicks (usually more remunerative ones) outside of Malta; however, whenever they were resident at the convent they had the right to sit on the Council, and thus were called 'balì capitolari'. The elderly knight represented by Caravaggio is thus immediately recognisable as an important dignitary of the Order. He is not shown in the full *manto di punta* worn by knights at special ceremonies (these long capes, as their Italian name implies, have sleeves that end in a point). Instead, Caravaggio depicts him more informally, wearing his everyday habit, with a white long-sleeve shirt underneath.

Looking solemnly towards the right side of the picture, and thus avoiding eye-contact with the spectator, the knight holds a rosary in his right hand and touches the hilt of his sword with his left (a small ring adorns his thumb). As several scholars have noted, the objects allude to the central duality of the *Sacra Religione*, an order of professed Catholic brothers who are also warriors (Gash 1997, p. 159). Caravaggio sets up the two gestures with the same care and intelligence that he had used in depicting the Grand Master's hands in the *Portrait of Alof de Wignacourt and a Page* (Paris, Louvre). The right hand is shown with the palm down; the left hand is shown palm up. The diagonal generated by the placement of the two hands animates the composition; it is mirrored subtly by the diagonal of the collar and the slightly downward tilt of the head. Probably painted towards the end of Caravaggio's sojourn on the island (which culminated with his daring escape to Sicily in October 1608), the *Portrait of a Knight* has an abbreviated, unfinished look. The figure's right hand in particular has little colour other than that of the ground itself. The same can be said for many areas of the face. What appears as brown areas of modelling 'over' the collar and cross is a wonderful illusion: these are simply places where the priming has been allowed to show through. Such elements are part of Caravaggio's late Maltese style and not signs that the artist failed to complete the picture. Caravaggio's loose treatment of the silk cross, which bends and almost 'breathes' with the movement of the chest supporting it, is a *tour de force* that anticipates the greatest passages of Frans Hals and Velázquez.

Conservators have detected several *pentimenti* in the work. Most significantly, a curtain was originally painted in the upper right. Caravaggio eliminated it in the final version. Radiographs also reveal that the position of the left hand was initially lower and may have held a cross instead of a sword. (For a full technical report, see Gregori 1991, pp. 318–24; and Gregori 1997, pp. 124–31.)

The early provenance of this work is unknown. It is cited in the Pitti inventories as a work by Francesco Bassano, but also as 'Cassana'. A label on the stretcher is inscribed 'Retrato de Cassana' (this was later modified to read 'Bassano'). It may be that the frame earlier held a portrait by the artist Cassana (probably Niccolò), which was then reused for Caravaggio's painting (Chiarini 1989, p. 16, n. 5). In 1696 the picture was transferred to the villa of Poggio Imperiale. By 1828, the portrait is listed by Inghirami at the Pitti as a work by 'Cassana Genovese' (see Chiarini and Padovani 2003, vol. 2, cat. no. 156). A rarely seen print of the picture (25.5 x 18.5 cm) reflects the confusion of the inventory records and the labels. Engraved by Gaetano Silvani (Parma 1798–1879), the print, which calls the sitter 'Ignoto', is inscribed 'Cassano dip.' in the bottom left corner. The engraving was originally published in vol. IV of *L'Imperiale e Reale Galleria Pitti illustrata*, ed. L. Bardi, Florence 1838. (A painted copy [after 1650?] of the Pitti image is illustrated by Marini 2001, cat. 95, p. 318.)

It was not until 1966, when Mina Gregori identified the painting as an autograph work by Caravaggio, that the *Portrait of a Knight* re-emerged from centuries of obscurity (Gregori 1974). Gregori has several times suggested that the Pitti portrait depicts Grand Master Alof de Wignacourt, a view she no longer embraces. In 1980, Ferdinando Bologna brought attention to another nineteenth-century print of the painting, this one implausibly claiming that the sitter represents Fra Niccolò Caracciolo di San Vito who died in 1689 (see Bologna 1992, p. 478, n. 23; and Gregori 1991, p. 318). Almost a decade later, Marco Chiarini (1989) published early inventory records (1666–70) describing a picture at Palazzo Pitti of similar dimensions as a portrait of 'March'Antonio Martelli con croce di Malta' ('Fra Marc'Antonio Martelli' in an inventory of 1696). Based on the suggestion of Ludovica Sebregondi Fiorentini, Chiarini put forward the idea that the painting might depict the Prior of Messina, Antonio Martelli, since no 'Marc'Antonio Martelli' is listed in the rolls of the Order. More recently, John Gash (1997) brought to light numerous archival records that demonstrate that Martelli resided in Malta during Caravaggio's sojourn on the island. New documentary evidence now makes it possible to paint an even more precise picture of Martelli's activities, both before and after Caravaggio's Maltese visit (some of the following information comes from Bosio 1684, vol. 3; Bonazzi 1897, vol. 1, p. 201; and Gash 1997).

A member of the distinguished Florentine Martelli family, Fra Antonio Martelli was born in 1534 and joined the Order of St John in 1558. He had a remarkably illustrious career, beginning with his valorous participation in the Great Siege of 1565, in which a massive Turkish invasion was successfully repulsed. During a military campaign in 1567, he was seriously injured by gunfire. Over the course of the following three decades, he participated in numerous campaigns with the Order, with the Venetian fleet, and in the service of the Grand Duke of Tuscany. In Malta, in the early years of the seventeenth century, Martelli was one of the most senior Italian knights, occupying the post of Lieutenant to the Admiral on more than one occasion. The Admiral was the head (or *pilier*) of the Italian knights. Elected Prior of Hungary in 1603, Martelli subsequently renounced this position in 1605 to become Admiral. In October 1606, following the death of the Prior of Messina, Aleramo de Conti della Langueglia, he took up this important post himself. Documents (to be published shortly) prove that Martelli was in Malta throughout Caravaggio's stay on the island. For the first two years of his tenure as Prior of Messina, he kept residence in Malta and administered his priory through procurators. The use of lieutenants was standard practice in the Order. During this period he also maintained vital business relations with Florence. He had been granted licence to move to his Priory in Messina already on 20 March 1608 but did not exercise it until several months later. As Sciberras (2002b, pp. 11–12) has recently shown, he was actually in Malta until late October 1608. By 4 November, he was in Messina, as a letter written to Grand Master Wignacourt on that date attests.

Martelli's motives for moving to Messina derive from his wish to restore its priory church and, more importantly, from an urgent need to deal with several lawsuits and illegal activities taking place there (AOM, Arch. 1388, f. 230r). In mid-June 1608, while Martelli was in Malta (perhaps watching Caravaggio complete his *Beheading of Saint John the Baptist*), remains of the martyred companions of Saint Placidus were discovered and unearthed during remodelling of the priory church, causing great communal joy and claims of miraculous healings in the city (Terrizzi 1998). Martelli was in Messina throughout much of the defrocked Caravaggio's stay in that city in 1609, leaving only to return to his native Florence after September of that year. Perhaps he took the Pitti portrait with him at this time. Martelli died in 1618, a year after being named General of Artillery of the Grand Duchy.

Martelli's right-hand man in Messina had been his Receiver Fra Orazio Torriglia, a knight of Genoese extraction who had been in the post since mid-1607 (Sciberras 2002b, p. 13). Torriglia, it is worth noting, entertained a friendly relationship with Giovanni Battista de' Lazzari, also of Genoese extraction, who commissioned the *Raising of Lazarus* from Caravaggio. De' Lazzari, in June 1609, was apparently oblivious of the fact that Michelangelo Merisi da Caravaggio 'militis gerosolimitanus', had been stripped of his knighthood six months earlier (Saccà 1907, pp. 66–7). Torriglia, it will be recalled, was the Receiver of Genoa in 1601–2, who was actively involved in getting Grand Master Wignacourt's suit of armour delivered to Malta (see our essay in the catalogue). Though it is unlikely that Caravaggio arrived in Messina wearing the habit of the Order, the locals' confusion over his status remains an intriguing problem. Caravaggio's *Portrait of Fra Antonio Martelli* is one of a handful of images of the sixteenth and seventeenth centuries that convey the sense of service, toughness and aristocratic privilege that prevailed in the culture of the Knights of Malta. Martelli clearly had suffered for the Order on more than one occasion. Despite his advanced age (he was 74 or 75 years old) and what appears to be a frail, even suffering body, he stands firm in the painting, presenting himself as a person of stature and ability. Caravaggio could not have failed to be impressed by such an intensely proud and accomplished individual. [k.s., d.m.s.]

Bibliography: Fogolari 1927, p. 118, pl. VII; Borea 1970, no. 23 (as 'ignoto pittore caravaggesco'); Gregori 1974; Cinotti 1983; Gregori in *Age of Caravaggio* 1985, no. 95; Chiarini 1989; Gregori 1991, no. 20, pp. 318–24; Gregori and Bonsanti 1996, p. 36; Gash 1997; Gregori 1997, no. 1h, pp. 124–31; Papi in Venice 2000, no. 49, pp. 197–9; Marini 2001; Spike 2001; Chiarini in Chiarini and Padovani 2003, cat. no. 156, pp. 110–11.

Gaetano Silvani (after Caravaggio), *Portrait of a Knight of Malta*. Valletta, Albert Ganado collection

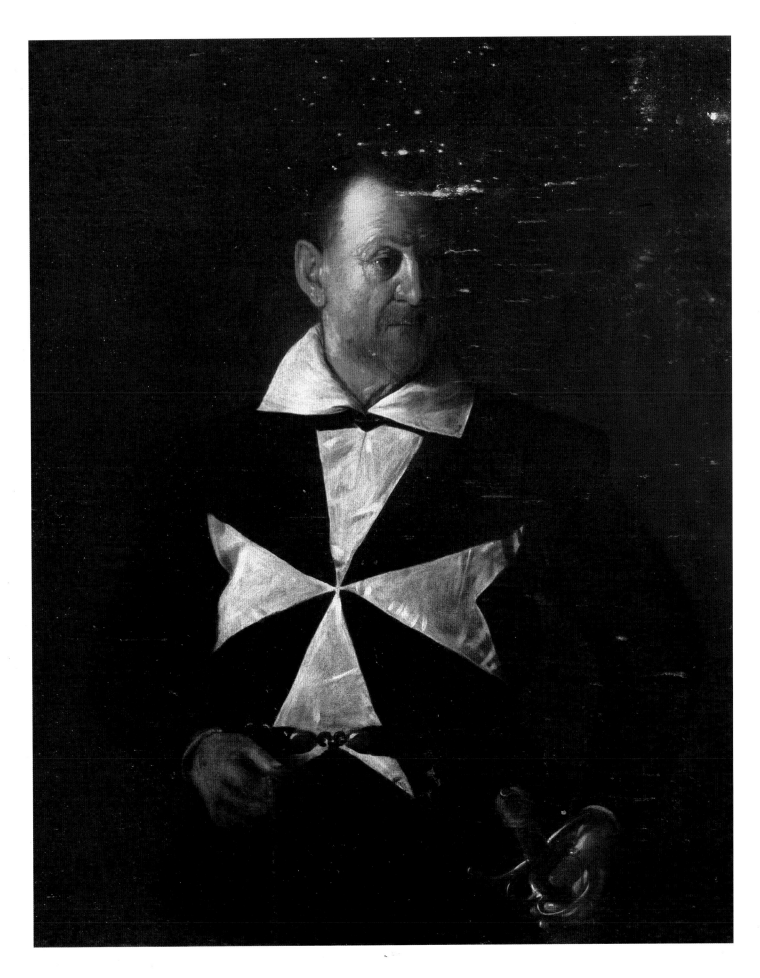

10. The Burial of Saint Lucy

oil on canvas, 408 x 300 cm
Syracuse, church of Santa Lucia al sepolcro, since 1984 in deposit at the Galleria Regionale, Palazzo Bellomo (property of the Fondo Edifici di Culto)

This is the first work Caravaggio painted in Sicily. It was completed in two months during his brief stay in Syracuse in the autumn of 1608, probably between 6 October, when the artist had already made his escape from Malta (on this date an injunction was issued by the Order's prosecutor summoning him to appear in court by 1 December to clear himself of the charges against him), and 6 December when he appears to have been in Messina (see the deed of commission for the large altarpiece for the church of the Crociferi, in which, however, he is not named, published by Saccà in 1907). He was undoubtedly living in this city in the first months of 1609, since *The Raising of Lazarus* was delivered on 16 June. In the words of Bellori (1672): 'having come to Syracuse, he did the picture for the church of Santa Lucia which stands on the seafront: he painted the dead saint with the bishop blessing her; and there are two men digging with spades in order to bury her'. Susinno's account(ms. 1724, ed. 1960) is more detailed and informative, telling how Caravaggio was welcomed to Syracuse by Mario Minniti, his friend and colleague from the years he spent in Rome, who procured for him the commission for the altarpiece from the city Senate. Capodieci (*Annali di Siracusa*, ms. Biblioteca Alagoniana di Siracusa, early nineteenth century, t. VIII, c. 456) maintained that the work was commissioned by Bishop Orosco II in 1586, but this affirmation is disproved by the documented dates we have for Caravaggio's activities.

The picture's autograph status has never been questioned, and the more modest quality of some parts, which some scholars (Urbani and Brandi 1951; Moir 1976) have attributed to the intervention of assistants, and in particular Minniti, seems rather to be due to nineteenth-century repaintings – the work has a rich literature substantiated by authoritative critical opinions, not always in agreement, on philological and stylistic questions, including subject, iconography, setting, characters, compositional organisation, the use of light, and comparisons and analogies with other works, whether by Caravaggio or others.

All the data and hypotheses have been assembled and carefully examined in recent monographs on Caravaggio (Cinotti 1983; Marini 1987 and 2001), to which we refer the reader for all the debated aspects of the picture as well as numerous appraisals and the impressive bibliography. In what follows we shall ignore traditional hypotheses that have long been refuted and draw on those critical arguments which have now largely gained acceptance, limiting ourselves to elements that can contribute to an authentic interpretation of the work.

The choice of subject, quite rare in the iconography of Saint Lucy, should perhaps be seen in connection with the location of this large altarpiece. According to local tradition, the church of Santa Lucia al sepolcro or Santa Lucia *extra moenia*, in the eastern part of the city (the ancient Acradina), was originally built on top of catacombs held to be the site of Lucy's martyrdom and burial. Moreover, the refurbishment of the old Romanesque church, which had stood derelict for centuries, took place in the years 1608–10, just when Caravaggio received the commission for the painting. In 1610 the church and adjacent monastery were assigned to the reformed minor Franciscan friars.

The setting for the burial has been commonly identified with the catacombs of Santa Lucia in Syracuse. Zuccari (1981 and 1987) maintains that there may be an explicit reference to the crypt of San Marziano, adjoining the catacombs of San Giovanni, which feature a characteristic double arch, linking this identification with the return to early Christian values which had informed the *Deposition* in the Vatican, in keeping with the cultural orientation of the Oratorians in Rome. Marini (1974) is surely more convincing when, in view of the fact that the catacombs of Santa Lucia were inaccessible until the turn of the nineteenth century, he suggests that the large curtain wall with archway providing a backdrop to the scene may be a precise reference to the Syracusan caves, and in particular the so-called 'Grotta dei cordari'. It is known that Caravaggio was able to visit the caves during his time in Syracuse, accompanied by the scholar and archaeology expert Vincenzo Mirabella. The artist himself gave the name 'Dionysius's Ear' to one of the most extraordinary caves, a name that is still in use today (Mirabella 1613; see also Russo 2000). Subsequently Marini (1987) argued, rightly to my mind, that Caravaggio 'operated a mnemonic synthesis of places in Syracuse having associations with archaeology and crypts, conferring on the setting of his painting the concordant features of a *latomia* and a catacomb'.

Half of the picture's space is dominated by a towering bare wall, with the crowd of figures characterised by shifts in perspective and bold foreshortening, highlighted by shafts of raking light, producing one of Caravaggio's greatest masterpieces, 'its novelty matched only by the simplicity of its conception' (Brandi 1977 and 1989). The gigantic grave-diggers, transfixed in their crude physicality, converge on the greatly foreshortened body of the saint, beyond which huddle the mute, grieving line of onlookers, and on the right in profile we see the bishop giving his blessing and a soldier in a cuirass. The palette of colours, typical of the late works, relies predominantly on tones of brown with a warm, amber-like luminosity which blots out the individual colours, only the grey-whites and the patch of bright red of the deacon's robe showing through. The whole is lit by a raking light which gives body to the forms and picks out details – faces, hands, folds in the clothes – of outstanding quality.

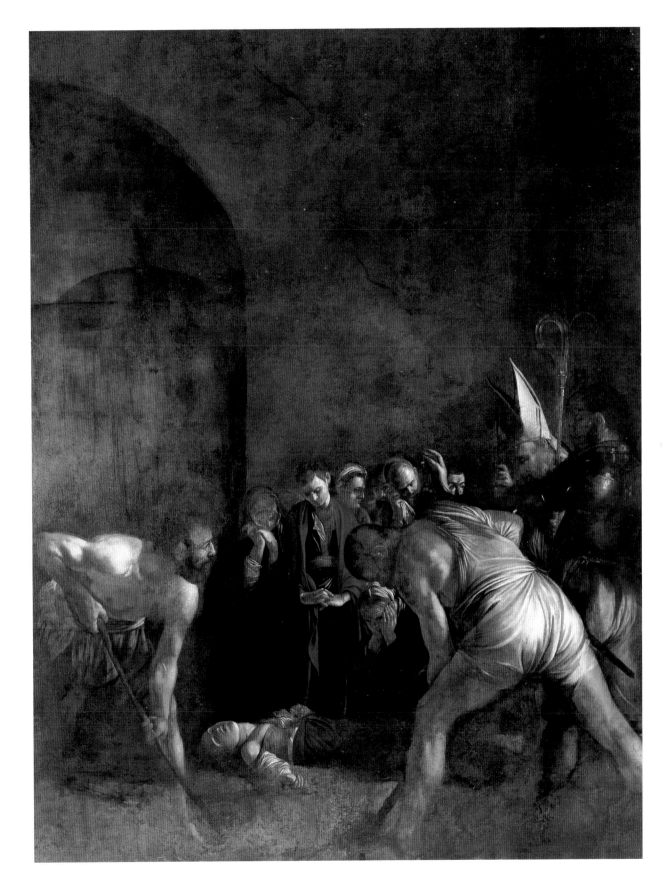

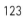

It is obvious, nonetheless, that the true originality of the painting lies in its compositional organisation: the diminishing line of figures, freed from the rigid laws of perspective, serves to expand the spatial depth, while by placing the main characters on a proscenium as it were, almost on the edge of the canvas, the artist heightens the drama of the event. Longhi, as always, has telling perceptions to offer (1952 and 1968), underlining 'the innovative idea of having the dimensions of the characters dwindle rapidly in space, dwarfed by the gigantic wall: a novel correlation in the tradition of Italian art, which Rembrandt the engraver was able to adopt'. And later, speaking of the juxtaposition of different planes, he points out the 'abrupt contrasts in size, jumps from "close ups" to "long shots" which Caravaggio was the only artist able to formulate at that time, capturing an aspect of reality whose reproduction later on would require elaborate technology'. What we witness is in fact almost a photographic still, intense and absolute in its tragic import.

The Burial of Saint Lucy is on one hand directly comparable with *The Beheading of Saint John the Baptist*, painted not long previously in Malta, for the unmistakable compositional and formal analogies (the setting, the relationship between the figures and the space, the use of light); on the other hand it anticipates some effects and expedients (the vertical perspective, the lining up of the figures, the hand of the bishop held up in blessing) which were re-elaborated in the Messina *Lazarus*. The face of Saint Lucy, with its bold foreshortening in a raking light and its livid colouring, has precise correspondences in *The Death of the Virgin* in the Louvre, *The Raising of Lazarus* in Messina and the *Sleeping Cupid* in Florence; while the figure of the old woman kneeling centre stage is almost identical to the one which features in the *Beheading*, both have their hands clasped to their face. Longhi (1928–9) maintains that in the composition, and in particular in the forms of the two grave-diggers in the foreground, there are reminiscences of the style of Antonio Campi.

The early copies, which are already mentioned in Susinno's biography, were mediocre but helpful in providing a more comprehensive view of the original, and they have been extensively studied in recent critical literature. Two are of dimensions only slightly smaller than the original: one in San Giuseppe di Siracusa, mistakenly attributed to Minniti (Wagner 1958; Moir 1976), but in fact a copy taken in 1797 by the Syracusan artist Raffaele Politi (see fig. 2, p. 83) and noted by Longhi (1952 and 1968) when it was still in the church of the Jesuit College, and another formerly in a private collection in Malta (Marini 1974). Three are in a smaller format: one in Sant'Antonio Abate, Palestrina (Rome), wrongly recorded by Longhi as being in the church of San Pietro, also mentioned by Wagner (1958), and two others in private collections, one at Scicli (Ragusa) and one in Rome, both mentioned by Marini (1974 and 1987).

There is an explicit reference to the painting, in a simplified form and with landscape elements added in the background, in one of the relief panels in silver (see fig. 4, p. 84) adorning the base of the statue of Saint Lucy in Syracuse cathedral, which can be dated to no later than the second decade of the seventeenth century (see Agnello 1928; Russo 1987).
There is also the engraving by Giuseppe Politi in his *Siracusa per i viaggiatori* (Syracuse 1835).
On its conservation and restoration history – from the first nineteenth-century interventions to the most recent, carried out by the Istituto Centrale del Restauro – the reader is referred to the essay by Cordaro (1984); while for the findings of X-ray analyses we can mention the recent article by Lapucci (1996). [*g.b.*]

Bibliography: Bellori 1672, ed. 1976, p. 227; Susinno 1724, ed. 1960, p.110; Capodieci 1813, II, p. 364; Privitera 1879, II, pp. 171–2; Saccà 1906–7 (1906, p. 58 note 1; 1907, p 78); Mauceri 1924–5, p. 562; Longhi 1928–9 (1928, I, p. 33 note 1; 1929, II, p. 304); Bottari 1935; Urbani and Brandi 1951, p. 61; Longhi 1952 and 1968, ed. 1982, pp. 106–8; Wagner 1958, pp. 153–5, 167–8, 222–3 notes 663–5; Marini 1974, pp. 45–6, 76–7 notes 357–60, 252, 443–4; Röttgen 1974, p. 254 note 179; Brandi 1977; Zuccari 1981, p. 103; Cinotti 1983, pp. 230, 284, 546–8; Barbera 1984, pp. 147–52; Cordaro 1984, pp. 269–93; Marini 1987, pp. 69–70, 534–6; Pacelli 1987, pp. 94–6; Zuccari 1987; Brandi 1989, pp. 148–50; Calvesi 1990, pp. 136, 144, 332, 381; Bologna 1992, pp. 273, 337–8; Pacelli 1994, pp. 85–7; Lapucci 1996, pp. 17–70; Bona Castellotti 1998, pp. 123–5; Barbera 2001, pp.106–8; Marini 2001, pp. 83–4, 547–9; Barbera 2003, pp. 20–5.

124

11. The Raising of Lazarus

oil on canvas, 380 x 275 cm
Messina, Museo Regionale,
inv. 984

Prior to the restoration carried out at the Istituto Centrale del Restauro in 1950–1 (Urbani and Brandi 1951) for the Caravaggio exhibition in Milan, commissioned by Longhi, the work was in a very poor state of conservation, being dark and largely overpainted, the result of ill-advised attempts at conservation (in 1670, 1820 and 1924). Thus although the work's autograph status is now universally recognised, this was long the subject of debate, with various scholars arguing that assistants had been involved (Mario Minniti for one). The X-ray analysis carried out by Lapucci (1994, pp. 17–37) proved, however, that it was all painted by the same hand. For Lapucci, the only remaining doubt concerns the mantle of Martha, which was painted using a broad brush with coarse bristles, different from the brush used elsewhere, and using colours (yellow-orange-iridescent red) which do not belong to the palette Caravaggio usually used. The picture comes from the high altar of the church of the Padri Crociferi of Camillo de' Lellis, damaged in the earthquake of 1783 and demolished in 1880. In 1879 it was taken to the Museo Civico Peloritano, following the suppression of the religious houses; it was moved to its current home following the 1908 earthquake (see Cinotti 1983, pp. 458–62, Ciolino Maugeri 1984, pp. 153–7, Marini 1987, pp. 536–9, and Pupillo 2001, pp. 109–11).

As has been recently pointed out by Molonia (1997), as early as 1613 'Monsignor D. Silvestro Marulì, or Maurolico, from Messina', noted in his *Historia Sagra intitolata Mare Oceano di tutte le religioni del mondo*, p. 427: 'In Messina San Pietro, formerly dei Pisani and then Parish Church, famous for the Oratory de' Medici known as de' Santi Cosmo e Damiano, and for *The Raising of Lazarus* by Caravaggio', giving us the first known mention of the picture. The Jesuit Placido Samperi (*ante* 1654, ed. 1742, p. 615) also records it in his *Messana Illustrata*, together with *The Adoration of the Shepherds* ('*utraque in magno pretio habita*'), with a correct attribution to Caravaggio, while Bellori provides a first, schematic description in which some inexact details are attributed to an unidentified informer (1672, ed. 1976, p. 227): '... and in the Church of the Ministers to the Sick, in the chapel of the Lazzari family, the *Raising of Lazarus*, who, being carried out of the tomb, stretches out his arms at the voice of Christ calling him and reaches out with one hand towards him. Martha is crying and Mary Magdalene is amazed, while one figure is holding his hand to his nose to fend off the stink of the corpse. It is a large picture, in which the figures are set against a cavern, with most of the light falling on Lazarus's naked body and on those supporting him, and is most highly regarded for the power of its imitation'. Susinno's account (ms. 1724, ed. 1960, pp. 110–12) gives more detailed information on the genesis of the picture, together with anecdotes (some lacking corroboration). He maintains that it was Caravaggio who proposed to the 'rich gentry in the Lazzaro household' the painting's subject, 'an allusion to their family name', and, as a result of the 'great pleasure' this idea gave his patrons, the artist had 'free rein to pursue his artfully conceived fantasy'. Pupillo (2001, p. 109) is surely right in affirming that 'many of the colourful details with which the biographer flavours his account correspond to his need to

substantiate the image of Caravaggio "the demented painter" as a mad and fiendish artist, excessive in his every action'. Thus little credit has been given to Susinno's account of a first version of the painting which Caravaggio himself slashed to pieces with a dagger in fury at criticisms levelled at it (Cinotti 1983, p. 459; Marini 1987, p. 539). It also appears improbable that, to paint the figure of Lazarus, the artist had 'a corpse disinterred which had been high for some days' and held in position by labourers, kept to their task at dagger point. Even the price of 1,000 *scudi*, which Susinno states to have been paid by the de' Lazzari, seems quite exorbitant in terms of the going rate for the artist in those years (Bologna 1992, p. 339).

From the document published by Saccà but subsequently destroyed (1907, pp. 66–9; republished in Macioce 2003, pp. 249–50), we know that on 6 December 1608 before a notary Giovan Battista de' Lazzari (member of a family of merchants originating from Castelnuovo di Scrivia in the Dukedom of Milan, who settled first in Genoa and then in Messina, where they are known to have resided by 1584; see Spadaro 1995) agreed with the Padri Crociferi to finance the construction of a central chapel for their church – (Natoli 1987, p. 217) – and to adorn it with a painting of the Madonna, Saint John the Baptist and other unnamed saints. While there is no mention of the artist in the contract, suggesting that he had not as yet arrived in Messina, in the rider added on 10 June 1609 ratifying the consignment of the altarpiece, the author is specified as 'Michelangelo Caravaggio militis Gerosolimitanus'. It is further stated that the painting showed the raising of Lazarus, approved by the friars in spite of the change of subject from that agreed in the contract (Saccà 1907, pp. 67–9; Macioce 2003, pp. 251–2). There has been a great deal of discussion concerning this new subject, attested by the documents, which in Susinno's account was actually proposed to the de' Lazzari by Caravaggio himself, indicating a degree of autonomy on the part of the artist *vis-à-vis* the terms of the commission. However, the circumstance, mentioned by Spadaro (1995), of the death of Tommaso de' Lazzari, brother to Giovan Battista and his business partner, in the year 1608 (the exact date is unknown), suggests that a topic alluding in some way to Giovan Battista's recent loss may have been deliberately chosen, the episode of the raising of Lazarus in St John's Gospel (2, 38–44), traditionally taken to prefigure Christ's death, being a suitable one. The subject must also have been designed to please the Crociferi friars, if the symbolic gesture of Lazarus, his body still in *rigor mortis* but his arms stretched out to embrace life, can be correctly interpreted as an allusion to the Order's emblem of a red cross emblazoned on the habit (Röttgen 1975, p. 64). In addition Pupillo (2001) has advanced the hypothesis that although Caravaggio had never previously worked for this Order, he may have had contact with its founder, Camillo de' Lellis, in the period when he was working on the Contarelli chapel (1599–1602), since de' Lellis was well acquainted with the Crescenzi family, who were the executors of Cardinal Matteo Contarelli.

As Zuccari points out (1987, p. 164), in this picture Caravaggio departs from the Gospel account, in which Lazarus is described as being buried in a cave sealed off by a stone, opting for the traditional iconography of a tomb in the ground sealed by a tombstone. Moreover, critics from Longhi onwards have drawn attention to elements from the repertoire of classic art (see Posèq 1998), while Zuccari (1981) has indicated analogies with

palaeo-Christian and Byzantine figurative motifs. Longhi (1952 and 1968, ed. 1982, p. 108) emphasised the remarkable invention of the shaft of light striking the body of Lazarus being brought back to life. It is the shaft of light which draws the attention of various figures, including one of the onlookers traditionally taken to be a self portrait of the artist, while the others are focusing on Lazarus. On the left stands the figure of Christ, his outstretched index finger being a literal reprise from *The Calling of Saint Matthew* in the Contarelli chapel. We know of no copies or engravings based on this work. [*g.b.*]

Bibliography: Maurolico 1613, p. 427; Samperi *ante* 1654, ed. 1742, p. 615; Bellori 1672, ed. 1976, p. 227; Susinno 1724, ed. 1960, pp. 110–12, 214 e 219; Hackert-Grano 1792, ed. 2000, pp. 105–8; Saccà 1907; Bottari 1935; Urbani-Brandi 1951; Longhi 1952 and 1968, ed. 1982, p. 108; Spear 1965; Röttgen 1975; Zuccari 1981, pp. 103–5; Cinotti 1983, pp. 230 and 458–62; Ciolino Maugeri 1984, pp. 153–7; Marini 1987, pp. 71–3 and 536–9; Natoli 1987, pp. 217–29; Pacelli 1987, p. 96; Zuccari 1987, p. 164; Calvesi 1990, pp. 42, 73, 144, 331, 339, 363, 381, 382, 396; Bologna 1992, pp. 89, 158, 218, 273–4, 276, 338–9; Campagna Cicala 1992, pp. 115–6; Lapucci 1994, pp. 17–37; Pacelli 1994, pp. 88–90; Spadaro 1995; Molonia 1997, pp. 140–1; Posèq 1998, pp. 93–106; Bona Castellotti 1998, pp. 125–9; Marini 1999, p. 38; Marini 2001, pp. 85–7, 322–3, 549–52; Pupillo 2001, pp. 109–11; Macioce 2003, pp. 249–50, II doc. 382; pp. 251–52, II doc. 387.

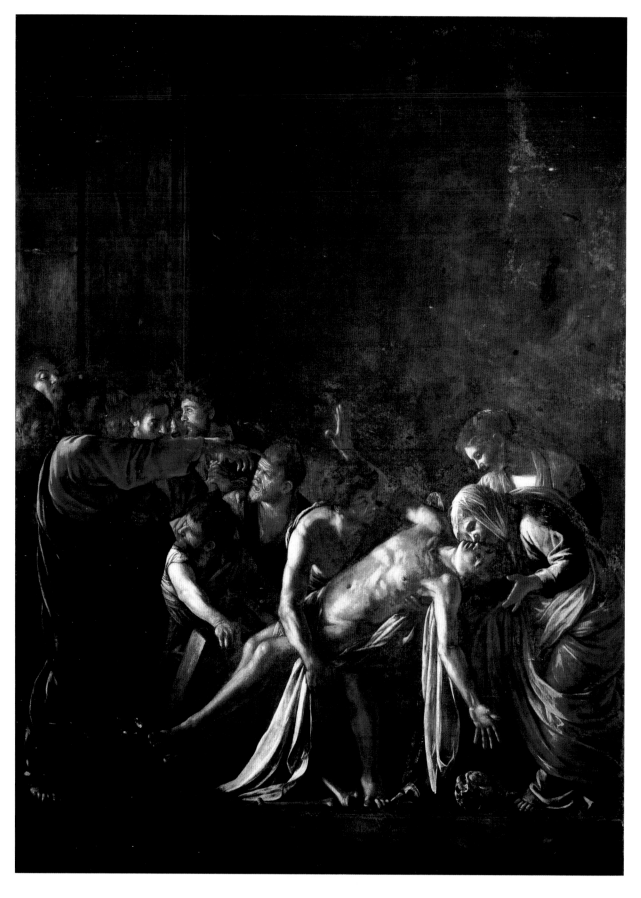

12. The Adoration of the Shepherds

oil on canvas, 314 x 211 cm
Messina, Museo Regionale,
inv. 983

Francesco Susinno (ms. 1724, ed. 1960, p. 113) maintained that this picture was commissioned from Caravaggio by the Senate of Messina for the high altar in the church of the Capuchin friars of Santa Maria la Concezione in the district of La Verza, near San Leo (destroyed by the earthquake of 1908), although there is no way of verifying this, since the archives of the notary Francesco Manna, responsible for drawing up all the Senate's contracts in those years, had already been lost before the earthquake. It entered the collections of the Museo Civico in 1887 following the suppression of the religious houses, and was moved to its current home following the 1908 earthquake. As Cinotti (1983) pointed out, the substantial payment of 1000 scudi, reported only by Hackert-Grano (1792, ed. 2000, p. 105), 'probably reflects the figure Susinno had named for the Lazarus' (Bologna 1992, p. 339). However, for a scrupulous overview of the work's critical history as well as the complete bibliography, I can once again refer the reader to the most recent publications (Cinotti 1983, pp. 457–8; Ciolino Maugeri 1984, pp. 158–61; Papi and Lapucci in Florence-Rome 1991, pp. 386–90; Marini 2001, pp. 552–3; Pupillo 2001, pp. 112–14). It was Samperi who made the first mentions of the large painting: at first, in his Iconologia (1644, p. 143), as a Madonna del Parto, 'a work by the excellent painter Michel'Angiolo da Caravaggio, admired by connoisseurs as showing singular accomplishment in terms of inventiveness', complete with a reproduction in a crude engraving by Placido Donia; and subsequently as a 'Christi Domini Natalitiorum' (Samperi before 1654, ed. 1742, p. 615). In the description given by Bellori (1672, ed. 1976, p. 227) – 'the Virgin with Child outside the decrepit stable with its planks and wooden beams' – the shepherd on the far right, 'leaning on his staff', is mistaken for Saint Joseph, who is in fact perfectly recognisable in the figure in the right foreground, wrapped in a voluminous cloak and with an unmistakable halo.

Nonetheless, in an account full of details (he alludes, for example, to the canvas being shortened at the top 'so that it would fit into the chapel') and perceptive observations, Susinno (pp. 113–14) hailed it as 'Caravaggio's greatest and most masterful picture', in clear contrast with the Lazarus, for in it 'this great naturalist avoided that clever outlining with shadows but showed himself natural without recourse to his virtuosity in shading'. With a certain amount of civic pride, the biographer attributes this evolution in Caravaggio's stylistic language to the quite improbable influence of the style of Antonio Catalano l'Antico, a local artist who worked in what can broadly be described as the Baroque idiom ('hearing praise for the sweetness of Cattalani l'Antico made him return to his senses'), only to contradict himself in another passage from his Vite in which he gives Caravaggio's scornful verdict on Catalano's products, dismissed in no uncertain terms as 'playing cards'.

Among the nineteenth-century Messinese sources we should mention Grosso Cacopardo (1821, p. 80), who observed how 'the group of three shepherds, expressed with such truthfulness ... seems to have been copied from the works of Polidoro', evoking a possible echo of the pictures in Messina by Caravaggio's famous compatriot, and in particular the celebrated Altobasso Nativity, now in the Museum.
While the work's autograph status has never been called into doubt, twentieth-century criticism of The Adoration of the Shepherds – 'certainly one of [his] most complex, thought out and finished works, from every point of view' (Papi in Florence-Rome 1991, p. 387) – has variously interpreted the chronology, iconography and the ideals of poverty it appears to have taken as its starting-point.
In terms of chronology, a large majority of scholars place the picture immediately after The Raising of Lazarus, although there are authoritative voices who argue for the contrary (L. Venturi 1951, p. 59; Mahon 1952, p. 19; Hinks 1953, p. 119; Jullian 1961, pp. 203–6; Bologna 1980, p. 36). While, as Pupillo maintains (2001, p. 114), 'there seems to be more logic in a sequence in which Caravaggio received first a private commission (that of de' Lazzari for the Ministri degli Infermi) and subsequently a public one (the gift of the Messinese Senate to the Capuchin friars)', in the absence of documentary evidence it is surely more prudent to adopt the position of Cinotti (1983, p. 460) who, while tending to assign the precedence to the Lazarus, pointed out how, 'since one is dealing with Caravaggio and his evolution, which is anything but canonical, the sequence Lazarus-Nativity cannot be asserted with absolute conviction'.
The iconography, with the Virgin lying on the straw – 'ignobly stretched out full length on the ground' in the words of Grosso Cacopardo (1821, p. 80), but for Cinotti (1983, p. 458) an 'idea of the most graceful and delicate geometry' – may perhaps derive from Byzantine models, in an echo of works Caravaggio would have seen during his stay in Sicily. For Friedlaender (1955, p. 127), who considers it 'unsurpassed in its expression of Filipine simplicity, poverty and humility', it is an explicit reference to the fourteenth-century iconography of the Madonna of Humility, emphasising the etymological root of humilitas in humus (ground); more recently Spadaro (1987, p. 290) put forward the hypothesis that the composition probably owes much to an old illustration of the Madonna del Parto which Samperi (1644, pp. 175–6) mentions in the Messina church of San Francesco d'Assisi belonging to the Observant Minors.

On the origin of the Senate's commission from Caravaggio and the iconography, evoking the ideal of poverty, Abbate (1984, pp. 51–2) has suggested that the Sicilian Capuchin Girolamo Errante, who had served as General of the Order and was in Messina in 1605, dying in Trapani in 1611, may have been 'instrumental in introducing the painter into the milieu of the Minorites, leading on to various commissions'. Returning to this hypothesis in a later publication, the scholar emphasised 'the iconographical choice of representing the Virgin in a "humble" attitude... [as] not in the least fortuitous' (Abbate 1999, p. 32). Nor must we ignore the fact, pointed out by Spadaro (1984, pp. 12–13; 1987, pp. 289–92), that in 1605 a figure of great prestige, the Observant Minor Fra Bonaventura Secusio, became bishop of Messina, continuing in office until 1609, so he too may have provided the link between the painter and his patrons. Other iconographical elements from the tradition of poverty observed by the Capuchins have been illustrated by Zuccari (1990, pp. 193–4) and Calvesi (1990, p. 363; 1999, p. 16). And as various commentators have remarked, the traditionally joyful topic of Christ's birth here takes on a sombre, sorrowful air, not unlike the 'funereal meditations of the Capuchins' (Marini 1987, p. 540).

In terms of its composition, the *Adoration* harks back to the monumental solemnity of Caravaggio's Roman works (in particular the *Death of the Virgin*, and also the *Doubting Thomas*), particularly in the group of shepherds. According to Cinotti (1983, p. 158) the 'solution of the shepherd's bare shoulder emerging with the remarkable physicality that so struck Susinno is an immediate precedent for the executioner in the *Salome* in Madrid'; this critic places great emphasis on 'the geometrical conception that governs the picture ..., a structure in which the geometry is identified with the expression of a particular sentiment'.

Nonetheless Roberto Longhi's appraisal has never been surpassed (1952, ed. 1982, pp. 108–9): 'He succeeded in completing for the Capuchins in Messina the exquisitely humble *Manger Scene with Shepherds*; and once again, this time in a more humane fashion, he strove to open up a new perspective in the relationship between space and figures. The Madonna looks lost, holding the tiny Child before the apprehensive gaze of the shepherds, as stolid as if cast in bronze. She is lying on a litter of prickly straw, hemmed in by animals as immobile as objects, while the merest glimmer of light seems to enter in, together with the surge of the unseen sea. Set down in front of us, a sort of "peasant still life" – napkin, loaf and carpenter's plane in three tones, white, brown and black – is reduced to a forlorn quintessence'. [*g.b.*]

Bibliography: Samperi 1644, p. 143; Samperi before 1654, ed. 1742, II, p. 615; Bellori 1672, ed. 1976, p. 227; D'Ambrosio 1685, p. 350; Susinno 1724, ed. 1960, pp. 113–14; Hackert and Grano 1792, ed. 2000, p. 105; Grosso Cacopardo 1821, p. 80; Saccà 1907, pp. 44–5 and 70–2; L. Venturi 1951, p. 59; Longhi 1952 and 1968, ed. 1982. pp. 108–9; Mahon 1952, p. 19; Hinks 1953, p. 119; Friedlaender 1955, pp. 127 and 216; Jullian 1961, pp. 203–6; Bologna 1980, p. 36; Cinotti 1983, pp. 230, 457–8; Ciolino Maugeri 1984, pp. 158–61; Marini 1987, pp. 73–4, 539–40; Natoli 1987, pp. 222–6; Pacelli 1987, p. 96; Calvesi 1990, pp. 332, 363, 388; Zuccari 1990, pp. 193–4; Papi and Lapucci in Florence-Rome 1991, pp. 386–90; Bologna 1992, pp. 273, 292, 339; Campagna Cicala 1992, pp. 114–15; Lapucci 1994, pp. 37–63; Pacelli 1994, pp. 87–8; Molonia 1997, pp. 140–1; Bona Castellotti 1998, p. 129; Posèq 1998, pp. 144–50; Abbate 1999, p. 32; Calvesi 1999, pp. 15–16; Marini 1999, p. 38; Pacelli 1999, p. 57; Pupillo 2001, pp. 112–14; Marini 2001, pp. 87–8, 552–3; Pupillo 2003, pp. 26–9.

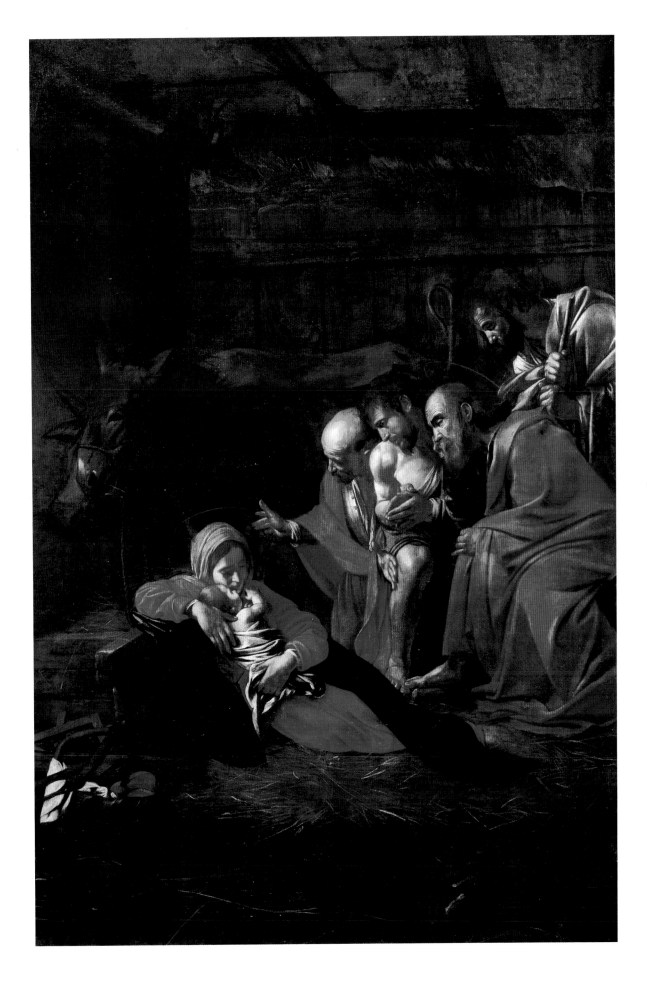

13. Salome with the Head of John the Baptist

oil on canvas, 114 x 137 cm
Madrid, Palacio Reale,
Patrimonio Nacional,
inv. 10010026

During the final years of his career, Caravaggio probed the subject of the killing of John the Baptist in three compositions of haunting power. In addition to the *Beheading* in Malta (see p. 74), his most important full-scale narrative painting of this period, Caravaggio explored the theme in two distinct paintings in the half-length format he had long used for the close-up investigation of narrative subjects (see also cat. no. 14). The murder of the Baptist is told in most complete form in Mark 6:22–28. John the Baptist was imprisoned after rebuking King Herod Antipas for marrying Herodias, his brother's wife. Herodias sought revenge for the insult through her daughter, who was not named in the Gospels, but later came to be identified as Salome. At Herod's birthday banquet, Salome's dancing so pleased the king that he rashly granted her any wish. Prompted by her mother, she demanded the head of the Baptist on a plate. Though distressed, Herod conceded and had the head brought to Salome and she in turn presented it to her mother.

The moment after Salome received the severed head from the executioner was ideal for a compact composition because it presented the essential confrontation of beauty and horror, of a cold-blooded villain and her righteous victim. Caravaggio was perhaps inspired by sixteenth-century Lombard half-length prototypes, in which the characters are displayed in a relief-like format. These balanced, static, and artfully posed compositions are transformed by Caravaggio, who endowed his depiction with a sense of informality and instantaneity that gives it a disquieting edge. In this work, Caravaggio examined the psychology of the scene, principally through figural attitude and facial expression, deliberately limiting the arm and hand gestures that play such an important expressive role in his other half-length narratives.

The scene is revealed by a powerful raking light that penetrates the darkness, focusing on the perpetrator of the crime. Adjacent to Salome, there is an unsettling void that emphasises her dark presence. She regards the viewer with cold unflinching eyes that are alive, but strangely hollow. She shows a faint hint of a smile, but she is no typical villain. Characteristically, Caravaggio gives her expression an enigmatic quality that conveys psychological complexity and allows for a wide range of interpretations. Some perceive Caravaggio's sympathy for Salome, herself a victim of her mother's hate. Those familiar with the sequence of the biblical narrative might wonder if Salome's pose and direct eye contact indicate that Caravaggio intended for the viewer to assume the role of the mother.

The red cloak proclaims Salome's regal status as well as her culpability and her *décolletage* suggests the means by which she gained this end. The horizontal position of the Baptist's head stresses its lifelessness, though the mouth is still open as if preaching. The youthful executioner turns to leave, looking back at his deed with his head bowed. Not sinister, he is powerless muscle just given a terrible task. He and the old woman establish a soulful mood with their lowered heads and expressions of resignation. The woman is not only Salome's counterpart in age; her detachment is a foil to Salome's because her gaze evokes the experience of a lifetime and a sobering lack of shock at what has occurred. The elliptical composition magnifies the Baptist's head while serving to underscore an air of languid fatalism.

It is not clear when the painting entered the Spanish royal collection. It might be the painting brought to Spain by the second Conde de Castrillo, Viceroy of Naples 1653–9 (Milicua in Madrid–Bilbao 1999–2000, p. 138), but it might also be the painting accurately described without attribution in the 1636 inventory of the Alcázar of Madrid (Harris 1974, n. 58, p. 236). Caravaggio's authorship was noted in royal inventories beginning in 1666. The painting was saved from the 1734 fire in the Alcázar, but lost its attribution. It was later called 'style of Caravaggio' until Longhi published it as fully autograph in 1927, initially identifying it as the painting Bellori mentions was dispatched from Naples in 1609 as a gift for Wignacourt (Longhi 1967, p. 124) (see cat. no. 14). The painting gained wide, although not universal, acceptance as the work of Caravaggio after it appeared in the 1951 exhibition. Following the reappearance of the London version, Longhi dated the Madrid painting in the Maltese period (Longhi 1959, p. 25). However, no consensus on the date of this painting has been reached; some date it late in Caravaggio's Roman period while others see it as one of the very last works of his career, contemporary with the *Martyrdom of Saint Ursula* (see survey of scholarly opinion in Marini 2001, no. 99, pp. 553–5). The solid, well-delineated and modelled forms and the use of symbolic and emotive colour would seem to preclude the later dating. Mahon (1952, p. 19) most convincingly dated the painting to 1607, placing it between the Brera *Supper at Emmaus* (cat. no. 2) and the Neapolitan altarpieces, the *Flagellation* (cat. no. 6) and *Seven Works of Mercy* (cat. no. 4). The Madrid painting shares the quiet melancholy that pervades the Brera

Supper. The Brera painting is also echoed in the elliptical composition, the compositional void, and the restrained use of gesture as well as the execution of the drapery and the head of the old woman. However, the tonal unity of the Brera *Supper* is abandoned in favour of strong colour and bold highlights on much firmer flesh in the manner of the two Neapolitan works. The condition of the painting has sometimes been characterised as poor, but the recent cleaning and restoration by María Carmen Alquezar Gómez of the Patrimonio Nacional has established that the work is in good condition. There are no major losses of paint and no signs of the painting having suffered damage in the Alcázar fire as has been sometimes claimed. The sporadic surface abrasion has long been evident, especially in some of the modelling of flesh tones and fabric.

The basic position of the figures was established with abbreviated strokes of white *abbozzo*. One marks the top of Salome's head and another indicates the tilt of the executioner's skull, both now apparent on the surface, particularly as the strokes do not follow the contours of the hair painted over them. A long, curving stroke apparently defines the executioner's chest a little to the left of its present position. The hilt of the sword has also been moved right. The highlight catching drapery over the shoulder of the executioner seems to be enforced *abbozzo*, and this is perhaps the case with the sweeping stroke that defines the shoulder blade.

This painting is one of the earliest in which Caravaggio explores the expressive use of a compositional void. X-radiography has shown two parallel *abbozzo* strokes running from near the top of the canvas to the level of Salome's shoulder, closer to her profile than to the edge of the canvas. This might simply mark the boundary of the void, but it might also indicate that Caravaggio was initially planning a drape, a wall, or perhaps a door as in the Malta *Saint Jerome Writing* (cat. no. 7).

A forthcoming publication by the conservation and scientific staff of the Patrimonio Nacional will add much to our understanding of the complexity of Caravaggio's late technique. [*d.c.*]

Bibliography: Keith 1998, pp. 47-9; Milicua in Madrid-Bilbao 1999-2000, pp. 138-41.

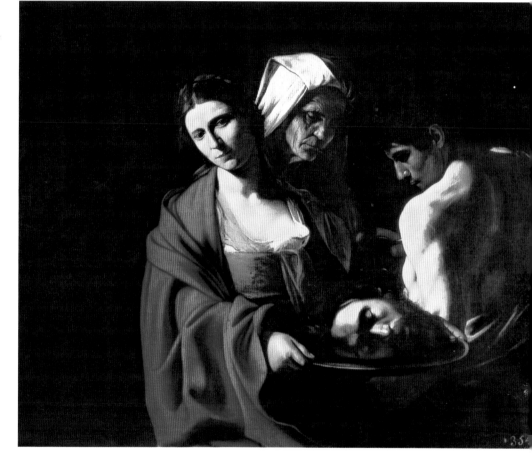

14. Salome receives the Head of John the Baptist

oil and egg on canvas,
91.5 x 106.7 cm
London, The National Gallery,
NG 6389

This painting is a variation on the theme Caravaggio first treated in the *Salome with the Head of the Baptist* in Madrid (see cat. no. 13). He employed the same three characters, but opted for the immediately preceding moment. The executioner is just placing the head in the charger and the horror is amplified by his dramatic thrusting of the severed head outward. The upright position and open mouth make it seem as though the Baptist breathes his last gasp or continues to preach. The almost delicate play of light behind the head, on Salome's hand, on the charger, and under the arm of the executioner, intensifies the focus on the head as well as its sense of presence. In accordance with the greater drama, the figures here are shown from a closer viewpoint and now virtually fill the dark space. The gravity of the scene is matched by the bleak colour range, dominated by flesh tones, black, white and brown, with even the red of Salome's lips and the blood in the gold charger subdued. Sharp highlights underscore the dynamism of this rendition.

As with the Madrid version, the half-length composition reflects Caravaggio's recollection of Leonardesque prototypes. Bernardino Luini's painting of the subject in the Uffizi represents the same moment and cast, and depicts Salome looking away. Caravaggio might also have remembered Titian's *Salome with the Head of the Baptist* (Rome, Galleria Doria-Pamphilj), then in the Salviati collection, for the complexity of her expression, but there is no trace of Titian's subtlety or sensuousness here.

The composition conveys the essential relationships between the characters with great simplicity and force. Although Salome looks away as the executioner places the head of John the Baptist in the charger, her culpability is clearly conveyed by the strong light focused on her, by the powerful thrust of the executioner's arm, and by the tilt of her head, which plainly echoes the executioner's. As in the Madrid painting, Salome's expression is strangely enigmatic. The sidelong glance can be read as austere and cunning, contemplating not the death she has caused, but the shock she will trigger when she presents her trophy, the ultimate symbol of power, at Herod's banquet. However, some see in this expression a faint glimmer of sorrow and shame, an inability to confront what she has done.

The coupling of heads is repeated, linking the sorrowful old woman and the Baptist. The woman's quasi-disembodied head emerges from behind Salome, her counterpart in age and attitude. Her beauty faded, she looks down at the severed head, her hands clasped to her chin, expressing dismay and compassion. The depth of her response is in marked contrast to that of her stoic counterpart in the Madrid version. She is the sympathetic Everywoman that Caravaggio used repeatedly in late compositions to lead the viewer into the prayerful, sorrowful mood of the picture.

The executioner's role becomes more profound in this version. Although his visage is dispassionate, his gesture serves to defer and assign blame. The foreshortened arm is virtually the mirror image of David's gesture in *David with the Head of Goliath* (cat. no. 16). This gesture usually signifies triumph, but is transformed by lowering the arm and distancing it from the figure to lend melancholy to the killer's reaction. The tilt of the executioner's head shares something with David too, but does not project quite the same air of sorrow. He is not the youthful executioner of the Madrid painting, but a well-known character fashioned after the same model or type created by Caravaggio for the tormentor in the upper left of the *Flagellation* (cat. no. 6) and seen in other late works. Longhi first published the painting as a late work by the artist in 1959, shortly after it was sold at the Hôtel Drouot, Paris (Longhi 1959, pp. 21–32). The National Gallery bought the painting in 1970 on the recommendation of Denis Mahon, but not all were convinced. Levey was troubled by the great distinction in technique between half-length narrative compositions and catalogued the National Gallery painting as 'Ascribed to Caravaggio' (Levey, 1971, p. 53). Kitson and Moir also expressed reservations about the attribution (Kitson 1969, p. 109; Moir 1976, p. 135). Otherwise, the painting has been generally accepted as the work of Caravaggio, with most scholars dating it to his second stay in Naples (Gregori 1985, p. 336). Although we know nothing of its early history, its presence in Naples seems assured by the existence of a copy in the Abbey of Montevergine near Avellino as well as numerous works seemingly inspired by the composition (Moir, 1976, p. 135). This painting is the prime candidate for a work that Bellori states Caravaggio sent from Naples to placate the Grand Master of the Knights of Malta after the painter's return from Sicily in the autumn of 1609. Bellori describes 'a half-length figure of Herodias with the head of Saint John in a basin' ('una mezza figura di Erodiade con la testa di San Giovanni nel bacino'), referring not unusually to Salome by her mother's name (Bellori 1672, p. 211). The subject was most appropriate for the leader of the Knights of St John and would have brought to mind the painter-knight's triumph in the *Beheading of the Baptist*, but Bellori adds that Caravaggio did not succeed in his aim. In truth, we do not know that the painting was ever sent to Wignacourt because no documentation of its presence on Malta has been discovered.

It is clear that the London *Salome* was created in Caravaggio's last years because it is an essay in laconic painting. It seeks to impart the gripping, emotive essence of the story with an austerely limited use of paint and colour that anticipates *The Denial of Peter* (cat. no. 17) and *The Martyrdom of Saint Ursula* (cat. no. 18). The finer tonal gradations of Caravaggio's earlier work become more starkly contrasted in this painting, but not quite to the degree seen in the *Denial* and *Saint Ursula*. The relative solidity of the forms in this work would seem to place it shortly before the very last paintings, which would accord with the implied date of 1609 for the work mentioned by Bellori.

Caravaggio seemingly applied the paint quickly and freely to the warm brown ground. Keith (1998) has shown that this impression of economy was very deliberately calculated. For instance, the shadows in the executioner's upraised hand are not the ground, but ground-coloured paint applied last, as is much of the shadow in the chest, neck, arm and eye sockets. The flashing highlights on Salome's sleeve, which mimic rough strokes of *abbozzo*, were laid on last to enhance this sketch-like quality. Though the ground colour was ostensibly used to limit the chromatic range, Caravaggio subtly extended its range by darkening it slightly in places, particularly the executioner's chest and tunic and in the background. Traces of both *abbozzo* and incisions are found, notably in the now visible ear of the old woman due to increased transparency of the covering paint (Keith 1998, pp. 45–9). The painting has suffered from abrasion and has a wide craquelure, but was always starkly painted to correspond with the abbreviated format and presentation of the Salome narrative. [*d.c.*]

Bibliography: Longhi 1959; Gregori in New York 1985, no. 96, pp. 335–7; Keith 1998, pp. 45–9.

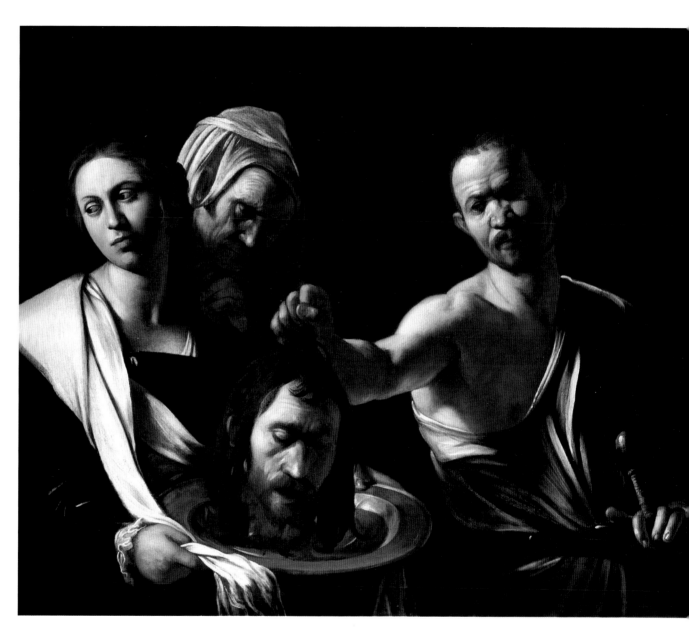

In their respective catalogues, M. Cinotti and G.A. Dell'Acqua (1983) and M. Marini (1987, new ed. 2001) have given a comprehensive and reliable account of this picture's history, the circumstances in which it arrived in Nancy, the various restorations it underwent over the years and the strange saga of its attribution. In an inventory of 31 March 1645 mention is made of 'a large picture of the Annunciation given by Duke Henry II, by the hand of the famous painter Michelangelo, with frame entirely gilt ...', but the painting was subsequently attributed to Guido Reni (catalogue of national possessions, 1790). What is indeed paradoxical is that hardly had it been reattributed to Caravaggio in 1948 by F.G. Pariset, the great specialist on seventeenth-century art in Lorraine, than it appeared in the Bordeaux May exhibition in 1955 as being by an 'unknown Caravaggesque'. It was Roberto Longhi who had virtually the last word on its attribution in 1959, dating it to Caravaggio's second stay in Naples.

The information contained in the two catalogues, to which we refer the reader, provides a complete account of the problem of the work's dating and iconography.

The question of the date has caused much ink to flow. Cinotti and Dell'Acqua were in favour of the second stay in Naples, in 1609 and 1610; Marini argued for its execution in Messina in 1609; Pacelli for a dating 'to either July 1608, that is while he was still in Malta, or December 1609, at the beginning of the second Neapolitan period'.

Art historians have also gone into the theological resonance of this *Annunciation*. Marini saw in it a presage of the tragedy of Golgotha; Calvesi (1971) was struck by the 'humble' iconography of the bare room, a deliberate allusion to the austere bedchamber of Federico Borromeo, a far cry from the usual reception room; Calvesi goes on to maintain that the angel was also depicted in the style of Borromeo: in the *De pictura sacra* it is laid down that angels should take the form of fire. Cinotti reminds us that Dell'Acqua gave a perceptive reading of the narrative time, 'so that the Virgin's genuflection comes just a moment after, indeed almost at the same time as, the angel's apparition from on high ... it is Caravaggio's achievement to have compressed the narrative sequence, rendering contemporaneous the key moments of the event's two protagonists' (Cinotti in Cinotti and Dell'Acqua 1983, note 34, p. 468).

Several art historians have come up with stimulating stylistic comparisons: Mina Gregori (1974) compares the attitude of the humble Madonna with that of Saint Ursula, and the Virgin's hand with that of the page who accompanies Alof de Wignancourt; and for Cinotti and Dell'Acqua (1983) the intensely introspective quality is found again in the humble woman in *The Raising of Lazarus*, while the parallel folds in the angel's robe recall Saint Lawrence in the Palermo *Nativity*. I believe we would do well to go back to the source of the scene, to be found in St Luke's Gospel: 'And in the sixth month the angel Gabriel was sent from God unto a city of Galilee, named Nazareth, to a virgin espoused to a man whose name was Joseph, of the house of David; and the virgin's name was Mary. And the angel came in unto her, and said, Hail, thou that art highly favoured, the Lord is with thee: blessed art thou among women. And when she saw him, she was troubled at his saying, and cast in her mind what manner of salutation this should be ... And behold, thou shalt conceive in thy womb, and bring forth a son, and shalt call his name Jesus ... The Holy Ghost shall come upon thee, and the power of the Highest shall overshadow thee ... And Mary said, My soul doth magnify the Lord, and my spirit hath rejoiced in God my Saviour. For he hath regarded the low estate of his handmaiden' (Luke I, 26–48). Not only has Caravaggio respected the text (including the shadow, and the lowly handmaiden), he has also shown himself fully conversant with the vocabulary of scriptural theology. The angels are named after their function as 'messengers'. When a spiritual communication has to pass from heaven to earth, the angels become mysterious messengers: Gabriel twice brings an annunciation (Luke I, 19 and 26). The angel is depicted on a cloud, an important symbol for the mystery of the divine presence, making God manifest while concealing him. Before taking his place in the clouds above the earth, the Son of Man was conceived by the Virgin Mary shrouded in the cloud of the Holy Spirit and of the power of the Almighty (Luke I, 35); the cloud manifests the presence of God and the glory of his transfigured Son. And finally, dream becomes reality in Mary when she is overshadowed by the presence of God (Luke I, 35), conceiving the One on whom the cloud will rest (see *Vocabulaire de théologie biblique*, Xavier Leon Dufour, Paris 1962, p. 716).

15. The Annunciation

134

oil on canvas, 285 x 205 cm
Nancy, Musée des Beaux-Arts, inv. 53

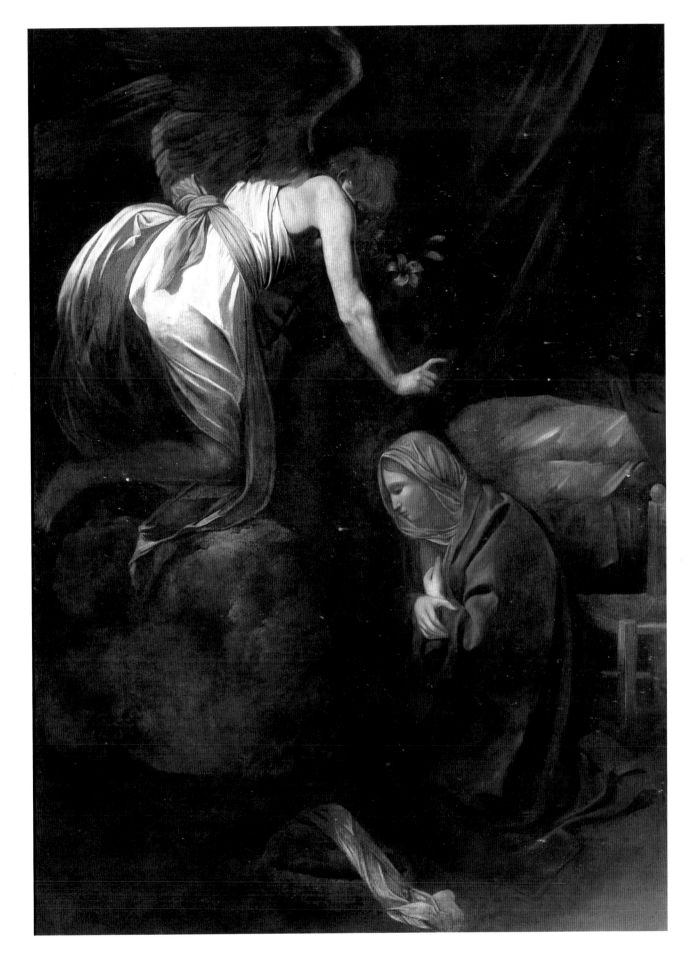

Jacques Bellange, *Annunciation*.
Paris, Bibliothèque Nationale
de France, Cabinet des Estampes

Anonymous painter from Lorraine,
17th century, *Portrait of Henry II
of Lorraine and his wife Margaret
of Mantua*. Florence, Galleria
Palatina

The Annunciation would indeed have featured in Chastel's
study *Le geste dans l'art* (Paris, ed. Levi 2001), for not only is
the work built around a relationship expressed in gesture, but
the viewer is struck by how the gestures contribute to the
organisation of the images. The composition is based on the
arrangement in space of two figures linked by attitudes and
gestures. The picture is dominated by an expressive gesture
bearing an unmistakable psychological content (the angel's
right arm and hand), a gesture which responds fully to the
composition's affective potential. In the angel's gesture we see
something of its essence. The hand performs the greeting and
the benediction (Luke I, 28), and at the same time gives an
authoritative but kindly counsel. Chastel recalls the prime role
of the index finger in the gesture of prayer, silence and
warning. As in other pictures by Caravaggio (*Saint Matthew
and the Angel*, the *Nativity with Saints Francis and Lawrence*),
the characters belong to two different spheres which are
brought momentarily into contact to convey the phenomenon
of supernatural inspiration. Caravaggio is surely *sans pareil*
when it comes to representing the divine and the supernatural.
The beauty of this picture derives, of course, from its execution,
but also from the contrast between the vortex of the figure of
the angel, brought to a peak of expressiveness in its
authoritative gesture, and the figure of the Virgin, humble and
submissive. We are struck both by the exaltation of a symbolic
gesture representing proclamation, injunction and regal
declaration, and the simplicity of the Gospel scene. In an essay
published in 1545 in Southern Italy, the Neapolitan physician
Bartolomeo Maranta discusses Titian's *Annunciation* and the
language of gesture. Gestures can be used to convey not only
who is speaking (the angel), but also *who is going to speak* (the
Virgin) (cited by Chastel 2001, p. 42). Caravaggio probably did
not know this essay, but he was certainly aware of the issue at
stake.
To conclude we can recall that the picture must have had an
enormous influence in Lorraine. It was certainly admired by
Georges de La Tour, and was engraved (or rather reinterpreted
as an engraving) by Jacques Bellange with mannerist
overtones. [*a.b.*]

Provenance: given by Henry II of Lorraine (who acceded to the
dukedom in 1608 and died in 1624) for the high altar of the
Cathedral of Nancy, founded in 1607 and consecrated in 1609.
Henry II married Margherita, sister of Cardinal Gonzaga (the
second son of the Duke of Mantua), Caravaggio's friend and
protector. For more details about the Duke's donation and also
the presence of an illegitimate son of his in Malta in 1608
aspiring to admission to the Order of Malta, see Calvesi 1990;
Macioce 1994; Cinotti-Dell'Acqua 1983; Marini 2001, p. 577.
Exhibitions: Bordeaux 1955.
Bibliography: Pariset 1948, pp. 108–10; Longhi 1959, p. 29;
Cinotti and Dell'Acqua 1983, n. 34, p. 466; Brejon and Volle
1988, p. 72; Macioce 1994, pp. 209–10; Marini 2001, n. 101,
p. 557; Pacelli 2002, p. 80, fig. 39, p. 81.

16. David with the Head of Goliath

oil on canvas, 125 x 101 cm
Rome, Galleria Borghese,
inv. 455

When it appeared, this was the most dramatic and moving representation of the story of David ever painted. Caravaggio's interpretation or 'invenzione' of the biblical topic revolutionised the existing iconographical tradition.

The picture belonged to Cardinal Borghese at least from 1613, for in this year there is a reference in the household accounts to payment for a frame, made to the joiner Annibale Durante. Also in 1613 it figured in an encomiastic poem by Scipione Francucci which constitutes the first description we have of the Cardinal's art collection in his villa at Porta Pinciana, the building which today houses the Galleria Borghese. Caravaggio is always specified as the author in the successive inventories of the collection, through to the catalogue of Adolfo Venturi (1893) and modern studies. Since Bellori mentioned that the David was painted for Cardinal Scipione Borghese, it was long assumed that it was done in a period in which the artist and prelate could have had direct contacts with each other. Thus it was dated to the final year of the artist's stay in Rome, 1605–6 (Pevsner 1927–8; L. Venturi 1921, ed. 1951; Mahon 1952), or immediately thereafter during his visits to Naples, Malta and Sicily (Longhi 1951 and 1952). In 1959 Roberto Longhi, in his description of the Salome in the National Gallery, London, pointed out the stylistic affinity with the David in the Galleria Borghese and identified in both works the style of the painter's final years, putting back the picture's execution to the start of his second stay in Naples, in September–October 1609.

Adopting this dating and referring it to the artist's biography, Calvesi proposed that this picture may have been a tribute sent from Naples to the Cardinal in order to ensure his benevolence and obtain a pardon for the death sentence that had been hanging over the artist since his murder of Ranuccio Tomassoni.

Following the technical and diagnostic analyses carried out during the restoration of all the works of Caravaggio in the Borghese collection (the last being the Madonna dei Palafrenieri in 1998), there can be no doubt about the difference in technique between the paintings done while he was in Rome and those, such as the Saint John and the David, which have much more in common with late works such as The Martyrdom of Saint Ursula, also recently restored. This is seen in the greater use of the so-called 'risparmio' in which light colours overlay the dark ones, the range of colours used, and the way in which the canvas was prepared initially. Proof that the picture was in Naples and dispatched from there to Scipione Borghese may lie in the copy which the Viceroy of

Naples had made immediately after the artist's death. The rightful ownership of the paintings which Caravaggio was carrying with him from Naples to Rome, two Saint Johns and a Magdalen (Pacelli 2002, p. 122), provoked such high feelings that it was apparently decided to settle the matter by having copies made by Baldassarre Alvise. This painter, up until now known only from documentary references, is here identified with the Bolognese artist Galanino, in Naples during this period, who according to Malvasia was responsible for the disastrous idea of bringing the ailing Annibale Carracci to Naples. A letter from Deodato Gentile dated 10 December 1610 states that a copy of the Saint John was made for the Viceroy, Count of Lemòs; other documents dated 5 November 1610 show that Baldassarre Alvise had already made two copies of Caravaggio's David, one of them in all probability intended for the Viceroy (Pacelli 2002, pp. 130–42). Thus in 1610 the picture was in Naples, presumably sharing the same fate as its 'twin', the Saint John the Baptist. The fact that in 1613 a payment was made in Rome for the manufacture of a frame suggests that the painting had been without one, perhaps making it easier to transport.

Even in the earliest accounts of the painting (Manilli and Bellori), the severed head of Goliath was identified as a self portrait of Caravaggio. In his description of Villa Borghese, Manilli (1650) added that in David the painter had portrayed 'his Caravaggino'. There are no historical grounds for such a hypothesis, and putative identifications of 'Caravaggino' with either Mao Salini or Cecco del Caravaggio are based on no firm evidence. The identification of Goliath as a self portrait, on the other hand, has found broad consensus among modern commentators and been interpreted in existential terms as representing Caravaggio himself in the role of victim.

In recent decades the quest for the meaning of this self-representation has led to a more thorough iconological investigation. As early as 1971 Calvesi, in the context of his interpretation of Caravaggio's art as the pursuit of salvation, considered this picture too to be part of the general moral theme of virtue triumphing over evil. In particular, Caravaggio's portrait of himself as a man beheaded is, according to Calvesi (1985), a desperate allusion to his death sentence, while his identification with the sinner Goliath is intended both to show his repentance and as a plea for forgiveness. The inscription discernible on the sword, which had been interpreted as the artist's signature (Wagner 1958), and even as the mark of the sword-maker (Macrae 1964, followed by Gregori 1985), was shown by Marini (1987) to be the Augustinian motto 'H.AS O S', humilitas occidit superbiam. Prior to this important hypothesis, Hibbard (1983) had already referred to Saint Augustine's interpretation of David as a prefiguration of Christ, but in a markedly different context. He made psychoanalytic associations, developing a previous hypothesis of Röttgen (1974) as taken up by Rossi (1989): torn between desire for punishment and desire for salvation, Caravaggio identifies himself both as the sinner Goliath and as the executioner David. Recently Preimesberger (1998) has analysed the work's profound rhetorical construction, drawing attention to its semantic multiplicity, to its ambiguity, and to the presence of irony and self-irony. Finally another psychologically based analysis has been proposed (Stone 2002), once again reducing the picture's contents to questions which are altogether too

modern and speculative and requiring a return to the dating 1605–6.

If we take into account the complex issues of that historical moment and Caravaggio's own mental condition, the extraordinary synthesis of moral and autobiographical content in this painting does indeed invite an Augustinian interpretation. Goliath, personifying sinfulness and the devil, is shown with the features of Caravaggio, who was under sentence of death and depicts himself as already beheaded. David, in contemplating him with compassion, is both a prefiguration of Christ (see Calvesi) and an allusion to the Pope, Christ's vicar on earth and the person to whom the artist's plea for pardon was addressed.

In view of the proposed affinity in both chronology and conception between the *David* and *The Martyrdom of Saint Ursula*, we can point to how the intense gaze, full of anguished compassion, with which David looks on the severed head of the villain, steeped in guilt, is repeated in the desperate, emotional expression with which the so-called 'protector' in the *Martyrdom* observes the tyrant, guilty of the slaying of Saint Ursula. We are in the presence of an expressiveness of extraordinary power, embodying Caravaggio's entire art. A contemplative, grieving and infinitely compassionate consciousness mourns doomed humanity, which is seen to be beyond redemption. [*a.c.*]

138

Bibliography: Francucci 1613, III, pp. 182–8, ed. 1647; Manilli 1650, p. 67; Bellori 1672, p. 208; A. Venturi 1893, p. 209; L. Venturi 1909, pp. 39, 42,43; L. Venturi 1921, ed. 1951, pp. 27, 55; Pevsner 1927–8; Longhi 1951, p. 25; Mahon 1951, p. 234; Milan 1951, p. XVII, 28; Longhi 1952, p. 14; Mahon 1952, p. 19; Della Pergola 1959, II, 114, pp. 79–80 with previous bibliography; Wagner 1958, pp. 13, 16, 20, 24, 108, 121–4, 127, 131, 133–5, 137, 140, 168, 178, 211, 213, 228, 230–3; Salerno-Kinkead 1966, p. 113; Fagiolo Dell'Arco 1968, pp. 50, 60; Frommel 1971, pp. 52ff.; Röttgen 1974, pp. 201, 210, 226–7; Pacelli 1977, p. 829; Bardon 1978; Bologna, in Pacelli and Bologna 1980, p. 41; Hibbard 1983, pp. 172, 62–267, 331–2; Gregori, in New York 1985, p. 97; Marini 1987, p. 100; Rossi 1989, pp. 152–5; Calvesi 1990, p. 148; Papi and Lapucci in Florence–Rome 1991, 16, pp. 282–9 with previous bibliography; Calvesi, in *Galleria Borghese*, 1994, pp. 281ff.; Pacelli 1994, p. 155; Gilbert 1995, p. 23; Preimesberger 1998, pp. 63–9; Spike 2001, pp. 311–15; Gregori 2001, pp.11–22; Marini 2001, p. 566; Pacelli 2002, *passim*; Stone 2002, pp. 19–42; Puglisi 2003, p. 411.

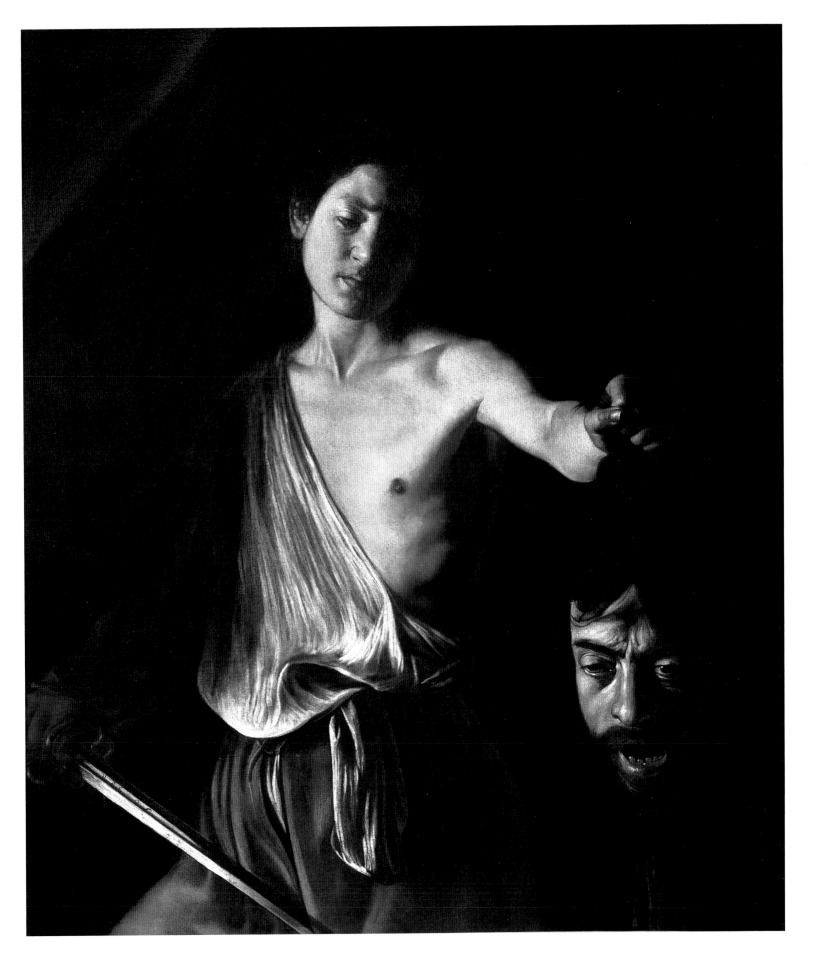

17. The Denial of Saint Peter

oil on canvas, 94 x 125.4 cm
New York, The Metropolitan Museum of Art (Purchase, Lila Acheson Wallace Gift, 1997), 1997.167

According to the account in the Gospels (Matthew 26:69–75; Mark 14:66–72; Luke 22:55–62; John 18:17–18, 25–27), when Christ was arrested Peter followed him into the courtyard of the high priest Caiaphas. There he was accused by three passers-by of being a disciple of Jesus. He denied each successively, thus fulfilling Christ's prophecy that before the cock crowed he would deny him thrice. Prior to the seventeenth century Peter's denial was usually included only as part of a Passion cycle. Even in the seventeenth century, in keeping with Counter-Reformation theology, it was Peter's repentance after his denial rather than the denial itself that was the most popular subject. Indeed, many treatments of the theme of the early seventeenth century seem to depend from Caravaggio's invention, notable for the condensation of the Gospel narratives into a dramatic confrontation involving just three figures, shown half-length (a format first explored in North Italy in the late fifteenth and sixteenth centuries). A simple mantel with some summarily described flames and shooting sparks establish the setting of Caravaggio's picture and create a geometric grid framing the action of the figures, disposed in a bilateral, frieze-like arrangement emphasising expressive contrasts. Just left of centre is a maid, her face part in light and part in shadow, who points accusingly with both hands at Peter. She turns to address a soldier, his open-mouthed, wide-eyed face enveloped in shadow, his gauntleted hand raised inquisitively. The three pointing hands are a synoptic way of referring to the three separate accusations. Opposite these two figures is Peter, his face and hands fully lit, his cupped hands emphatically pointing to his chest in what might be thought of as a combination of the rhetorical gestures for indication ('who me?') and penitence (see Andrea de Jorio's classic attempt at an archaeology of gesture, *La mimica degli antichi investigate nel gestire napoletano*, 1832, under *Me* and *Pentimento*, with citations from Quintilian). Peter's contorted face, his forehead corrugated with a combination of anger and self-recrimination, is as memorable as any by the mature Rembrandt. As is often the case with Caravaggio, light is used both dramatically and symbolically to indicate enlightenment: Peter's awareness of his sin – and thus his repentance – occurs at the moment of his denial.

The compositional and narrative strategies Caravaggio adopts in this picture – of great concision and efficacy – depend on his Roman experience but move beyond the more obviously descriptive approach of those works. This is particularly true of his increasing emphasis on clearly choreographed gesture. Caravaggio's exploration of a rhetoric of gesture ultimately derived from Quintilian and Cicero owed much to his competition with Annibale Carracci in the Cerasi Chapel in Santa Maria del Popolo in Rome. What he appropriated from Annibale was formal gesture as a means of conferring a dignified, Latin accent on a naturalistic style that had been criticised as 'popular' and lacking in decorum. We need only recall Bellori's admiration of the *Entombment* and Susinno's description of the *Adoration of the Shepherds* (no. 12) to realise the importance this formal language of gesture assumed in Caravaggio's work. Although it has received little comment, Caravaggesque painting increasingly came to depend on a distinction between the informal and even crude gestures employed in genre paintings and a more elevated language of formal gesture for religious paintings. Few examples illustrate Caravaggio's appropriation of this classically based rhetoric of gesture better than the *Calling of Peter and Andrew* (Royal Collections), the authorship of which was previously much disputed; cleaning has revealed it to be an autograph work by Caravaggio dating from c.1601–3. Without this Roman, Carraccesque phase Caravaggio's later work would have assumed a very different character. It is in this sense that we may view a painting like the *Denial of Saint Peter* as among his most resolved statements in a classical vein.

Yet, however much it may grow out of his earlier Roman experience, the style of the *Denial of Saint Peter* is characteristic of those paintings done at the very end of his career. It has the concentrated gestural and expressive force of the Messina *Raising of Lazarus*, but its closest analogies are unquestionably with the *Martyrdom of Saint Ursula*, with which it must be more or less contemporary. As in that work, so here Caravaggio probes with unparalleled poignancy a dark world burdened by guilt and doom, suggesting to some scholars an intersection with his biography. Bona Castellotti (1998, ed. 2001, p. 135) gives eloquent expression to this idea: 'Nella simultaneità di sentimenti in antitesi fra loro non è arbitrario cogliere un'allusione alle condizioni psicologiche del pittore, proteso in un crescente istinto di autoidentificazione con alcuni dei suoi più tragici soggetti.' Coupled with formal gesture as a conveyor of meaning is Caravaggio's use of costume to insist on painting as a staged fiction. Just as, in the *Martyrdom of Saint Ursula*, the king wears a piece of near-contemporary armor, thus breaking down the fiction of an imagined past, so in the *Denial of Saint Peter* the soldier's helmet is taken from a precise model of late fifteenth or early sixteenth-century manufacture similar to one now in the Bargello, Florence (inv. C 1634: see Scalini in Bertelà and Strozzi 1989, p. 217). The same helmet was used by Carracciolo in his *Liberation of Saint Peter* in the Pio Monte della Misericordia, Naples, and it perhaps made the rounds in Naples as a studio prop.

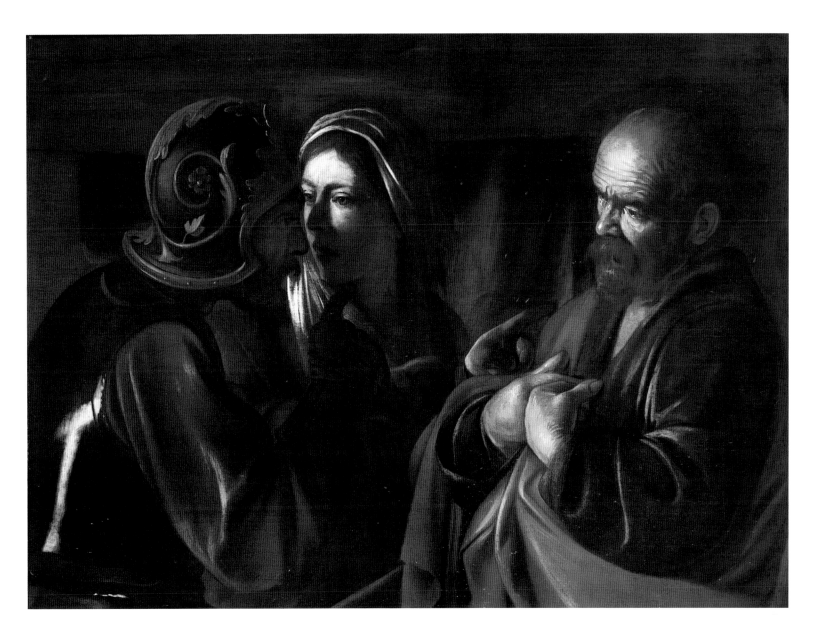

The picture was acquired after the second world war by Vincenzo Imparato Caracciolo of Naples. When shown it in 1952, Longhi suggested Manfredi as its author, but following its cleaning and restoration (1959-64) by Pico Cellini, he reascribed it to Caravaggio (on this see Marini 1987, p. 508). First referred to in print by Pierre Rosenberg and then more fully published by Marini, the picture quickly gained wide acceptance. Aside from Marini, who has repeatedly argued that it is a work of Caravaggio's first Neapolitan period, scholars have recognised it as among Caravaggio's last works, especially for the reductive approach to technique — what we might think of as 'essential painting'. The distinction between Caravaggio's first and second Neapolitan periods and the direction of his art towards greater narrative concision, a more rapid and summary execution, and a pervasive, dark tonality, is now well established and will be evident in this exhibition in the comparison between the two versions of *Salome with the Head of John the Baptist* in Madrid (from the first Neapolitan period) and London (from the second).

Marini (1979) was the first to suggest an identification of the picture with 'Un'Ancella con S. Pietro negante, et una altara mezza figura per traverse, p.mi 5, e 4 del Caravaggio, D. 250' cited in a 1650 inventory of the Savelli family (Campori 1870, p. 162). This must be the same picture listed, without attribution, in a 1624 inventory of the Savelli palace at Ariccia and then, again, in 1631, in Palazzo Savelli, Rome, as 'Un S. Pietro con l'ancella cornice dorata' (see Testa 1998, p. 348). The early inventories establish that the picture belonged to Paolo Savelli (died 1632). When he acquired it remains uncertain: it is not listed in the 1611 inventory of the furnishing at Ariccia, but the picture was clearly known by a number of artists active in Rome shortly after that date. A painting in the Galleria Corsini, Rome, formerly ascribed to the Master of the Judgement of Solomon and now recognised as the work of the young Ribera when still in Rome — and thus dating to c.1613-15 — clearly derives from the Savelli painting (see Papi 2002, p. 22, 34-5; Spinosa 2003, pp. 30-4), as does — even more clearly — a privately owned canvas by Lionello Spada (Negro and Roio, 1997, pp. 24, 26); Spada returned to Bologna from Rome and Malta in 1614.

The documents related to the *Martyrdom of Saint Ursula* and three pictures painted for Scipione Borghese establish that in Naples Caravaggio was receiving commissions for gallery pictures from outside the city. However, it is no less clear from Deodato Gentile's letter to Cardinal Borghese on 29 July 1610 that the canvases which remained in Caravaggio's hands at the time of his death were quickly snatched up by collectors (see Pacelli 1994, p. 121). Paolo Savelli's interest in Caravaggesque painting is known through his patronage of Orazio Gentileschi, documented from 1613 to 1615 but probably beginning in the first decade of the century; he owned no fewer than twelve paintings by the artist (see Christiansen, in Christiansen and Mann 2001, pp. 36-7, note 56). Was Savelli in direct contact with the artist in Naples, or did Scipione Borghese, who we know was in continuous touch with the artist (see cat. no. 18), conceivably play a role in the purchase of the painting? In 1606-7, when he was associate Vice Legate to Ferrara, Paolo Savelli had assisted Scipione in obtaining Dosso Dossi's canvases with the story of Aeneas, then still in the Este castle in Ferrara. Might Scipione have returned the favour?

In 1650 the Savelli collection was being offered for sale to the Duke of Modena and the picture must have been sold soon thereafter, which would explain why it was not known to Bellori. (An attempt to associate the painting with another work described by Bellori has been disproved: the picture he described is still in the sacristy of San Martino in Naples.) Much has been conjectured about the circumstances under which the picture was exported from Italy in 1964 and deposited in a bank in Switzerland. What has not been noted is that in 1976 Elena Carracciolo and Ian Dik, who had acquired the picture, were taken to court for illegally exporting the painting. The case was examined by the Corte d'Apello di Roma and dismissed. Following that decision the picture was acquired by Shickman Gallery, New York. At the time of its purchase by the Metropolitan Museum a complete review of the legal status of the picture was made and a full statement released (see *New York Times*, 20 June 1997, p. C28; *The Art Newspaper*, no. 72, 1997, p. 9). [k.c.]

Bibliography: Rosenberg 1970, p. 104; Volpe 1972, p. 71; Marini 1973, pp. 189-94; Marini 1974 pp. 39, 40, 224, 428-9; Röttgen 1974, 202; Moir 1976, p. 162 note 290; Nicolson 1979, p. 33 (ed. 1989, p. 81); Marini 1979, pp. 15, 36 note 4; Gregori in Whitfield and Martineau 1982, pp. 40, 130; Hibbard 1983, p. 341; Cinotti 1983, pp. 548-9 no. 67; Gregori in New York-Naples 1985, p. 350; Christiansen 1986, pp. 430-1, 445; Marini 1987, pp. 61, 508-9; Bologna 1992, p. 344; Pacelli 1994, pp. 99-100; Puglisi 1998, pp. 351, 411 no. 86; Testa 1998, pp. 348-9; Bona Castellotti 1998 (ed. 2001), p. 135; Spike 2001, p. 230, cat. 57; Papi 2002, p. 22; Gregori, in Rome-Milan-Vicenza 2004, p. 54.

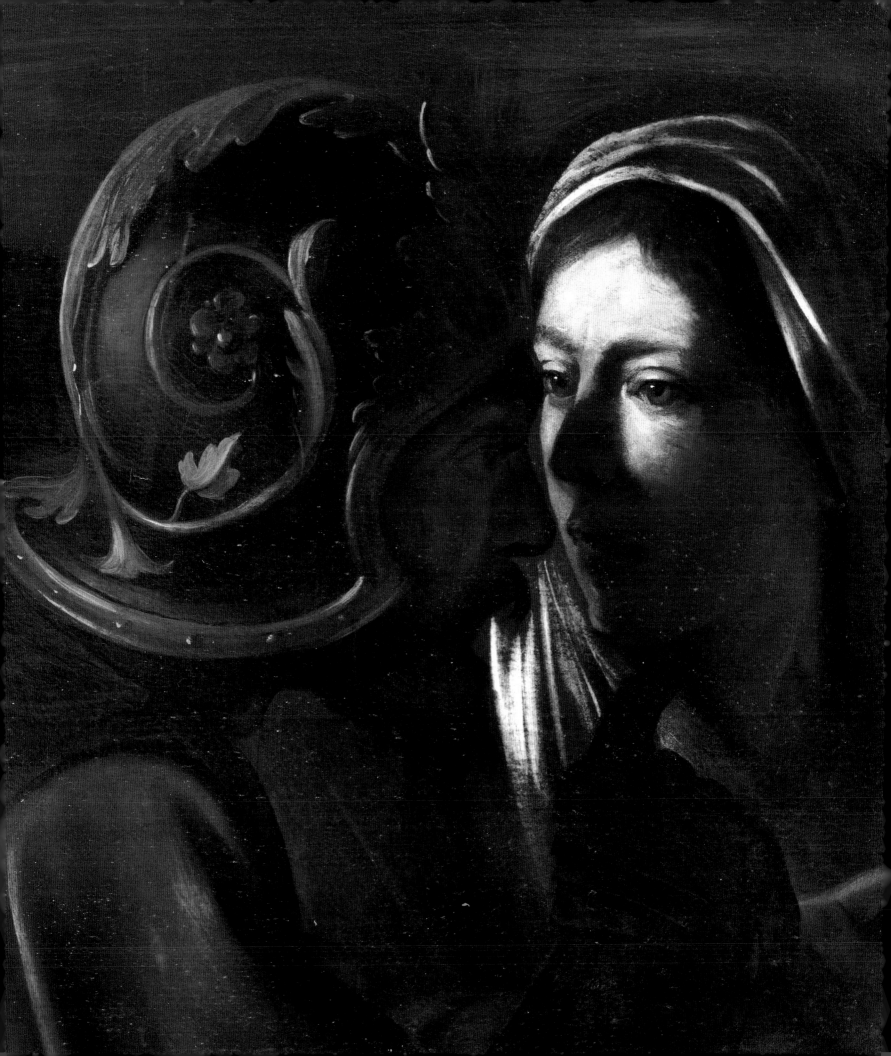

18. The Martyrdom of Saint Ursula (Saint Ursula transfixed by the Tyrant)

oil on canvas, 143 x 180 cm
Naples, Palazzo Zevallos,
collection of Banca Intesa

The iconography of this painting, which at first sight appears baffling, is connected with an early medieval legend of the Princess Ursula, martyred with her companions beneath the walls of Cologne. In this legend, Ursula resists the overtures of the sovereign who wants to take her as his wife. On being refused, he, 'overcome by rage, cleaves her breast with an arrow loosed from his bow' (Ravasi in Rome–Milan–Vicenza 2004, p. 18). The episode recurs at the end of the thirteenth century in the *Legenda Aurea* by Jacopo da Voragine. Caravaggio left out all mention of the martyrdom of the companions, which figured in the iconographical tradition, and concentrated on the key moment of the slaying of the saint. In fact the best formulation of the title is the one found in a list of pictures owned by Marcantonio Doria in 1620: 'Saint Ursula transfixed by the Tyrant'. The recent restoration has revealed the existence, at the centre of the picture, of the hand of one of the on-lookers thrust forward to protect the saint from the arrow in flight. There are pictorial precedents for this detail too. For example, in the panel featuring the martyrdom in Hans Memlinc's famous shrine of Saint Ursula in St John's Hospital in Bruges, the saint is shown at the camp of the king of the Huns. While the king prepares to fire and she is about to be pierced by the arrow, a warrior between the two figures holds up his left hand in order to protect her (see Max J. Friedländer, *Early Netherlandish Painting, Hans Memlinc and Gerard David*, vol. VI, part I, with commentary and notes by Nicole Veronee-Verhaegen, Leiden–Brussels 1971, n. 24, plate 75). Then again Ludovico Carracci, who painted a *Martyrdom of Saint Ursula* in about 1600 for the church of San Domenico in Imola, depicted not only a warrior drawing his bow to fire but also two warriors in the middle, one seeking to dissuade the marksman, and the other who holds aloft the ensign with one hand and tries to protect the saint from the oncoming arrow with the other (see *Ludovico Carracci*, exhibition catalogue curated by Andrea Emiliani, Bologna 1993, n. 55, pp. 118–19). Caravaggio seems to have been familiar with this variant, and turned it to account in portraying the episode as it comes to a climax.
On 11 May 1610 Lanfranco Massa, the agent in Naples for Marcantonio Doria, Prince of Angri and Duke of Eboli, wrote to his master: 'I had intended to send you the picture of Saint Ursula this week, but to make sure of sending it perfectly dry I put it out yesterday in the sun, which made the paint dry out more quickly than Caravaggio had done in order to give it to us; I must go round to the said Caravaggio to find out how I can be sure of not ruining it; Signor Damiano has seen it, and was amazed, like everyone else who's seen it.' (letter in Archivio Doria d'Angri, in the Archivio di Stato di Napoli, parte II, b290;

discovered by Giorgio Fulco and passed on to V. Pacelli, who published it in his essay *Le evidenze documentarie (e i rapporti artistici fra Napoli e Genova agli inizi del Seicento)*, in Bologna 1980, p. 24). In the same letter, which includes a reference to a possible second commission from Doria, the painter is referred to with the words 'whom I know to be a friend of yours'. The picture was completed at the beginning of May 1610 and despatched to its owner on 27 May; we know it to have arrived in Genoa on 18 June.
Caravaggio had visited Genoa from 29 July to 24 August 1605, when it appears he was asked to paint the loggia of a villa belonging to 'Prince Doria' but refused, in spite of being offered a substantial sum. This episode is referred in a letter dated 24 August 1605 written by Fabio Masetti, ambassador of the Duke of Este in Rome, who says he had it from Cardinal Francesco Del Monte. We cannot be sure whether the 'Prince Doria' of the letter was in fact Marcantonio, and so it is not certain that Caravaggio had previously had dealings with him. What we do know is that Marcantonio had had connections with Naples ever since the end of the sixteenth century, when he married Isabella della Tolfa, daughter of Carlo, Count of San Valentino, and widow of Agostino Grimaldi, Prince of Salerno, Duke of Eboli and Marquis of Diano, who in turn was the son of the banker Nicolò, one of the most important financiers of the Spanish court. This marriage enabled Marcantonio to extend his own and family interests in the south of Italy. Moreover, in 1604 he had received a significant gift from the Neapolitan church of San Giovanni a Carbonare, 'the illustrious relic of the precious blood of Christ's precursor Saint John the Baptist'. This relic is unfailingly recorded, together with Caravaggio's *Saint Ursula*, in the inventories of Marcantonio's legacy. Other links between the Doria family and Naples are documented in connection with the regular voyages made by the Doria fleets.
Taken to Genoa as soon as the paint was dry, *The Martyrdom of Saint Ursula* remained there permanently until 1832, when it was taken back to Naples, together with most of the estate of Maria Doria Cattaneo. The inventory of the legacy of Giovan Carlo Doria, drawn up in Naples between 21 August and 6 February 1855, following his death on 4 August 1854, also specifies that the work was in Naples in Palazzo Doria d'Angri at the Spirito Santo.
It is quite likely that the Doria d'Angri, taking fright like all the pro-Bourbon legitimists at Garibaldi's exploits in 1860, moved their most precious belongings to their villa at Eboli. The *Saint Ursula* would have been among them, and it probably remained there, gradually falling into oblivion, together with other pictures which were too large to be transported, such as the vast *Slaughter of the Innocents* by Giovan Battista Paggi.
The story of the work's rediscovery and identification, goes back fifty years. In the years 1954–5 the present writer, travelling in the company of the then director of the Museo Provinciale di Salerno, Professor Venturino Panebianco, had the opportunity to visit Villa Romano Avezzano at Eboli, which – as later emerged – had belonged to the Doria d'Angri family. Among the few pictures we found there, I recognised a copy of a Bernardo Cavallino that found its way to the Hermitage in St Petersburg. I also saw a *Slaughter of the Innocents*, which later proved to be by Paggi, and a work whose iconography could not be readily deciphered (as it then seemed to me), but which

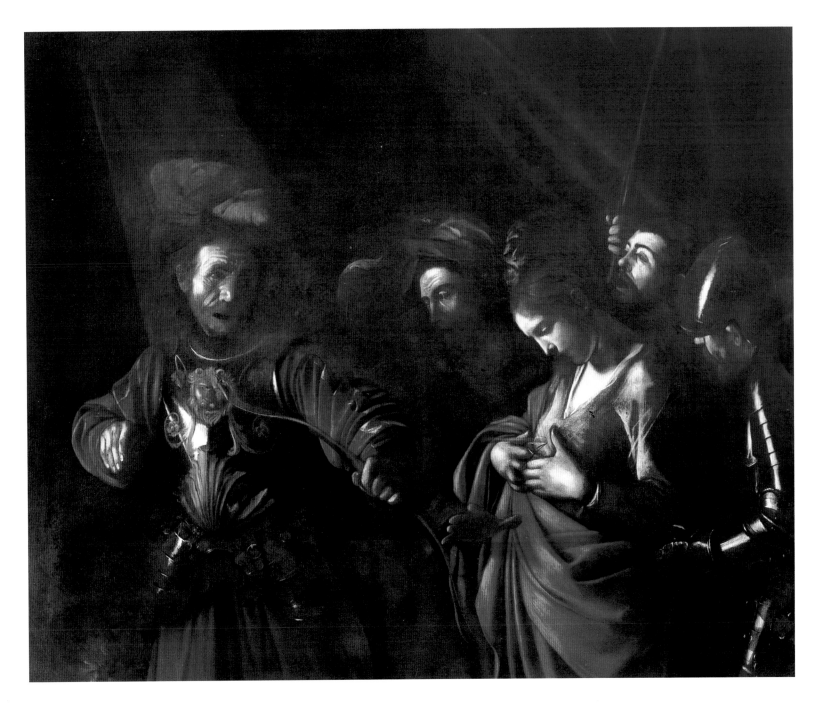

struck me more forcibly than any of the others. Having obtained photographs of the pictures from the owner, and fresh from my studies conducted during the Caravaggio exhibition held in Milan in 1951, I began wondering about the undoubtedly Caravaggesque features of this picture. I lost no time in mentioning it to Roberto Longhi, whom I encountered frequently in those years. I remember that at that particular meeting Professoressa Mina Gregori was also present, at the time an assistant to Longhi. It would be unhistorical on my part to claim that I showed Longhi the photograph of that work convinced I had found a new Caravaggio. In fact I asked him whether it might not be a Caravaggio from the Neapolitan period, and I remember being quite insistent. But Longhi would have none of it: at most it might be a work by Bartolomeo Manfredi. Only now do I realise that in those years Longhi tended to make free with the name of Manfredi. He had done the same thing in 1952 with reference to a *Denial of Saint Peter* (see cat. no. 17) belonging to the Imperato Caracciolo family in Naples, now recognised as an autograph Caravaggio and in the Metropolitan Museum, New York.

The respect due to a man still recognised today as such an eminent 'Caravaggist', and all the more so in those years on the part of a young acolyte, led me to undervalue the fact that Longhi's verdict had been given merely on the basis of a photograph. Although duly intimidated, I did not renounce my opinion, nor lose sight of the picture, which had meanwhile been brought to Naples. Thus when towards the end of 1962 the Soprintendenza of Naples began planning the exhibition *Caravaggio e caravaggeschi* to be held in Athens and Naples, I did my utmost to persuade the organising committee, made up of Italo Faldi, Raffaello Causa and Giuseppe Scavizzi, not to miss the chance of including that rarity. They consented, and my role in its inclusion was placed on record, but regrettably with some inexactitudes that affected the work's subsequent critical history.

The catalogue entry, compiled by Scavizzi, referred to the topic of the picture as an 'allegorical subject'. He stated that the work was 'traditionally' attributed to Manfredi (while this was only the hypothesis of Longhi, given orally and reported by myself), and chose to prefer the opinion of Raffaello Causa, who maintained that this 'allegorical subject' was to be considered a youthful work by Mattia Preti, with 'lively reminiscences not only of French and Northern artists (Valentin, Stomer, etc.), but also of Battistello and Sellitto', in chronological contiguity with the allegorical composition of 'Albertina del Torino' (see Scavizzi in Naples 1963, n. 50, p. 36, tav. 6b). Remaining for a moment on the subject of the 1963 exhibition, it seems appropriate to cite at least one passage from a review of the exhibition written by Filippa Maria Aliberti (see Aliberti 1963, p. 785). In this article, which has been universally passed over but of which I possess an offprint with a hand-written dedication, the critic had this to say: '*The Betrayal of Christ...* known from the copy in Odessa [and now from the original found in Dublin]. *This work was called to mind by a detail in a painting presented in the exhibition as a probable work by Mattia Preti, namely the face emerging on the right from the dark background in the* Allegorical Subject *from the Romano-Avezzano collection, in which we seem to recognise a reprise of the self-portrait of Caravaggio in* The Betrayal of Christ, *and it may be that this consideration will prove to have interesting*

developments' (my italics). I feel obliged to point out that this singular intuition was linked to my own opinion, which while the exhibition was on I circulated among my friends, including, in Rome, Dottoressa Aliberti and her husband Eraldo Gaudioso. Furthermore, the correspondence between the managers of the then Banca Commerciale, recently published by Dottoressa Denise Pagano (see Pagano in Rome-Milan-Vicenza 2004, p. 99, notes 38–40), shows that the attribution of the work to Caravaggio, which up until then had not been advocated by anyone apart from myself, but which had gained new currency following the discovery of inscriptions on the back, was still a matter of conjecture. Attributed to 'Anonymous Caravaggesque' while it was in the hands of the restorer Antonio De Mata, who was in favour of removing the later additions, the picture was the object of adamant refusals to consider its attribution to Caravaggio. 'Let me tell you quite frankly', the Bank's chief executive Monti wrote to the local manager Tonelli, 'since this picture is neither a Rembrandt nor a Caravaggio, it strikes me as excessive to go to all the trouble of restoring it to the original dimensions ... Let's not overdo things!' In the meantime De Mata had discovered on the back of the picture 'the inscription attributing the work to Michelangelo da Caravaggio with the date 1616'. Tonelli had mentioned this to Professor Causa during 'dinner in the house of mutual friends' and received the assurance that an inscription of the kind 'only testifies to an early attribution of the painting to the great artist: he personally [Causa] was convinced of the authorship of the young Mattia Preti'. Thus the chief executive Monti was able to assert, on 24 December 1973, at the close of a crucial year: 'the painting is certainly not by Caravaggio, but is well executed and undoubtedly by a skilful artist, and I believe the attribution to Preti to be exact'. This was how things stood when, also on account of its increased prestige deriving from its new owners, the work came to be taken into 'serious consideration' by Mina Gregori (1975, pp. 44–8, with reproduction fig. 21).

In fact Gregori began her appraisal with the strangely elliptical statement that the picture 'appeared, from the Romano-Avezzano collection, in the Caravaggio exhibition in Naples 1963, on the indication of Ferdinando Bologna, with the attribution to Mattia Preti, as a modification of the previous attribution, under the habitual name of convenience Manfredi'. Such an expression might well lead people to think that the attribution to Preti had been proposed by me. We have already recalled, however, the account given in the entry in the exhibition catalogue, which moreover Gregori herself cites several times. As for the previous attribution to Manfredi, I repeat that it was made orally by Longhi in response to my question as to whether the picture might not be attributed to Caravaggio himself. In spite of all this, Mina Gregori came out in favour of reattributing the work to Caravaggio. In the light of what was soon to emerge, there is no doubt that this was a notable step forward. But at the time not even this proposal found the consensus it deserved. For example, Giovanni Testori, writing in the *Corriere della Sera* on 8 October 1975, greeted it with considerable scepticism, giving it much less credit than the two other attributions to Caravaggio put forward by Gregori in the same article, even though these were far less plausible. Five years later we also find Maurizio Marini proposing, albeit with reserve, that the picture be attributed to

the Messinese artist Alonzo Rodríguez. Moreover, although Gregori wrote on that occasion that 'from a recent conversation with Raffaello Causa, I understand that he too tends to think as I do', Mia Cinotti stated in 1983: 'however, in a meeting we had in Naples in spring 1978 [Causa] seemed to me to be still "tending" to Preti' (see Cinotti 1983, n. 37, p. 475). Early in 1980, when amid all the uncertainties an impasse seemed to have been reached, Vincenzo Pacelli, who was a collaborator of mine during my term as Professor of Medieval and Modern Art History at the University of Naples (now known as the 'Federico II'), showed me, full of excitement at the discovery, the above-mentioned letter dated 11 May 1610, found by Giorgio Fulco in the Archivio Doria d'Angri (all the other documents emerged later, when investigations were intensified following this lead). I remember telling him immediately of my conviction that in order to recognise a *Saint Ursula*, or rather a *Martyrdom of Saint Ursula*, painted by Caravaggio, and in that phase of his career above all, you had to begin by ignoring previous treatments of the subject, not only by such remote figures as Tommaso da Modena in Treviso, or Carpaccio in Venice, but also by more recent artists, and in particular Ludovico Carracci, who had produced two versions: the one in Bologna dating from 1592, and that in Imola, signed and dated in a year which is generally read as 1600. Ruling out any suggestion that Caravaggio was ready to 'waste time' making a traditional representation with, perhaps, a landscape in the background and virgins and their executioners all over the place, one had to imagine a composition concentrating quite single-mindedly on the crux of the story, so as to capture the *dénouement* with startling clarity. The iconographical philosophy of the artist's entire production is based on this principle, and the pictures from the last years represent its most stringent application. At that point I recalled the picture I had discovered in 1954 and which in the years 1963–75 had known the vicissitudes I have set out above. Since it was there in Naples, just a short walk away, in the head office of the Banca Commerciale at 'Toledo', there was no difficulty about seeing it and photographing it once more. At the same time we inspected the inscriptions found by De Mata, which, apart from the year '1616', which can surely be ascribed to a mistaken memory, showed not only that it was the work of Caravaggio, but also that it had belonged to 'M. A. D.', quite clearly the initials of Marco Antonio Doria. Moreover the dedicatee must have died shortly beforehand, since the initials had a cross placed over them. Thereafter it was not difficult to prove that the picture did in fact come from the Doria legacy, and that it had been at its rightful home in Eboli, where it was found, since the villa there, before becoming the property of the Romano-Avezzano family early in the twentieth century, had belonged to the Doria family, Princes of Angri and Dukes of Eboli.

Ultimately it was the question of the iconography of the painting which proved to be most difficult to resolve. The true subject of the Romano-Avezzano work had been impenetrable right from the start. One needed a profound knowledge of Caravaggio's idiosyncratic interpretation of iconography, particularly in his religious paintings, to bring about that mental 'short circuit' which was needed to link the unprecedented scene of an assassination by an arrow shown in the picture with the death from an arrow of the virgin Ursula. It is high time that the following facts are given their due recognition: the affirmations repeated on various occasions – in 1982, 1985 and again recently, on the occasion of the exhibition promoted by Banca Intesa, as the Commerciale is now known – to the effect that the rediscovery of the *Saint Ursula* was the exclusive merit of Professoressa Mina Gregori, and that the discovery of the Neapolitan/Genoese documents served merely to confirm the attribution to Caravaggio which she had been advocating since 1973 (London–Washington 1982, n. 19, pp. 131–3; Naples–New York 1985, p. 31; and also Bonazzoli 2004), are in stark contrast with the fact that there was no obvious reason to refer *those* particular documents to *that* particular picture. The rightly jealous custodian of the letter of Lanfranco Massa, Vincenzo Pacelli, for one, would never have made the connection with the Romano-Avezzano picture.

The Martyrdom of Saint Ursula, or rather *Saint Ursula transfixed by the Tyrant,* is in all likelihood the last picture, and also the best documented, to have been painted by Caravaggio before he set off to meet his death, in the belief he was going to receive the so desperately desired pardon. [*f.b.*]

19. Saint John the Baptist

oil on canvas, 159 x 124.5 cm
Rome, Galleria Borghese,
inv. 262

Critics now concur in considering this *Saint John the Baptist* one of the last works to have been painted by Caravaggio, in 1610, during his second stay in Naples, on the eve of his attempted return to Rome in the hope of a papal pardon. It is also one of the works that has been most fully documented by recent studies and discoveries (in particular, Pacelli 1994). We know for certain that Caravaggio was carrying it with him, together with another *Saint John the Baptist* and a *Mary Magdalene*, on his last sea voyage bound for Rome, following five years on the run after being sentenced to death for the murder of Ranuccio Tomassoni in 1606. He had set out on this voyage in the belief that, on his arrival, he would receive the Pope's pardon, secured through the good offices of Cardinal Scipione Borghese and thanks to his protector Cardinal Gonzaga. The passion of Cardinal Borghese for art and collecting was well known: since 1606 he had possessed the *Madonna del Palafrenieri*, which he acquired from the confraternity of this name after it had been rejected for the Vatican; in 1607, with the artist banned from Rome, he had acquired two of his youthful works through the seizure of the art collection of the Cavalier d'Arpino; and in all probability he had just taken delivery of the *David* and may already have owned the *Saint Jerome*. He was the intended recipient of the precious package of three pictures, as a gift for his intercession with Paul V. But, as Pacelli has demonstrated, on landing at Palo, a little port to the north of Rome which Caravaggio may have chosen as holding out more hope that he could pass unobserved there since he was still banned from papal territory, he was arrested and detained by the papal guards. The arrest had the tragic consequence of separating Caravaggio from his belongings. According to the version already given by Baglione in 1642, which now finds more detailed confirmation in the newly discovered documents, on being set free two days later he found that the boat he had been travelling on was no longer in the port, and in a desperate attempt to catch up with it at its next port of call, he set out on foot towards Port'Ercole where he died on 18 July 1610, possibly from malaria, without managing to retrieve his pictures. Some important letters which Pacelli has recently found and published contain proof, together with much other information, that the three pictures were indeed destined for Cardinal Borghese, and that in the end this *Saint John the Baptist* was the only one to enter his collection. It seems very likely that, in order to persuade Scipione Borghese to intervene and secure the pardon, Caravaggio sent him the *David* from Naples (Calvesi 1994, Pacelli 1994).

Both the *Saint John the Baptist* and the *David* were celebrated by Scipione Francucci in a poem written in 1613. The *Saint John the Baptist* does not figure in the descriptions of Villa Borghese (the Cardinal's suburban residence outside Porta Pinciana) because from an early date it was kept in Palazzo Borghese a Ripetta (his town house, where it was recorded by Scannelli in 1657), although it does appear in the various inventories of the family's effects. In the documents concerning the Borghese collection, the picture continued to be correctly attributed until 1790, when a mistaken attribution to Valentin de Boulogne made its first appearance and was perpetuated down to Adolfo Venturi (1893). Authorship was definitively restored to Caravaggio by Lionello Venturi, on the basis of the poem by Francucci (1909, 1910). For a long time critics were divided as to the work's chronology, some ascribing it to the artist's Roman period and the years 1605–6 when both Caravaggio and Cardinal Borghese were living in Rome, while others considered it a late work, mainly on stylistic grounds. Now, thanks to our fuller knowledge of the role of the painting in Caravaggio's last years, it can be unquestionably ascribed to his second stay in Naples, and more precisely to the spring of 1610.

Pacelli's detailed reconstruction has shown that while Caravaggio was under arrest in Palo the boat in which he had been travelling had returned to Naples with his belongings, and the paintings had been handed over to Costanza Colonna, Marquise of Caravaggio, his protector and host during his final stay in Naples. In Rome Scipione Borghese lost no time in finding out what had become of the paintings, showing not only that he knew they were intended for him, but also just how much store he set by them. In fact it is the letters sent from Naples to Scipione Borghese by the nuncio Deodato Gentile, from 29 July onwards, which prove how matters really stood. From this series of letters we learn that, following the artist's death, the fate of the pictures had kindled a voracious desire to possess it both in the Prior of the Knights of Malta in Capua and in the Count of Lemos, Viceroy of Naples. While the claims of the Knights probably came to nothing because at the time of his his death Caravaggio was no longer a member of the Order, having been expelled, the intervention of the Viceroy proved decisive for their eventual destiny. In fact Scipione Borghese only ever received one of the three paintings intended for him. According to the convincing reconstruction pieced together by Pacelli, the second *Saint John the Baptist*, which the scholar identifies with the one now in a private collection in Germany, was kept by the Count of Lemos, and the *Mary Magdalene* by the Marquise of Caravaggio. Other documents previously published by Pacelli (1977; 1994) show that, in the months following Caravaggio's death, and while the question of the ownership of his last works was still being resolved, the Viceroy ordered copies of the *David* and the *Saint John*, both destined for Scipione Borghese. The copyist Baldassarre Alvisi, whose name has come down to us in the documents but who has not until now been further identified, is probably the Baldassarre Aloisi Galanino known from various references to have been in Naples in this period (Coliva in Madrid–Bilbao 1999, p.142). In addition to the sensational episode recounted by Guido Reni to Malvasia and related by the latter in his *Felsina* (ed. 1841, II, p. 93), according to which Galanino burst into Reni's house in Rome at night time bearing

the coffin of a child he had carried all the way from Naples, the main reference to him occurs in a letter in which Monsignor Agucchi announced the death of Annibale Carracci in 1609, adding in a postscript that it was Galanino who had been responsible for the madcap scheme of bringing the already ailing painter to Naples (Malvasia ed. 1841, I, p. 320). It should also be noted that the name of Aloisi is often found in the version 'Baldassarre degli Alvigi' (Malvasia ed. 1841, I, p. 304) or 'Alvisi' (Luigi Crespi). [a.c.]

Bibliography: Francucci 1613, III, pp. 266–8, ed. 1647; Scannelli 1652, pp. 198–9; A. Venturi 1938, p. 139; L. Venturi 1909, pp. 93, 41; idem 1910, pp. 272, 276; idem 1912, p. 4; Longhi 1928, p. 201; idem in Milan 1951, p. 28; idem 1952, p. 32 (see also II ed. 1968, p. 45); Mahon 1952, p. 19; Della Pergola, II, 1959, 113, pp. 78–9, with previous bibliography; Longhi 1959; Marini 1987, p. 101; Calvesi 1990, p. 148; Papi and Lapucci in Florence–Rome 1991, 22, pp. 348–55, with previous bibliography; Calvesi 1994 in *Galleria Borghese*, p. 281; Pacelli 1994, pp. 119ff.; Gilbert 1995, pp. 13ff.; Puglisi 1998, n. 87; Coliva in Madrid–Bilbao 1999, pp. 142–3; Coliva in Bergamo 2000, pp. 220–1; Marini 2000[1], p. 569; Spike 2001, pp. 295–9; Puglisi 2003, p. 411.

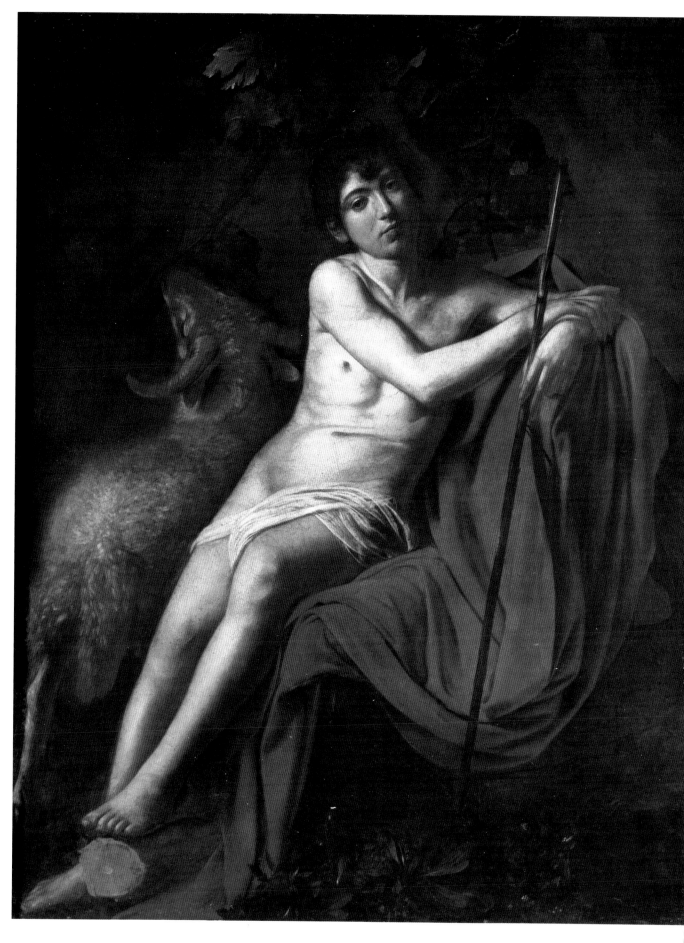

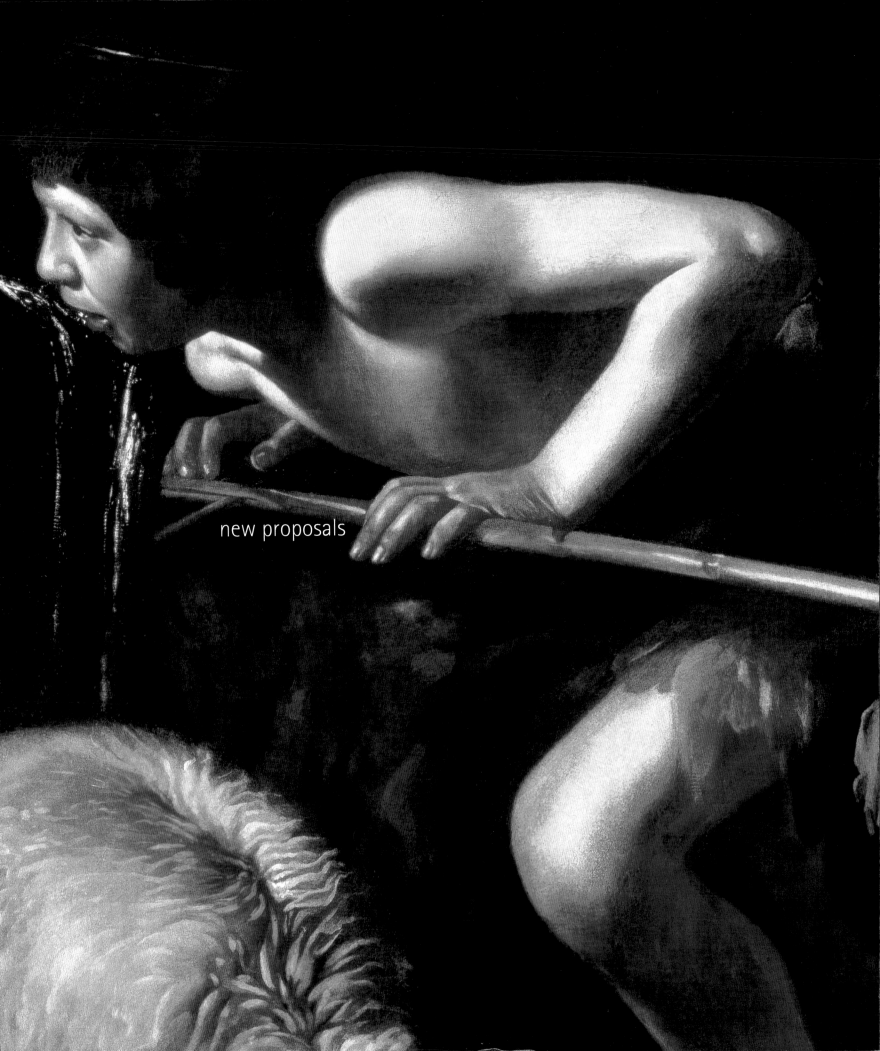

new proposals

20. Saint Francis in Meditation

oil on canvas, 128.2 x 97.4 cm
Carpineto Romano, church
of San Pietro, in deposit at
the Galleria Nazionale d'arte
antica, Palazzo Barberini,
Rome (Property Fondo
Edifici di Culto)

Two versions of *Saint Francis in Meditation* have traditionally been attributed to Caravaggio, the one shown in this exhibition (cat. no. 3) and the one in the church of Santa Maria della Concezione in Rome (see fig. 1a on p. 172). The Santa Maria della Concezione picture was published by Cantalamessa in 1908. Doubt about its autograph status was raised by Brugnoli in 1968, when he found an identical *Saint Francis* in the church of San Pietro in Carpineto Romano. A complex debate ensued, which was finally resolved in 2000 following the restoration and scientific analysis of the two pictures which showed that the Carpineto canvas was the original by Caravaggio (Vodret 2000). The *Saint Francis* of Carpineto proved not only to have a series of compositional *pentimenti* (while there were none in the picture in the Concezione), but also, and decisively, showed evidence of a technique – seen in the preparation and construction of the figure – which is analogous to that found in other works by Caravaggio, and quite alien to the one used in the Roman version.

Confirmation of the technical data came from the stylistic appraisal of the two paintings, carried out after cleaning had removed the layers of oxidised varnish, making the picture much more legible. While apparently very similar, the two works actually contain a series of significant differences. Among these we would single out the more confident spatial construction of the *Saint Francis* of Carpineto, and the difference in quality of some of the details, such as the treatment of the girdle round the habit, which is distinctly superior in the picture now in Palazzo Barberini.

However, the crucial difference between the two works lies in the overall representation of the figures: mellow, 'amiable', and illuminated by a warm light that models the outlines in the Concezione picture; rugged and harsh in Caravaggio's original, and lit by a livid, raking light.

While the technical and stylistic data have made it possible to establish the Carpineto picture as autograph, there are still question marks concerning its dating and commission, and also the identity of the painter who made the copy in the Concezione, which is nonetheless a work of unmistakable quality. In the light of the most recent documentary studies (Testa 2002), the most plausible hypothesis continues to be the one put forward by Brugnoli. On the evidence of the modification made to the saint's habit in the Carpineto picture – the saint was originally dressed 'alla cappuccina', and the pointed cowl was changed to the rounded one worn by the Reformed Minors – she associated the picture with an episode we know to have occurred involving Cardinal Pietro Aldobrandini. When the Cardinal founded the church of Carpineto in 1609, he had first intended to bestow it on the Capuchins, but subsequently chose to assign it to the Reformed Minors.

The dating which currently appears most convincing – on both stylistic and technical grounds – coincides with Caravaggio's stay on the estates of the Colonna family, in the summer of 1606. These estates bordered on land owned by the Aldobrandini (Brugnoli 1970). We should, however, note the opinion of Marini, who dates the picture to 1609 and the artist's stay in Sicily.

At present it is not possible to establish for whom the *Saint Francis* was painted. The prevailing opinion is that it was a private commission from Pietro Aldobrandini, and that he subsequently donated it, after having the cowl modified, to the house of the Reformed Minors in Carpineto. Another possibility, which to my mind should not be ruled out, is that it was painted for the Colonna family, who are known to have given the Capuchin Order their protection ever since 1536. Only later did it come into the hands of Pietro Aldobrandini, who left it to the monastery in Carpineto (Vodret 2004) – probably after his death in 1621.

The version in the Concezione, which is a faithful reproduction of the original *Saint Francis* with the Capuchin cowl, must obviously have been made before the cowl's modification and certainly prior to 1617, the year of the death of Francesco de Rusticis, who donated the picture to the Capuchin church of Santa Maria della Concezione (Cantalamessa 1908, Vodret 2000). Various hypotheses have been made concerning the identity of the copyist. The present author has proposed Bartolomeo Manfredi (Vodret 2000), and this attribution has already found some consensus (Marini 2001). In my opinion, the key factor for identifying Manfredi as the copyist lies in the way in which the harsh, rugged features of Caravaggio's powerful original have been toned down and mellowed. We know from Mancini (1617–21) that this was a characteristic trait of the paintings Manfredi produced in the style of Caravaggio. [*r.v.*]

Bibliography: Mancini 1617–21, ed. 1956; Cantalamessa 1908, pp. 401–2; Brugnoli 1970, pp. 11, 13, 15; Vodret 2000, pp. 140–5; Marini 2001, p. 564, with complete critical bibliography; Testa 2002, p. 140; Vodret 2004, in press.

151

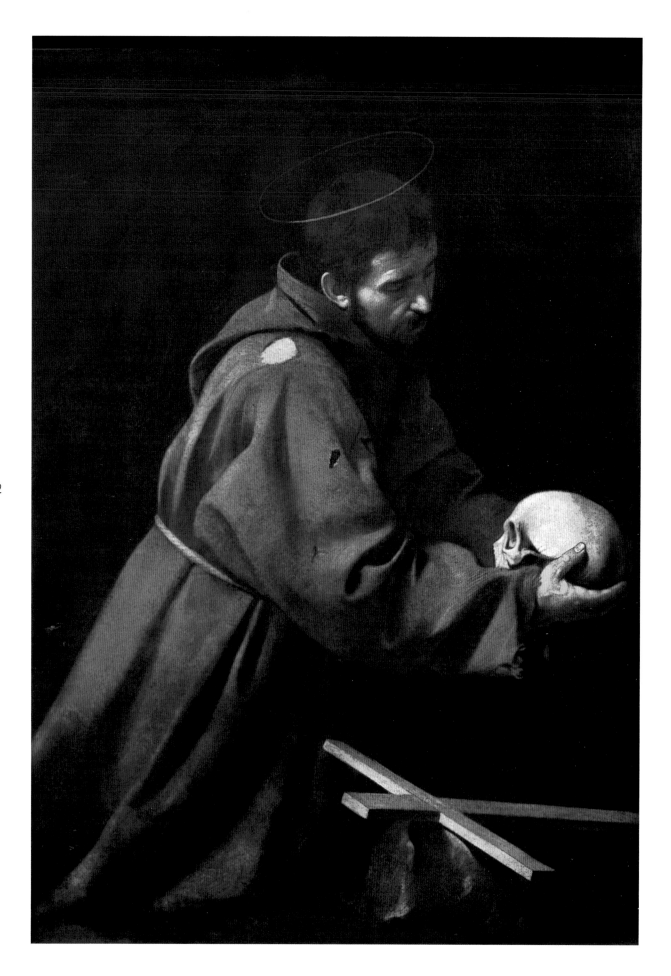

21. Saint John the Baptist at the Spring

oil on canvas, 45.5 x 65.5 cm
Rome, private collection

This was one of Caravaggio's favourite subjects, to which he returned during his final years. The large canvas featuring *The Beheading of Saint John the Baptist*, made in 1608 for the oratory of the Knights of St John, adjacent to the cathedral of Valletta on Malta, is the only one he actually signed. The picture showing Saint John as a full-length figure, painted during his second stay in Naples for the Fenaroli chapel in the church of Sant'Anna dei Lombardi in this city, is lost. Since Saint John was the patron of the Order of the Knights of Malta, it is possible that Caravaggio received further requests for works on this subject. We do know that when he left Naples for Rome in July 1610 he took with him on the felucca a Magdalen and 'two Saint Johns'. One *Saint John* was delivered to Cardinal Scipione Borghese in August 1611, after a copy had been made in Naples on the initiative of the Viceroy Don Pedro Fernandez de Castro, Count of Lemos, while the second one has never been identified.

A representation of the saint drinking directly from the spring was discovered in the Bonello collection in Malta (100 x 73 cm). Roberto Longhi, on a visit to the island in 1914, was told that the painting came from Italy, and he pronounced it to be a copy after Caravaggio, but later changed his mind and published it as an autograph work (1951, pp. 31–4). This attribution was at first endorsed by Denis Mahon (1952, p. 20, note 98), but he retracted this opinion in an oral communication. Since the 1970s the work has been classified in the lists of Benedict Nicolson (1979, pp. 331, and 1989, p. 80) as a copy, either ruined or drastically repainted, and other scholars have expressed the same opinion (Spear 1979, p. 318; Gash 1980, p. 117; Hibbard 1983, p. 340).

In this picture the intensity of the action is diluted by the unusually extensive foreground and the inclusion of a landscape in the background beneath an azure Neapolitan sky. In 1976 Alfred Moir drew attention to the work exhibited here, also comprising a half-length figure like the Bonello version but smaller in size, suggesting that it had affinities with the work of Valentin or Caracciolo or their workshops. It belongs to a private collection in Rome and was published some years ago by Amadore Porcella (n.d. [1969], p. 13) as an autograph work of Caravaggio. Two copies of practically the same dimensions are known of this Roman picture, showing that these must be more or less the dimensions of the original. One of these copies (45.5 x 65.5 cm) was in a collection in Florence in 1999, the other (55 x 74 cm) was acquired by the Galleria Estense in 1993 following a bequest by Silvia Vandelli of Sassuolo (I am grateful to Angelo Mazza for this information).

Marini, who has always maintained that the work in the Bonello collection was autograph (1987, p. 286, and subsequent editions), has repeatedly published the Roman picture (1974, 1987, 1989) as a cut-down copy, although it does not figure in the recent edition of his monograph (2001). In the early nineties it was possible to examine this painting at first hand, and following the positive identification of Claudio Strinati, I too became convinced that it is the original (Gregori 1993). The same opinion was reached by Denis Mahon (oral communication) and John Spike (2001), and recently, following his own first-hand examination, by Carlo Giantomassi of the Istituto Centrale del Restauro. A first inspection is enough to identify some of the characteristics of the process Caravaggio used in painting directly onto canvas. This has been well illustrated by James L. Greaves and Meryl Johnson in their investigation of *The Conversion of Mary Magdalene* in Detroit (1974, pp. 565–6) and by Thomas M. Schneider in connection with the restoration of *The Crown of Thorns* in Prato (1976, pp. 679–80 and 1987, p. 120). Both analyses drew attention to the existence of visible 'substructure brushworks'. Similar findings have been published for the *Judith and Holofernes* (Christiansen 1986) and, more recently, *The Taking of Christ* in Dublin (Benedetti 1993, pp. 736–7). As Schneider made clear, the changes that came to light should not be considered as *pentimenti*, but rather as adjustments made by the artist as he was working, for as a rule he did not make a drawing before setting to work. In this picture (Gregori 1993, p. 13; Schneider 1993, pp. 22–3) the most obvious changes, identified during restoration work, involve the forehead, which was at first rather lower, and the ear lobe, which Caravaggio moved to the left, in an intervention that was quite common for him, indicating the importance he attributed to the ears as initial points of reference. As other examples of this distinctive practice we can cite the ruffian in the foreground in the Prato *Crown of Thorns* (Gregori 1976, p. 675; Schneider 1976, p. 679), two of the onlookers in *The Tooth-puller*, the naked man in the right foreground in *The Martyrdom of Saint Matthew* (Gregori 1994, photograph by Antonio Quattrone), Judas in *The Taking of Christ* in Dublin (Benedetti 1993, p. 736, n. 36), and the sitter in the *Portrait of a Gentleman (Ritratto virile)* in a private collection reported by me in 1998.

Other changes were made in the hands, which always seem to have given Caravaggio problems. The details which strike the viewer, such as the bony fingers, the right thumb lying flat like a drumstick and the markedly curved nails, correspond to physical alterations associated with a lung complaint, and bring to mind the comment by Bellori that the artists who followed in Caravaggio's footsteps painted 'deformities' and made 'the fingers gnarled, the limbs contorted by ailments' (1672, p. 213). In other late works Caravaggio featured hands which were 'febrile and deformed, the marks and agents of a wretched life' (I apologise for quoting myself), as in the hand on the table, belonging to the man seated on the right, in *The Tooth-puller* in the Galleria Palatina, Florence, and the hand of Christ in the *Ecce Homo*. Two copies of the latter work were

published in *Paragone* (Gregori 1990; Papi 1990), following which the original was found and is included in this catalogue (see cat. no. 22). The affinities between *Saint John the Baptist at the Spring*, *The Tooth-puller* and the *Ecce Homo*, as well as the concentrated spatial dimension which characterises the latter work, suggest that all three should be dated to the end of Caravaggio's stay in Malta, or more probably to the period he spent in Sicily.

Caravaggio had some difficulty depicting the hands of the young saint right at the front of the picture. Under ultraviolet light the ring finger of the right hand was seen to have been placed differently, while the little finger was eliminated and covered up with the dark paint of the background. In the preliminary *abbozzo*, the thumb of the left hand had been put in and was subsequently painted out, while the index finger was in a different position (Gregori 1993, p. 11; Schneider 1993, p. 23). Less significant adjustments were also seen in the nose, the arm and the line separating chin and throat, which was brought lower than in the original *abbozzo*. Some incisions were detected in the right hand which indicated the initial placing of the fingers.

When the Roman picture, the Bonello version and the other two copies are compared, the first is striking for the vehement, unhesitating brushstrokes used. They denote a perfect adhesion between conception and execution, while the rapid and lively description, confirmed by the X-ray analysis, corresponds to the graphic power with which the action and the light focused on the youth are presented.

An intense but graded strip of shadow separates the cheek from the mouth, thrust out eagerly in the act of drinking. Other points in which the light is dwelt on include the line running along the chin, the narrow strip of flesh standing out against the profile of the neck, and the glow behind the nape of the neck which lights up the sheepskin. This is the sort of 'trick of light' which appealed to the painter's eye and which recurs in analogous situations in a number of his works. When set against the other versions, the Roman picture is particularly vivid in the depiction of the sheepskin and of the water issuing from the spring and beading on the lips of the young saint. The anatomical rendering and representation of the face are also more thorough and convincing than in the Bonello version or the two copies found subsequently, while the passages of light and shadow are less schematic. From a formal point of view, the most difficult detail to reproduce was undoubtedly the mouth, which the painter built up with a continuous circular motion which is strikingly effective as a naturalistic representation of the act of drinking. At the same time, as in other pictures, Caravaggio drew on theatrical masks and on the spouts in the form of grotesque heads on ancient fountains (Gregori 1993, pp. 7–9).

The depiction of the saint drinking directly from the spring without using a cup is an iconographical anomaly which may well have an unorthodox symbolic significance. It was reproduced in other depictions of Saint John in Southern Italy and Spain.

These considerations, together with the work's visual, symbolic and conceptual originality, make it altogether characteristic of Caravaggio. Its naturalistic force coincides with the spiritual impetus of a soul in the pursuit of truth, with Christ as the fountainhead, and the posture of the saint expresses man's reaching out towards his Divine Maker. The same iconography has also been used in depictions of

Bibliography: Porcella undated (but 1969); Marini 1974, pp. 249, 441; Moir 1976, p. 161 note 289; Marini

the saint as a full-length figure (Bologna 1991, pp. 23–4, 57; Gregori 1993, p. 15). Variants with the saint completely nude and also as *Amor at the Well* (Papi 2001, pp. 123–4, n. 9, 135–7, n. 17) were produced by Cecco del Caravaggio. For all these reasons we can conclude that the prototypes of the representation with both half-length and full-length figures are to be attributed to Caravaggio. [*m.g.*]

1987, pp. 286, 532–3; Marini 1989, pp. 286, 532–3; Gregori 1993; Schneider 1993; Spike 2001, pp. 222–3 and cat. no. 65.

154

22. Ecce Homo

oil on canvas, 83.3 x 104 cm
Private collection

I was given the opportunity of examining this picture by Paolo Sapori, who has given me permission to publish it in an article to be published in the near future in the journal *Paragone*, which will also give an account of the X-ray analysis he has carried out. He was persuaded, and I share his opinion, that this is the original by Caravaggio of the picture I came across in a private collection in about 1986 and which I published as a copy in 1990, associating it with Caravaggio. It should probably be seen in connection with the report left by Saccà (1906–7, 1907, p. 64) of four *Scenes of the Passion* commissioned in 1609 from Caravaggio by the Messinese nobleman Nicolò di Giacomo, only one of which, *The Road to Calvary*, is known to have been completed, almost certainly with half-length figures ('Christ with the Cross on his shoulders, the Lady of Sorrows and two soldiers, one playing the trumpet, which proved to be a truly excellent work, and [for which I] paid 46 *oz.*, and the other three the Painter has undertaken to bring me in the month of August, the payment for them to be agreed with this painter whose mind is unhinged'). At the time I told the restorer Pico Cellini of my findings, and advised the owners to put the painting in his hands. The work is now in the G.F. Cortez collection in New York (Marini 2001, pp. 332, 558), while Cellini took the ill-advised step of publishing it as an original by Caravaggio (1986), without informing me.

Subsequently Gianni Papi (1990) reported a second version kept in the Santuario del Bambino Gesù di Praga at Arenzano, near Genoa, originally in the church of Sant'Anna in Genoa. He maintained that it was the autograph version, but I was not prepared to endorse this hypothesis. I refer the reader to my article (Gregori 1990) and that of Papi for further details on the first phase of research into this work, which was immediately recognised as having the hallmarks of Caravaggio's output in the final months spent in Sicily and Naples.

The existence of the copy of a work by Caravaggio with this subject was reported by Elena Fumagalli (1994, p. 106; ed. 1996, p. 145) on the basis of a list of paintings which had belonged to the Siennese Michelangelo Vanni. This man, whose father Francesco and brother Raffaello were both painters, was engaged to procure pictures for the second Count of Villamediana during the latter's stay in Italy (1611–15). The Count is known from various sources to have been interested in the work of Caravaggio. The list, which lacks any indication of provenance, mentions 'a painting on canvas where there is an Ecce Homo, with Pilate, and two soldiers, all half-length, or even less, which is a copy from Michel Agnolo da Caravaggio, but well done, and well conserved'.

There is also a record of this copy in the correspondence between Giulio Mancini and his brother Deifobo as belonging to Vanni (Maccherini 1997, pp. 71–92). However, there is no mention of a work on this subject by Caravaggio in a list of paintings which the Count of Villamediana of Genoa purchased from Vanni and requested permission to export from Siena (Fumagalli 1994, pp. 105–6). Marini (2001, p. 560) puts forward the hypothesis, unsupported by documentary evidence, that the copy of the *Ecce Homo* remained in Genoa, a gift from the Count to the Carmelite friars of Sant'Anna. The work published by Papi came originally from that church, although it is now at Arenzano near Genoa (in the Santuario del Bambino Gesù di Praga), and is presumably to be identified with this copy.

Two other documents (Abbate 1999, pp. 11–46; Marini 2001, p. 558) seem to refer to *The Road to Calvary*, painted for Nicolò di Giacomo in Messina, and the *Ecce Homo*. In the inventory of the picture collection of Don Andrea Valdina, Marquis of La Rocca, drawn up on his death in 1659, no. 8 is 'a Christ with the cross on his shoulders by Caravaggio' and no. 7 an 'Ecce Homo', presumably a pendant to number 8, since two *Scenes of the Passion* are mentioned in 1672 as hanging in the castle of La Rocca, now Roccavaldina, in the province of Messina (Abbate 1999, pp. 11–56; Marini 2001, p. 558).

The discovery of the third, identical treatment of the subject of the *Ecce Homo* fulfils the expectations of those who, like me, hoped that one day we would indeed come across the original. Even on a first appraisal the difference between this and the other two versions stands out in the powerful contrast of light and shadow which, thanks also to the excellent state of conservation, enhances the colours and lends vividness to what in the others appears feeble and even somewhat sentimental.

In the limited space the artist has allowed himself (and I would recall the analogous composition of the *Saint John the Baptist at the Spring*), the figures are admirably distributed, comfortable and unconstrained, so as to form a sort of semicircle around the disquieting void of the shadow. The painting's clarity of conception demonstrates that, even in the tragic final years, when he was at work the artist can hardly be said to have 'his mind unhinged'.

The heads of Christ and the figure immediately behind him are so closely juxtaposed that they seem to issue from a single body, an effect found in other late works by Caravaggio, notably the *Salome with the Head of Saint John the Baptist* in the versions in London (cat. no. 14) and Madrid (cat. no. 13). The figure's crude, mask-like expressiveness, which is even more baleful in the skeletal first draft that emerges in the X-ray, harks back to the Dürer engravings for the Albertina *Passion* and *Large Passion*.

Caravaggio frequently adopted the rhetorical device of the 'contrapposto', bringing it to life in his dramatis personae, and at the same time drawing on the expressive potential of the theatrical tradition. We would do well to trace this sophisticated two-fold approach in his youthful works in order to grasp its origins and import. In *The Cardsharps* and *The Fortune-Teller*, featuring gambling and trickery, the painter alludes, not without irony, to the moral and exemplary purpose of the genre scene, examples of which were circulated above all in engravings produced in Northern Europe. Taking comedy and genre representations, with their underlying moral message, as his starting-point (Gregori 1985, pp. 215, 217; see also Puglisi 1998, p. 75; Guarino, in *Masterpieces* 1999, pp. 18–19), Caravaggio came to base his religious paintings on the opposition between good and evil, victim and villain. The *Ecce Homo*, in its simple schema, provides an illuminating example of this procedure.

The two contrasting faces seem to epitomise two extremes which take on a symbolic, universal value. At the same time the figures themselves appear to be in motion (and this emerges most clearly in the autograph version we are presenting here). They are depicted as if starting forward, with an ease and spontaneity deriving from Caravaggio's habit of working from life.

A second *contrapposto* is embodied in the two protagonists, Christ leaning forward and Pilate. In the dynamic of the picture Pilate fulfils a carefully judged function, his office indicated by his cap, his intense expression fixing the onlooker. His features are deeply scored, and even the mass of his cloak, iridescent and with the folds picked out by the light (an effect which is not present in the two copies), is carefully calculated.

Turning to the figure in the background, the original allows me to correct my previous appraisal; with the aid of the X-ray, it is possible to discern the artist's first intentions. He is not a torturer, but an onlooker who is participating and judging, like the chorus in a tragedy, his sorrowing humanity brought out more strongly in the first draft than in the finished work. This presence is like that of the man in *The Martyrdom of Saint Ursula* who stands to one side of the saint and protects her with an outstretched hand, as has emerged in the recent restoration. His face is similarly marked by grief and sorrowful compassion.

Turning to the figure of Christ himself, we can start with the crown of thorns, which in this picture comes across as a living object, thanks to the play of light; the same can be said of the two thorns which stand out against the soldier's shoulder, pointed up by a specific brushstroke. As in the *Ecce Homo* in Genoa, tiny drops of blood fall from the crown of thorns, those on Christ's body seeming to be imprinted with particular delicacy for fear of tainting its purity. The face conforms to the model of the Christ in Genoa, but, in a significant extension of the work's meditational scope, it is more emaciated and suffering, the pallor increased by the contrast with the flushed and puffy left eye.

The nostril is moulded according to a formula which is also found in the other three faces, and is such a constant feature in Caravaggio that it can almost be regarded as a trademark. In the hands in the foreground there is a reprise of the details and attitude found in the man observing the scene on the right in *The Tooth-puller* and in the *Saint John the Baptist at the Spring*. The cross-shaped rod held by *Saint John* is depicted with the same care as the rod which Christ is holding in the *Ecce Homo*, as emerges from the changes it underwent during the work's execution. *The Tooth-puller* and the *Saint John* can also be dated to the final months Caravaggio spent in Sicily and then Naples.

In terms of execution, which is the key to my advocacy of the painting's autograph status, I find this rediscovered work to correspond in full to the requirements I set out when publishing the version now in New York, concerning the impasto of the flesh, the distribution of the light sources and the long commanding brushstroke. I did in fact fail to find the latter in Christ's white loincloth as he leans against the parapet in the New York picture, while here this garment is rendered with the same technique as is used elsewhere to build up patches of light and shade. It also has a fraying edge, a detail that is not unusual in Caravaggio (see, for example, the habit of *Saint Francis* in Cremona, the garment of one of the criminals in the *Flagellation* in Rouen and the cloth used to hold up the Christ Child in the *Madonna of Loreto*), which the copyists (or copyist) of the *Ecce Homo* misunderstood.

Other indications of considerable interest emerged from the X-ray analysis. It is not possible to present them here, and I illustrate them in the essay due to appear in *Paragone*.

This *Ecce Homo* in a horizontal format was known in Southern Italy. Unmistakable, free derivations by Caracciolo have been reported by the present author (Gregori 1990, pp. 24–6) and by Papi (1990, p. 39), who does not rule out the possibility that Caravaggio saw the picture in Genoa. Nonetheless, his versions fail to capture the strong moral message of the original, offering instead a devotional interpretation, of considerable intensity, of the *imago doloris*. The picture is unpublished. Restoration was carried out in 2003 in the Giovine e De Vero laboratories in Turin. [*m.g.*]

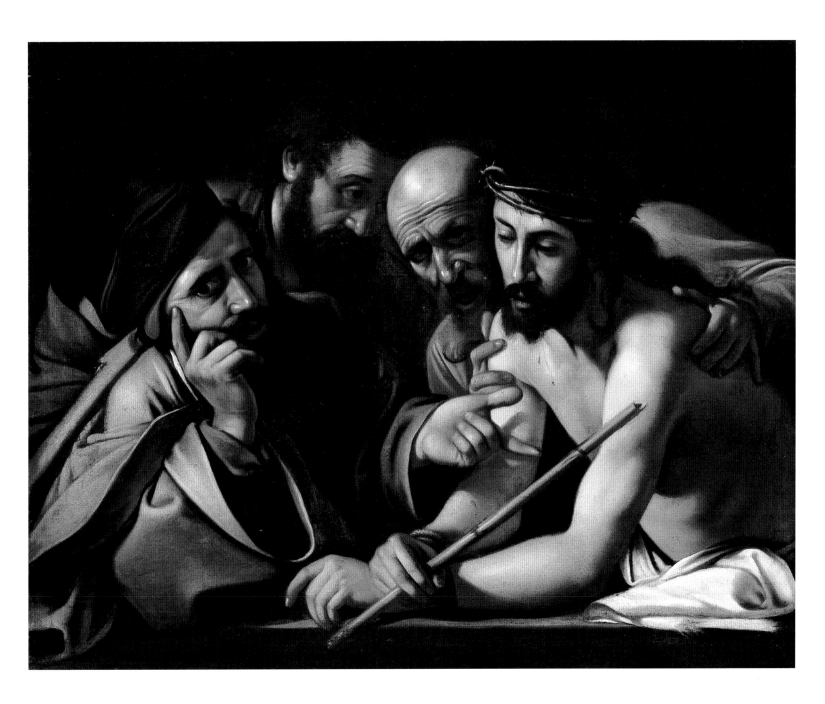

23. Salome with the Head of Saint John the Baptist [in a Basin]

158

oil on canvas, 91.8 x 71.5 cm
Private collection

According to Bellori, as soon as Caravaggio got back to Naples from Sicily, having fled from Malta and the Order of the Knights of Jerusalem in disgrace, 'seeking ... to placate the Grand Master, he sent him as a gift a half-length figure of Herodias with the head of Saint John in a basin'. The name 'Herodias' is presumably a mistake, because it is obvious that the subject is Salome, Herodias's daughter. Bellori himself, writing a little further on in the same work about Honthorst and his *Martyrdom of Saint John the Baptist*, painted for Santa Maria della Scala in Rome, says correctly: 'being nearby the daughter of Herodias ... with the plate at her side' (see Bellori 1672, p. 236). Having made this clarification, it must be said at once that critics, and in particular Roberto Longhi, made a point of trying to identify the said 'Herodias/Salome' in one or other of the two late works of Caravaggio featuring this episode: the picture from the Casita del Principe at the Escorial (now in the Palacio Real, Madrid), and the one now in the National Gallery, London. However, not enough notice was taken of the fact that these two works both feature three 'half-length figures' and not just one, as Bellori quite unequivocally specifies ('*a* half-length figure of Herodias'). This brings us to a picture, at Presicce near Lecce, which was involved in a series of thefts and dubious transactions, and has finally been restored to its former owners on the basis of a court sentence. It features a 'half-length figure' of Salome 'with the head of Saint John in a basin' which not only corresponds exactly to the description given by Bellori but bears all the hallmarks of Caravaggio, and indeed of the final months of his activity. Furthermore, the work presents an interpretation of the story which could hardly be more innovative or remarkable, especially for the unprecedented pose of the girl, who is shown carrying the head tucked under her arm, for all the world as if it was a bundle of clothes fresh from the wash and destined for the mangle. To tell the truth, when the painting was first shown to the present author, before it had been cleaned, I had the impression that it did indeed feature the 'Herodias' described by Bellori, but that it was perhaps a copy by a Neapolitan artist, and more specifically by Battistello Caracciolo. When I saw the picture again during its cleaning by the Caravaggio connoisseur Pico Cellini, I had no hesitation in sharing his opinion that this was indeed the original. But truth compels me to add that the picture subsequently suffered, at the hands of Cellini himself, from unnecessarily extensive and conspicuous integrations and some over hasty touching up. Another intervention had become indispensable, and this time the picture was entrusted to the knowledgeable care of the restorers Carlo Giantomassi and Donatella Zari. They restored the picture to its near-original state and this provided indisputable confirmation of the authorship of Caravaggio. The Presicce picture is to date the only one which corresponds in all respects to the one described by the artist's biographer; furthermore, it has decisive affinities with paintings done in Malta and Naples in the period 1608–9. If one looks closely, one can see that 'Herodias/Salome' is the same girl who is bending over to receive the head of the Baptist in the *Beheading* in Malta; the basin too is the same as the one depicted in the Malta picture; and the head of Saint John the Baptist itself is indeed extremely similar to the one in the picture in the Escorial, which in all likelihood must have been painted in quick succession. [*f.b.*]

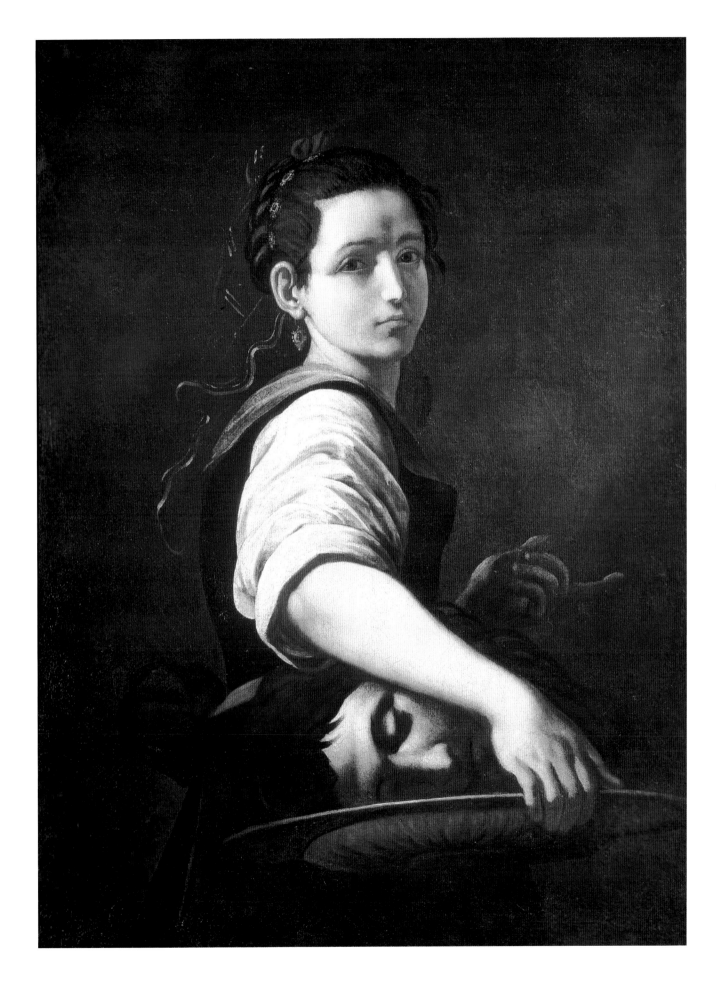

24. Saint John the Baptist at the Spring

oil on canvas, 127 x 95 cm
Private collection

Back in Naples following his escape from Malta and stay in Sicily, Caravaggio was again given hospitality by the Marquise Costanza Colonna in her Chiaia residence (later Palazzo Cellamare) following an incident at the Taverna del Cerriglio, when he was injured, possibly during a brawl (but not by emissaries of the Knights of Malta, as some sources have maintained). While awaiting the papal pardon, Caravaggio decided to set off by sea for Rome. In July 1610 he embarked on a felucca sailing to the Lazio coast, taking with him, in the words of Baglioni, 'the two Saint Johns and a Magdalen' destined for Cardinal Scipione Borghese, a long-standing admirer of his. Ever since his flight from Rome after the murder of Ranuccio Tommasini, Caravaggio had kept in contact with the Cardinal in the hope that he could assist him in obtaining the longedfor authorisation to return to the eternal city. We know from the extensive documentation assembled in recent years that, having gone ashore in secret at Palo, a small port a few kilometres to the north of Rome, the artist was recognised and arrested by the pontifical guards, only to be set free two days later following the intervention of a person of some consequence, who has still not been identified but who must presumably have been either Costanza Colonna or Scipione Borghese. Meanwhile the felucca, with all the artist's belongings, including the three paintings, had returned to Naples, leaving Caravaggio, 'seized by a fury' and 'like a madman', to make his own way northwards along the coast of the Maremma to Porto Ercole, where he died in a hospice on 18 July 1610 from an attack of *febbre maligna*. We know that, on the felucca's return to Naples, the three pictures on board were taken to the residence of the Marquise of Caravaggio, where the Prior of the Order of the Knights of Saint John in Capua had them impounded, on the grounds that since Caravaggio was a 'professed Knight', they became the legal property of the Order on his death. The Marquise took issue with this claim because Caravaggio had been expelled from the Order; Cardinal Borghese meanwhile appealed first to the Bishop of Capua and then (on the latter's suggestion) to the Viceroy of Naples, the Count of Lemos, to have the three works meant for him duly delivered. In the end it was decided, although we still do not know how agreement was reached, to give the Cardinal only one of the two *Saint Johns*, the one now in the Galleria Borghese in Rome and included in the exhibition (see cat. no. 19). We know nothing about the fate of the other *Saint John* or the *Magdalen*, apart from the fact that copies were made of them in Naples, probably with the authorisation of the Viceroy, who may well have had custody of them.

In 1951 Roberto Longhi, on the strength of a first-hand examination he had carried out many years previously, published a *Saint John the Baptist at the Spring* in the Bonello collection in Malta (55 x 74.5 cm) as an autograph work of Caravaggio, without giving any further information. In the picture, which had long been in a very poor state of conservation, the saint is depicted almost half-length, lying on the ground drinking at the spring, with a landscape scene inserted at the top. Since then many commentators have concurred with Longhi's opinion, often only on the basis of photographic reproductions: some have related the Bonello picture to the original that went missing from the felucca on its return to Naples (Mahon, Grassi, Bottari, Ottino, Bologna and Kitson; Marini maintains that only the landscape is apocryphal), some have expressed doubts as to its autograph status (Jullian, Cinotti, Gregori), and others again (including Wagner, Spear and Hibbard) have rejected the attribution to Caravaggio. Subsequently Mina Gregori has proposed another *Saint John the Baptist at the Spring* as autograph, to be associated with the *Saint John* by Caravaggio that went missing (receiving the recent endorsement of J. Spike). Formerly held by Gasparrini in Rome and now in a private collection, it also features in this catalogue (see cat. no. 21). In this case the composition, of which an identical version is known in a private collection in Florence (also published by Gregori as an early copy), has a horizontal format and smaller dimensions, but otherwise is very similar to the Bonello picture, apart from the absence of a background landscape.
Other early copies with the same theme are known, all deriving from a single prototype and all featuring a full-length figure of the saint, almost standing, drinking from the spring, with in addition the Lamb of God at the bottom. In all these copies the composition is developed vertically with respect to the picture formerly held by Gasparrini. Among them the most striking, not least for the precise correspondences with the picture we are presenting, is the one which Longhi considered to be a copy from a lost original by Caravaggio, subsequently attributed by Gregori and Causa to Alonzo Rodriguez, a painter who lived in Naples from 1605 to 1611. Three other works derived from the same picture are to be found in the Galleria Nazionale d'Arte Antica, Rome, currently in deposit in the premises of the Presidenza del Consiglio; in the Cathedral of Plasencia in Spain; and in the Kunsthistorisches Museum, Vienna. The first two are described as works by an unknown Southern Italian artist, while the third, attributed to Pedro Orrente, a Spanish artist who worked in Naples between 1607 and 1611, has the figure of Saint John reversed and facing in the other direction from the figure in the copy attributed to Rodriguez. In the latter, 'a version, formerly on the art market in Rome', Gregori (1993) identifies 'the most faithful derivation of the *Saint John the Baptist at the Spring*'. In 1963, when it was still in the hands of the antiques dealer Canessa, Roberto Longhi certified it as a 'derivation from a lost Caravaggio of the final period, probably done in Naples, in all likelihood by Battistello' (the photograph of the painting, with Longhi's identification written on the back, is conserved in the Longhi Foundation archives in Florence).

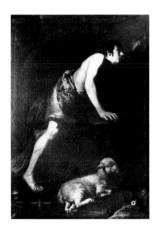

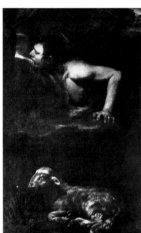

162

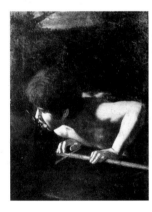

Unknown painter of Southern Italy, *Saint John the Baptist at the Spring*. Rome, Galleria Nazionale d'Arte Antica, in deposit at the Presidenza del Consiglio dei Ministri

Pedro Orrente, attr., *Saint John the Baptist at the Spring*. Vienna, Kunsthistorisches Museum

Unknown painter of Southern Italy, *Saint John the Baptist at the Spring*. Malta, Bonello collection

The painting under discussion here is identical, in subject and dimensions, to the picture attributed to Rodriguez (see fig. 15 on p. 39). It appeared in a London auction (at Sotheby's on 29 July 1998, lot 137) as a 'Caravaggesque work', its provenance given as from a Swiss family, purchased in Rome in the nineteenth century. It was subsequently published by Marini as a possible copy by Battistello Caracciolo of a lost original by Caravaggio, but only on the basis of his examination of the photograph printed in the auction catalogue. Spike in turn, without having seen either the work at first hand or a photograph of it following its restoration, included it in his monograph on Caravaggio among the attributed works.

This picture was painted on a canvas of the size traditionally referred to as *imperatore*. When it was put up for auction at Sotheby's, prior to restoration, it was disfigured by oxidised varnish, patches of old glue and two or three old repaintings from different periods, which had covered and altered the original colours, making it difficult to distinguish some of the details. What could be clearly made out was the shape and colouring of the lips, the jet of water which divides into two separate spouts as it emerges from the rock, and the drop falling from the half-open mouth of the young saint. Three rays of light converge on his face, pointing up some details, and help to define the perspective of the composition as a whole: one lighting up the cross-shaped stick which lies at a slight diagonal to the imaginary line of the horizon and on which, in a significant gesture, the hand of the Baptist is resting while he leans against the rock; one glancing off and highlighting the saint's forearm, placed parallel to the horizon; and one bathing the Lamb of God, lower left, seen full on by the viewer but at right angles to the horizon, serving as a foil to the figure of the youth slaking his thirst at the spring. During restoration, which revealed the original quality of the paint surface, it was possible to make out, under a microscope, that the areas of paint containing white lead, applied over the draft which also contained white lead, being double thickness, had coagulated, perhaps because the picture, with the oil-based paints which had not been allowed to dry out properly, had been placed near a source of heat or in a particularly warm place, such as the hold of a felucca in July (it appears, moreover, that the *Saint John* of the Galleria Borghese suffered a similar fate). Furthermore, various *pentimenti* revealed by the X-ray analysis show that some parts of the picture underwent changes with respect to the initial draft or *abbozzo*. There were changes to the arm, placed higher and to the right; the left hand, which was raised above the arm; the staff, which was lengthened; the left leg, which was brought higher up; and the shoulder, which was partially covered by the sheepskin.

From what has been said so far, it seems clear that the three versions of the subject – the Bonello picture and the two identical copies, ex-Gasparrini and private Florentine collection – were all based, albeit each with its own variants, on the Sotheby picture when it was still in Naples in Caravaggio's workshop, before it had been completely finished. This is supported by the fact that in the original version, before it was modified and completed, the upper part of the picture bore remarkable affinities with the three works featuring half-length figures, while three other details were virtually identical: the position of the youth's arm, placed a little higher up, the shadow falling on

his shoulder, which did not produce the final effect of dense, robust volume; and the placing of the sheepskin.

The solutions adopted in the Bonello, ex-Gasparrini and Florentine collection versions thus appear to be the outcome of a process by which the qualities inherent in the picture discussed here became progressively diminished, above all on account of the deficiency in structural clarity and the scant density of paint which characterise all of Caravaggio's late production. In addition, as evidence that this is indeed the original, painted during his second stay in Naples, and in all likelihood the second of the two *Saint Johns* he is known to have taken with him on leaving Naples, we can point to the highly emotional presentation of the episode, its sober dramatic tension, and the compelling naturalistic vigour with which the physical and expressive features are represented. All these elements emerge from its exceptional and incontrovertible pictorial quality, as well as from the curtailed rendering of some of the anatomical details (including the left foot, blocked in but left practically unfinished, or the left hand in which the paint constituting the basis of the flesh was merely overlaid with vigorous 'jerky' brushstrokes of a light colouring to give it volume) which is typical of the artist's late style, coinciding with his period in Sicily and return to Naples. In support of the hypothesis that the painting on view here should be identified, in the light of everything we have outlined here, with the second *Saint John* that Caravaggio took with him in the felucca, as a gift for Cardinal Borghese, and which never reached him, I have so far received the oral communications of Sir Denis Mahon, Mina Gregori and Nicola Spinosa. What still has to be established is when and in what tortuous ways the picture left Naples, and, in particular, the residence of either the Marquise Colonna or the Viceroy, Count of Lemos, and found its way into the Roman collection where it remained throughout the nineteenth century. [f.p.]

Bibliography: Marini 2001¹, p. 545; Spike 2001, p. 224, n. 65.

old copies

Anonymous, first quarter of the 17th century
25a. Saint Mary Magdalene in Ecstasy

oil on canvas, 109 x 93 cm
Bordeaux, Musée des Beaux-Arts, inv. 1966-1-2

Wybrandt de Geest
(1592–c.1661)
25b. Saint Mary Magdalene in Ecstasy

oil on canvas, 110 x 87 cm
inscribed on a cartouche painted in *trompe l'oeil*: *imitando Michaelem / Angelum Carrava... / Mediolan. / Wymbrandus de Geest / Friesus / a. 1620*
Barcelona, Private collection

We do not intend to analyse here the picture formerly in the Klain collection – 'this archetype destined for such fame', nor to compare it with the version reported by Longhi, known only from an old photograph (Pacelli 2002, fig. 76). We want instead to present two copies made at the beginning of the seventeenth century: the first, by an anonymous painter, in the Museum of Bordeaux, and the second, signed and dated 1620, by a Dutch painter, Wybrandt de Geest, in a private collection in Barcelona. These are two of some twenty copies that have been studied by Bodart (1966), Moir (1976), Cinotti and Dell'Acqua (1983), Marini (2001) and most recently Pacelli (2002).

The progenitor of these copies is a remarkable painting of a saint, depicted life size three-quarters on, her body seeming to stand out from the canvas. This perspective and mode of presentation were to have an immense success over the best part of three centuries.

The reconstruction of the painting's history, assembled by Pacelli (1994), is no less remarkable. A letter written by Donato Gentile, Bishop of Caserta and nuncio in the Kingdom of Naples, to Cardinal Scipione Borghese on 29 July 1610, within a few days of the artist's death, tells of three pictures, two of which if not all three had only been completed in the days before Caravaggio left Naples on his ill-fated journey to Rome: 'on its return the felucca took the last things belonging to him to the house of the Marquise of Caravaggio, who lives in Chiaia, from where Caravaggio had set: I immediately sent to see whether there were pictures there, and found that there are none apart from the two Saint Johns and the Magdalen, and they are in the aforesaid house of the Marquise, to whom I sent straightaway to request ...' (Pacelli 1994, p. 121).

Three other letters give us further information which can be summarised as follows: a *Saint John the Baptist* (vertical format) was delivered to Cardinal Scipione Borghese in Rome; another *Saint John the Baptist* (horizontal format; now in Germany, private collection, see Pacelli 2002, fig. 59) was given to the Viceroy, Count of Lemos; while the picture that concerns us here, the half-length *Saint Mary Magdalene in Ecstasy*, was taken to Naples to the house of Costanza Colonna, who was living in the residence of her nephew Luigi Carafa Colonna, Palazzo di Chiaia. Thus Caravaggio's original was in Naples during the seventeenth century and not in Rome as has sometimes been maintained.

The iconographical treatment of Mary Magdalene is also most unusual. No critic has failed to comment on the anguish distorting her features, and the sense of grief, repentance and inner turmoil. And the way in which the artist dwells on the visualisation of the ecstasy is a clear anticipation of the treatment it was to receive in the Baroque period and from Bernini.

The treatment of the subject is extremely innovative: the saint is shown without her principle attributes, the jar of ointment, and the skull and cross. In Pacelli's words, 'as in other iconographical choices, Caravaggio gave a literal interpretation of the passage from the gospels ... the Lombard artist had no need to introduce any symbols to allude to her contrition, repentance, supplication ... his expressive force must have been so profoundly disturbing to the artists who set out to copy him

that almost all of them inserted the attributes, such as skull, cross, jar of ointment, which did not feature in the original'. In fact the copyists, and following them other artists who made their own adaptations, never dared to present the saint alone, without her attributes. In so doing they were conforming to the precepts set out in 1582 by Gabriele Paleotti (1522–1597), recommending the representation of saints in ecstasy, accompanied by their attributes and borne up by angels, to emphasise their mystical experiences, which were inaccessible to ordinary people. Federico Borromeo's *De estaticis mulieribus et illustris*, published in Milan, shows the level of interest his contemporaries took in the subject. He describes the intensity of the mystical rapture which, he said, often gives mystics the aspect of death.

Caravaggio's painting met with extraordinary success, particularly in the first half of the seventeenth century. In our analysis of the two copies, from Bordeaux and Barcelona, we shall examine the success of Caravaggio's composition with artists from Northern Europe; and its diffusion throughout the South of France (we can recall that Mary Magdalene chose to spend the last thirty years of her life in Provence). It should always be borne in mind that of the numerous copies made many were not based on the original, but were taken from other copies, whichh accounts for the many variants in the treatment of space and luminosity (Bodart' study, taken up by Cinotti, simply distinguished between light and dark versions, and is no longer valid) and in the inclusion of attributes: we are in fact confronted by free reworkings.

The Colonna picture – and this fact is crucial – is known to have been copied twice by Finson (Marseilles, Musée des Beaux-Arts; Saint-Rémy de Provence, private collection, see Pacelli 2002, figs 72–3) and possibly three times. A little-known passage by Philippe de Chennevières (1874) concerns the third copy: 'a third analogous [picture] believed to be by Caravaggio, showing various features of his work: a lighter tone, the presence of the canonical attribute of the jar of perfume; a different modelling of the folds in the garment; the crossed hands shown in a uniform light, without strong chiaroscuro effects'. Taking this as their starting-point, critics have been tempted to attribute other copies of the *Magdalen* to Finson (notably the versions in Bordeaux and Poitiers). The *Magdalen* in Bordeaux has also been attributed to Renier (?) by Moir, but it seems more appropriate to consider it an anonymous work. It appears to have been based on the original and not on the picture in Marseilles (a large fold in the right sleeve is identical in the Bordeaux and ex-Klain collection pictures, while it is less voluminous in the picture in Marseilles).

The picture from Barcelona was made in 1620 by Rembrandt's brother-in-law, Wybrandt de Geest. We know that this artist was in Rome between 1614 and 1618, and in Holland from 1621 onwards; in the intervening period he was presumably in Italy. The signature, of crucial importance, has given rise to a range of commentaries. '*Imitando Michaelem Angelum ...*' stands as a sort of tribute to the Lombard artist: 'I, de Geest, do nothing but imitate Caravaggio; I do not say copy, but imitate, because I allow myself to add the traditional attributes of this sinner, and particularly the skull'.

It was possible to view the two copies together when this exhibiiton was presented in Naples. The first (Bordeaux) keeps faithfully to the original, apart from the significant addition of

the skull on the right; the second (Barcelona) is a fairly free interpretation of the original, with the drapery of the garment in the lower section completely reworked, a very different representation of the hands and arms, and the conspicuous additions of the two attributes (skull and jar), as well as the cartouche. Caravaggio's original would

Pariset (1948) and Cinotti (1971), strike us as being particularly judicious: the first is that many of the copies known in France had a direct bearing on the cultural formation of Georges de La Tour; in fact, after Caravaggio, only La Tour ever produced such an original interpretation of Mary Magdalene (New York, The Metropolitan Museum); the

Provenance: a) held by the dealer J.O. Leegenhoek, Paris, bought by the Bordeaux Museum in 1965.
Exhibitions: b) Jos de Meyere and Juan J. Luna in *La pintura holandese del siglo de oro; la escuela de Utrecht*, Madrid–Bilbao–Barcelona 1992–3, n. 32.

Bibliography: a) Huyghe 1960, p. 278 (probably

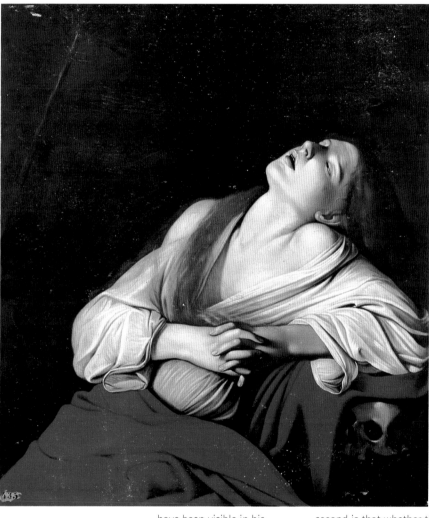

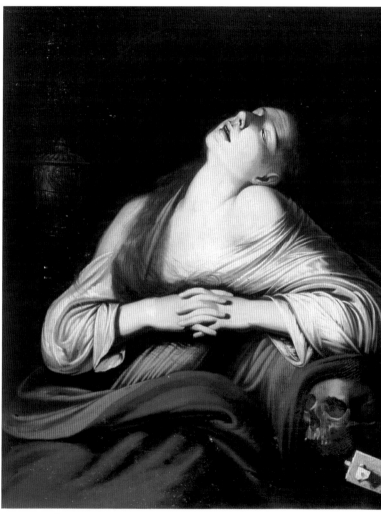

have been visible in his workshop in 1606 and subsequently in the Carafa Colonna residence in Naples, from August 1610 onwards. A large number of artists are known to have been to admire it, whether Northerners (Finson, de Geest) or Neapolitans (De Simone?, Caracciolo, the author of the ex-Carvalho picture). Two observations, made by

second is that whether this Mary Magdalene is in agony or in ecstasy the painting proved to be of 'great importance for the way in which this theme was developed by painters in Northern Europe'. Indeed, what a copy, or interpretation, Rubens could have made! [*a.b.l.*]

Finson); Bodart 1970, p..104 n. 6 (Northern painter); Cinotti and Dell'Acqua 1983, p. 543; Habert 1987 n. 14; Marini 2001[1], n. 76, pp. 508–9; Pacelli 2004, p. 184 and fig. 86 (Finson)
b) Ainaud de La Sarte 1947; Cinotti and Dell'Acqua 1983, n. 64, p. 542; Marini 2001[1], n. 76, p. 508; Pacelli 2002, p. 66, fig. 74.

In a letter dated 25 September 1607, from Pourbus to the Duke of Mantua, mention is made of two pictures by Caravaggio that were for sale in Naples: one a 'Rosary' (now identified as the altarpiece of the *Madonna of the Rosary* in Vienna), the other a 'Holofernes with Judith', which, since it was in Naples at that date, must obviously be a second version of the picture on this subject which Caravaggio made in Rome for Ottavio Costa, now in the Museo d'Arte Antica, Rome. As explained by Cinotti (1983, p. 453), Marini supposed that Pourbus had mistaken for Judith a figure which was in fact Salome. On two occasions (1974 and 1981) this critic asserted that the 'Judith' was to be identified with the 'Salome' now in London. He later changed his mind (Marini 1987[1], n. 70, pp. 503–4 and elsewhere; Marini 1987[2], pp. 59–80), although the hypothesis also received the support of Vincenzo Pacelli (1994, p. 59). In a will made in Amsterdam on 19 September 1617, however, the Flemish painter Louis Finson declares that he was the joint owner, with his colleague Abraham Vinck, of a 'Rosary' and a 'Judith and Holofernes' by 'Michael Angel Crawats'. This gives us further documentation of the two pictures recorded by Pourbus as being in Naples, and which were purchased and brought to Holland by the two painters. The original statement in the will reads as follows: '*twee stucken schildereyen beyde con Michael Angel Crawats, d'een wesende een Rosarius en d'andere Judith en Holopharnis*' (see Bredius 1918, n. 273, pp. 198–9; and Macioce 2003, n. II doc. 451, p. 284). There can thus be no doubt that the picture in question did feature this subject.

Giving due credit to the accuracy of earlier written accounts, Leone de Castris had proposed identifying the new 'Holofernes with Judith' with an original which must for the time being be considered lost. The copy in the Banco di Napoli collection must have been taken from that original (see P. Leone de Castris, in *Il patrimonio* 1984, pp. 36–8; and R. Middione in Napoli 1989, p. 26). Although we are reluctant to go along with Leone de Castris, and with Middione and Marini (following his change of mind), in attributing this copy to Louis Finson (it has features which are markedly different to those usually found in the work of the Bruges painter), the identification of the prototype of the copy in question with the picture by Caravaggio referred to by Pourbus can be considered definitive. This not only enables us to form a fairly accurate idea of what this second and more modern version of the subject Caravaggio had already painted in Rome must have looked like, it also gives us a new and fundamental point of reference for the reconstruction of the development of his art during his first stay in Naples, and indeed enables us to be more definite about the chronology of the paintings he worked on there.

Inasmuch as one can judge from a copy, it is evident that the work followed on from the *Seven Works of Mercy* and the *David* in Vienna. It features the strikingly original figure of an old woman with a goitre, such as one would easily have come across in the depressed south. (Caravaggio here reveals himself a retentive pupil of his old teacher, Peterzano, who depicted a similar figure in the fresco of the *Adoration of the Shepherds* done at Garegnano in 1578–82, a work which had already provided concrete inspiration for the young Caravaggio in his *Sick Bacchus*.) In its straightforward derivation from a living model, the woman immediately brings to mind the similar figure that appears in *The Crucifixion of Saint Andrew*. It seems certain that the *Judith* and the *Saint Andrew* were painted at about the same time, so that the two pictures can be dated to April–June 1607 or thereabouts. We can add that the figure of the old woman with a goitre singled out in the *Judith* made history both in Naples and among the Flemish artists then working in the city. In what is in all probability a reprise of the same model, it recurs in the important painting in a private Neapolitan collection which, interpreted as a *Denial of Saint Peter* and also attributed to Louis Finson, was included in the exhibition *Civiltà del Seicento a Napoli* (see Naples 1984, vol. I, p. 277, n. 2.89, with a mediocre reproduction). On this painting, which should in fact be assigned to the Maestro dell'Emmaus in the Museum of Pau, see Bologna 1991, pp. 63 and 66, detail in fig. 30, whole p. 268, n.2. 14.

For the sake of completeness, we can recall that the painting illustrated here was considered by Fausta Navarro in 1991 to be a copy of a lost original by Artemisia Gentileschi. [*f.b.*]

Anonymous 17th century
26. Judith and Holofernes (copy of the second version)

oil on canvas, 140 x 180 cm
Naples, Museo Pignatelli,
Sanpaolo Banco di Napoli
collection

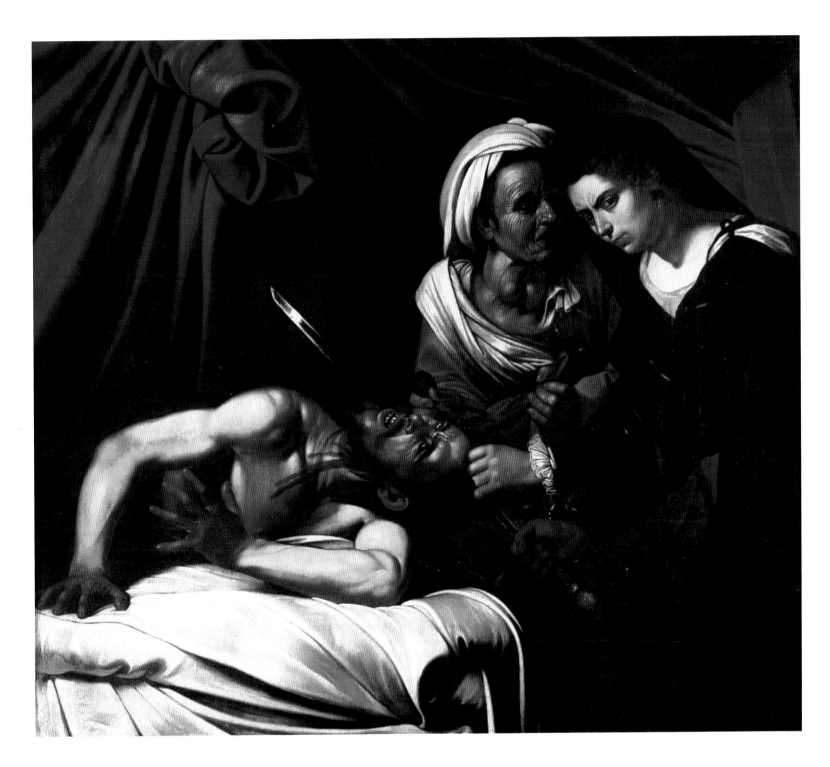

The picture is listed with no indication of author or provenance in the report made on 22 April 1925 when it was consigned to the Pinacoteca Civica of Macerata by the civic authorities, 'after having lain neglected for many years, together with other paintings, in a municipal storeroom'. Thereafter the work appears in the inventory of the Pinacoteca drawn up in April 1947 with the information that it had been part of the collection of the Dominican friar Tommaso M. Borgetti. In 1833 this prelate had bequeathed to the municipality of Macerata his impressive library and 'everything which on his death proved to be his property' (on Borgetti see P. Cartechini 1993, pp. 47–51).

In addition to this picture from Macerata, published for the first time in 1943 by Roberto Longhi, who had known it since 1926, two other versions of the same subject are known. The first is in the Museo Civico di Castello Ursino, Catania, and the second in the collection of the heirs of the neo-classical painter Vincenzo Camuccini at Cantalupo Sabino (Rieti). These three works have had a complicated critical and attributive history, the contrasting opinions expressed over the years giving the measure of the difficulties still facing anyone wishing to give a complete account of Caravaggio's art and trace the complex fortunes of the artist's prototypes in the innumerable copies and derivations they gave rise to.

As noted above, the *Christ at the Column* from Macerata was published by Longhi in 1943 as a copy from an original dating from Caravaggio's last period, which he tentatively identified as the version in Catania, although previously (1915) he had attributed the latter to the young Battistello, as a derivation from the *Flagellation* in San Domenico Maggiore, Naples. Some years later (1951), following Bottari's publication of the work in Catania, Longhi revised his opinion and pronounced the latter to be inferior in quality to the Macerata picture.

Subsequently (1960) Longhi, on the basis of information passed on by the restorer Antonio De Mata, attributed a third copy of the *Christ at the Column* to Vincenzo Camuccini, known for his activity as copyist. This work was considered by Longhi to be worthy of the original by Caravaggio, which 'must be dated to soon after the paintings in Santa Maria del Popolo'. Marini thought differently, and tentatively affirmed the Camuccini picture as an original which had once been in the Borghese collection. This association was, however, ruled out by Cinotti on the basis of iconographical considerations. While there has been a certain consensus of opinion that the three versions all derive from a lost original by Caravaggio, this hypothesis has been rejected – mainly in favour of the theory that it is by one of the artist's Southern Italian followers striving to emulate the *Flagellation* in Naples – by Mahon (1951), Friedlaender (1954), Baumgart (1955), Wagner (1958), Jullian (1961), Kitson (1969), Cinotti (1971; now in favour) and Moir (1976), who believed it be a copy from Valentin. More recently Campagna Cicala (1984) has tentatively associated the *Christ at the Column* in Catania with two paintings, *The Road to Calvary* and the *Flagellation,* belonging to the Fondazione Lucifero in Milazzo, which she attributes to the Sicilian Caravaggesque painter Mario Minniti. Marini (2001) has seen a possible connection between the Catania version and the pictorial culture of the Veneto, and in particular with Carlo Saraceni and his follower, the so-called 'Pensionante'. Furthermore, Marini offers some reflections on the 'technical

and stylistic differences between the versions of Catania and Macerata in relation to the different objectives guiding the choices of the copyists: explicitly faithful (and hence passive) in the latter case (although it fell victim to the "fig leaf syndrome" in the addition of a piece of loincloth on the hip which destroyed the dynamic touch of the knot tied clumsily on the abdomen, looking as if it could unravel and cause the garment to fall at any moment), while the former reveals a superior quality *vis-à-vis* the attempt to interpret Caravaggio's prototype'.

While this assessment can be endorsed for the Macerata picture with respect to the addition of the piece of loincloth on Christ's right hip, constituting a blatant distortion of the model, the overall level of the picture is by no means inferior, as emerged following restoration in 1987. Possessed of a rapid, sure hand, the anonymous copyist shows himself thoroughly conversant with the characteristics of Caravaggio's art, especially in the dramatic chiaroscuro of Christ's torso and powerful neck, and also in the striking effect of the dark mass of the head of his captor, seen from behind, in the foreground. On the question of the dating of Caravaggio's prototype, critics have been divided between his Roman period (Mahon, Hinks, Marini, Gregori, Puglisi) and his first stay in Naples. Those in favour of the latter have rightly drawn attention to the links, whether it is considered as a copy from Caravaggio or the work of a follower, with the *Flagellation* of San Domenico Maggiore of 1607, and with *The Crown of Thorns* in Vienna, particularly for the figure of Christ, modelled on a prototype in the classic mould. [*g.ba.*]

Bibliography: Longhi 1943, pp. 18–19; Bottari 1949, pp. 217–18; Longhi 1951, pp. 41–2; Mahon 1951, p. 234; Hinks 1953, pp. 71–2, 110, cat. 39; Friedlaender 1954, p. 150; Baumgart 1955, p. 114, cat. 17; Friedlaender 1955, p. 207; Jullian 1955, pp. 83–4; Wagner 1958, p. 230; Berne Joffroy 1959, pp. 323, 371, note to fig. LX; Longhi 1960, pp. 30–1; Jullian 1961, pp. 175, 182, notes 41–3, 232; Longhi 1961, p. 181 (ed. 1915); De Logu 1962, p. 158; Moir 1967, I, p. 254; II, p. 59, C 4a-b; Ottino Della Chiesa 1967, p. 104, cat. 79a-b; Kitson 1969, pp. 105–6, cat. 79a-b; Cinotti in Dell'Acqua and Cinotti 1971, pp. 136, 199, note 507; Cinotti 1973, p. 305, sez. V2; Marini 1974, pp. 123, 368–9; Nicolson 1974, p. 624; Moir 1976, pp. 118, cat. 106a-c, 158, note 278; Marini 1979, p. 36, note 2; Nicolson 1979, p. 32; Marini 1980, p. 28, cat. 22; Marini 1981, pp. 366, 368; Cinotti 1983, p. 561, cat. 79; Campagna Cicala 1984, pp. 120, f. 18, 141, n. 76; Campagna Cicala in Syracuse 1984, p. 175; Marini 1987, pp. 420–2; Cinotti 1991, p. 144; Papi in Florence-Rome 1991, p. 300; Gregori in New York-Naples 1985, p. 318; Gregori 1994, p. 148, n. 28; Guastella (ed.) 1997; Puglisi 1998, p. 398, n. 22; Pagano (ed.) 1999, p. 26; Marini in Palermo 2001, pp. 126–8.

27. Anonymous, 17th century, copy after Caravaggio Christ at the column

168

oil on canvas, 133 x 100 cm
Macerata, Pinacoteca Comunale, inv. n. 49

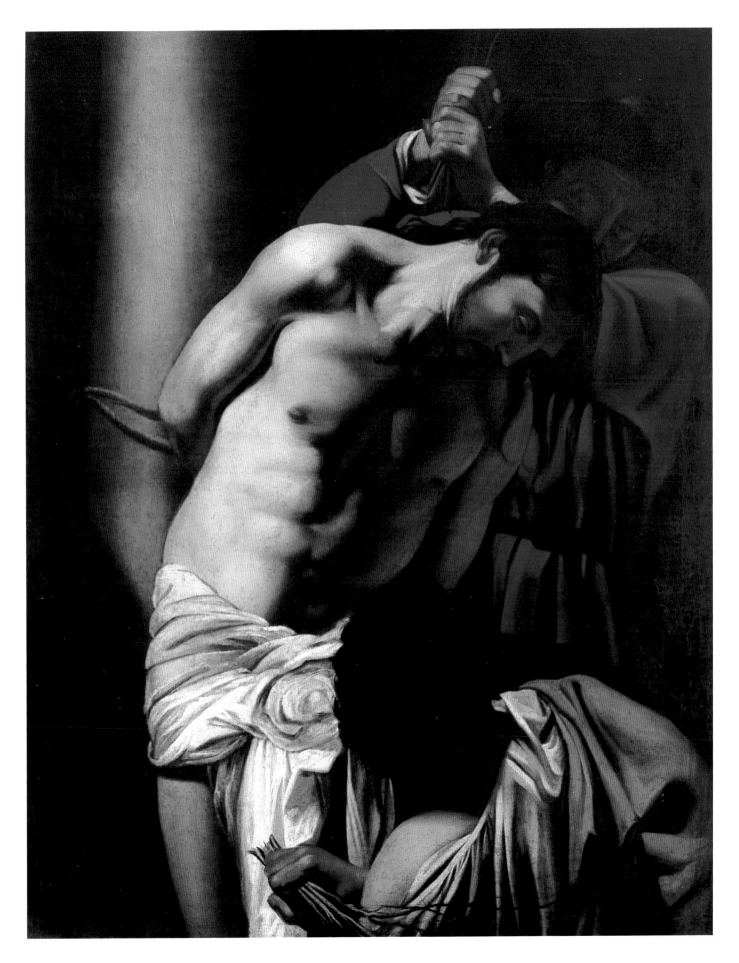

This picture was reported by Spadaro (1987) when it was still in the Prefecture of Catania, where it had been assigned in temporary deposit from the Museo Civico di Castello Ursino since 1954. It is highly likely that it belonged to the prestigious art collection of the President of the Supreme Court of Justice of Palermo,

correspond to the original by Caravaggio (stolen in 1969), corroborate the hypothesis, put forward by Spadaro and Marini (2001), that it is identical with the copy commissioned in 1627 from the Palermo artist Paolo Geraci by Don Gaspare Orioles, Count of Bastiglia and Baron of Fontanafredda, together with another copy

the celebrity of their authors that justified this commission in what were in effect still early days. Another factor would have been Orioles's contacts with a group of lively young noblemen, cultured prelates, successful merchants from Genoa and other cities, and various intellectuals (Abbate 2001, p. 77). The situation was in

dealings with Caravaggio during the latter's brief stay in Syracuse (Malignaggi 1987). The prevailing grey cast in this copy, pointed out by Spadaro, must surely be attributed to the state of conservation and the oxidisation of the paints, for overall it is of good quality workmanship and very faithful to the original, apart from some weak areas and the less varied manner in which the paint was applied. Paolo Geraci cannot be considered an outstanding figure among Palermo artists of the first half of the seventeenth century. Giovanni Mendola (1999, p. 72) has recently come up with a series of documentary data showing Geraci to have been born in 1601 and active in the years 1623 to 1631. He appears to have been an assiduous copyist, and the six pictures taken 'from the papers of Baxiano (Bassano)' and commissioned from him in 1623 by Don Giuseppe Alliata may be indicative of his role in the circulation of prints and drawings which had flourished in Sicily for decades.
Marini (1987, n. 96, p. 549) advances the tentative suggestion that 'two sketches may be linked' to the picture in question (in sanguine and chalk on paper, 155 x 185 mm, in a private collection in Milan). They show a study for the head of a putto, *recto*, and a study for a figure and a hand with a scroll, *verso*, and were noted by Testori (1984, pp. 143–50, particularly pp. 146ff.), who attributed them to Caravaggio. [*v.a.*]

Paolo Geraci
(documented in Palermo 1621–1631)
28. The Nativity with Saints Lawrence and Francis

oil on canvas, 280 x 210 cm
Catania, Museo Civico
di Castello Ursino, inv. 2477

170

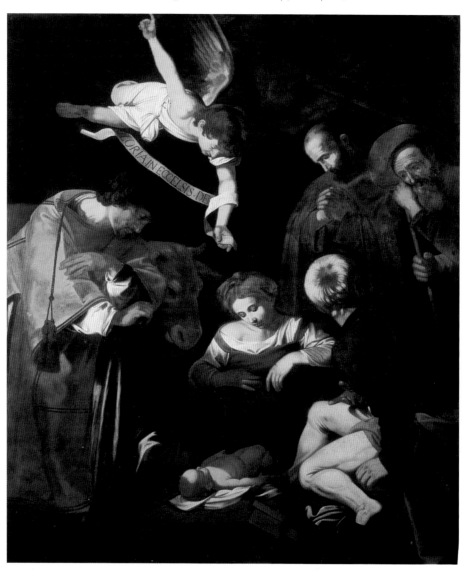

G.B. Finocchiaro. In 1826 he bequeathed his collection to the Comune di Catania, and it was kept first in the Museo Civico dei Benedettini, and thereafter at Castello Ursino (Davì in Palermo 2001). This would bear out its provenance as Palermo. The dimensions, which

of Raphael's celebrated *Spasimo di Sicilia*, still at that time in Palermo, according to the document published by Filippo Meli (1955–6, p. 219), reproposed by Moir (1967, vol. I, p. 183, note 5) and Marini (1974, n. 88, p. 454, E.1). It must have been the fame of these two paintings and

fact very similar to the one which in Rome produced Caravaggio's first patrons, and which elsewhere in Sicily produced figures such as Vincenzo Mirabella, of an aristocratic Syracusan family, scientist, poet and antiquarian, whom we know to have had first-hand

Bibliography: Spadaro 1984, pp. 291–2; Davì in Palermo 2001, p. 122; Marini in Palermo 2001, pp. 132–4, with previous bibliography.

register of paintings
edited by Denise Maria Pagano
and Mariella Utili

1a. **Saint Francis in Meditation**. Rome, church of Santa Maria della Concezione

1b. **Saint Francis in Meditation**. Carpineto Romano, church of San Pietro (in deposit in the Galleria di Arte Antica, Rome)

2. **Saint Mary Magdalene in Ecstasy**, Rome, private collection (formerly Klain collection)

3. **The Supper at Emmaus**. Milan, Pinacoteca di Brera

4. **Saint Francis in Meditation**. Cremona, Museo Civico Ala Ponzone, Pinacoteca

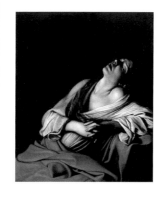
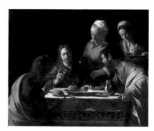
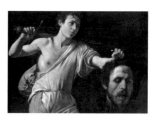
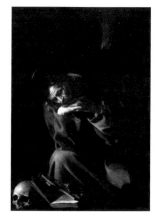

172

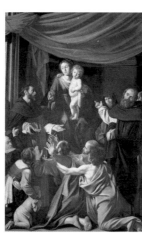
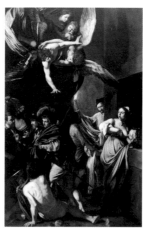

5. **Madonna of the Rosary**. Vienna, Kunsthistorisches Museum

6. **The Seven Works of Mercy**. Naples, Pio Monte della Misericordia

7. **David with the Head of Goliath**. Vienna, Kunsthistorisches Museum

8. **David and Goliath**.
London, private collection

9. **The Crucifixion of Saint Andrew**. Cleveland, Museum of Art

10. **The Crowning with Thorns**. Vienna, Kunsthistorisches Museum

11. **Judith and Holofernes**. Naples, Museo Pignatelli, Sanpaolo Banco di Napoli collection

12. **The Holy Family with Saint John the Baptist**. New York, The Metropolitan Museum of Art (in deposit from Otero-Silva Collection, Caracas)

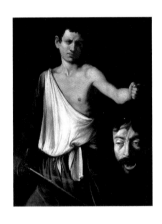
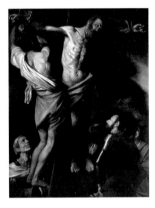
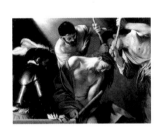
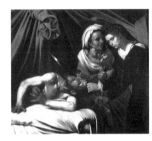
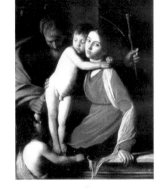

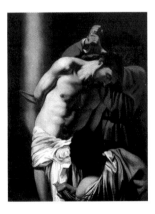
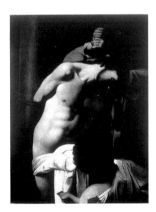
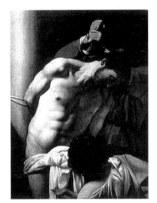
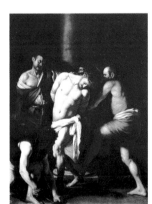

13a. **Christ at the Column**. Macerata, Pinacoteca Civica

13b. **Christ at the Column**. Catania, Museo Civico Castello Ursino

13c. **Christ at the Column**. Cantalupo Sabino, Camuccini collection

14. **The Flagellation**. Naples, Museo di Capodimonte (in deposit from church of San Domenico Maggiore)

15. **Saint Sebastian.**
Rome, private collection

16a. **The Flagellation.**
Rouen, Musée des Beaux Arts

16b. **The Flagellation.**
Switzerland, private collection

174

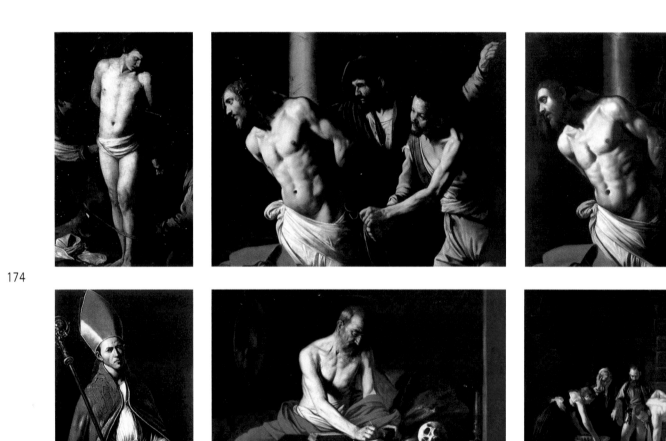

17. **Saint Januarius showing his Relics.**
Palmer Museum of Art, Pennsylvania State University, gift of Mary Jane Harris

18. **Saint Jerome Writing.**
Valletta, Museum of the Co-Cathedral

19. **The Beheading of Saint John the Baptist.** Valletta, Co-Cathedral

20. **Portrait of Alof de Wignacourt with Page.** Paris, Musée du Louvre

21. **Portrait of Alof de Wignacourt, Grand Master of the Knights of Malta.** Rabat, Wignacourt College Museum

22. **Sleeping Cupid.** Florence, Galleria Palatina

23. **Portrait of a Knight of Malta (Fra Antonio Martelli?).** Florence, Galleria Palatina

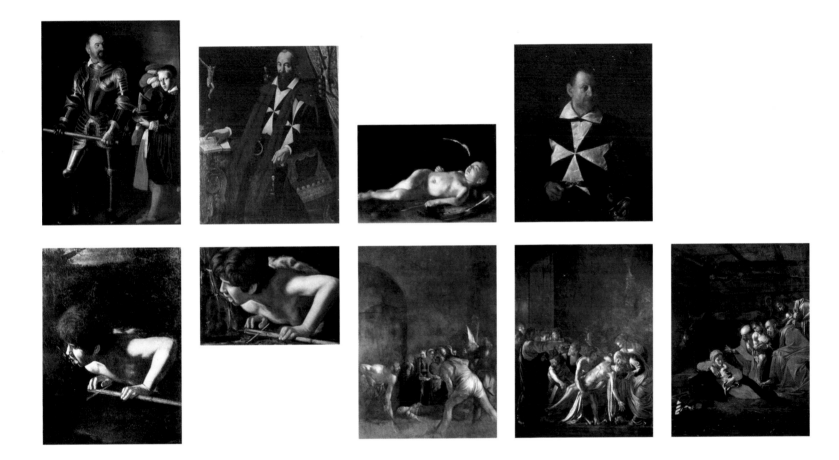

24. **Saint John the Baptist at the Spring.** Malta, Bonello collection

25. **Saint John the Baptist at the Spring.** Rome, private collection

26. **The Burial of Saint Lucy.** Syracuse, Palazzo Bellomo (in deposit from church of Santa Lucia)

27. **The Raising of Lazarus.** Messina, Museo Regionale

28. **The Adoration of the Shepherds.** Messina, Museo Regionale

29. **The Nativity with Saints Francis and Lawrence.**
Formerly Palermo, Oratorio della Compagnia di San Lorenzo

30. **The Tooth-Puller.**
Florence, Galleria Palatina

31. **The Vision of Saint Jerome.** Worcester, Museum of Fine Arts

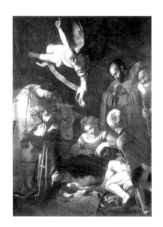

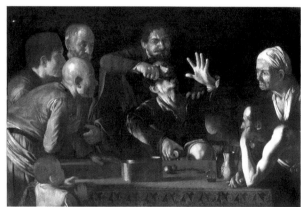

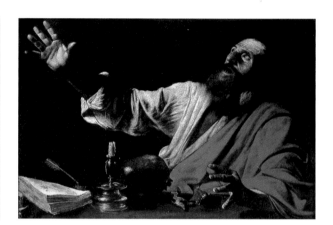

176

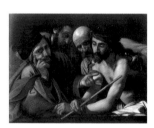

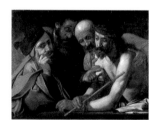

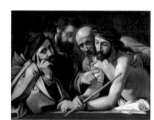

32a. **Ecce Homo.** New York, Cortez collection

32b. **Ecce Homo.** Arenzano, Santuario del Bambino Gesù di Praga

32c. **Ecce Homo.** Private collection

33. **Salome with the Head of Saint John the Baptist.** Madrid, Palacio Real

34. **Salome with the Head of Saint John the Baptist.** Rome, private collection

35. **Salome receives the Head of Saint John the Baptist.** London, National Gallery

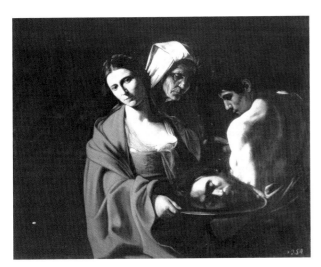

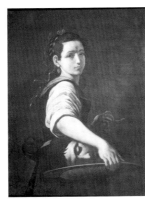

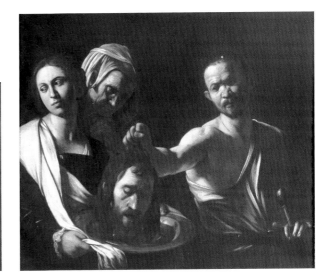

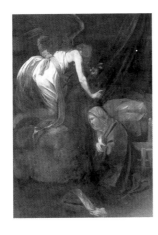

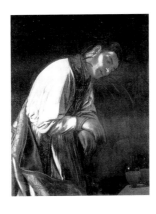

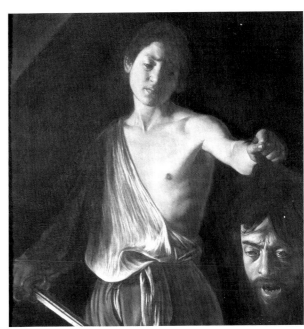

36. **The Annunciation.** Nancy, Musée des Beaux-Arts

37. **Saint Januarius Beheaded.** Rome, Galleria Nazionale Arte Antica (in deposit from Palestrina, church of Sant'Antonio Abate)

38. **David with the Head of Goliath.** Rome, Galleria Borghese

39. **The Denial of Saint Peter.**
New York, The Metropolitan
Museum of Art

40. **The Martyrdom
of Saint Ursula.** Naples,
Palazzo Zevallos, Banca
Intesa collection

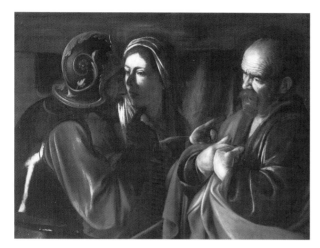

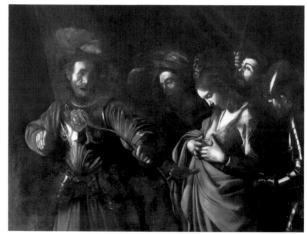

41. **Saint John the Baptist
reclining.** Munich, private
collection

42. **Saint John the Baptist.**
Rome, Galleria Borghese

43. **Saint John the Baptist
at the Spring with a Lamb.**
London, private collection

The works by Caravaggio listed below can all be ascribed to the years covered by the exhibition; while most are undoubtedly autograph, some are attributed to him, and some are copies from originals that have either disappeared or have not been found. The annotations, which make no claim to being exhaustive, present the evaluations of scholars who over the last fifteen years have published monographic studies, complete with an index of the artist's works; the one study dating back more than fifteen years is that of Mia Cinotti (1983), considered a fundamental reference work for all subsequent studies. Also included are essays or catalogues of recent exhibitions of particular significance which have made new contributions to scholars' knowledge of the final period of the artist's activity. The works which feature in this catalogue are given in the order corresponding to the conclusions on their dating reached by the authors of the catalogue entries.

An asterisk denotes works on which scholars are not unanimous.

1a. *Saint Francis in Meditation
Rome, church of Santa Maria della Concezione
1b. *Saint Francis in Meditation
Carpineto Romano, church of San Pietro (in deposit in the Galleria di Arte Antica, Rome)

Cinotti 1983: b) original, 1606 end of Roman period or while in Lazio, a) copy (p. 417); 1991: a) original, 1603 (p. 211); b) copy, 1606 (p. 215)
Gregori 1985: a) original, 1603–6, b) copy 1603 or shortly afterwards (p. 294); 1994: a) original, c.1605 (p. 151)
Calvesi 1990: b) original, 1606–8; a) copy (p. 425)
Bologna 1992: both probable copies from unidentified original datable to c.1606 (p. 331)
Spike 2001: b) original, c.1595 (p. 45); a) autograph replica, c.1602 (p. 46)
Marini 2001[1]: b) original, Palermo (?) 1609; a) good copy (p. 562)
Puglisi 2003: a)1603–c.1606; b) probable copy (p. 402)
Vodret 2000: b) original, summer 1606; a) Bartolomeo Manfredi?, before 1617 (pp. 140–5); 2004 a) Manfredi?, between 1610 and 1617 (p. 211)

2. *Saint Mary Magdalene in Ecstasy, Rome, private collection (formerly Klain collection)

Cinotti 1983: copy?, summer 1606 (p. 542); 1991: copy?, 1606 (p. 215)
Gregori 1985: original?, 1607 (p. 314); 1994: copy, c.1606 (p. 152)
Calvesi 1990: original, June–September 1606 (p. 425)
Bologna 1992: copy from unidentified original, datable to between 31 May and September 1606 (p. 331)
Spike 2001: original, 1610 (p. 237)
Marini 2001[1]: original, Paliano (?) 1606 post 31 May? (p. 507); 2004: idem
Pacelli 2002: original, period in Lazio (p. 161)
Puglisi 2003: attribution uncertain, 1606 (p. 405)

3. The Supper at Emmaus, Milan, Pinacoteca di Brera

Cinotti 1983: 1606 months spent in Lazio (p. 463); 1991: 1606 (p. 215)
Gregori 1985: end of Roman period (p. 308); 1994: c.1606 (p. 152)
Calvesi 1990: June–September 1606 (p. 425)
Bologna 1992: post 31 May–September 1606 (p. 332)
Spike 2001: Zagarolo 1606 (p. 175)
Marini 2001[1]: Paliano (?) 1606 post 31 May (p. 505)
Puglisi 2003: 1606 (p. 405)

4. Saint Francis in Meditation
Cremona, Museo Civico Ala Ponzone, Pinacoteca

Cinotti 1983: months spent in Lazio (p. 423); 1991: c.1606 (p. 215)
Gregori 1985: summer 1606–early in first Neapolitan period (p. 312); 1994: 1605–6 (p. 152); 2000: between 1603–4 and c.1606 (p. 215)
Calvesi 1990: c.1606 (p. 425)
Bologna 1992: first half of 1610 (p. 342)
Marini 2001[1]: Rome 1603 (p. 482)
Spike 2001: c.1608 (p. 208)
Pacelli 2002: end of first Neapolitan period or second Neapolitan period (p. 97)
Puglisi 2003: attributed, c.1606 (p. 405)

5. Madonna of the Rosary, Vienna, Kunsthistorisches Museum

Cinotti 1983: early 1607 (p. 553); 1991: 1607 (p. 217)
Gregori 1985: first Neapolitan period (p. 335); 1994: 1606–7 (p. 152)
Calvesi 1990: October 1606–June 1607 (p. 425)
Bologna 1992: 1605–6 (p. 236)
Spike 2001: September 1606–July 1607 (p. 179)
Marini 2001[1]: Naples 1606–post 6 October 1607 (p. 512), probably the Radolovich altarpiece (p. 509)
Pacelli 2002: Naples post September 1607 (p. 54)
Prohaska 2002: 1603–4
Puglisi 2003: 1606–c.1607 (p. 405)

6. The Seven Works of Mercy
Naples, Pio Monte della Misericordia

Cinotti 1983: late 1606–9 January 1607 (p. 471); 1991: 1606 (p. 216)
Calvesi 1990: October–December 1606 (p. 425)
Bologna 1992: October(?) 1606–9 January 1607 (p. 332)
Gregori 1994: 1606–7 (p. 152)
Spike 2001: 1606 (p. 184)
Marini 2001[1]: Naples 1606–7 before 9 January (p. 509)
Pacelli 2002: October/December 1606–January 1607 (p. 21)
Puglisi 2003: 1606–7 (p. 405)

7. *David with the Head of Goliath
Vienna, Kunsthistorisches Museum

Cinotti 1983: first Neapolitan period 1606–7 (p. 550); 1991: c.1607 (p. 216)
Calvesi 1990: 1607 (p. 425)
Bologna 1992: late 1606–early 1607 (p. 333)
Gregori 1994: 1607 (p. 153)
Spike 2001: c.1607 (p. 197)
Marini 2001[1]: Naples 1607 (p. 529)
Puglisi 2003: attributed, c.1607 (p. 408)
Prohaska in press: Caravaggio?

8. *David and Goliath
London, private collection

Gregori 2000: original, first Neapolitan period (p. 17)
Marini 2001[1]: copy by Baldassarre Alvise, c.1610 (p. 608)

9. The Crucifixion of Saint Andrew
Cleveland, Museum of Art

Cinotti 1983: 1607 (p. 422); 1991: c.1607 (p. 218)
Gregori 1985: second Neapolitan period (p. 349); 1994: 1607 (p. 153)
Calvesi 1990: 1609–10 (p. 427)
Bologna 1992: first half of 1607 (p. 333)
Spike 2001: 1607 (p. 200)
Marini 2001[1]: Naples 1607 before 13 July (p. 533)
Pacelli 2002: January–May 1607 (p. 39)
Puglisi 2003: 1609–c.1610 (p. 410)

10. The Crowning with Thorns
Vienna, Kunsthistorisches Museum

Cinotti 1983: included in attributed works, but favoured as autograph (p. 565); 1991: c.1607 (p. 217)
Gregori 1985: first Neapolitan period (p. 318); 1994: c.1603 (p. 150)
Calvesi 1990: 1601–4 (p. 413)
Bologna 1992: first half of 1607 (p. 334)
Marini 2001[1]: Rome 1599 (p. 429)
Prohaska 2001: Roman period 1602–c.1605 (p. 290)
Spike 2001: c.1604 (p.163)
Pacelli 2002: Naples summer 1607 (p. 59)
Puglisi 2003: attributed, c.1603 (p. 402)

11. *Judith and Holofernes
Naples, Museo Pignatelli, Sanpaolo Banco di Napoli collection

Calvesi 1990: copy, October 1606–June 1607 (p. 425)
Cinotti 1991: copy attributed to Finson from original that has disappeared, 1606–c.1607 (p. 216)
Bologna 1992: copy from original as yet unidentified, first half of 1607 (p. 334)
Gregori 1994: copy, 1607 (p. 152)
Marini 2001[1]: copy by Finson, from original painted in Naples before 25 September 1607, on the basis of Leone de Castris 1984 (p. 517)
Spike 2001: copy from original painted 1606–7 (see CD-Rom)
Pacelli 2002: copy by anonymous Neapolitan, from original painted in first Neapolitan period (p. 54)
Puglisi 2003: copy, 1607 (p. 407)

12. *The Holy Family
with Saint John the Baptist
New York, The Metropolitan
Museum of Art (in deposit from
Otero-Silva Collection, Caracas)

Cinotti 1983: best-known
version of this picture, datable
1600-1, perhaps autograph
(p. 416); 1991: copy, c.1600 (p. 206)
Calvesi 1990: copy, 1606-7 (p. 425)
Bologna 1992: work attributed
but must be discounted (p. 350)
Gregori 1994: original, 1607 (p. 152)
Marini 2001[1]: original, Naples
post 20 August 1607 (p. 518)
Spike 2001: original, c.1605
(p. 160)
Christiansen 2001: original,
c.1604 (p. 36)
Puglisi 2003: c.1607, from lost
original

13a. *Christ at the Column
Macerata, Pinacoteca Civica
13b. * Christ at the Column
Catania, Museo Civico Castello
Ursino
13c. * Christ at the Column
Cantalupo Sabino, Camuccini
collection

Cinotti 1983: a) copy, from
original painted in Naples in
1607 (p. 561); 1991: c) copy?,
c.1607 (p. 218)
Gregori 1985: a, b, c) copies from
original painted in Neapolitan
period (p. 326); 1994: c) copy,
1598-9 (p. 148)
Calvesi 1990: c) copy from
original painted in c.1600 (p. 423)
Bologna 1992: a, b, c) copies,
from unidentified original,
April-May 1607 (p. 336)
Marini 2001[1]: c) original?, Rome
1599 (p. 427); 2001[2]: a) copy, b)
circle of Carlo Saraceni? (p. 128)
Spike 2001: c) among the
attributed works, a) and b) copies
(see CD-Rom)
Puglisi 2003: c) copy?,
1598-c.1599 (p. 199)

14. The Flagellation
Naples, Museo di Capodimonte
(in deposit from church of San
Domenico Maggiore)

Cinotti 1983: 1607 (p. 469);
1991: 1607 (p. 217)
Gregori 1985: 1607 (p. 326);
1994: 1607 (p. 153)
Calvesi 1990: first half of 1607
(p. 425)
Bologna 1992: 11 May-June
1607; September/October
1609-June/July 1610 (p. 336)
Marini 2001[1]: Naples before 11
May 1607 (p. 530)
Spike 2001: 1607 (p. 192)
Pacelli 2002: 1607 (p. 41)
Puglisi 2003: 1607 (p. 406)

15. *Saint Sebastian
Rome, private collection

Cinotti 1983: copy from lost
original painted in first
Neapolitan period (p. 564); 1991:
copy?, 1607 or later (p. 218)
Calvesi 1990: copy, 1607-10
(p. 426)
Bologna 1992: copy from
unidentified original, datable
1609-10 (p. 343)
Gregori 1994: copy, 1607 (p. 153)
Marini 2001[1]: autograph, Naples
1607 (p. 527)
Spike 2001: possibly original
(see CD-Rom)
Pacelli 2002: copy, from original
painted in Naples in 1607 (p. 64)
Puglisi 2003: copy?, c.1607 (p. 406)

16a. *The Flagellation
Rouen, Musée des Beaux Arts
16b. *The Flagellation
Switzerland, private collection

Mahon: a) and b) originals, first
Neapolitan period
Cinotti 1983: a) original, Naples
1607, b) copy (p. 545); 1991:
a) original, c.1607 (p. 218)
Gregori 1985: a) original, b) copy
done in first Neapolitan period
(p. 322); 1994: a) original, 1607
(p. 152)
Calvesi 1990: a) copy, 1606-7
(p. 425)
Bologna 1992: a) autograph not
certain, second Neapolitan
period, b) copy (p. 343)
Marini 2001[1]: a) original, Naples
1607, b) copy by artist of
Neapolitan school, affinities
with Finson (p. 520)
Spike 2001: a) original, c.1607
(p. 196), b) copy (see CD-Rom)

Pacelli 2002: a) original, Naples
no later than 1607, b) copy (p. 61)
Puglisi 2003: a) original c.1607
(p. 406)

17. *Saint Januarius showing
his Relics
Palmer Museum of Art,
Pennsylvania State University,
gift of Mary Jane Harris

Pacelli 1989: Filippo Vitale
(pp. 67 ff.)
Calvesi 1990: copy, 1607 (p. 425)
Bologna 1992: copy from Tanzio
da Varallo (p. 351)
Gregori 1994: copy, 1607 (p. 153)
Marini 2001[1]: copy by Finson
from lost original, Naples 1607
(p. 526)
Spike 2001: copy (see CD-Rom)
Puglisi 2003: copy?, c.1607 (p. 408)

18. Saint Jerome Writing
Valletta, Museum of the Co-
Cathedral

Cinotti 1983: Malta 1607 (p. 445);
1991: c.1607 (p. 220)
Calvesi 1990: July
1607-September 1608 (p. 426)
Bologna 1992: Malta after 13
July 1607 (p. 337)
Gregori 1994: 1608 (p. 153)
Marini 2001[1]: Malta 1608 (p. 541)
Spike 2001: Malta 1607 (p. 206)
Pacelli 2002: Malta July 1607
(p. 52)
Puglisi 2003: 1607-8 (p. 408)

19. The Beheading of Saint
John the Baptist
Valletta, Co-Cathedral

Cinotti 1983: Malta 1608 (p. 445);
1991: 1608 (p. 223)
Calvesi 1990: July
1607-September 1608 (p. 426)
Bologna 1992: before
August-September 1608 (p. 337)
Gregori 1994: 1608 (p. 154)
Marini 2001[1]: Malta before
14 July-before 29 August 1608
(p. 539)
Spike 2001: 1608 (p. 212)
Pacelli 2002: Malta 1608 (p. 76)
Puglisi 2003: 1608 (p. 408)

20. *Portrait of Alof de
Wignacourt with a Page
Paris, Musée du Louvre

Cinotti 1983: Malta 1607-8
(p. 488); 1991: c.1608 (p. 220)
Gregori 1985: 1608 (p. 330);
1994: c.1608 (p. 153)
Calvesi 1990: July
1607-September 1608 (p. 426)
Bologna 1992: original as yet
unidentified, after July
1607-before September 1608
(p. 337)
Marini 2001[1]: Malta c.1608
(p. 537)
Spike 2001: 1607 (p. 206)
Pacelli 2002: Malta 1608 (p. 69)
Puglisi 2003: 1607-8 (p. 408)

21. *Portrait of Alof
de Wignacourt, Grand Master
of the Knights of Malta
Rabat, Wignacourt College
Museum

Cinotti 1983: included in
attributed works but cannot be
ascribed to Caravaggio (p. 562);
1991: included in attributed
works (p. 230)
Marini 2001[1]: copy from
unknown original, painted in
Malta 1607 (p. 536)

22. Sleeping Cupid
Florence, Galleria Palatina

Cinotti 1983: last work done in
Malta (p. 433); 1991: 1608 (p. 223)
Calvesi 1990: 1608 (p. 426)
Bologna 1992: second half of 1608
(p. 338)
Gregori 1994: 1608-9 (p. 154)
Marini 2001[1]: Malta 1608 (p. 542)
Spike 2001: 1608 (p. 208)
Pacelli 2002: Malta 1608 (p. 78)
Puglisi 2003: 1608 (p. 409)

23. *Portrait of a Knight
of Malta (Fra Antonio Martelli?)
Florence, Galleria Palatina

Cinotti 1983: original, subject
unidentified (p. 435); 1991: Alof
de Wignacourt?, 1608 (p. 223)
Gregori 1985: end of stay in
Malta, Wignacourt? (p. 334);
1994: 1608-9 (p. 154); 1999:
Malta between July 1607 and
April 1608, Marc'Antonio
Martelli, on the basis of Chiarini
1989 and Gash 1997 (p. 209)
Calvesi 1990: 1608-10 (p. 426)
Bologna 1992: work attributed
but to be discounted; identified

with Niccolò Caracciolo di San
Vito (p. 351)
Marini 2001[1]: Malta prior to 1608,
Alof de Wignacourt (p. 545)
Spike 2001: c.1608, Antonio
Martelli
Pacelli 2002: not autograph (p. 83)
Puglisi 2003: c.1608 (p. 409)

24. *Saint John the Baptist
at the Spring
Malta, Bonello collection

Cinotti 1983: among attributed
works (p. 560); 1991: copy?,
c.1608 (p. 223)
Calvesi 1990: copy?, July
1607-September 1608 (p. 426)
Bologna 1992: autograph,
May-June 1610 (p. 345)
Gregori 1993: copy (p. 6)
Marini 2001[1]: Malta 1608 (p. 544)
Spike 2001: copy (see CD-Rom)

25. *Saint John the Baptist
at the Spring
Rome, private collection

Gregori 1994: original, 1608-9
(p. 154)
Marini 2001[1]: copy (p. 545)
Spike 2001: original, Malta
c.1608 (see CD-Rom)
Puglisi 2003: attributed, 1608-9
(p. 409)

26. The Burial of Saint Lucy
Syracuse, Palazzo Bellomo
(in deposit from church of Santa
Lucia)

Cinotti 1983: prior to December
1608 (p. 547); 1991: c.1608
(p. 225)
Calvesi 1990: October-November
1608 (p. 426)
Bologna 1992:
October-December 1608
Gregori 1994: 1608-9 (p. 154)
Marini 2001[1]: Syracuse after 6
October 1608 (p. 547)
Spike 2001: October-December
1608 (p. 214)
Pacelli 2002: no later than
December 1608 (p. 85)
Puglisi 2003: 1608 (p. 409)

27. The Raising of Lazarus
Messina, Museo Regionale

Cinotti 1983: after 6 December 1608–before 10 June 1609 (p. 459); 1991: 1609 (p. 225)
Calvesi 1990: December 1608–May 1609 (p. 426)
Bologna1992: 6 December 1608–10 June 1609 (p. 338)
Gregori 1994: 1608–9 (p. 154)
Marini 2001[1]: 6 December 1608–before 10 June 1609 (p. 549)
Spike 2001: 1608–9 (p. 218)
Pacelli 2002: no later than June 1609 (p. 90)
Puglisi 2003: 1608–9 (p. 409)

28. The Adoration of the Shepherds
Messina, Museo Regionale

Cinotti 1983: 1609 (p. 458); 1991: c.1609 (p. 225)
Calvesi 1990: November 1608–first half of 1609 (p. 426)
Bologna1992: first half of 1609 (p. 339)
Gregori 1994: 1609 (p. 154)
Marini 2001[1]: Messina 1609 (p. 552)
Spike 2001: 1609 (p. 226)
Pacelli 2002: 1609 (p. 88)
Puglisi 2003: 1608–9 (p.409)

29. The Nativity with Saints Francis and Lawrence
Formerly Palermo, Oratorio della Compagnia di San Lorenzo

Cinotti 1983: summer 1609 (p. 481); 1991: 1609 (p. 225)
Calvesi 1990: 1609 (p. 427)
Bologna 1992: third quarter of 1609 (p. 340)
Gregori 1994: 1609 (p. 155)
Marini 2001[1]: Palermo before 20 October 1609 (p. 560)
Spike 2001: 1609 (p. 230)
Pacelli 2002: summer 1609 (p.92)
Puglisi 2003: 1609 (p. 410)

30. *The Tooth-Puller
Florence, Galleria Palatina

Cinotti 1983: included in attributed works, but believed to be by an imitator of Caravaggio in his final Roman phase (p. 559); 1991: included in attributed works, 1609–10 (p. 230)
Christiansen 1986: original (p. 434)
Gregori 1985: Maltese-Sicilian period or final Neapolitan period (p. 342); 1994: autograph status

reconfirmed, 1608–9 (p. 154)
Calvesi 1990: possible original completed by another hand, 1608–9 (p. 426)
Bologna 1992: attributed but to be discounted (p. 352)
Spike 2001: among the attributed works (p. 254)
Marini 2001[1]: work of Sicilian workshop of Alonzo Rodriguez (p. 573)
Puglisi 2003: attributed, 1608–10 (p. 410)

31. *The Vision of Saint Jerome
Worcester, Museum of Fine Arts

Cinotti 1983: included in attributed works (p. 566); 1991: included in attributed works, 1609 (p. 230)
Marini 2001[1]: Messina 1609 (p. 555)
Spike 2001: among attributed works (see CD-Rom)

32a. *Ecce Homo
New York, Cortez collection
32b. *Ecce Homo
Arenzano, santuario del Bambino Gesù di Praga
32c. *Ecce Homo
Private collection

Papi 1990: b) original, Sicilian-Neapolitan period
Gregori 1994: a) copy, c.1609 (p. 155); 2004: c) presented here as original from the final Sicilian-Neapolitan period
Marini 2001[1]: a) original, Messina before 9 August 1609 (p. 558); b) copy by Sicilian artist
Spike 2001: a) and b) among attributed works (p. 254)
Puglisi 2003: a) copy?, 1609 (p. 410)

33. Salome with the Head of Saint John the Baptist
Madrid, Palacio Real

Cinotti 1983: second Neapolitan period (p. 456); 1991: 1609–c.1610 (p. 227)
Gregori 1985: first Neapolitan period (p. 335); 1994: c.1609 (p. 155)
Calvesi 1990: 1609–10 (p. 426)
Bologna 1992: last two months of 1609 (p. 341)
Milicua 1999–2000: first Neapolitan period or Maltese period (p. 141)
Marini 2001[1]: Messina 1609 (p. 553)

Spike 2001: 1608–10 (p. 221)
Pacelli 2002: Naples 1609–10 (p. 97)
Puglisi 2003: 1609–c.1610 (p. 410)

34. *Salome with the Head of Saint John the Baptist
Rome, private collection

Bologna 1992: original, October 1609 (p. 340)
Marini 2001[1]: Battistello Caracciolo (p. 326)
Spike 2001: Caracciolo? (see CD-Rom)

35. Salome receives the Head of Saint John the Baptist
London, National Gallery

Cinotti 1983: Naples 1607 (p. 453); 1991: c.1607 (p. 220)
Gregori 1985: second Neapolitan period (p. 336); 1994: 1607 (p. 153)
Calvesi 1990: 1608–10 (p. 426)
Bologna 1992: second Neapolitan period (p. 343)
Milicua 1999–2000: second Neapolitan period (p. 138)
Marini 2001[1]: Naples 1607 (p. 524)
Spike 2001: c.1608 (p. 221)
Pacelli 2002: Naples between September 1607 and April 1608 (p. 64)
Puglisi 2003: 1609–c.1610 (p. 410)

36. The Annunciation
Nancy, Musée des Beaux-Arts

Cinotti 1983: 1609–10 (p. 468); 1991: 1609–c.1610 (p. 227)
Calvesi 1990: 1608–9 (p. 426)
Bologna1992: 1609–10 (p. 345)
Gregori 1994: c.1609 (p. 155)
Marini 2001[1]: Messina 1609 (p. 557)
Spike 2001: 1608–10 (p. 189)
Pacelli 2002: Malta July 1608, or Naples December 1609 (p. 82)
Puglisi 2003: 1609–c.1610 (p. 410)

37. *Saint Januarius Beheaded
Rome, Galleria Nazionale Arte Antica (in deposit from Palestrina, church of Sant'Antonio Abate)

Cinotti 1983: included in attributed works (p. 562); 1991: included in attributed works, 1607 or 1609 (p. 230)
Gregori 1985: copy from lost original (p. 314)
Calvesi 1990: original, 1606–9 identified with Sant'Agapito, patron saint of Palestrina (p. 425)
Bologna1992: attributed but to be discounted (p. 351)
Marini 2001[1]: original, Naples after 20 October 1609 (p. 565)
Spike 2001: Neapolitan follower of Caravaggio, c.1610 (see CD-Rom)

38. David with the Head of Goliath
Rome, Galleria Borghese

Cinotti 1983: Naples 1609–10 (p. 503); 1991: 1609–10 or 1610 (p. 227)
Gregori 1985: late work (p. 338); 1994: 1605–6 or 1610 (p. 155)
Calvesi 1990: 1609–10 (p. 427); 1999–2000: last Neapolitan period (p. 14)
Bologna 1992: May–June 1610 (p. 345)
Marini 2001[1]: Naples, 1609–10, before 11 May (p. 566)
Spike 2001: 1610 (p. 239)
Pacelli 2002: 1610 (p. 157)
Puglisi 2003: 1610 (p. 411)

39. The Denial of Saint Peter
New York, The Metropolitan Museum of Art

Cinotti 1983: second Neapolitan period (p. 549); 1991: 1609–c.1610 (p. 227)
Gregori 1985: final Neapolitan period (p. 350); 1994: 1609–10 (p. 155)
Calvesi 1990: 1609–10 (p. 427)
Bologna 1992: first half of 1610 (p. 344)
Marini 2001[1]: Naples 1607 (p. 522)
Spike 2001: 1607/10 (p. 233)
Pacelli 2002: 1610 (p. 99)
Puglisi 2003: 1609–c.1610 (p. 411)

40. The Martyrdom of Saint Ursula
Naples, Palazzo Zevallos, Banca Intesa collection

Cinotti 1983: 1610 (p. 474); 1991: 1610 (p. 227)
Gregori 1985: final Neapolitan period (p. 352); 1994: 1610 (p. 155)
Calvesi 1990: 1610 (p. 427)
Bologna 1992: no later than 11–27 May 1610 (p. 344)
Marini 2001[1]: Naples before 11 May 1610 (p. 570)
Spike 2001: April–May 1610 (p. 236)
Pacelli 2002: 1610 (p. 100)
Puglisi 2003: 1610 (p. 411)

41. *Saint John the Baptist reclining
Munich, private collection

Bologna 1992: copy from lost original painted for Sant'Anna dei Lombardi (p. 342)
Marini 2001[1]: original, Naples before 18 July 1610 (p. 574)
Spike 2001: original, 1610 (p. 235)
Pacelli 2002: original, last months in Naples (p. 142)

42. Saint John the Baptist
Rome, Galleria Borghese

Cinotti 1983: 1610 (p. 502); 1991: 1609–c.1610 (p. 277)
Calvesi 1990: 1609–10 (p. 427)
Bologna 1992: second quarter of 1610 (p. 344)
Gregori 1994: 1609–10 (p. 155)
Marini 2001[1]: Naples before 11 May 1610 (p. 569)
Spike 2001: 1609–10 (p. 234)
Pacelli 2002: 1610 (p. 251)
Puglisi 2003: 1610 (p. 411)

43. *Saint John the Baptist at the Spring with a Lamb
London, private collection

Marini 2001[1]: Battistello Caracciolo, 1612–c.1613 (p. 362)
Spike 2001: possibly late autograph (see CD-Rom)
Peretti 2004: presented here as original, 1610

182 Unknown painter of the 17th century, *Portrait of Michelangelo Merisi da Caravaggio*. Private collection

Documentary and bibliographical sources
Edited by
Antonio Ernesto Denunzio

The list of documents and sources refers only to the seventeenth century and to the final years of Caravaggio's activity, when he lived in Naples, Malta and Sicily. In the strictly documentary part, only those sources which can be linked with virtual certainty to the artist's works and personal affairs have been included. For the inventorial sources it was deemed more useful to indicate the bibliographical reference. Grateful thanks go to Antonella Lippo and Mercedes Simal López for their collaboration. Abbreviations: AAS, Archivio di Stato di Amsterdam; AIM, Archivio dell'Inquisitore di Malta, Mdina; AHN, Archivo Histórico Nacional; AOM, Archivio dell'Ordine di Malta, La Valletta; APMM, Archivio del Pio Monte della Misericordia; ASBN, Archivio Storico del Banco di Napoli; ASMn, Archivio di Stato di Mantova; ASMo, Archivio di Stato di Modena; ASMs, Archivio di Stato di Messina; ASN, Archivio di Stato di Napoli; ASV, Archivio Segreto Vaticano; BAV, Biblioteca Apostolica Vaticana; BNN, Biblioteca Nazionale di Napoli Vittorio Emanuele III.

Documentary sources

1606, 6 October
ASBN, Banco di Sant'Eligio, Giornale copiapolizze, matr. 31. Commission from Nicolò Radolovich for an altarpiece to be delivered in the month of December with the *Madonna and Child between Saints Dominic, Francis, Nicholas and Vitus*, (for complete transcription of the documents and relative bibliography, where not otherwise indicated, the reader is referred to S. Macioce, *Michelangelo Merisi da Caravaggio. Fonti e documenti 1532–1724*, Rome 2003).

1606, 25 October
ASBN, Banco di Sant'Eligio, Giornale copiapolizze, matr. 31. Caravaggio withdraws 150 *ducati* from the Banco di Sant'Eligio, where he had previously deposited the money received from Radolovich. Payment was made by means of an order to be cashed at the Banco del Popolo.

1606, 25 October
ASBN, Banco di Santa Maria del Popolo, vol. di bancali del 25 October 1606. Caravaggio cashes the order issued the same day by the Banco di Sant'Eligio.

1607, 9 January and 20 February
ASN, Pio Monte della Misericordia, Libro Maggiore, 1605–1618, 185, c. 171. Sums earmarked by the Banco del Pio Monte della Misericordia for 'una cona per la detta chiesa'.

1607, 9 January
ASBN, Banco della Pietà, Giornale copiapolizze, matr. 3, c. 25.
ASBN, Banco di Santa Maria del Popolo, vol. di bancali del 9 gennaio 1607.
ASBN, Banco di Santa Maria del Popolo, giornale copiapolizze, matr. 59, c. 66. Payments for the *Seven Works of Mercy*.

1607, 11 May
ASBN, Banco dello Spirito Santo, Giornale copiapolizze, matr. 44. Payment to Caravaggio of 100 *ducati* on behalf of Tommaso de Franchis, which presumably refers, like the document of 28 May 1607, to the *Flagellation* for the church of San Domenico Maggiore.

1607, 28 May
ASBN, Banco di Sant'Eligio, Libro maggiore dei creditori, vol. 1, matr. 17, c. 2032. Further payment of 40,09 *ducati* on behalf of Tommaso de Franchis.

1607, 3 July
ASMn, Archivio Gonzaga, b. 824. Letter from Ottavio Gentili to the Duke of Mantua informing him of the writer's intention of asking Caravaggio for help – although in all likelihood he had already left for Malta – in evaluating the Prince of Conca's picture collection (I.M. Iasiello, *Vincenzo I e il Regno di Napoli*, in R. Morselli, ed., *Gonzaga. La Celeste Galleria. L'esercizio del collezionismo*, Milan 2002, pp. 357–62, esp. p. 361).

1607, 22 and 26 July
AIM, Processi, vol. 28A, cc. 295r, 295v, 297r, n. 83. Evidence given to the Inquisitor of Malta showing that Caravaggio was on the island from at least 13 July 1607.

1607, 20 August
ASMo, Cancelleria Ducale Estense, Ambasciatori, Roma. Fabio Masetti, ambassador of the Duke of Modena Cesare d'Este, reports that in Rome 'si tratta la pace per il Caravaggio' so that he can return to the city.

1607, 15 September
ASMn, Archivio Gonzaga, Napoli, b.824. Letter from the Duke's agent Ottavio Gentili usually associated with the sale in Naples of the *Madonna of the Rosary*.

1607, 25 September
AAMn, Archivio Gonzaga, Autografi, b. 7, cc. 212–213. Letter from Frans Pourbus to Vincenzo Gonzaga concerning the sale in Naples of two works of Caravaggio, the *Madonna of the Rosary* and a *Judith*.

1607, 29 December
AOM, Arch., vol. 1386, Lettere di Alof de Wignacourt, 1607, cc. 232v–324r-v. Letters of the Grand Master dealing with negotiations for admittance into the Order of an unspecified person, whom scholars identify as Caravaggio.

1608, 7 February
ASV, Secr.Brevium, 428, cc. 365, 366. Request from Alof de Wignacourt for a papal brief authorising the admission into the Order of Malta of two unspecified persons. One of them, guilty of murder, is generally identified as Caravaggio.

1608, 15 February
ASV, Secr. Brevium, 428, cc. 364, 367. Brief of Paul V for the admission into the Order of Malta of two persons never actually named.

1608, 14 July
AOM, Liber Bullarum, Gran Maestro Alof de Wignacourt, 1607–1609, vol. 456, c. 282. Edict of the Grand Master providing for Caravaggio to be created a Knight of the Order of Malta.

1608, 27 August
AOM, Arch., 103, Liber Conciliorum, 1608–1610, c. 9r. Document relating to the causes of Caravaggio's imprisonment in Malta.

1608, 6 October
AOM, Liber Conciliorum, vol. 103, c. 13v. The Grand Master Alof de Wignacourt and the Council of the Order give orders to apprehend Caravaggio, who has escaped from prison in Malta.

1608, 20 November
AOM, Liber Conciliorum, vol. 103, cc. 32v–33. Sentence for Caravaggio to be expelled from the Order of Malta.

1608, 27 November
AOM, Liber Conciliorum, vol. 103, 1608–1610, c. 32v. Decree of the Grand Council of the Order of Malta stripping Caravaggio of his knight's habit.

1608, 1 December
AOM, Liber Conciliorum, vol.103, cc. 33v–34r. Expulsion of Caravaggio from the Order of Malta.

1609, 10 June
ASMs, Notaio Giuseppe Plutino, 6 dic. 7°, ind. 1608 (documento distrutto). Consignment to the Padri Crociferi in Messina by Giovan Battista de' Lazzari of the *Raising of Lazarus* by Caravaggio.

1609 (in reality 1610), 18 July
Porto Ercole, Parrocchia di Sant'Erasmo, registro dei morti. News of the death of Caravaggio at Porto Ercole.

1609, before August
Messina, Archivio privato della baronessa Flavia Arau di Giampaolo. Commission given to Caravaggio by Niccolò di

Giacomo for four *Passion Scenes*, one of which, *Christ carrying the Cross*, is stated to have been delivered and paid for.

1609, 24 October
BAV, Urb.Lat., 1077, c. 529r. Notice sent from Rome to the court of Urbino concerning the presumed death of Caravaggio in Naples.

1610
Savignano sul Rubicone, Biblioteca della Rubiconiana Accademia dei Filopatridi, ms. 59. Poem by Marzio Milesi on the death of Caravaggio.

1610, 11 May
ASN, Archivi Privati, Archivio Doria d'Angri, parte II, b. 290. Letter from Lanfranco Massa, agent for Marcantonio Doria in Naples, concerning *The Martyrdom of Saint Ursula*.

1610, 27 May
ASN, Archivi Privati, Archivio Doria d'Angri, parte II, b. 293, c. 3. Letter from Lanfranco Massa and bill of freight concerning despatch to Genoa of *The Martyrdom of Saint Ursula*.

1610, 18 July
BAV, Vat. Lat., 7927, Inscriptiones et Elogia di Marzio Milesi, c. 133r. Epitaphs composed on the death of Caravaggio by Marzio Milesi.

1610, 28 and 31 July
BAV, Urb. Lat., 1078, cc. 537r e 562r. News sent to the court of Urbino concerning the death at Porto Ercole of Caravaggio.

1610, 29 July
ASV, Segreteria di Stato, Napoli, 20A, cc. 222r–v. First of a series of five letters sent by the papal nuncio in the Kingdom of Naples, Deodato Gentile, to Cardinal Scipione Borghese concerning the circumstances of Caravaggio's death and the disputed ownership of some of his last works. See also subsequent documents dated 31 July, 9 August, 10 December, also in ASV.

1610, 31 July
ASV, Segreteria di Stato, Napoli, 20A, c. 226r. See annotation to previous document.

1610, 19 August
ASN, Lettere dei viceré a diverse autorità, reg. 2172, c. 115 (documento distrutto). Letter containing a claim to the property of Caravaggio which remained at Porto Ercole, presumably from the Viceroy of Naples, Count of Lemos.

1610, 5 November
ASBN, Banco dello Spirito Santo, Giornale copiapolizze, 5 novembre 1610. Payment to the painter Baldassarre Alvise for two copies of a *David* by Caravaggio.

1610, 10 December
ASV, Segreteria di Stato, Napoli, 20A, cc. 404r–v. See document dated 29 July 1610.

1611, 19 August
ASV, Segreteria di Stato, Napoli, 20B, cc. 352r–v. See document dated 29 July 1610.

1611, 26 August
ASV, Segreteria di Stato, Napoli, 20B, c. 367r. See document dated 29 July 1610.

1612, 26 December
ASN, Monasteri soppressi, vol. 1008, c. 180v. Decision by the Dominican friars of Santa Maria della Sanità in Naples to have completed a painting of the *Circumcision* begun, according to a later annotation in a different hand, by Caravaggio.

1613, 27 August
APMM, Libro delle conclusioni particolari fatte dalli Signori Governatori del Monte della Misericordia, 1° settembre 1603–21 maggio 1624, c. 42v. The Governors of the Pio Monte, expressing full satisfaction for the quality of the *Seven Works of Mercy*, decide to declare the picture inalienable.

1613, 27 August
APMM, Libro delle conclusioni particolari fatte dalli Signori Governatori del Monte della Misericordia, 1° settembre 1603–21 maggio 1624, c. 57. The Governors approve the Count of Villamediana's request to have a copy made of the *Seven Works of Mercy*.

1613, 27 August
APMM, Libro delle conclusioni particolari fatte dalli Signori Governatori del Monte della Misericordia, 1° settembre 1603–21 maggio 1624, seduta del 27 agosto 1613. The Governors of the Pio Monte decree the inalienability of the *Seven Works of Mercy*.

1617, 19 September
AAS, Fondi Notarili, Notaio P. Ruttens. Testament of the Flemish painter Louis Finson in which the *Madonna of the Rosary* and a *Judith* by Caravaggio are mentioned.

1621, 1 June
APMM, concl.A.F. 63, n. di seduta 295. The Governors of the Pio Monte, reversing a previous decision in favour of the Count of Villamediana, decree that the *Seven Works of Mercy* is never to be copied.

1630, 27 February
AAS, Fondi Notarili, Notaio W.Cluijt, n. 25. Document referring to the sale in Amsterdam of a copy of the *Madonna of the Rosary* painted by Louis Finson.

1651
Archivio del convento dei domenicani presso la chiesa di San Paolo ad Anversa. The *Madonna of the Rosary*, acquired by a group of artists, including Rubens, is hung in the church of the Dominicans in Antwerp.

1651, 15 October
ASN, Archivi Privati, Archivio Doria d'Angri, parte I, notaio Battista Borrone, b. 222, c. 132r. Testament of Marcantonio Doria in which *The Martyrdom of Saint Ursula* is specified as part of the legacy to his eldest son Nicolò.

Post 1652
BNN, Sezione manoscritti, Fondo nazionale, XB 21, c. 368. Description of the *Flagellation* in San Domenico Maggiore contained in an addition to the 'Parte seconda o' vero supplimento a Napoli Sacra di Cesare d'Engenio Caracciolo' by Carlo de Lellis.

1658
AHN, Nobleza, Osuna, leg. 434–3/18, 'Quenta de los mrs que entraron en poder de Rafael Albarez Agte del conde mi sr de Benavte en Valld desde prim° de julio de 654 asta fin de 658'. Restoration of the *Crucifixion of Saint Andrew* at Valladolid (M. Simal López, *Los condes-duques de Benavente en el siglo XVII. Patronos y coleccionistas en su villa solariega*, Benavente 2002, p. 64, note 239).

1688, 25 January
ASN, Monasteri soppressi, San Domenico Maggiore, vol. 598, cc. 615–618. Copy of the notarial act dated 1675 formalising the intention of replacing the *Flagellation* in the de Franchis chapel with a statue of the Madonna of the Rosary.

Bibliographic sources

1613
V. Mirabella, *Dichiarazioni della pianta dell'antiche Siracuse, e d'alcune scelte medaglie d'esse, e de' principi che quelle possedettero descritte da don Vincenzo Mirabella e Alagona cavalier siracusan*, Naples.

1619–c.1620
G. Mancini, *Considerazioni sulla pittura*, I ed. Rome 1956–7.

1620
G.B. Marino, *La galeria del cavalier Marino, distinta in pitture, et sculture*, Milan.

1623
D.C. D'Engenio, *Napoli sacra di d.Cesare D'Engenio, napolitano. Ove oltre le vere origini, e fundationi di tutte le Chiese, Monasterij, Spedali, & altri luoghi sacri della città di Napoli, e suoi Borghi si tratta di tutti li corpi, e Reliquie di Santi ...*, Naples.

1629
J. Baudoin, G. Bosio, P. De Boissat, *Histoire des chevaliers de l'Ordre de S.Jean de Jérusalem contenant leur admirable constitution et police... ci-devant écrite par le feu S.D.B.S.D.L. (de Boissat, sr de Licieu, traduit de G.Bosio), et en cette dernière éditio...*, Paris.

1630
G.C. Capaccio, *Il Forastiero: Dialogi di Giulio Cesare Capaccio Academico Otioso...*, Naples.

1634
F. De Petri, *Dell'historia napoletana scritta dal signor Francesco de' Pietri libri due...*, Naples.

1642
G. Baglione, *Le vite de' pittori scultori et architetti, Dal pontificato di Gregorio XIII del 1572 in fino a' tempi di Papa Urbano Ottauo nel 1642...*, Rome.

1644
P. Samperi, *Iconologia della gloriosa Vergine Madre di Dio Maria protettrice di Messina*, Messina.

1649
F. Pacheco, *Arte de la pintura, su antiguedad y grandezas: descriuense los hombres eminentes que ha auido...*, Seville.

1654
C. de Lellis, *Parte seconda o' vero supplimento a Napoli Sacra di D. Cesare d'Engenio Caracciolo...*, Naples.
1672
G.P. Bellori, *Le Vite de' Pittori, Scultori et Architetti moderni*, Rome.
1674
L. Scaramuccia, *Le finezze de' pennelli italiani ammirate e studiate da Girupeno sotto la scorta di Raffaello d'Urbino*, Pavia.
1675
J. von Sandrart, *Der Teutschen Accademie der Bau-Bil und Mahlerey-Künste*, Nuremberg.
1685
P. Sarnelli, *Guida dè forestieri, curiosi di vedere, e d'intendere le cose più notabili della regal città di Napoli e del suo amenissimo distretto...*, Naples.
1688
A. Félibien, *Entretiens sur les vies et sur les ouvrages des plus excellens peintres anciens et modernes*, Paris.
1692
C. Celano, *Notitie del bello, dell'antico, e del curioso della città di Napoli, per i signori forastieri...*, Naples.

Inventories

1611 *'Pinturas grandes' nella fortezza di Benavente*
Otro *(scil. quadro)* ques San Genaro obispo origl de Carabajo y guon de perú
Otro ques q.° los pies lavo nro Sor a sus discipulos origl de Carabayo (M.Simal López, *Los condes-duques de Benavente en el siglo XVII. Patronos y coleccionistas en su villa solariega*, cit., pp. 189–93, nn. 13, 36, 164, also for previous bibliography. In the same inventory another picture is referred to, 'ques San Andrés original en lienço i cornisa de hébano', which cannot be identified for certain with Caravaggio's *Crucifixion of Saint Andrew*. According to Simal López the picture was also kept at Valladolid, in the family residence, of which no inventories are known from this period).

1620 *Marcantonio Doria*
Sant'Orsola confitta dal tiranno del Caravaggio (V. Pacelli-F. Bologna, 'Caravaggio 1610: la "Sant'Orsola confitta dal tiranno" per Marcantonio Doria', in *Prospettiva*, XXIII, 1980, pp. 24–45, esp. p. 44).
1631 *Juan de Lescano*
Un ecce homo con pilato que lo maestra al pueblo, y un sazon que le viste de detras la veste porpureas quadro grande original del caravaio y esta pintura es estimada en mas de 800 D (G. Labrot, *Collections of Paintings in Naples 1600–1780. Documents for the history of collecting*, New York–Paris 1992, p. 57, n. 21).
1648 *Giovanni Francesco Salernitano, Barone di Frosolone*
Lo David di Caravaggio D 50.0.00 (G. Labrot, *Collections of Paintings in Naples 1600–1780*, cit., p. 80, n. 7)
Un Jona mezza figura di Caravaggio D 30.0.00 (ivi, p. 80, n. 39).
1651 *Ferrante Spinelli di Tarsia*
Dipinto di Caravaggio di soggetto ignoto (M. Marini, *Caravaggio 'pictor praestantissimus'*, Rome 2001, p. 586).
Undated, probably 1653 *Dipinti del X conte-duca di Benavente nel palazzo di Valladolid*
El martirio de s. Andrés o s. Felipe quadro grande de mano de Micael Anguel Carauachio (M. Simal López, *Los condes-duques de Benavente en el siglo XVII. Patronos y coleccionistas en su villa solariega*, cit., pp. 235–6).
1653 *Beni inclusi nel 'mayorazgo' del X conte-duca di Benavente, don Juan Alfonso Pimentel, nel palazzo di Valladolid.*
Galería baja, San Andrés Conde 16Q500 (M. Simal López, *Los condes-duques de Benavente en el siglo XVII. Patronos y coleccionistas en su villa solariega*, p. 231, n. 33. The legal institution of *'mayorazgo'*, abolished in Spain in 1820, sanctioned the inalienability of the part of a patrimony acquired by inheritance).
1653 *Palazzo di Valladolid*
Un lienço muy grande de pintura de San Andrés desnudo quando le estan poniendo en la cruz con

tres sayones y una muger con moldura de ebano todo lo tasaron en mill y quinientos ducados [...] es de Micael Angel Carabacho orixinal
otro lienço de un santo obispo la cabeza degollada con moldura negra de pino original de Carabacho todo ello en mill reales (E. García Chico, 'El palacio de los Benavente', in *Boletín de la Real Academia de Bellas Artes de la Purísima Concepción de Valladolid*, XVIII, 1946, p. 20).
1654 *Ferrante Spinelli, Principe di Tarsia*
Un altro dell'jstessa figura di Caravaggio quadro *(scil. Una testa di Gioseppe)*, (G. Labrot, *Collections of Paintings in Naples 1600–1780*, cit., p. 95, n. 67).
1676 *Pompeo d'Anna*
Un quadro di frutti e fiori de Caravaggio con cornice jndorata (G.Labrot, *Collections of Paintings in Naples 1600–1780*, cit., p. 131, n. 48).
1685 *Ascanio Filomarino, Duca della Torre*
Un altro dell'istessa misura *(scil palmi 3 e 4)* coll'istessa cornice *(scil. cornice liscia intagliata d'oro)* coll'istoria di S. Francesco col compagno del pittore Caravaggio (G. Labrot, *Collections of Paintings in Naples 1600–1780*, cit., p. 161, n. 14. See also R. Ruotolo, 'Aspetti del collezionismo napoletano: il cardinale Filomarino', in *Antologia di belle Arti*, 1 March 1976, pp. 71–82, esp. p. 80).
1688 *Eredità del Marchese Ferdinando Vandeneynden*
Un altro *(scil. quadro)* di pal. 8 e 10 in circa con cornice indorata consistente la Flagellatione di Nostro Signore alla colonna mano di Michel'Angelo Caravaggio
Un altro di p. 8 e 10 con cornice indorata la presa di Nostro Signore nell'orto mezza figura mano di Michel'Angelo Caravaggi
Un altro di p. 8 e 10 con cornice indorata consistente l'Incoronazione di spine di N.S. mezze figure al naturale mano di Michel'Angelo Caravaggio (R. Ruotolo, *Mercanti-collezionisti fiamminghi a Napoli. Gaspare Roomer e i Vandeneynden*, Massa Lubrense 1982, pp. 14, 27, 31, 36).
1699 *Carlo de Cardenas, Conte di Acerra e Marchese di Laino*

Due quadri di palmi 4 e 3 con cornisce liscia indorata che in uno S. Giovanni Battista copia del Caravaggio, e nell'altro S. Maria Maddalena. Originale del Caravaggio (G. Labrot, *Collections of Paintings in Naples 1600–1780*, cit., p. 208, n. 136)
Un quadro di palmi 6 e 5 con cornice liscia ordinaria entrovi la flagellatione di Nostro Signore del Caravaggi (ivi, p. 209, n. 57).
Un quadro di palmi 4 e 3 con cornice nera ordinaria entrovi S. Pietro che trova la Moneta nel pesce per pagare il tributo del Caravaggio (ivi, p. 209, n. 59).
Copies from Caravaggio were present in the collections of Juan de Lescano (1631, *San Francesco in orazione*) and Gaspare San Giovanni Toffetti (1651, *Cristo coronato di spine con figure*) (G. Labrot, *Collections of Paintings in Naples 1600–1780*, cit., p. 57, n. 42, and p. 87, n. 29).

Works mentioned as paintings by Caravaggio in old texts or documents

Apparizione dell'angelo ai pastori (*Appearance of the Angel to the Shepherds*), mentioned in an inventory of the church of the Girolamini dated 1626, recorded in the chapel of the Santissima Natività. In the same church, in the chapel dedicated to Sant'Agnese Vergine e Martire, mention is made of another unspecified picture by Caravaggio, 'fatto a spese della Signora Belluccia Coccia' (for a detailed account of all the pictures and relative bibliography see M. Marini, *Caravaggio 'pictor praestantissimus'*, cit., pp. 581–7).
San Giovanni Battista (*Saint John the Baptist*), recorded by G.C. Capaccio (1630) in the house of Don Onofrio Carmignano.
Nozze di santa Caterina (*The Marriage of Saint Catherine*), recorded again by Capaccio in the house of Giovanni Simone Moccia.
Ritratto di un giovine con un fiore di melarancio in mano (*Portrait of a youth holding a pomegranate flower*), mentioned by G.P. Bellori (1672) as

belonging to Juan de Tasis y Peralta, second Count of Villamediana, resident in Naples from 1611 to 1614.
'Istoria di s. Gio: Batt.a che riceve la Benedizione dal P.re con grandi figure dal naturale mano di Michel'Angelo da Caravaggio alto p.mi 8 e largo 101/2', painting of *Saint John the Baptist being blessed* present in 1664 in the Serra di Cassano collection, subsequently perhaps taken to Spain.
San Girolamo con un teschio nella meditazione della morte (*Saint Jerome with Skull meditating on Death*), mentioned by G.P. Bellori in Palazzo Magistrale at Valletta.
Maddalena (*Magdalene*), recorded by Bellori in the Cappella degli Italiani in San Giovanni dei Cavalieri in Malta.
San Girolamo che stà scrivendo sopra il libro (*Saint Jerome writing in a book*), painted according to G.P. Bellori for the Padri Cappuccini of the church of Santa Maria la Concezione in Messina.
San Girolamo in meditazione (*Saint Jerome in meditation*), mentioned by F.Susinno as belonging to Count Adonnino.
Cristo Portacroce (*Christ carrying the Cross*), one of the four *Passion Scenes* painted for the Messinese gentleman Niccolò di Giacomo.
Resurrezione di Cristo, San Francesco riceve le stimmate, San Giovanni Battista, (*Resurrection of Christ, Saint Francis receiving the Stigmata, Saint John the Baptist*), works documented as being done by Caravaggio for the church of Sant'Anna dei Lombardi in Naples.

Bibliography
*Edited by
Ornella Agrillo*

186

Archive Sources

Abbreviations
ABF = Archivio Buonarroti,
Fondazione Casa Buonarroti,
Florence
ASF = Archivio di Stato, Florence

ABF, Filza 104, *Lettere di fra
Francesco Buonarroti a
Michelangiolo suo fratello
1589-1610.*
ABF, Filza 46, *Lettere a
Michelangelo il Giovane.*
ASF, Notarile Moderno 16758,
Noveri Calici, *Testamenti
1666-74.*
ASF, Carteggio d'Artisti 12,
*Lettere artistiche di Annibale
Ranuzzi 1656-70.*
ASF, Guardaroba medicea 826,
*Inventario de' Mobili e Masserizie
dell'Eredità del Ser.mo e Rev.mo
S.re Principe Cardinale Leopoldo
di Toscana.*

Undated
Porcella, A., *Un capolavoro
ritrovato del Caravaggio:
Il S. Gerolamo che scrive*, Rome
[1969?].
1582
Paleotti, G., *Discorso intorno
alle immagini sacre e profane*,
Bologna 1582.
1613
Francucci, S., *La Galleria
dell'Illustrissimo e Reverendissimo
Signor Scipione Cardinale
Borghese cantata in versi*, Arezzo
1613.
Maurolico, S., *Historia Sagra
intitolata Mare Oceano di tutte
le religioni del mondo*, Messina
1613.
Mirabella, V., *Dichiarazione delle
piante delle antiche Siracuse e
d'alcune scelte medaglie d'esse,
de' Principi che quelle possedettero*,
Naples 1613.
1620-30
Giustiniani, V., *Lettera sulla
pittura al signor Teodoro
Amideni*, 1620-30, in *Lettere
memorabili dell'Ab. Michele
Giustiniani*, Rome 1675, III,
n. LXXXV, published in *Raccolta
di lettere sulla pittura, scultura ed
architettura scritte da' più celebri
personaggi dei secoli XV, XVI XVII*,
eds G. Bottari and S. Ticozzi,
Milan 1822-5, VI, 1822, pp. 121-9,
now in Giustiniani, V., *Discorsi
sulle arti e sui mestieri*, ed. A. Banti,
Florence 1981, pp. 41-5.
1642
Baglione, G., *Le vite de' pittori,
scultori et architetti. Dal
pontificato di Gregorio XIII
del 1572 in fino a' tempi di Papa
Urbano Ottauo nel 1642 ...*, Rome
1642.
1644
Samperi, P., *Iconologia della
Gloriosa Vergine Madre di Dio
Maria protettrice di Messina*,
Messina 1644, facsimile reprint,
introduction by G. Lipari, E. Pispisa,
G. Molonia, Messina 1990.
1650
Manilli, J., *Villa Borghese fuori
di Villa Pinciana descritta
da Iacomo Manilli romano
guardaroba di detta villa*,
Rome 1650.
1654
Samperi, P., *Messana illustrata...*
(before 1654), edn Messina 1742.

1657
Scannelli, F., *Il microcosmo
della pittura, overo Trattato diviso
in due libri ...*, Cesena 1657,
facsimile reprint, annotated
index by R. Lepore, Bologna 1989.
1672
Bellori, G.B., *Le vite de' pittori,
scultori et architetti moderni*,
Rome 1672, ed. E. Borea, Turin
1976.
1678
Malvasia, C.C., *Felsina pittrice.
Vite de pittori bolognesi ...*,
Bologna 1678, rec. edn Bologna
1841.
1684
Bosio, G., *Dell'Istoria della Sacra
Religione et Illustrissima Militia
di San Giovanni Gierosolimitano*,
3 vols, Rome 1594 [I-II] - 1602
[III], ed. cit. 2nd edn of vol III,
Naples 1684.
1685
D'Ambrosio, G.A., *Quattro
portenti della Natura, dell'Arte,
della Grazia e della Gloria*,
Messina 1685.
1703-15
Dal Pozzo, B., *Historia della Sacra
Religione militare di S. Giovanni
Gerosolimitano detta di Malta*, I,
Verona 1703; II, Venice 1715.
1724
Susinno, F., *Le vite de' pittori
messinesi e di altri che fiorirono
in Messina (1724)*, ed. V.
Martinelli, Florence 1960.
1728
Vertot, Abbé R.A. de, *The History
of the Knights of Malta*, 2 vols,
London 1728.
1733
Pirro, R., *Sicilia Sacra*, additions
by V.M. Amico, Palermo 1733,
ed. Bologna 1987.
1792
Hackert, F., and Grano, G.,
Memorie de' Pittori Messinesi,
Naples 1792, ed. S. Bottari,
Messina 1932.
1813
Capodieci, G.M., *Antichi
monumenti di Siracusa illustrati*,
2 vols, Syracuse 1813.
1821
Grosso Cacopardo, G., *Memorie
de' pittori messinesi e degli esteri
che in Messina fiorirono dal
secolo XII sino al secolo XIX*,
Messina 1821, facsimile reprint
Bologna 1972.

1834
Inghirami, F., *Galleria dei quadri
a Palazzo Pitti*, Florence 1834.
1835
Politi, G., *Siracusa pei viaggiatori
ovvero descrizione storica,
artistica, topografica delle attuali
antichità di Ortigia, Acradina,
Tica, Napoli, ed Epipoli che
componevano l'antica Siracusa*,
Syracuse 1835.
1846
Baldinucci, F., *Notizie dei professori
del disegno da Cimabue in qua ...*,
Florence 1681-1728, ed. F. Ranalli,
IV, Florence 1846.
1860
Chiavacci, E., *Guide de la Galerie
Royale du Palais Pitti*, Florence
1860.
1870
Campori, G., *Raccolta di cataloghi
ed inventari inediti*, Modena
1870.
1873
Villabianca, F.M., Emanuele e
Gaetani, marchese di, *Il Palermo
d'Oggigiorno*, ms. Biblioteca
Comunale di Palermo, Qq E 91-92,
now in *Biblioteca Storica
e Letteraria di Sicilia*, Palermo
1873, reprinted ed. G. Di Marzo,
Sala Bolognese 1974.
1879
Privitera, S., *Storia di Siracusa
antica e moderna*, 2 vols, Naples
1879.
1893
Venturi, A., *Il Museo e la Galleria
Borghese*, Rome 1893.
1897
Bonazzi, F., *Elenco dei cavalieri
del S.M. Ordine di S. Giovanni
di Gerusalemme ricevuti nella
veneranda lingua d'Italia dalla
fondazione dell'Ordine ai nostri
giorni*. Parte Prima (dal 1136
al 1713), Naples 1897.
1903
Laking, G.F., *A Catalogue of the
Armour and Arms in the Armoury
of the Knights of St. John of
Jerusalem now in the Palace*,
Valetta, Malta, London 1903.
Maindron, M., 'Le Portrait du
Grand-Maître Alof de Wignacourt
au Musée du Louvre. Son Portrait
et ses armes à l'Arsenal de Malte',
in *Revue de l'Art ancien et moderne*,
24, 1903, pp. 241-54, 339-52.

1906–7
Saccà, V., 'Michelangelo da Caravaggio pittore. Studi e ricerche', in *Archivio Storico Messinese*, VII, 1906, pp. 40–69; VIII, 1907, pp. 41–79.

1908
Cantalamessa, G., 'Un quadro di Michelangelo da Caravaggio', in *Bollettino d'Arte*, XI, 1908, pp. 401–2.

1909
Giglioli, O.H., 'Notiziario: R. Galleria Pitti', in *Rivista d'Arte*, VI, 1909, pp. 150–6.
Venturi, L., 'Note sulla Galleria Borghese', in *L'Arte*, XII, 1909, 1, pp. 31–50.

1910
Venturi, L., 'Studi su Michelangelo da Caravaggio', in *L'Arte*, XIII, 1910, 3, 25, pp. 191–201; 3, 35, pp. 268–84.

1912
Venturi, L., 'Opere inedite di Michelangelo da Caravaggio', in *Bollettino d'Arte*, VI, 1912, pp. 1–18.

1915
Longhi, R., 'Battistello', in *L'Arte*, XVIII, 1915, pp. 58–75, 120–37, now in *Opere complete. Scritti giovanili 1912–1922*, I, Florence 1961, pp. 177–211.

1918
Bredius, A., 'Jets over de Schilders Louis, David en Pieter Finson', in *Oud Holland*, XXXVI, 1918, 273, pp. 197–204.

1921
Venturi, L., *Il Caravaggio*, Rome 1921.

1922
Florence, Palazzo Pitti: exh. cat., *Mostra della pittura italiana del Sei e Settecento*, Rome 1922.
Marangoni, M.1, 'Note sul Caravaggio alla Mostra del Sei e Settecento', in *Bollettino d'Arte*, II, 1922, pp. 217–29.
Marangoni, M.2, *Il Caravaggio*, Florence 1922.

1924–5
Mauceri, E., 'Il caravaggismo in Sicilia e Alonso Rodriguez pittore messinese', in *Bollettino d'Arte*, IV, 1924–5, 12, pp. 559–71.

1927
Fogolari, G., *Il ritratto veneziano e genovese nel Seicento*, in *Il ritratto italiano dal Caravaggio al Tiepolo alla mostra di Palazzo Vecchio nel MCMXI, sotto gli auspici del Comune di Firenze*, Bergamo 1927, pp. 101–30.

Longhi, R., 'Un S. Tommaso del Velásquez e le congiunture italo spagnole tra il '5 e il '600', in *Vita Artistica*, II, 1927, 2, pp. 4–12, now in *Opere complete. II. Saggi e ricerche 1925–1928*, Florence 1967, pp. 300–6.
Marangoni, M., *Arte Barocca: revisioni critiche*, Florence 1927.

1927–8
Pevsner, N., 'Eine Revision der Caravaggio-Daten', in *Zeitschrift für Bildende Kunst*, LXI, 1927–8, pp. 386–92.

1928
Agnello, G., 'Un capolavoro dell'oreficeria siciliana', in *Per l'Arte Sacra*, 1928, 4/5, pp. 3–15.
Longhi, R., *Precisazioni nelle Gallerie italiane. I: R. Galleria Borghese*, Rome 1928.

1928–9
Longhi, R., 'Quesiti caravaggeschi'. I: 'Registro dei tempi'; II: 'I precedenti', in *Pinacotheca*, I, 1928, 1, pp. 17–33; II, 1929, 5/6, pp. 258–320, now in *Opere complete*, IV, Florence 1968, pp. 82–143.

1933
von Schneider, A., *Caravaggio und die Niederländer*, Marburg 1933, 2nd edn Amsterdam 1967.

1935
P. Antonino da Castellammare, *Il Padre fra Girolamo da Polizzi della Provincia di Palermo*, Palermo 1935.
Bottari, S., 'Un'opera dimenticata di Michelangelo Merisi da Caravaggio', in *L'Arte*, XXXVIII, 1935, 1, pp. 39–47.

1937
P. Antonino da Castellammare, *Della venuta dei Cappuccini in Sicilia*, Palermo 1937.

1943
Longhi, R., 'Ultimi studi sul Caravaggio e la sua cerchia', in *Proporzioni*, I, 1943, pp. 5–63, now in *Opere complete: Studi Caravaggeschi*, I, Florence 1999, pp. 1–54.

1947
Ainaud, J., de Lasarte, 'Ribalta y Caravaggio', in *Anales y Boletin de los Museos de Barcelona*, 3/4, 1947, pp. 345–413.

1948
Pariset, F., *Georges La Tour*, Paris 1948.

1949
Bottari, S., 'Opere inedite e poco note dei Musei di Catania e Siracusa', in *Emporium*, 1949, pp. 202–20.
Giglioli, O.H., *Giovanni da San Giovanni. Studi e ricerche*, Florence 1949.

1951
Longhi, R., 'Sui margini caravaggeschi', in *Paragone*, II, 21, 1951, pp. 20–34.
Mahon, D., 'Egregius in Urbe Pictor: Caravaggio Revised', in *The Burlington Magazine*, XCIII, 580, 1951, pp. 223–34.
Milan: exh. cat., *Mostra del Caravaggio e dei Caravaggeschi*, Florence 1951.
Urbani, G., and Brandi, C., 'Restauri caravaggeschi per la Sicilia. Schede di restauro', in *Bollettino dell'Istituto Centrale del Restauro*, II, 1951, 5/6, pp. 61–91; 7/8, pp. 47–84.
Venturi, L., *Caravaggio*, preface by B. Croce, Novara 1951, 2nd edn Novara 1963.

1952
Longhi, R., *Il Caravaggio*, Milan 1952.
Mahon, D., 'Addenda to Caravaggio', in *The Burlington Magazine*, XCIV, 586, 1952, pp. 3–23.

1953
Grassi, L. *Il Caravaggio*, Rome 1953.
Hinks, R., *Michelangelo Merisi da Caravaggio. His Life, His Legend, His Works*, London 1953.

1954
Friedlaender, W., 'Book rewiews. R. Hinks, *Michelangelo Merisi da Caravaggio*', in *The Art Bulletin*, XXXVI, 1954, 2, pp. 149–52.

1955
Baumgart, F., *Caravaggio. Kunst und Wirklichkeit*, Berlin 1955.
Bordeaux: exh. cat., *L'Age d'or espagnol. La peinture en Espagne et en France autour du caravagisme*, ed. G. Martin Mèry, Bordeaux 1955.
Friedlaender, W., *Caravaggio Studies*, Princeton 1955; other edns New York 1969, 1972; Princeton 1974; Ann Arbor 1994.
Jullian, R., 'Caravage à Naples', in *Revue des Arts*, V, 1955, 2, pp. 79–90.
Scicluna, H.P., *The Church of St. John in Valletta*, Rome 1955.

1955–6
Meli, F., 'Nuovi documenti relativi a dipinti di Palermo dei secoli XVI e XVII', in *Atti dell'Accademia di Scienze, Lettere e Arti di Palermo*, series IV, XVI, 1955–6, 1, part II, pp. 193–223.

1956–7
Mancini, G., *Considerazioni sulla pittura*, ed. A. Marucchi, Rome 1956–7.

1957
Carità, R., 'Il restauro dei dipinti caravaggeschi della cattedrale di Malta', in *Bollettino dell'Istituto Centrale del Restauro*, fasc. 29/30, 1957, pp. 41–82.

1958
Hess, J., 'Caravaggio's Paintings in Malta: Some Notes', in *The Connoisseur*, CXLII, 1958, pp. 142–7.
Wagner, H., *Michelangelo da Caravaggio*, Bern 1958.

1959
Berne-Joffroy, A., *Le dossier Caravage*, Paris 1959, new edn Paris 2000.
Della Pergola, P., *Galleria Borghese. I dipinti*, Rome 1959.
Longhi, R., 'Un'opera estrema del Caravaggio', in *Paragone*, X, 121, 1959, pp. 21–32.

1960
Hoog, M., 'Attributions anciennes à Valentin', in *La Revue des Arts. Musée de France*, X, 1960, 6, pp. 267–78.
Longhi, R., 'Un originale del Caravaggio a Rouen e il problema delle copie caravaggesche', in *Paragone*, XI, 121, 1960, pp. 23–36.

1961
Jullian, R., *Caravage*, Lyon and Paris 1961.

1962
De Logu, G., *Caravaggio*, Milan 1962.
Dufour, X.L., *Vocabulaire de théologie biblique*, Paris 1962.

1963
Aliberti, F.M., 'La mostra del Caravaggio e dei Caravaggeschi a Napoli', in *Realtà del Mezzogiorno*, III, n. 6, June 1963, p. 785.
Naples: exh. cat., *Caravaggio e i caravaggeschi*, Naples 1963.

1964
Della Pergola, P., 'L'Inventario Borghese del 1693', in *Arte antica e moderna*, VII, 1964, 26, pp. 219–30; 28, pp. 451–67.
Macrae, D., 'Observation on the Sword in Caravaggio', in *The Burlington Magazine*, CVI, 738, 1964, pp. 412–16.

1965
Spear, R., '*The Raising of Lazarius*: Caravaggio and the Sixteenth Century Tradition', in *Gazette des Beaux-Arts*, CVII, 55, 1965, pp. 65–70.

1966
Bodart, D., 'Intorno al Caravaggio: la Maddalena del 1606', in *Palatino*, X, 1966, pp. 118–26.
Bottari, S., *Caravaggio*, Florence 1966.
Salerno, L., Kinkead, D.T., and Wilson, W.H., 'Poesia e simboli nel Caravaggio. I dipinti emblematici. Temi religiosi. Realtà e composizione storica', in *Palatino*, X, 1966, pp. 106–17.

1967
Denaro, V., *The Houses of Valletta*, Malta 1967.
Longhi, R., 'Un *San Tommaso* del Velázquez e le congiunture italo-spagnole tra il Cinque e il Seicento', in *Opere complete. II. Saggi e ricerche 1925–1928*, Florence 1967, pp. 300–6.
Moir, A., *The Italian Followers of Caravaggio*, Cambridge (Mass.) 1967.
Ottino Della Chiesa, A., *L'opera completa di Caravaggio*, foreword by R. Guttuso, Milan 1967.

1968
Brugnoli, M.L., 'Un San Francesco da attribuire al Caravaggio e la sua copia', in *Bollettino d'Arte*, LIII, 1968, 1, pp. 11–15.
Fagiolo Dell'Arco, M., 'Le Opere di Misericordia: contributo alla poetica del Caravaggio', in *L'Arte*, 1968, 1, pp. 37–61.
Longhi, R., *Caravaggio*, Rome 1968.

1969
Kitson, M., *The Complete Paintings of Caravaggio*, Harmondsworth 1969.

1970
Bodart, D., *Louis Finson*, Brussels 1970.
Florence: exh. cat., *Caravaggio e Caravaggeschi nelle Gallerie di Firenze*, ed. E. Borea, Florence 1970.
Paris: exh. cat., *Le siècle de*

Rembrandt. Tableaux hollandais des collections publiques françaises (Paris 1970-1), Paris 1970.

Salerno, L., 'Caravaggio e i Caravaggeschi', in *Storia dell'Arte*, 7/8, 1970, pp. 234-48.

1971

Calvesi, M., 'Caravaggio o la ricerca della salvazione', in *Storia dell'Arte*, 1971, 9/10, pp. 93-141.

Dell'Acqua, G.A., and Cinotti, M., *Il Caravaggio e le sue grandi opere da San Luigi dei Francesi*, Milan 1971.

Frommel, C.L., 'Caravaggio und seine Modelle', in *Castrum peregrini*, XCVI, 1971, pp. 21-56.

Levey, M., *National Gallery Catalogues: The Seventeenth and Eighteenth Century Italian Schools*, London 1971.

Pérez Sánchez, A.E., 'Caravaggio e i Caravaggeschi a Firenze', in *Arte Illustrata*, IV, 37/38, 1971, pp. 85-9.

Schleier, E., 'Caravaggio e i caravaggeschi nelle Gallerie di Firenze. Zur Ausstellung in Palazzo Pitti, Sommer 1970', in *Kunstchronik*, XXIV, 1971, 4, pp. 85-102.

1972

Causa, R., *La pittura del Seicento a Napoli dal naturalismo al Barocco*, in *Storia di Napoli*, V. 2, Naples 1972, pp. 915-94.

Florence: exh. cat., *Firenze restaura. Il laboratorio nel suo quarantennio. Guida alla mostra*, ed. U. Baldini e P. Dal Poggetto, Florence 1972.

Volpe, C., 'Annotazioni sulla mostra caravaggesca di Cleveland', in *Paragone*, XXIII, 263, 1972, pp. 50-76.

1973

Immagine del Caravaggio, Cinisello Balsamo 1973.

Marini, M.[1], 'Caravaggio 1607: la *Negazione di Pietro*', in *Napoli Nobilissima*, XII, 1973, pp. 189-94.

Marini, M.[2], *Io, Michelangelo da Caravaggio*, Rome 1973.

Seville: exh. cat., *Caravaggio y el naturalismo español*, Seville 1973.

1974

Greaves, J.L., and Johnson, M., 'Detroit's *Conversion of the Magdalen* (The Alzaga Caravaggio). 2. New Findings on Caravaggio's Technique in the Detroit *Magdalen*', in *The Burlington Magazine*, CXVI, 859, 1974, pp. 564-72.

Gregori, M., 'A New Painting and Some Observations on Caravaggio's Journey to Malta', in *The Burlington Magazine*, CXVI, 859, 1974, pp. 594-603.

Harris, E., 'Caravaggio y el naturalismo español', in *Arte Illustrata*, LVIII, 1974, pp. 235-45.

Marini, M., *Io Michelangelo da Caravaggio*, new edn Rome 1974.

Nicolson, B., 'Recent Caravaggio Studies', in *The Burlington Magazine*, CXVI, 859, 1974, pp. 624-5.

Röttgen, H., *Il Caravaggio. Ricerche e interpretazioni*, Rome 1974.

Spezzaferro, L., 'Detroit's *Conversion of the Magdalene* (The Alzaga Caravaggio). 4. The Documentary Findings: Ottavio Costa as a Patron of Caravaggio', in *The Burlington Magazine*, CXVI, 859, 1974, pp. 579-86.

1975

Gregori, M., 'Significato delle mostre caravaggesche dal 1951 a oggi', in *Novità sul Caravaggio. Saggi e contributi. Bergamo 1974*, Conference Proceedings, ed. M. Cinotti, Milan 1975, pp. 27-60.

Potterton, H., '*The Supper at Emmaus*' by Caravaggio, London 1975 (Painting in Focus, 3).

Röttgen, H., 'La *Resurrezione di Lazzaro* del Caravaggio', in *Novità sul Caravaggio. Saggi e contributi. Bergamo 1974*, Conference Proceedings, ed. M. Cinotti, Milan 1975, pp. 17-26.

Spezzaferro, L., 'Ottavio Costa e Caravaggio: certezze e problemi', in *Novità sul Caravaggio. Saggi e contributi. Bergamo 1974*, Conference Proceedings, ed. M. Cinotti, Milan 1975, pp. 103-18.

1976

Gregori, M., 'Addendum to Caravaggio: the Cecconi *Crowning with Thorns* reconsidered', in *The Burlington Magazine*, CXVIII, 883, 1976, pp. 671-9.

Moir, M., *Caravaggio and His Copyists*, New York 1976.

Schneider, T.M., 'Technical Analysis', in *The Burlington Magazine*, CXVIII, 883, 1976, pp. 679-80.

1977

Banti, A., *Giovanni da San Giovanni pittore della contraddizione*, Florence 1977.

Brandi, C., 'Come riscoprire un Caravaggio. Restaurato il *Seppellimento di S. Lucia*', in *Corriere della Sera*, 10 April 1977.

Meloni Trkulja, S., 'Per l'amore dormiente di Caravaggio', in *Paragone*, XXVIII, 331, 1977, pp. 46-50.

Pacelli, S., 'New Documents Concerning Caravaggio in Naples', in *The Burlington Magazine*, CXIX, 897, 1977, pp. 819-29.

Scribner III, C.S., '*In alia effigie*: Caravaggio's London *Supper At Emmaus*', in *The Art Bulletin*, LIX, 3, 1977, pp. 375-82.

Tzeutschler Lurie, A., and Mahon, D., 'Caravaggio's Crucifixion of Saint Andrew from Valladolid', in *The Bulletin of the Cleveland Museum of Arts*, LXIV, 1977, pp. 3-24.

1978

Bardon, F., *Caravage ou l'experience de la matière*, Paris 1978.

Marini, M., '*Michael Angelus Caravaggio Romanus*'. Rassegna degli studi e proposte, Rome 1978.

Sammut, E., 'The Trial of Caravaggio', in Valletta: exh. cat., *The Church of St. John in Valletta 1578-1978. An Exhibition Commemorating the Fourth Centenary of its Consecration*, ed. J. Azzopardi, Malta 1978, pp. 21-7.

Spike, J., '*The Church of St John in Valletta 1578-1978* and the Earliest Record of Caravaggio in Malta: an Exhibition and its Catalogue', in *The Burlington Magazine*, CXX, 906, 1978, pp. 626-8.

Valletta: exh. cat, *The Church of St John in Valletta 1578-1978. An Exhibition Commemorating the Fourth Centenary of its Consecration*, ed. J. Azzopardi, Malta 1978.

1979

De Floriani, A., *Bartolomeo da Camogli*, Genoa 1979.

Marini, M., *Michael angelus caravaggio romanus*, I, 1979.

Nicolson, B., *The International Caravaggesque Movement. Lists of Pictures by Caravaggio and His Follower throughout Europe from 1590 to 1630*, posthumous edn by L. Vertova, Oxford 1979.

Spear, R.E., 'The International Caravaggesque Movement', in *The Burlington Magazine*, 914, CXXI, 1979, pp. 317-22.

1980

Bologna, F., 'L'identificazione del dipinto (e i rapporti artistici fra Genova e Napoli nei primi decenni del Seicento)', in Bologna, F., and Pacelli, V., 'Caravaggio 1610: la *Sant'Orsola confitta dal tiranno* per Marcantonio Doria', in *Prospettiva*, XXXIII, 23, 1980, pp. 30-45.

Gash, J., *Caravaggio*, London 1980.

Marini, M., *Caravaggio. Werkverzeichnis*, Frankfurt Berlin Vienna 1980.

Patricolo, R., *San Giorgio dei Genovesi e le sue epigrafi*, Palermo 1980.

Trasselli, C., 'I rapporti tra Genova e la Sicilia: dai Normanni al '900', in *Genova e i Genovesi a Palermo. Genova, 13 dicembre 1978-13 gennaio 1979*, Conference Proceedings, Genoa 1980, pp. 13-37.

1981

Marini, M., 'Caravaggio e il naturalismo internazionale', in *Storia dell'arte italiana. VI*, second part: *Dal Medioevo al Novecento*, vol. II: *Dal Cinquecento all'Ottocento*, I: *Cinquecento e Seicento*, Turin 1981, pp. 347-445.

Zuccari, A.[1], 'La politica culturale dell'Oratorio romano nella seconda metà del Cinquecento', in *Storia dell'Arte*, 1981, 41, pp. 77-112.

Zuccari, A.[2], 'La politica culturale dell'Oratorio romano nelle imprese artistiche promosse da Cesare Baronio', in *Storia dell'Arte*, 1981, 42, pp. 171-93.

1982

Florence: exh. cat. *La città degli Uffizi* (Florence 1982-3), Florence 1982.

London-Washington: exh. cat. *Painting in Naples 1606-1705: From Caravaggio to Giordano* (London-Washington 1982-3), eds C. Whitfield and J. Martineau, London 1982.

Longhi, R., *Caravaggio*, ed. G. Previtali, Rome 1982.

Malignacci, D., 'L'altare gaginiano di San Giorgio e gli episodi artistici a Palermo nel terzo decennio del Cinquecento', in *Genova e i Genovesi a Palermo, Palermo, 21-23 marzo 1980,* Conference Proceedings, Palermo 1982, pp. 52-60.

Mosco, M., *La Galleria Palatina: il quadro e la cornice*, in Florence: exh. cat., *La città degli Uffizi* (Florence 1982-3), Florence 1982.

Patricolo, R., 'La Cappella dei mercanti genovesi nel chiostro della Basilica di San Francesco d'Assisi in Palermo', in *Genova e i Genovesi a Palermo, Palermo, 21-23 marzo 1980*, Conference Proceedings, Palermo 1982, pp. 85-110.

Pedone, S., 'Il Cardinale Giannettino Doria Arcivescovo di Palermo e Presidente del Regno di Sicilia', in *Genova e i Genovesi a Palermo, Palermo, 21-23 marzo 1980*, Conference Proceedings, Palermo 1982, pp. 111-25.

Rome: exh. cat., *L'immagine di S. Francesco nella Controriforma* (Rome 1982-3), Rome 1982.

Sebregondi Fiorentini, L, 'Francesco dell'Antella, Caravaggio, Paladini e altri', in *Paragone*, anno XXXIII, no. 383-5, 1982, , pp. 107-22.

1983

Cinotti, M., 'Michelangelo Merisi detto il Caravaggio. Tutte le opere', in *I pittori bergamaschi dal XIII al XIX secolo. Il Seicento*, I, Bergamo 1983, pp. 203-641.

Hibbard, H., *Caravaggio*, London 1983.

Pizzorusso, C., 'Un tranquillo dio: Giovanni da San Giovanni e Caravaggio', in *Paragone*, XXXIV, 405, 1983, pp. 50-9.

Rotolo, F., 'Le cappelle pisane nella Basilica di San Francesco e l'arco di S. Rainieri nella Cappella dei Lombardi', in *Immagine di Pisa a Palermo, Palermo-Agrigento-Sciacca, 9-12 giugno 1982*, Conference Proceedings, Palermo 1983, pp. 335-55.

1983-4

Bologna, F., 'Sul passaggio a Eboli della *Sant'Orsola* del 1610 e una *Strage degli innocenti* di Giovan Battista Paggi', in Bologna, 'Tre note caravaggesche', in *Prospettiva*, nn. 33-6, April 1983 – January 1984, special issue *Studi in onore di Luigi Grassi*, pp. 202-11.

188

1984

Abbate, V., 'I tempi del Caravaggio. Situazione della pittura in Sicilia (1580-1625)', in Syracuse: exh. cat., *Caravaggio in Sicilia, il suo tempo, il suo influsso* (Syracuse 1984-5), Palermo 1984, pp. 43-76.

Campagna Cicala, F., 'Intorno all'attività di Caravaggio in Sicilia. Due momenti del caravaggismo siciliano: Mario Minniti e Alonzo Rodriguez', in Syracuse: exh. cat., *Caravaggio in Sicilia, il suo tempo, il suo influsso* (Syracuse 1984-5), Palermo 1984, pp. 101-44.

Cordaro, M., 'Il restauro del *Seppellimento di Santa Lucia*', in Syracuse: exh. cat., *Caravaggio in Sicilia, il suo tempo, il suo influsso* (Syracuse 1984-5), Palermo 1984, pp. 269-93.

Naples: exh. cat., *Civiltà del Seicento a Napoli* (Naples 1984-5), Naples 1984.

Il patrimonio artistico del Banco di Napoli. Catalogo delle opere, ed. N. Spinosa, Naples 1984.

Syracuse: exh. cat., *Caravaggio in Sicilia, il suo tempo, il suo influsso* (Syracuse 1984-5), Palermo 1984.

Spadaro, A., 'Caravaggio in Sicilia. Irrequieto, ma non fuggitivo. Proseguendo l'indagine sul soggiorno siciliano del Caravaggio', in *Foglio d'Arte*, VIII, 12 December 1984, pp. 10-18, 24.

Testori, G., *Caravaggio e il disegno*, in *Fra Rinascimento, Manierismo e Realtà. Scritti in memoria di Anna Maria Brizio*, Milan 1984, pp. 143-50.

Zuccari, A., *Arte e committenza nella Roma di Caravaggio*, Rome 1984.

1985

Calvesi, M., 'Le realtà del Caravaggio. Prima parte (vicende)', in *Storia dell'Arte*, 53, 1985, pp. 51-85.

Gregori, M., 'Caravaggio. Paintings by, after, or attributed to Caravaggio', in New York: exh. cat. *The Age of Caravaggio*, ed. K. Christiansen, New York 1985, pp. 200-353.

Naples: exh. cat., *Caravaggio e il suo tempo*, Milan 1985.

New York: exh. cat., *The Age of Caravaggio*, ed. K. Christiansen, New York 1985.

Pacelli, V., and Brejon de Lavergnée, A., 'L'eclisse del committente? Congetture su un ritratto nella *Flagellazione* di Caravaggio rivelato dalla radiografia', in *Paragone*, XXXVI, 419/421, 1985, pp. 208-18.

Spezzaferro, L., 'Un imprenditore del primo Seicento: Giovanni Battista Crescenzi', in *Ricerche di Storia dell'Arte*, 26, 1985, pp. 50-73.

1986

Cellini, P., 'Ho trovato un nuovo Caravaggio' (ed. D. Trobadori), in *L'Illustrazione Italiana*, VI, 30 May 1986, pp. 84-92.

Christiansen, K., 'Caravaggio and *L'esempio davanti del naturale*', in *The Art Bulletin*, LXVIII, 3, 1986, pp. 421-45.

Cucinotta, S., *Popolo e clero in Sicilia nella dialettica socio-religiosa fra Cinque e Seicento*, Messina 1986.

Segrebondi Fiorentini, L., 'Francesco Buonarroti, cavaliere gerolosimitano e architetto dilettante', in *Rivista d'Arte*, anno XXXVIII, serie IV, II, 1986, pp. 49-86.

Varriano, J., 'Caravaggio and the Decorative Arts in the two *Suppers at Emmaus*', in *The Art Bulletin*, LXVIII, 2, 1986, pp. 218-24.

1987

Buhagiar, M., *The Iconography of the Maltese Islands: 1400-1900*, Valletta 1987.

Cremona: exh. cat., *Dopo Caravaggio. Bartolomeo Manfredi e la Manfrediana Methodus*, Milan 1987.

Gregori, M., *Dal Caravaggio al Manfredi*, in Cremona: exh. cat., *Dopo Caravaggio. Bartolomeo Manfredi e la Manfrediana Methodus*, Milan 1987, pp. 19-25.

Habert, J., *Bordeaux. Musée des Beaux-Arts. Peinture italienne XVe-XIXe siècles*, Paris 1987.

Macioce, S., 'Caravaggio a Malta: il *San Girolamo* e lo stemma Malaspina', in *L'ultimo Caravaggio e la cultura artistica a Napoli, in Sicilia e Malta. Siracusa-Malta 1985*, Conference Proceedings, ed. M. Calvesi, Syracuse 1987, pp. 175-81.

Malignacci, D., 'La Natività del Caravaggio e la Compagnia di San Francesco nell'Oratorio di San Lorenzo', in *L'ultimo Caravaggio e la cultura artistica a Napoli, in Sicilia e Malta. Siracusa-Malta 1985*, Conference Proceedings, ed. M. Calvesi, Syracuse 1987, pp. 279-88.

Marini, M.[1], *Caravaggio. Michelangelo Merisi da Caravaggio 'Pictor Praestantissimus.' La tragica esistenza, la raffinata cultura, il mondo sanguigno del primo Seicento nell'iter pittorico completo di uno dei massimi rivoluzionari dell'arte di tutti i tempi*, Rome 1987.

Marini, M.[2], *La 'Giuditta' del 1607. Un contributo a Caravaggio e a Louis Finson*, in *L'ultimo Caravaggio e la cultura artistica a Napoli, in Sicilia e Malta. Siracusa-Malta 1985*, Conference Proceedings, ed. M. Calvesi, Syracuse 1987, pp. 147-73.

Natoli, E., 'I luoghi di Caravaggio a Messina', in *L'ultimo Caravaggio e la cultura artistica a Napoli, in Sicilia e Malta. Siracusa-Malta 1985*, Conference Proceedings, ed. M. Calvesi, Syracuse 1987, pp. 217-29.

Pacelli, V., 'Dalla *Sant'Orsola* alle *Sette opere*, un percorso all'inverso ricordando i dipinti maltesi e siciliani', in *L'ultimo Caravaggio e la cultura artistica a Napoli, in Sicilia e Malta. Siracusa-Malta 1985*, Conference Proceedings, ed. M. Calvesi, Syracuse 1987, pp. 81-103.

Posèq, A.W.G., 'A Note on Caravaggio's *Sleeping Amor*', in *Source. Notes in the History of Art*, VI, no. 4, 1987, pp. 27-31.

Russo, M., 'La statua e la cassa di S. Lucia nell'ambito della produzione orafa a Siracusa', in *Il Barocco in Sicilia tra conoscenza e conservazione*, eds M. Fagiolo and L. Trigilia, Syracuse 1987, pp. 125-43.

Schneider, T.M., 'La "maniera" e il processo pittorico del Caravaggio', in *L'ultimo Caravaggio e la cultura artistica a Napoli, in Sicilia e Malta. Siracusa-Malta 1985*, Conference Proceedings, ed. M. Calvesi, coordination L. Trigilia, Syracuse 1987, pp. 117-38.

Spadaro, A., *Note sulla permanenza di Caravaggio in Sicilia*, in *L'ultimo Caravaggio e la cultura artistica a Napoli, in Sicilia e Malta. Siracusa-Malta 1985*, Conference Proceedings, ed. M. Calvesi, Syracuse 1987, pp. 289-92.

Tokyo: exh. cat., *Space in European Art*, Tokyo 1987.

L'ultimo Caravaggio e la cultura artistica a Napoli, in Sicilia e Malta. Siracusa-Malta 1985, Conference Proceedings, ed. M. Calvesi, Syracuse 1987.

Zuccari, A., 'La pala di Siracusa e il tema della sepoltura in Caravaggio', in *L'ultimo Caravaggio e la cultura artistica a Napoli, in Sicilia e Malta. Siracusa-Malta 1985*, Conference Proceedings, ed. M. Calvesi, Syracuse 1987, pp. 147-73.

1988

Brejon de Lavergnée, A., and Volle, N., *Musées de France. Repertoires des peintures italiennes du XVIIe siècle*, Paris 1988.

1989

Azzopardi, J.[1], 'Documentary Sources on Caravaggio's Stay in Malta', in *Caravaggio in Malta*, ed. P. Farrugia Randon, Malta 1989, pp. 19-44.

Azzopardi, J.[2], 'Caravaggio's Admission into the Order: Papal Dispensation for the Crime of Murder', in *Caravaggio in Malta*, ed. P. Farrugia Randon, Malta 1989, pp. 45-56.

Brandi, C., *Sicilia mia*, Palermo 1989.

Caravaggio in Malta, ed. P. Farrugia Randon, Malta 1989.

Chiarini, M., 'La probabile identità del "cavaliere di Malta" di Pitti', in *Antichità Viva*, 28, no. 4, 1989, pp. 15-16.

Cutajar, D., 'Caravaggio in Malta. His Works and His Influence', in *Caravaggio in Malta*, ed. P. Farrugia Randon, Malta 1989, pp. 1-18.

Gaeta Bertelà, G, and Paolozzi Strozzi, B., *Atti del Medio Evo e del Rinascimento: Omaggio ai Carrand 1889-1989*, Florence 1989.

Marini, M., *Caravaggio. Michelangelo Merisi da Caravaggio 'Pictor Praestantissimus'*, 2nd edn Rome 1989.

Naples: exh. cat., *Capolavori dalle collezioni d'arte del Banco di Napoli*, ed. N. Spinosa, Naples 1989.

Nicolson, B., *Caravaggism in Europe*, 2nd edn, ed. L. Vertova, 3 vols, Turin 1989.

Rossi, S., 'Un doppio autoritratto di Caravaggio', in *Quaderni di Palazzo Venezia*, VI, 1989, pp. 149-55.

1990

Calvesi, M., *Le realtà del Caravaggio*, Turin 1990.

Christiansen, K., *A Caravaggio Rediscovered 'The Lute Player'*, New York 1990.

Gregori, M., 'Sulla traccia di un altro *Ecce Homo* del Caravaggio', in *Paragone*, XLI, 489, 1990, pp. 19-27.

Papi, G., 'Un nuovo *Ecce Homo* del Caravaggio', in *Paragone*, XLI, 489, 1990, pp. 28-43.

St Paul's Grotto: Church and Musem at Rabat, Malta, ed. J. Azzopardi, Rabat 1990.

Warma, S.J., 'Christ, First Fruits, and the Resurrection: Observations on the Fruit Basket in Caravaggio's London *Supper at Emmaus*, in *Zeitschrift für Kunstgeschichte*, LIII, 1990, 4, pp. 583-6.

Zuccari, A., 'San Felice e i luoghi d'arte cappuccini: dal convento di San Bonaventura ai tuguri dipinti dal Caravaggio', in *San Felice da Cantalice: i suoi tempi, il culto e la diocesi di Cittaducale dalle origini alla canonizzazione del santo. Atti del Convegno di Studi Storici nel IV Centenario della morte di S. Felice da Cantalice. Rieti-Cantalice-Cittaducale 1987*, Rieti 1990, pp. 175-223.

1991

Bologna, F., 'Battistello e gli altri. Il primo tempo della pittura caravaggesca a Napoli', in Naples: exh. cat., *Battistello Caracciolo e il primo naturalismo a Napoli* (Naples 1991-2), ed. F. Bologna, Naples 1991, pp. 15-180.

Cinotti, M., *Caravaggio. La vita e l'opera*, Bergamo 1991.

Cropper, E., 'The Petrifying Art: Marino's Poetry and Caravaggio', in *Metropolitan Museum Journal*, 26, 1991, pp. 193-212.

Florence-Rome: exh. cat., *Michelangelo Merisi da Caravaggio. Come nascono*

i capolavori (Florence-Rome 1991–2), ed. M. Gregori, Milan 1991, 2nd edn Milan 1992.

Istituto Centrale del Restauro, *Il San Girolamo di Caravaggio a Malta. Dal furto al restauro*, Rome 1991.

Naples: exh. cat., *Battistello Caracciolo e il primo naturalismo a Napoli* (Naples 1991–2), ed. F. Bologna, Naples 1991.

1992

Bologna, F., *L'incredulità del Caravaggio e l'esperienza delle 'cose naturali'*, Turin 1992.

Campagna Cicala, F., *Messina. Museo Regionale*, Palermo 1992.

Madrid-Bilbao-Barcelona: exh. cat., *La pintura holandese del siglo de oro: la escuela de Utrecht* (Madrid-Bilbao-Barcelona 1992–3), Madrid 1992.

Pinacoteca di Brera: Scuole dell'Italia centrale e meridionale, Milan 1992.

1993

Benedetti, S., 'Caravaggio's *Taking of Christ*, a Masterpiece Rediscovered', in *The Burlington Magazine*, CXXXV, 1088, 1993, pp. 731–41.

Cartechini, P., 'Macerata e la sua biblioteca', in *La Biblioteca Mozzi-Borgetti di Macerata*, ed. A. Sfrappini, Rome 1993, pp. 13–54.

Corradini, S., *Caravaggio. Materiali per un processo*, Rome 1993.

Gash, J., 'Painting and Sculpture in Early Modern Malta', in *Hospitaller Malta, 1530–1798: Studies on Early Modern Malta and the Order of St. John of Jerusalem*, ed. V. Mallia-Milanes, Malta 1993, pp. 509–603.

Gregori, M., 'Il *San Giovannino* alla sorgente del Caravaggio', in *Paragone*, XLIV, 519/521, 1993, pp. 3–20.

Jacopo da Voragine, *The Golden Legend*, trans. W. Granger Ryan, Princeton 1993.

Schneider, T.M., 'L'orecchio del Caravaggio o come distinguere un originale da una copia', in *Paragone*, XLIV, 519/521, 1993, pp. 21–3.

1994

Calvesi, M., *Scipione Borghese e Caravaggio*, in *La Galleria Borghese*, ed. A. Coliva, Rome 1994, pp. 272–97.

Cappelletti, F., and Testa, L., *Il trattenimento di virtuosi: le*

collezioni secentesche di quadri nei Palazzi Mattei di Roma, Rome 1994.

Espinel, C.H., 'Caravaggio's "L'Amore dormiente": a Sleeping Cupid with Juvenile Rheumatoid Arthritis', in *The Lancet*, 344, 1994, pp. 1750–2.

Fumagalli, E., 'Precoci citazioni di opere del Caravaggio in alcuni documenti inediti', in *Paragone*, XLV, 1994, 535/537, pp. 101–16, new edn in *Come dipingeva il Caravaggio. Atti della giornata di studio. Firenze, 28 gennaio 1992*, ed. M. Gregori, Milan 1996, pp. 143–8.

La Galleria Borghese, ed. A. Coliva, Rome 1994.

Gregori, M., *Caravaggio*, Milan 1994.

Lapucci, R., *Documentazione tecnica sulle opere messinesi del Caravaggio*, in *Come dipingeva il Caravaggio. Le opere messinesi* (*Quaderni dell'attività didattica del Museo Regionale di Messina*, 4), Messina 1994, pp. 17–67.

Macioce, S., 'Caravaggio a Malta e i suoi referenti: notizie d'archivio', in *Storia dell'Arte*, 81, 1994, pp. 207–28.

Pacelli, V., *L'ultimo Caravaggio, dalla Maddalena a mezza figura ai due San Giovanni (1606–1610)*, Todi 1994.

Schnapper, A., *Curieux du Grand Siècle: Collections et collectionneurs dans la France du XVIIe siècle (II – Oeuvres d'art)*, Paris 1994.

Sire, H.J.A., *The Knights of Malta*, New Haven and London 1994.

1995

Agosti, B., *Collezionismo e archeologia cristiana del Seicento. Federico Borromeo e il Medioevo artistico tra Roma e Milano*, Milan 1995.

Bell, J.C., 'Light and Color in Caravaggio's *Supper at Emmaus*', in *Artibus et Historiae*, XVI, 1995, 31, pp. 139–70.

Gilbert, C.E., *Caravaggio and His Two Cardinals*, University Park (Pa.) 1995.

Rome: exh. cat. *Caravaggio e la collezione Mattei*, Milan 1995.

Spadaro, A., *La 'Resurrezione di Lazzaro' e la famiglia di Giovanni Battista Lazzari patrizio di Castelnuovo signore del castello di Alfano committente messinese del Caravaggio*, Catania 1995.

1996

Azzopardi, J., 'Un "San Francesco" di Caravaggio a Malta nel secolo XVIII: commenti sul periodo maltese del Merisi', in *Michelangelo Merisi da Caravaggio: la vita e le opere attraverso i documenti*, Conference Proceedings, ed. S. Macioce, Rome 1996, pp. 195–211.

Balsamo, J., 'Les Caravage de Malte: le témoignage des voyageurs français (1616–1678)', in *Come dipingeva il Caravaggio. Atti della giornata di studio. Firenze, 28 gennaio 1992*, ed. M. Gregori, Milan 1996, pp. 151–3.

Come dipingeva il Caravaggio. Atti della giornata di studio. Firenze, 28 gennaio 1992, ed. M. Gregori, Milan 1996.

Florence: exh. cat., *Caravaggio da Malta a Firenze*, eds G. Bonsanti and M. Gregori, Milan 1996.

Lapucci, R., 'Dopo Messina, Siracusa: ulteriori chiarificazioni per la tecnica dei dipinti siciliani del Caravaggio', in *Il 'seppellimento di Santa Lucia' del Caravaggio. Indagini radiografiche e riflettografiche*, eds G. Barbera and R. Lapucci, Syracuse 1996, pp. 17–70.

Michelangelo Merisi da Caravaggio: la vita e le opere attraverso i documenti, Conference Proceedings, ed. S. Macioce, Rome 1996.

1997

Gash, J., 'The Identity of Caravaggio's *Knight of Malta*', in *The Burlington Magazine*, CXXXIX, 1128, 1997, pp. 156–60.

Maccherini, M., 'Caravaggio nel carteggio familiare di Giulio Mancini', in *Prospettiva*, LXXXVI, 1997, pp. 71–92.

Molonia, G., 'Caravaggio a Messina', in *Messina. Storia e civiltà*, ed. G. Molonia, Messina 1997, pp. 140–1.

Naples: exh. cat. *San Gennaro tra fede, arte e mito* (Naples 1997–8), ed. P. Leone de Castris, Naples 1997.

Negro, E., and Roio, N., *Pietro Faccini 1575/76–1602*, Modena 1997.

Per lustro e decoro della città. Donazioni e acquisizioni al Museo Civico di dipinti dei secoli XV–XIX, ed. C. Guastella, Catania 1997.

Salonika: exh. cat. *Michelangelo Merisi da Caravaggio e i suoi primi seguaci*, ed. M. Gregori, Salonika, 1997.

Stone, D.M.[1], 'The Context of Caravaggio's *Beheading of St. John* in Malta', in *The Burlington Magazine*, CXXXIX, 1128, 1997, pp. 161–70.

Stone, D.M.[2], 'In Praise of Caravaggio's *Sleeping Cupid*: New Document for Francesco dell'Antella in Malta and Florence', in *Melita Historica*, XII, no. 2, 1997, pp. 165–77.

1998

Bona Castellotti, M., *Il paradosso di Caravaggio*, Milan 1998.

Cinotti, M., *Caravaggio. La vita e l'opera*, Bergamo 1998.

Keith, L., 'Three Paintings by Caravaggio', in *National Gallery Technical Bulletin*, XIX, 1998, pp. 37–51.

Langdon, H., *Caravaggio. A Life*, London 1998; New York 1999.

Posèq, A.W.G., *Caravaggio and the Antique*, London 1998.

Preimesberger, R., *Golia e Davide*, in *Docere delectare movere. Affetti, devozione e retorica nel linguaggio del primo barocco romano. Roma, 19–20 gennaio 1996*, Conference Proceedings, Rome 1998, pp. 61–9.

Puglisi, C., *Caravaggio*, London 1998.

Terrizzi, F., 'I Compagni Martiri di San Placido a Messina', in *L'Ordine di Malta ed il Tempio di San Giovanni Gerosolimitano a Messina*, Messina 1998, pp. 51–91.

Testa, L., 'Presenze caravaggesche nella collezione Savelli', in *Storia dell'Arte*, 93/94, 1998, pp. 348–52.

1999

Abbate, V., 'La città aperta. Pittura e società a Palermo tra Cinque e Seicento', in Palermo: exh. cat. *Porto di mare 1570–1670. Pittura a Palermo tra memoria e recupero*, ed. V. Abbate, Naples 1999, pp. 11–56.

Calvesi, M., 'Sobre algunas pinturas de Caravaggio: la *Buenaventura*, el *San Francisco* de Hartford, el *David y Goliat* de la Borghese y las dos *Natividades* sicilianas', in Madrid-Bilbao: exh. cat. *Caravaggio* (Madrid-Bilbao 1999–2000), Madrid 1999, pp. 10–17.

Cutajar, D., *History and Works*

of Art of St John's Church, Valletta-Malta, 3rd edn Malta 1999.

Florence: exh. cat. *Caravaggio al Carmine. Il restauro della 'Decollazione del Battista' di Malta*, eds M. Ciatti and C. Silla, Milan 1999.

La Flagellazione di Caravaggio. Il restauro, ed. D.M. Pagano, Naples 1999.

Gregori, M., *Decollazione del Battista*, in Florence: exh. cat., *Caravaggio al Carmine. Il restauro della Decollazione del Battista di Malta*, eds M. Ciatti and C. Silla, Milan 1999, pp. 33–8.

Hartford-Toronto: exh. cat., *Caravaggio's 'St John' and Masterpieces from the Capitoline Museum in Rome*, eds M.E. Tittoni, P. Masini and S. Guarino, Hartford 1999.

Madrid-Bilbao: exh. cat., *Caravaggio* (Madrid-Bilbao 1999–2000), Madrid 1999.

Marini, M., *Caravaggio y España: momentos de Historia y de Pintura entre la Naturaleza y la Fe*, in Madrid-Bilbao: exh. cat., *Caravaggio* (Madrid-Bilbao 1999–2000), Madrid 1999, pp. 29–48.

Mendola, G., *Dallo Zoppo di Gangi a Pietro Novelli. Nuove acquisizioni documentarie*, in Palermo: exh. cat., *Porto di mare 1570–1670. Pittura a Palermo tra memoria e recupero*, ed. V. Abbate, Naples 1999, pp. 57–87.

Pacelli, V., 'Reconsideraciones sobre las vicissitudes artistica y biográficas del ultimo Caravaggio', in Madrid-Bilbao: exh. cat., *Caravaggio* (Madrid-Bilbao 1999–2000), Madrid 1999, pp. 49–62.

Palermo: exh. cat., *Porto di mare 1570–1670. Pittura a Palermo tra memoria e recupero*, ed. V. Abbate, Naples 1999.

Salamone, L., 'L'Archivio privato gentilizio Papé di Valdina', in *Archivio Storico Messinese*, LXXIX, 1999.

Sciberras, K., 'Ciro Ferri's Reliquary for the Oratory of S. Giovanni Decollato in Malta', in *The Burlington Magazine*, CXLI, 1999, pp. 392–400.

2000

Bandera, M.C., 'Caravaggio, Malta e l'Ordine di San Giovanni', in Venice: exh. cat., *Lungo il tragitto crociato della vita,*

ed. L. Corti, Venice 2000,
pp. 187–96.
Bergamo: exh. cat., *Caravaggio.
La luce nella pittura lombarda*,
eds C. Strinati and R. Vodret,
Milan 2000.
Gallo, N., 'Lo stemma dei
Malaspina di Fosdinovo sulla tela
del San Girolamo del Caravaggio
a Malta: Note e osservazioni', in
*Atti e Memorie della Deputazione
di Storia patria per le antiche
province modenesi*, 22, serie XI,
2000, pp. 255–62.
Gregori, M., 'Un nuovo Davide
e Golia del Caravaggio', in
Paragone, LI, 31, 2000, pp. 11–22.
Rossi, F., 'Caravaggio e le armi.
Immagine descrittiva, valore
segnico e valenza simbolica',
in Bergamo: exh. cat., *Caravaggio.
La luce nella pittura lombarda*,
eds C. Strinati and R. Vodret,
Milan 2000, pp. 77–88.
Russo, S., *Vincenzo Mirabella
cavaliere siracusano*,
Palermo-Syracuse 2000.
Treffers, B., *Caravaggio nel
sangue del Battista*, Rome 2000.
Vannugli, A., 'Enigmi caravaggeschi:
i quadri di Ottavio Costa',
in *Storia dell'Arte*, XCIX, 2000,
pp. 55–83.
Venice: exh. cat., *Lungo il tragitto
crociato della vita*, ed. L. Corti,
Venice 2000.
Vodret, R., 'Il giallo dei due
S. Francesco', in *Ars*, IV, 2000, 11,
pp. 140–5.

2001
Abbate, V., 'Contesti e momenti
del primo caravaggismo a
Palermo', in Palermo: exh. cat.,
*Sulle orme di Caravaggio tra
Roma e la Sicilia*, eds V. Abbate,
G. Barbera, C. Strinati and R.
Vodret, Venice 2001, pp. 77–97.
Chastel, A., *Le geste dans l'art*,
Paris 2001.
London-Rome: exh. cat., *The
Genius of Rome*, ed. B.L. Brown,
London and Milan 2001.
Macioce, S., 'Precisazioni sulla
biografia del Caravaggio a
Malta', in Palermo: exh. cat.,
*Sulle orme di Caravaggio tra
Roma e la Sicilia*, eds V. Abbate,
G. Barbera, C. Strinati and R.
Vodret, Venice 2001, pp. 25–37.
Marini, M.[1], *Caravaggio 'pictor
praestantissimus.' L'iter artistico
completo di uno dei massimi
rivoluzionari dell'arte di tutti i
tempi*, 3rd edn Rome 2001.
Marini, M.[2], 'Michelangelo

da Caravaggio in Sicilia', in
Palermo: exh. cat. *Sulle orme di
Caravaggio tra Roma e la Sicilia*,
eds V. Abbate, G. Barbera, C.
Strinati and R. Vodret, Venice
2001, pp. 3–23.
*The Palace of the Grand Masters
in Valletta*, ed. A. Ganado,
Valletta 2001.
Palermo: exh. cat. *Sulle orme di
Caravaggio tra Roma e la Sicilia*,
eds V. Abbate, G. Barbera,
C. Strinati and R. Vodret, Venice
2001.
Papi, G., *Cecco del Caravaggio*,
Soncino 2001.
Prohaska, W., *Kunsthistorisches
Museum Wien*, Munich 2001.
Rome-Berlin: exh. cat.,
*Caravaggio e i Giustiniani. Toccar
con mano una collezione del
Seicento*, ed. S. Danesi Squarzina,
Milan 2001.
Rome-New York: exh. cat.,
Orazio e Artemisia Gentileschi
(Rome-New York 2001–2), eds K.
Christiansen and J.W. Mann,
Milan 2001.
Sciberras, K., and Stone, D.M.,
'Saints and Heroes. Frescos
by Filippo Paladini and Leonello
Spada', in *The Palace of the
Grand Masters in Valletta*,
ed. A. Ganado, Valletta 2001,
pp. 139–57.
Sebregondi, L., 'Commende
gerosolimitane a Firenze: tracce
di storia artistica', in *Riviera
di Levante tra Emilia e Toscana.
Un crocevia per l'Ordine di San
Giovanni.
Genova-Rapallo-Chiavari 1999*,
Conference Proceedings,
ed. J. Costa Restagno, Bordighera
2001, pp. 576–607.
Spike, J.T., *Caravaggio*, New York
and London 2001.

2002
*Caravaggio nel IV Centenario
della Cappella Contarelli.
Convegno Internazionale
di Studi, Roma, 24–26 maggio
2001*, Conference Proceedings,
ed. C. Volpi, Città di Castello 2002.
Farina, V., *Giovan Carlo Doria
promotore delle arti a Genova
nel primo Seicento*, Florence 2002.
Freller, T., 'On the Trail
of Caravaggio: Joachim
von Sandrart in Malta', in
*Melitensium Amor: Festschrift in
honour of Dun Gwann Azzopardi*,
eds T. Cortis, T. Freller
and L. Bugeja, Malta 2002,
pp. 289–300.

Galea, M., *Grandmaster Alophe
de Wignacourt 1601–1622*,
Malta 2002.
Macioce, S., 'Caravaggio a Malta:
precisazioni documentarie',
in *Caravaggio nel IV Centenario
della Cappella Contarelli.
Convegno Internazionale
di Studi, Roma, 24–26 maggio
2001*, Conference Proceedings,
ed. C. Volpi, Città di Castello
2002, pp. 155–69.
*Melitensium Amor: Festschrift in
honour of Dun Gwann Azzopardi*,
eds T. Cortis, T. Freller and L. Bugeja,
Malta 2002.
Pacelli, V., *L'ultimo Caravaggio*,
Naples 2002.
Papi, G., 'Jusepe de Ribera a
Roma e il Maestro del Giudizio
di Salomone', in *Paragone*, 3. series,
LIII, 44, 2002, p. 21–43.
Prohaska, W., and de Ruggieri, B.,
*Analisi scientifiche e storico-
artistiche della Madonna
del Rosario e del 'Davide' del
Caravaggio a Vienna*, Conference
'E modernamente si è messo
in uso di parar li Palazzi
compitamente con quadri': Fonti
e documenti per la storia del
collezionismo in Italia e in Europa
Centrale, Roma, Università della
Sapienza, Istituto Storico
Austriaco, 21–22 febbraio 2002*,
Website Progetto Giove, European
Union, 2002.
Robb, P., *M.*, London 1998; Milan
2002.
Sciberras, K.[1], 'Frater Michael
Angelus in Tumultu: The Cause
of Caravaggio's Imprisonment
in Malta', in *The Burlington
Magazine*, CXLIV, 1189, 2002,
pp. 229–32.
Sciberras, K.[2], 'Riflessioni su
Malta al tempo del Caravaggio',
in *Paragone*, LIII, 3rd series,
no. 44, 2002, pp. 3–20.
Stone, D.M., 'In Figura Diaboli:
Self and Myth in Caravaggio's
David and Goliath', in *From
Rome to Eternity: Catholicism
and the Arts in Italy, ca. 1550–1650*,
eds P.M. Jones and T. Worcester,
Leiden 2002, pp. 19–42.
Testa, L., '...in ogni modo
domatina uscimo: Caravaggio
e gli Aldrobandini', in *Caravaggio
nel IV Centenario della Cappella
Contarelli. Convegno
Internazionale di Studi, Roma,
24–26 maggio 2001*, Conference
Proceedings, ed. C. Volpi, Città
di Castello 2002, pp. 129–54.

Treffers, B., *Caravaggio. Die
Bekehrung des Künstlers*,
Amsterdam 2002.

2003
*La Galleria Palatina e gli
Appartamenti Reali di Palazzo
Pitti. Catalogo dei dipinti*,
eds M. Chiarini and S. Padovani,
II, *Catalogo*, Florence 2003.
Ganado, A., *Valletta Città Nuova.
A Map History (1566–1600)*,
Valletta 2003.
Macioce, S., *Michelangelo Merisi
da Caravaggio. Fonti e documenti
1532–1724*, Rome 2003.
Navarro, F., 'Caravaggio e i
caravaggeschi', in *La Galleria
Palatina e gli Appartamenti Reali
di Palazzo Pitti. Catalogo
dei dipinti*, eds M. Chiarini
and S. Padovani, I, *Storia
delle collezioni*, Florence 2003,
pp. 220–1.
Puglisi, C., *Caravaggio*, London
2003.
Syracuse: exh. cat., *Caravaggio.
Due capolavori a confronto*,
ed. G. Barbera, Syracuse 2003.
Spinosa, N., *Ribera. L'opera
completa*, Naples 2003.
Spiteri, S.C., *Armoury of the
Knights*, rev. edn Malta 2003.

2004
Bonazzoli, F., 'Così il Caravaggio
ha riavuto la sua Orsola', in
'Il segno di Caravaggio', *Corriere
della Sera Eventi*, June 28, 2004.
Cremona-New York: exh. cat.,
*Pittori della realtà. Le ragioni
di una rivoluzione da Foppa
e Leonardo a Caravaggio e Ceruti*,
eds M. Gregori and A. Bayer,
Milan 2004.
Rome-Milan-Vicenza: exh. cat.,
*L'ultimo Caravaggio: il 'Martirio
di Sant'Orsola' restaurato*, Milan
2004.
Vodret, R., 'I *doppi* di Caravaggio:
le due versioni del S. Francesco
in meditazione', in *Storia dell'Arte*,
108, 2004.

Forthcoming
Prohaska, W., and Cardinali, M.,
'Il *David* di Caravaggio?', in *Atti
del Colloquio Internazionale:
Caravaggio e il suo ambiente,
Roma, Biblioteca Hertziana,
30–31 gennaio 2004*.
Sciberras, K., and Stone,
D.M., 'Malaspina, Malta,
and Caravaggio's *St Jerome*,
in *Paragone*.
Sebregondi, L., *San Jacopo
in Campo Corbolini*.
Stone, D.M., *'The Apelles
of Malta': Caravaggio and his
Grand Master*.

Printed in January 2005
for Electa Napoli

Photocomposition: Grafica Elettronica, Napoli
Pre-printing and printing: SAMA, Quarto (Napoli)
Binding: Legatoria S. Tonti, Mugnano (Napoli)